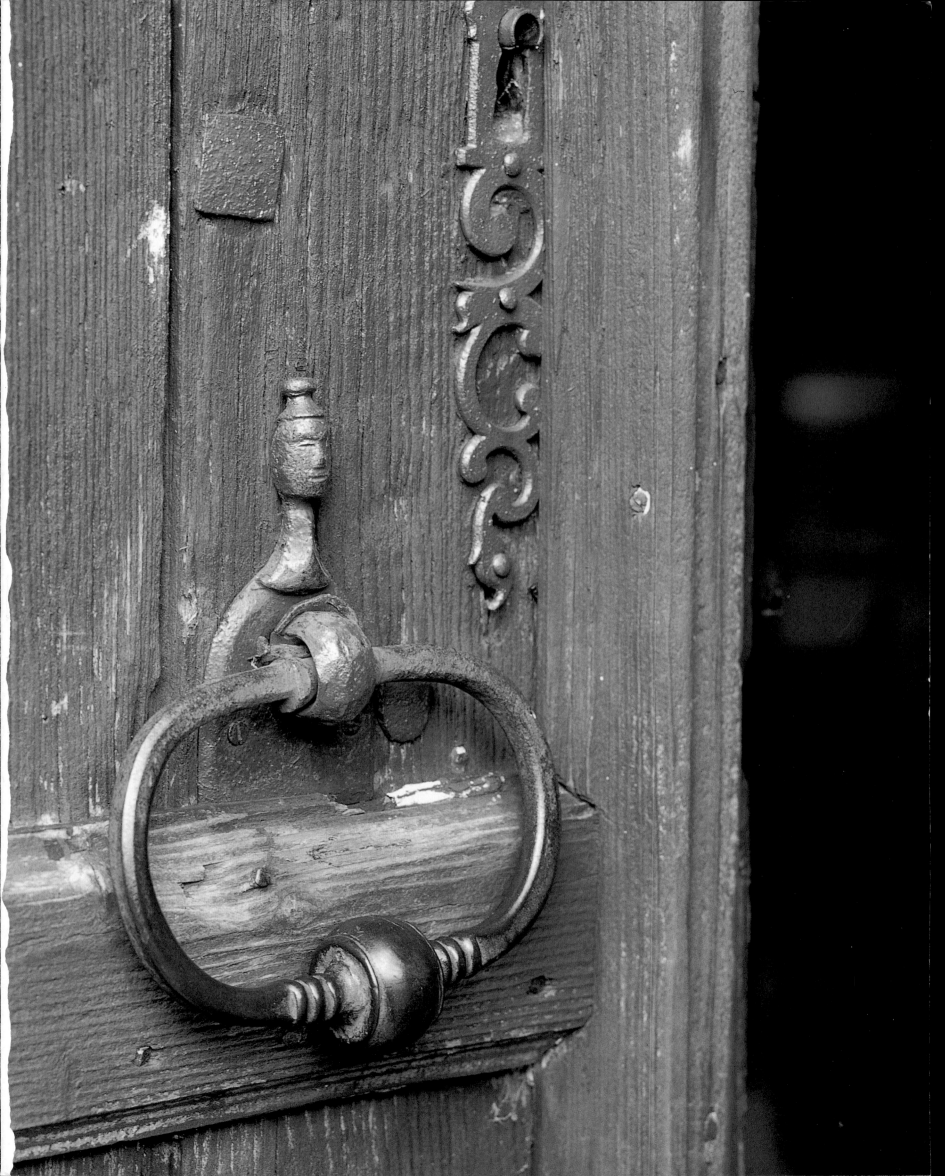

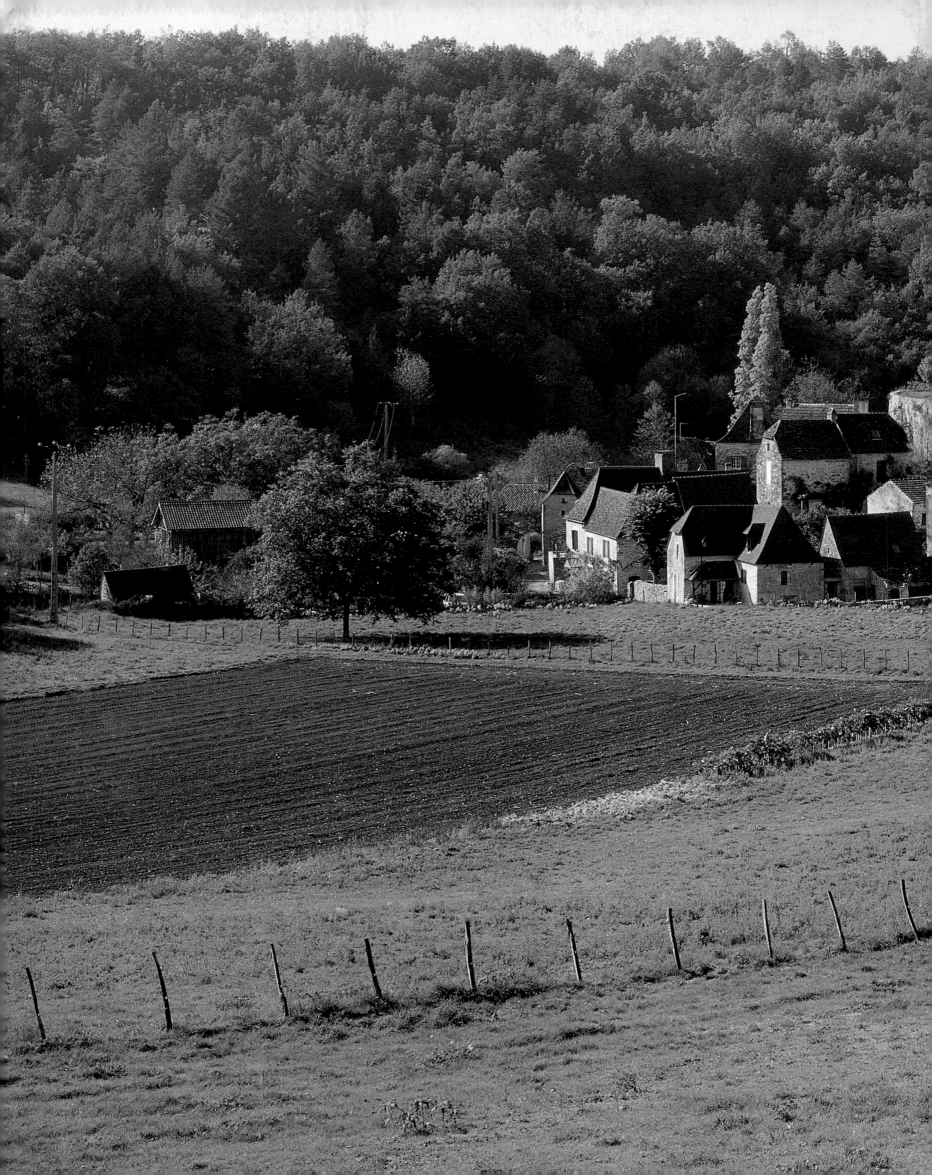

JAMES BENTLEY PHOTOGRAPHS BY HUGH PALMER

The Most Beautiful Villages of the Dordogne

with 258 color illustrations

T&H

THAMES AND HUDSON

AUTHOR'S ACKNOWLEDGMENTS
My text is dedicated to Audrey Bentley and Hardi Bharj, with
whom I have laughed as we have spent much time together
exploring the Périgord.

PHOTOGRAPHER'S ACKNOWLEDGMENTS
I am very grateful to all the kind and helpful people I met in the
Périgord, especially to Denis and Jan Sitwell, and to Guy and
Julie Erskine. These pictures are dedicated to the memory of
my aunt Margaret Ogle, life-long traveller and the greatest
company.

Half-title *A delightful example of Périgourdin craftsmanship in detail,*
the massive handle to the door of the church at Beauregard-et-Bassac,
Périgord Blanc, is also a reminder of the traditional power of religion in
the area.

Preceding pages *Buildings in a landscape in the Périgord Noir: the fine château*
of Berbiguières looks over its accompanying hamlet, near Beynac.

These pages *A bucolic scene near the hamlet of Turnac, opposite Montfort,*
on the river Dordogne.

Overleaf *A land of magnificent houses and vineyards, the Périgord Pourpre*
boasts many substantial castles, like the Château de Bannes, north of the
village of Beaumont-du-Périgord.

© 1996 Thames and Hudson Ltd, London
Text © 1996 James Bentley
Photographs © 1996 Hugh Palmer

First published in the United States of America in 1996 by
Thames and Hudson Inc., 500 Fifth Avenue, New York, New York 10110

Library of Congress Catalog Card Number 96-60055
ISBN 0-500-54201-5

Printed and bound in Singapore

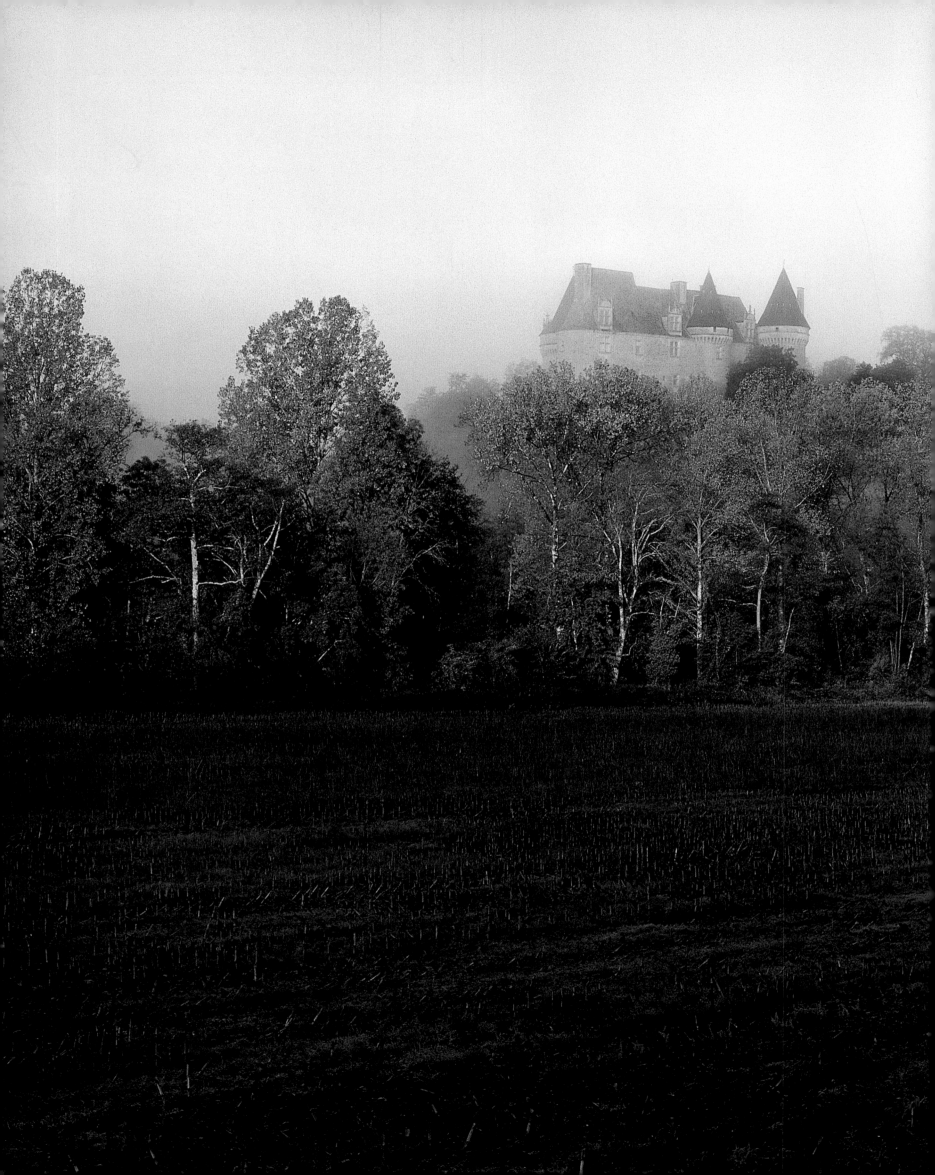

CONTENTS

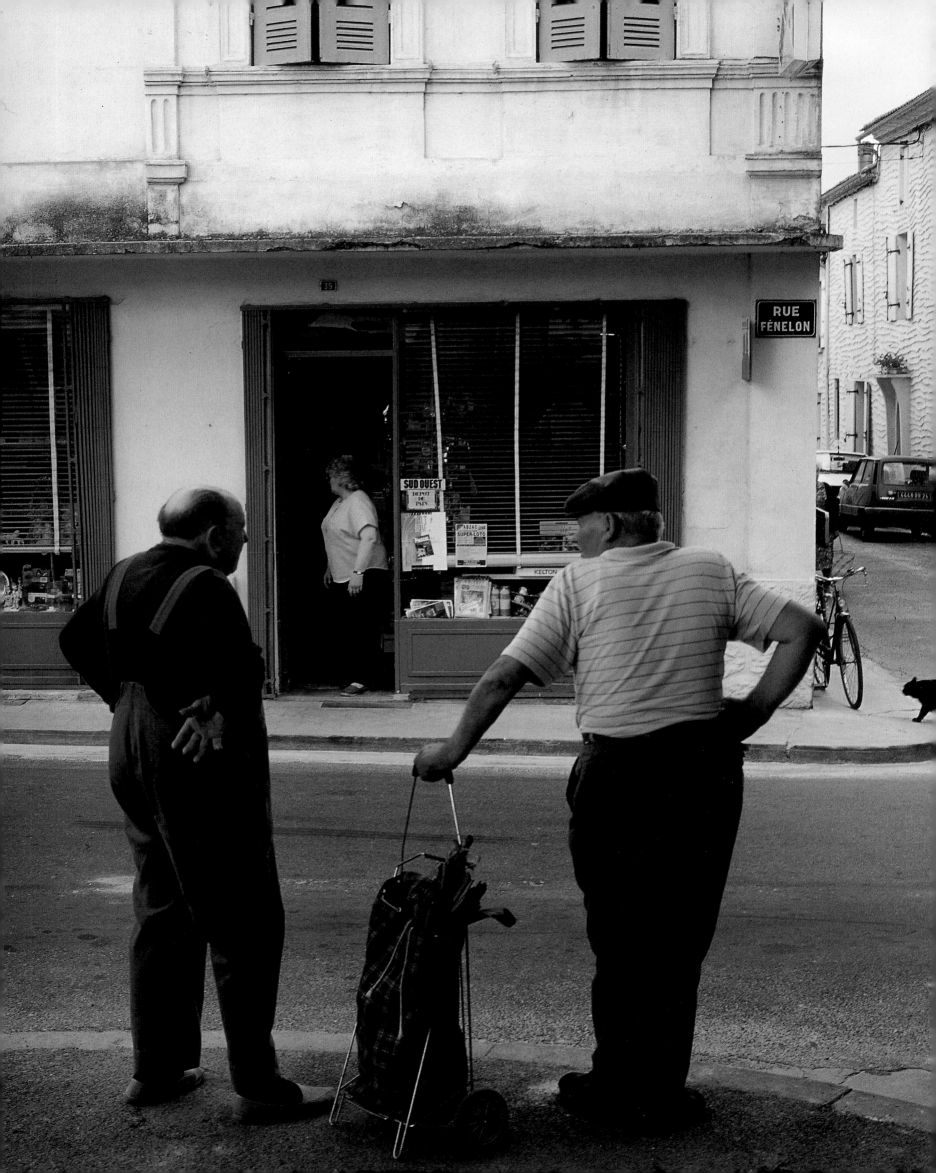

INTRODUCTION

Across the river Dordogne two medieval fortresses glare at each other, rising above two minuscule villages. One of them, Château Beynac, was a bastion of the French throughout the Hundred Years' War. The other, Château de Castelnaud, was the stronghold of the English. Both châteaux can be visited today, visible legacies of the strife-torn history of the Périgord, where the past is ever present. The present *département* of the Dordogne was created out of the former Périgord during the administrative changes wrought by the French Revolution. Its inhabitants still doggedly use the old name for their region, as indeed do most of the many foreign visitors and residents. Only the British, settled there in substantial numbers, refer to it consistently as the Dordogne.

Along with the rest of Aquitaine, the Périgord was part of the dowry of Queen Eleanor of France who, eight weeks after her marriage to the French King Louis VII was annulled, married the future King of England, Henry Plantagenet. She and her husband were crowned in Westminster Abbey on 19 December 1154, but Louis VII consistently refused to allow that Aquitaine belonged to the English. From that time until 1453 the kings of France and England disputed the territory, sowing it with a thousand defensive châteaux, some now in ruins, some perfectly preserved. Because of these dynastic quarrels, a tiny Périgourdin village, such as Saint-Léon-sur-Vézère with fewer than 350 inhabitants, may be protected by as many as three châteaux.

More strife was engendered by the Albigensian Crusade, begun in 1208 to wipe out the Christian heresy of Catharism which was flourishing in southern France. And even when these hostilities ceased, the Périgord remained turbulent, ravaged by civil war, plague, peasant revolts and finally by the French Revolution.

All this has left visible marks and legacies in countless entrancing villages. For example, the remains of an Augustinian abbey, sacked by the Huguenots during the sixteenth-century Wars of Religion, stand in magnificently fortified Domme, which now houses fewer than 900 inhabitants and was founded by the French King Philippe le Hardi in 1280. Deep in one of the forests of the Périgord are the melancholy ruins of Château de l'Herm, destroyed by peasants during an uprising. Château Mareuil is another romantic ruin, pillaged at the time of the Revolution. And on the façade of the medieval church at Monpazier you can still read words inscribed by the eighteenth-century revolutionaries to declare their belief in a Supreme Being and the immortality of the soul.

Conversation piece (opposite): a delightful demonstration of the steady pace of life in the Périgord Pourpre; it is hard to imagine that the region was once divided by strife.

A reference to the strong gastronomic traditions of the region: this figure of a duck decorates the wall of a café at Bourdeilles, Périgord Vert.

Because of incessant war, even the churches of the Périgord are often fortified (the most powerful in the entrancing village of Saint-Amand-de-Coly, the second most powerful in the haphazardly quaint village of Besse). And in the thirteenth century rival English and French monarchs commissioned their seneschals to build a series of spectacularly fortified new foundations to defend their claims to this part of France. Known as *bastides*, many have survived intact and today number among the finest villages of France.

In the Périgord visible history pushes itself yet further into the past. At Breuil families still inhabit stone houses built by the Gauls. No other part of the world displays more traces of the Paleolithic age. Neolithic men and women also lived here, though their remains are fewer. Prehistoric men and women painted and carved the walls of caves, most of which were opened up only in the nineteenth and twentieth centuries – the most celebrated those at Lascaux. Written history began with the tribe known as the Petrucorii, who built an arena still to be seen (transformed into a children's playground) in the capital of the *département* and who gave the Dordogne its traditional name: the Périgord.

Four colours – *green*, *white*, *purple*, and *black* – officially designate the four regions of the Périgord, effectively symbolizing the diversity of the third largest *département* of France. *Green* evokes the verdant woods and fields of the northern crescent, *white* the limestone valleys of the centre, *purple* the full-bodied red wine produced in the area around Bergerac, and *black* the renowned truffles of the southeast, the 'black diamonds' of classic French cuisine. Traditional ways have not died out here. The immaculate herds of cows which chew their cud in the fields of the Périgord almost invariably include a bull. Artificial insemination has yet to reach much of this region, where the old ways of farming prevail to a remarkable degree.

The northernmost part, around the town of Nontron, boasts gentle, lake-strewn pastures. Further south, around Mareuil-sur-Belle, these give way to fields of wheat and maize, while further south around Ribérac the fields support flocks of sheep. Around Périgueux, the capital and geographical heart of the Périgord, gorse-tufted hills alternate with warm, sometimes humid valleys, and this region has concentrated on growing fruit, particularly strawberries, as well as the collecting of the prized black truffles.

South of Périgueux the *département* neatly divides into the territory around Bergerac and the region of Sarlat-la-Canéda. The former is wine and tobacco country, the latter the richest part of the Périgord, with yet more oaks and truffles, with fields of tobacco, walnut trees and goose farms producing *foie gras*.

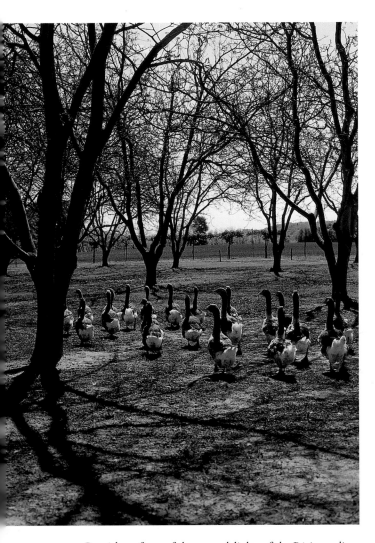

Providers of one of the great delights of the Périgourdin table, foie gras, *geese are reared extensively in the Périgord Noir.*

Because such a convoluted terrain does not easily lend itself to modern methods of cultivation, some farms are so small as to be barely viable, especially when the French laws of inheritance divide them still further. In some parts a form of strip farming still prevails, with families cultivating scattered clutches of land on which they nevertheless manage to grow enough for themselves and even have something left over to sell on the markets and fairs which have remained central to the economy of this region since medieval times.

But because the farms are so small, many of them unable to support more than a couple of persons, a retreat from the land which began in the nineteenth century still continues. At the end of the nineteenth century there were nearly 200,000 Dordogne farms. Today there are fewer than 50,000 and about another 1,000 disappear every year. One visible result is the neglected state of many of the forests of the Périgord, trees left to grow unattended and in consequence spindly and wild. Yet in other parts, in the southern part around Besse for example, the forests are lush, dark, lovely and deep.

Around the *bastides* the countryside is also well-tilled and productive. To attract men and women to their new foundations, the medieval French and English monarchs had to offer them charters with unusual freedoms, almost invariably including the right to own land outside the *bastide* and to sell their produce at the local market. As a result, this land was cleared and assiduously tended. Centuries later the effect of these thirteenth- and fourteenth-century charters can be seen in the soil of the Périgord.

Until recent years the river trade was another essential part of the economy of the Périgord. Five major rivers, the Dordogne itself, the Isle, the Vézère, the Auvézère and the Dronne, meet west of the *département*, their waters swollen by smaller, poplar-lined tributaries such as the Céou and the Dropt. Even as late as the early part of the present century the rivers constituted the principal means of transport for the population. Light boats would sail as far as Bordeaux, carrying wood, fruit and wine. Then the boats would be broken up, their wood used for other purposes. Heavier boats were used to sail back, tacking from side to side along the Isle and the Dordogne. These days, the old-fashioned boats mostly transport tourists.

Beside these rivers rise châteaux, merchants' houses, water-mills and restaurants. Dominating a huge loop in the river Dordogne is Château Montfort, one of many built in the Middle Ages to control the river trade. A restaurant today will be called the Maison du Passeur, indicating that here once lived a ferryman and his family. Traditional dishes (*carpe farcie au foie gras* or *friture périgourdine*, for example) still survive from the days when the fish of these rivers was part of the staple diet of the people of the Périgord.

Overleaf
Picking stones from the earth near Tocane-Saint-Apre, Périgord Vert; this traditional act of clearing the land seems to provide a direct link with times long gone by.

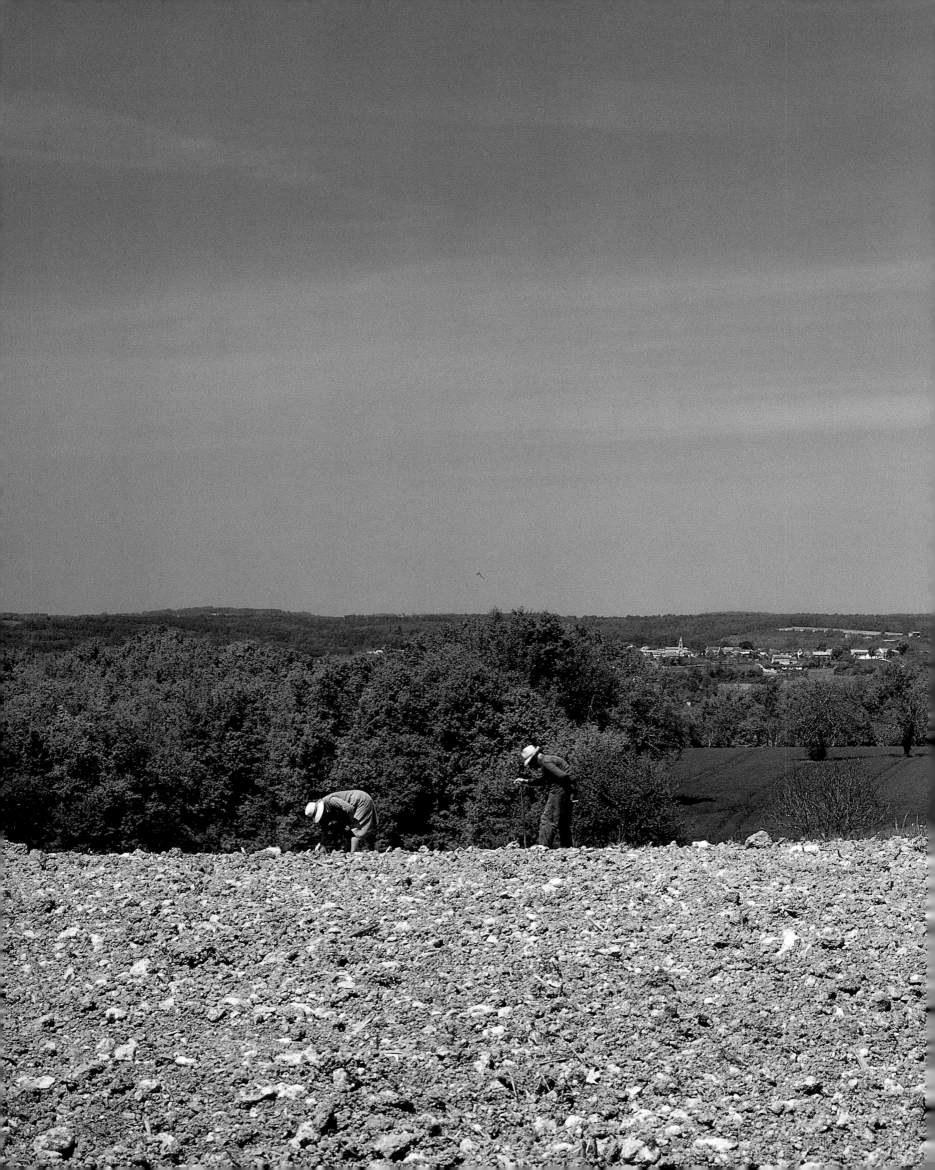

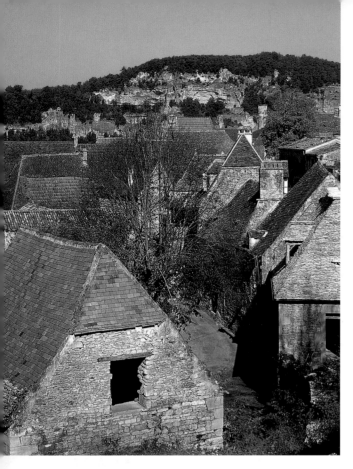

The terracotta roofs of Saint-Julien, Périgord Noir, look towards the dominant power in the land, the bastide *of Domme. Stones from the cliff in the background provided the main building material for the houses.*

The traditional houses of the Périgord have changed very little over the centuries; their grace and charm continue to add allure to many of the most beautiful villages of this region. Some are built out of the local yellow-white limestone, sometimes cut into rough-hewn blocks, at other times sliced into slabs; others are built of wattle and daub, or cob; many are half-timbered. Some have pillars and balustrades; others boast scrolled dormer windows. Yet the three-storeyed houses in the villages of the Périgord (and in particular the farmhouses) have a style that has not changed for centuries. Many retain steep roofs made not of tiles but of stones (known locally as *lauzes*). Usually the whole family lived in the middle storey, which was occasionally divided into two, separating the bedroom from the living room, but was more usually simply a long, high and cool dwelling area.

Above, in the rafters, tobacco leaves were dried. Below, in the cellar and storehouse, often entered by a swing-door cut in two, wine fermented in barrels set astride two massive legs. Today, these three storeys will often have been transformed into living rooms, bedrooms, bathrooms and dining rooms. The dry-stone walls will have been pointed. But the traditional structure remains visible, scarcely modified by the twentieth century. The true aspect of the Périgourdin village is an ancient one.

Today, well over half the population of the Périgord lives in communities of fewer than 2,000 inhabitants. Houses cluster in hamlets or spread out within hailing distance of each other. Farm buildings surround three sides of a courtyard, the fourth side open to the road. Some hamlets possess a tiny, rarely used chapel, and a small graveyard. Many still preserve a communal oven for baking bread. And in the surrounding fields you can see circular, dry-stone cabins with quaintly shaped stone roofs, in which farm labourers, *vignerons* and shepherds used to take shelter and sometimes still do.

In addition, the Périgord possesses no fewer than 800 Romanesque churches, some half of which are still of original construction, most of them roofed with ancient *lauzes*. Seemingly modest villages, such as Cénac-et-Saint-Julien near Domme, boast churches whose gargoyles and bosses display all the inventiveness (and occasionally vulgarity) of the medieval mind. No-one had enough money to transform these churches into Gothic or Renaissance edifices, so that many villages of the Périgord have preserved these ecclesiastical jewels of the Romanesque era. For the same reason, many (such as magical La Roque-Gageac) still have ancient kilns and troglodyte homes.

Crucially important to the survival of these villages was the weekly or bi-weekly market, conducted according to rights granted in the Middle Ages and still jealously treasured. In many of the loveliest

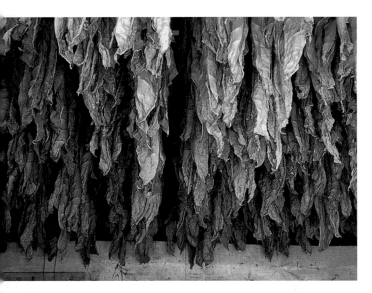

Still a staple crop of the Périgord Noir, tobacco would once have been dried in the house itself; here, the golden leaves provide a dramatic sight in a barn at Cénac.

villages of the Périgord the most imposing building is the medieval market-hall. And ancient measures for weighing grain still survive in such superb places as Monpazier and Villefranche-du-Périgord.

The traditional speech and folklore of the Périgord has also survived. When the farmer's wife calls her husband Moïse from the field for his midday soup, she cries not 'Moïse' but Moïsche'. Her ancestors used the same diction. Anyone seeking a hairdresser in a village or town here must look not for the sign 'La Coiffeuse' but for 'Lou Frisou'. Folklore festivals abound, when villagers do not put on a cabaret act for tourists, but truly exult in their traditions.

Religious festivals also remain important in Périgourdin villages. On Palm Sunday twigs are cut from trees and taken to church, to be blest by the parish priest. On All Saints' Day the villagers will trim the hedge of the graveyard and tidy up the graves, waiting for the priest to come to bless the dead. Shrove Tuesday is a time for slaughtering pigs. In countless villages, patronal festivals are still observed with both devotion and merriment.

Equally important are the fairs. Walnuts, *foie gras*, strawberries, chestnuts, pigs, geese and mushrooms appear at long-established annual events in the villages. The local gastronomy, one of the most renowned in France, is heavily coloured by the wines of the Bergerac region, where the sixteenth-century essayist and diplomat Michel de Montaigne lived in a most beguiling village. He wrote, 'I hope death finds me planting my cabbages, not so much caring about death as about the imperfect state of my garden.' Cabbages do indeed still grace tables in the Périgord, often now *farcis* with minced veal, garlic, breadcrumbs and eggs. Then into their coffee the diners will pour a generous slug of Périgourdin *eau-de-vie*.

Like Michel de Montaigne, present-day villagers in the Périgord, savouring the past in the present, remain content and welcoming. As Maurice Robert put it, 'Generations have found here an especially hospitable earth, offering them natural shade, the basic material for their tools, the delicious warmth of the slopes, the abundant water of rivers, the game of the plateaux and plains – a Paradise, or at least a Promised Land.'

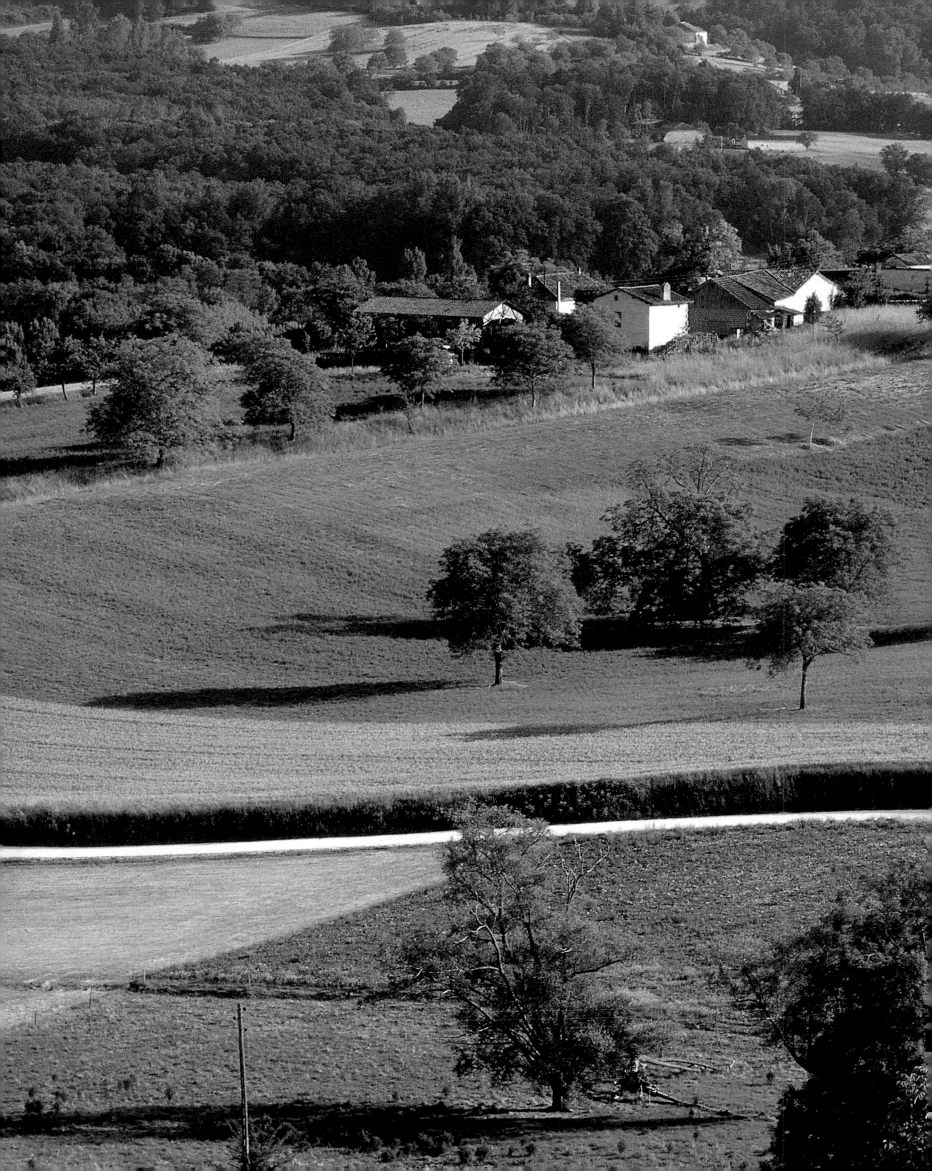

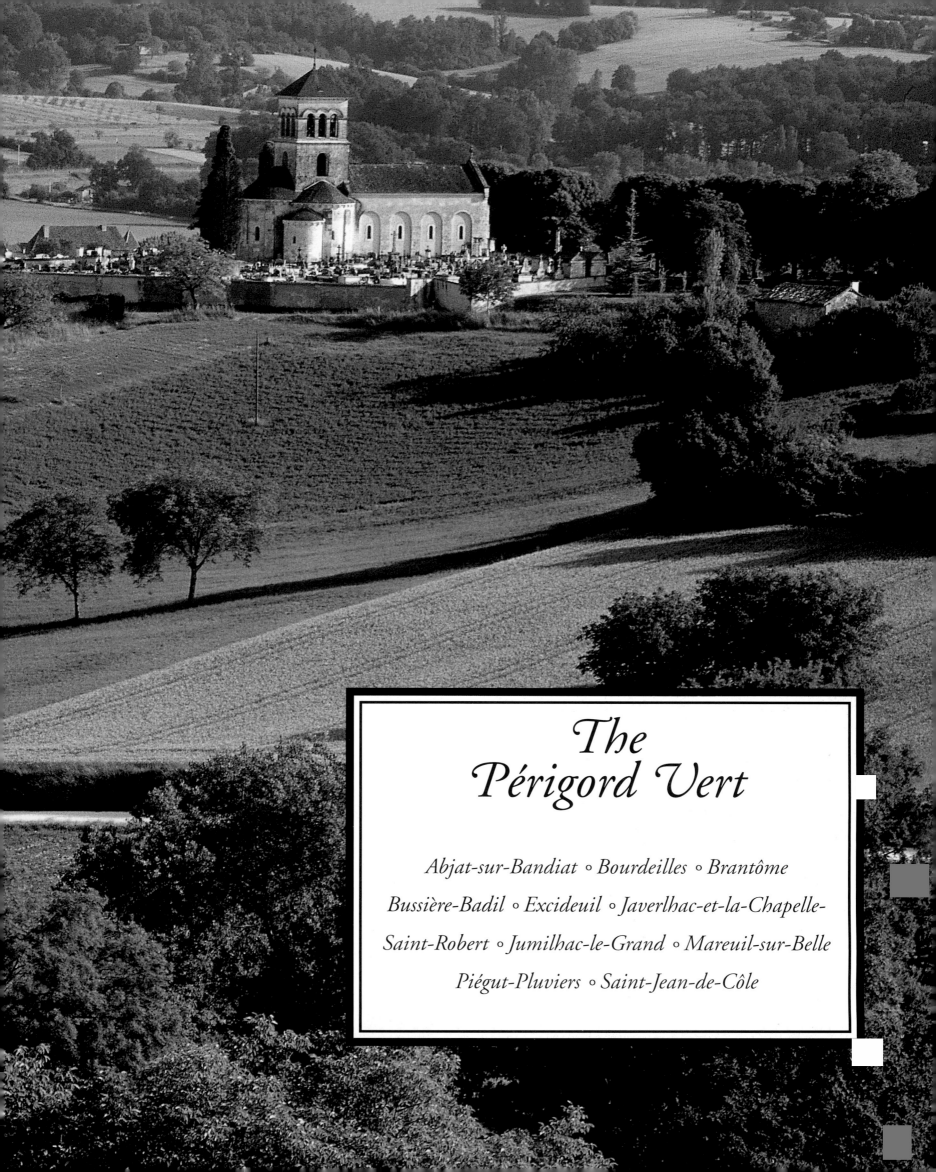

The
Périgord Vert

Abjat-sur-Bandiat ∘ Bourdeilles ∘ Brantôme

Bussière-Badil ∘ Excideuil ∘ Javerlhac-et-la-Chapelle-

Saint-Robert ∘ Jumilhac-le-Grand ∘ Mareuil-sur-Belle

Piégut-Pluviers ∘ Saint-Jean-de-Côle

Northern Dordogne, which borders on the Limousin, has been known as the Périgord Vert ever since Jules Verne so described it, captivated by this region when he visited the Périgord in the late nineteenth century. It stretches from Lanouaille in the north-east as far as La Roche-Calais in the south-west, taking in en route such enticing villages and towns as Nontron, Brantôme, Bourdeilles and Ribérac.

This crescent-shaped region is indeed always green. Even in high summer the humidity of its climate renders the fields and the woodlands verdant. A multitude of rivers water its soil and have shaped its landscape. Around Lanouille flow the Auvézère, the Isle, the Haute-Loue and the Loue, the last deep and narrow. The gorges of the Auvézère and Loue also water the region around Excideuil, as does the river Ravillon. South of Excideuil the valleys of the limestone Causse are fertile, the limestone itself often surfacing magnificently, especially around Brantôme at the heart of the Périgord Vert.

Brantôme is on one of the major rivers of this part of the Périgord, the Dronne, its waters untamed until they reach Saint-Pardoux-la-Rivière, south-east of Nontron. Swollen by tributaries such as the Côle and the Trincou, the Dronne then flows from Brantôme south-west towards Ribérac, passing through the lovely village of Tocane-Saint-Apre on its way.

At Terrasson the waters of the Vézère enter the *département* of the Dordogne and immediately introduce visitors to prehistory. Just above Terrasson the bronze age oppidum of La Roche-Libère, stretching for more than two kilometres, has ancient stone huts, an arena and the base of a watch tower. Not surprisingly, first the Gauls and then the Romans occupied this strategic but also welcoming site.

Many of the most seductive villages of the Périgord Vert derive part of their charm from these rivers. Some (such as Saint-Jean-de-Côle beside the river whose name it bears or Javerlhac-et-la-Chapelle-Saint-Robert on the Bandiat) grew up around monastic foundations, and monasteries were invariably founded beside rivers. In other places a château overlooks a river, such as that of Jumilhac-le-Grand. In all three villages the river turned the wheels of mills which still survive, and the Bandiat is also rich in forges, which once brought the region prosperity.

Today much of the Périgord Vert's wealth derives from the powerful cattle which graze in particular around Excideuil, where in the nineteenth century General Bugeaud, former governor of Algeria, ameliorated the lot of the local farmers by introducing new species of grass. Most of the beef of the Périgord comes from this region, as does much of the veal from its white calves.

Finally, a completely different aspect of the Périgord Vert is presented by its forests, particularly the Double, which covers some 50,000 hectares and was once entirely inhospitable and a haven for brigands, fugitives and poor charcoal burners. Winter here brings rain. Summer brings mists. The pines, oaks and chestnut trees border on lakes and marshes. In the eighteenth century a measure of prosperity reached the Double as the forest was exploited for the naval bases at Bordeaux and La Rochelle. Even so, in 1793 some deputies from the Gironde were eaten by wolves here. The Double was finally conquered by the monks of La Trappe-de-Bonne-Espérance, who founded a monastery near Echourgnac in 1866 and began to drain the swamps. Today, the region around Echourgnac has been transformed into a favoured haunt of holidaymakers and tourists, and nuns have replaced the monks.

Preceding pages
The view south towards Saint-Madeleine-et-Montagrier in the valley of the Dronne reveals the verdant scenery which gives the region its name.

The Périgord Vert is washed by many rivers, large and small; here, the Dronne (opposite) flows through idyllic scenery on its way past Tocane.

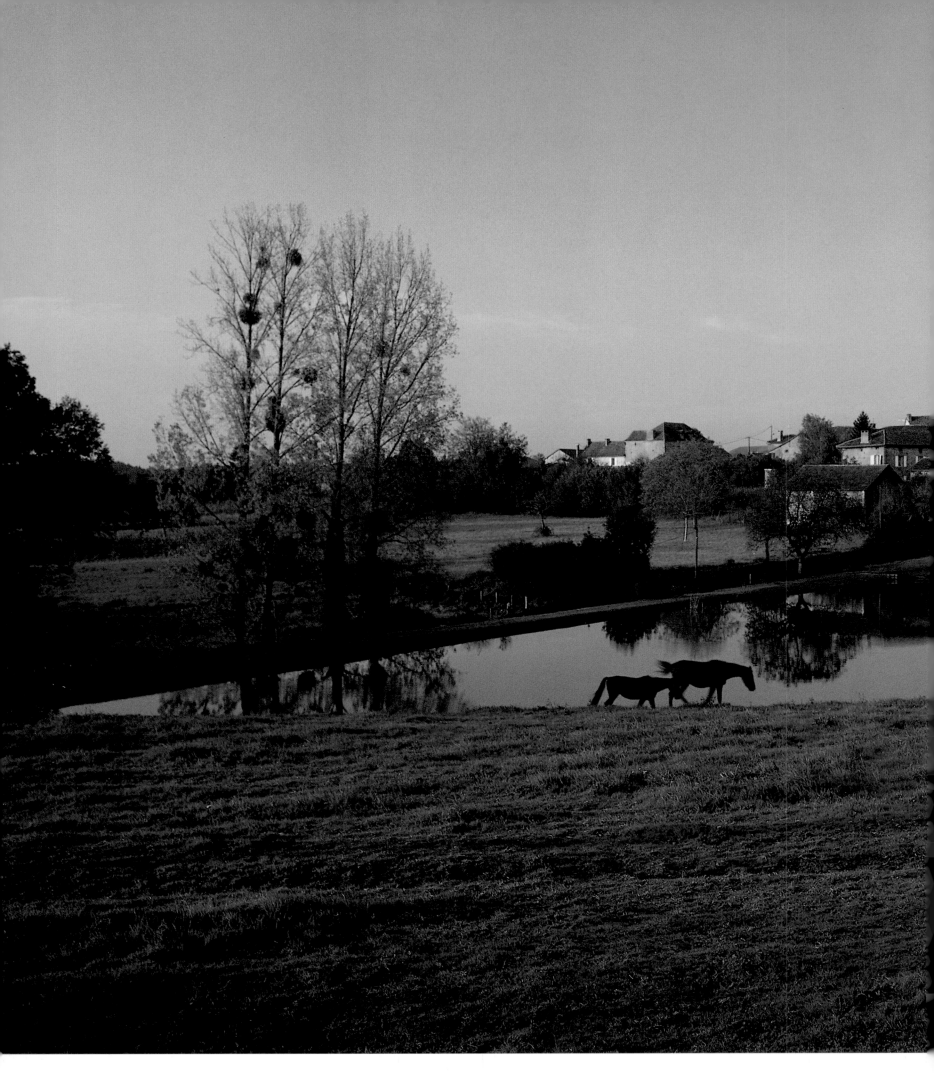

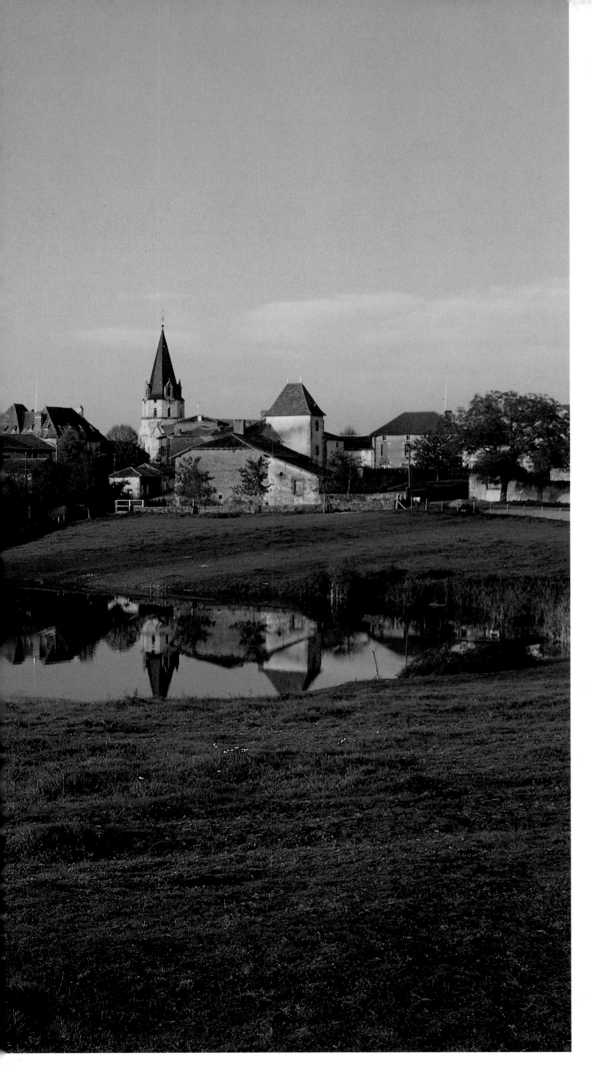

Abjat-sur-Bandiat

On a lovely lakeside site inhabited since the Merovingian era, Abjat-sur-Bandiat, north-east of Nontron, was coveted by medieval lords and became prosperous because of the mills and forges on the banks of the river Bandiat. Abjat's name indicates that this was once a Gallo-Roman stronghold (as do many of the Périgourdin place-names ending in 'ac', here corrupted to 'at'). In the eighteenth century the forges alongside the Bandiat were supplying the navy based at Rochefort with cannons, cannon-balls, mortars and gun-carriages. Once a populous spot, as its prosperity declined in the nineteenth century Abjat lost about a thousand inhabitants.

Some of the mills survive to add charm to this village, as do little waterfalls and cascades as well as the woodlands of the Ballerand forest. Sixteenth-century Château Ballerand dominates the river, while the medieval Château de la Malignie still glowers aggressively nearby.

Abjat-sur-Bandiat boasts a Romanesque church, dating from the thirteenth century but restored and altered in the sixteenth and seventeenth centuries. Its powerful belfry was rebuilt in 1874. The church is well worth visiting for its treasures, all dating from the seventeenth century: stone statues, and especially a painted wood-carving of Christ crucified.

Abjat's Manoir de Grospuy dates from the fifteenth century, and three kilometres east rises the nineteenth-century Château de l'Étang. To the north-west, en route for Piégut-Pluviers, the road crosses the bridge of the Charelle, where in 1640 the lord of Thiviers, who was attempting to abduct a young girl, was massacred by a group of peasants and buried beneath the bridge. The reprisal was savage. Peasants were hanged, broken on the wheel, imprisoned or sent to the galleys. Local markets and fairs were suppressed and belfries thrown to the ground.

Surrounded by streams, lakes and woodlands, the peaceful village of Abjat-sur-Bandiat languishes around the nineteenth-century spire of its church, a late addition to a Romanesque structure. The mill-pond in the foreground reminds us of the prosperous past of the village, when the river Bandiat was harnessed for water power.

*T*he tranquil streets of Abjat (below *and* right), *colourfully bedecked in bunting and flowers, tell us that this is the hour of the mid-day meal and early afternoon rest.*

*T*his view of the parish church of Abjat-sur-Bandiat (opposite) *shows the strength of the original Romanesque structure.*

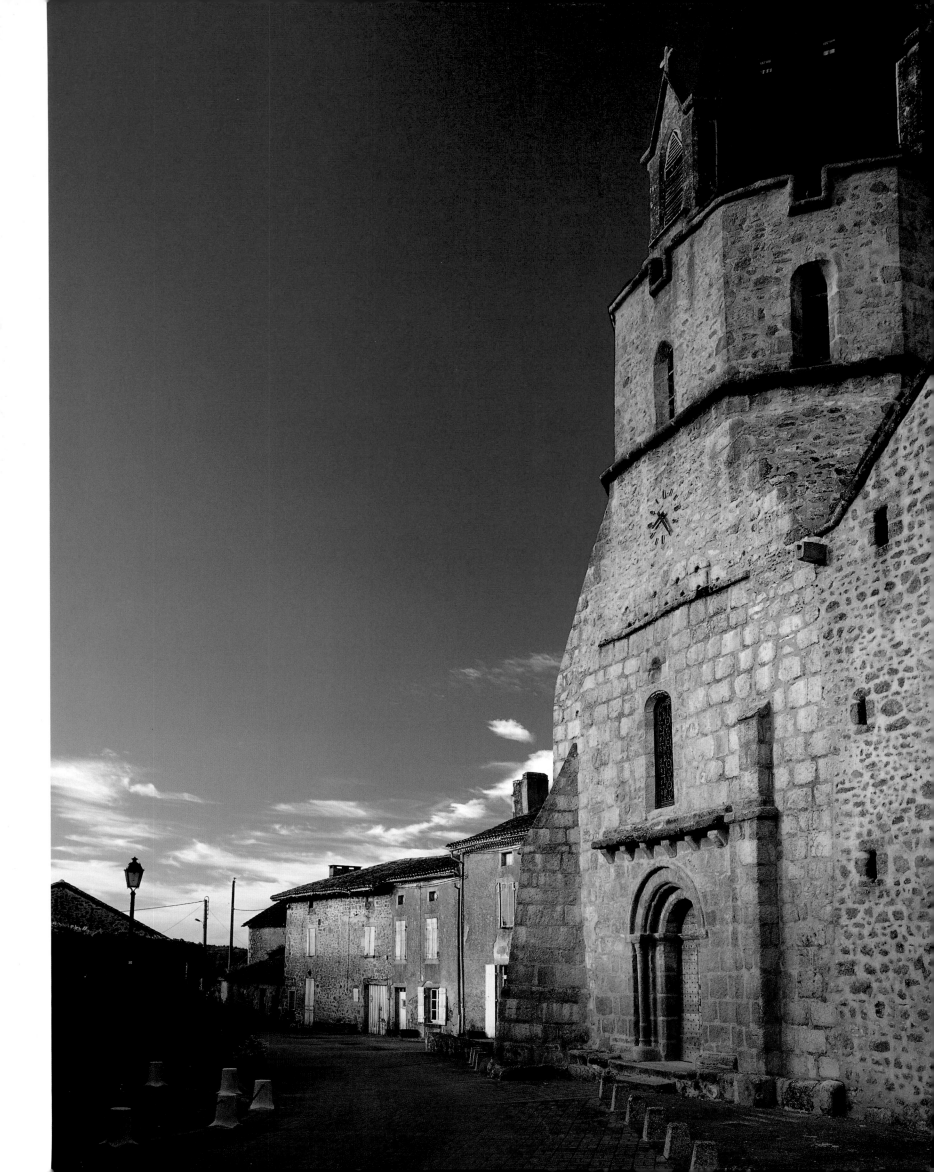

The river Bandiat flows swiftly enough to power this old mill (opposite), *a memory of the production of cereals on which the village long depended for its prosperity.*

*S*een from across one of the many stretches of water which surround it, Abjat stands boldly outlined against the sky (above). *The rural aspect of the village is perfectly exemplified by this barn entrance* (right). *Note the irregularly chiselled stones above the lintel, with massive ones at each corner, typical of Périgourdin building.*

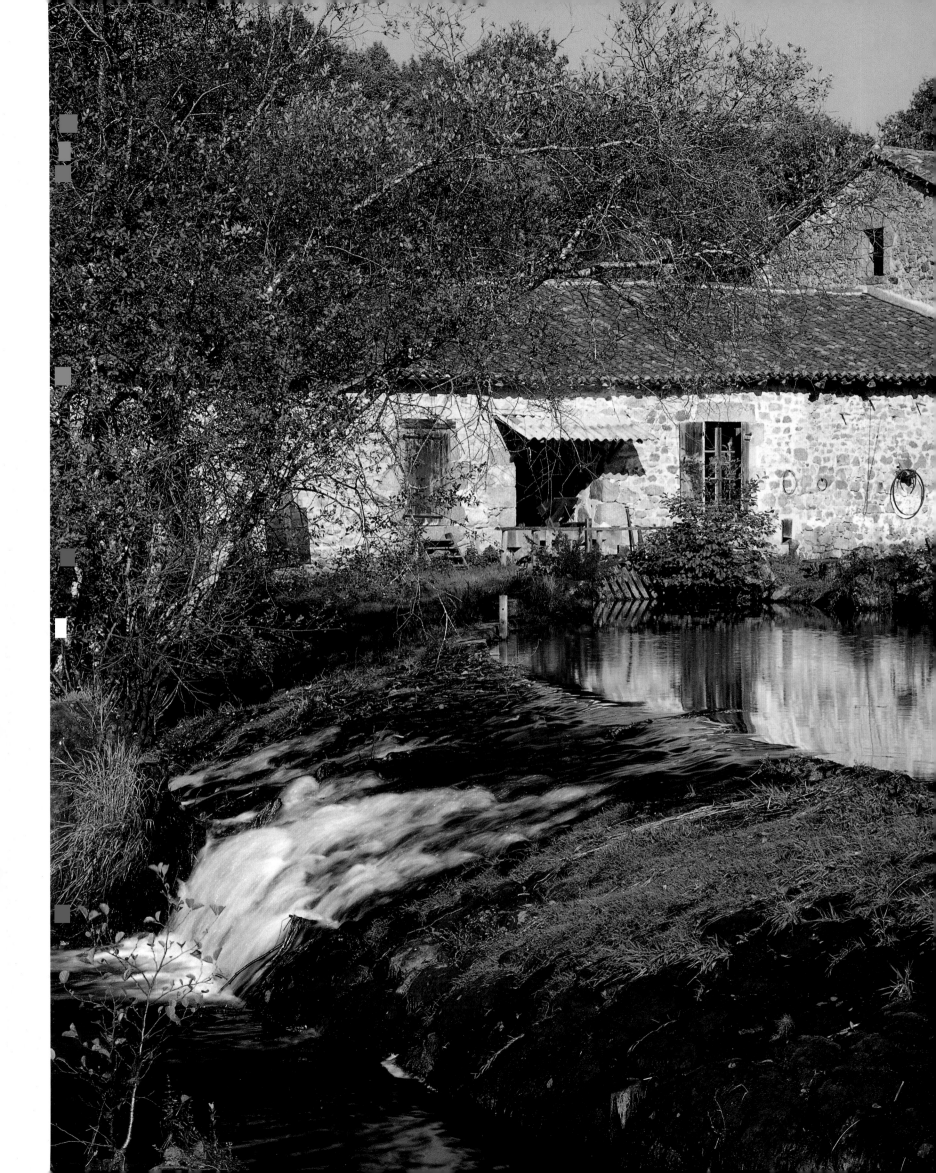

Bourdeilles

Though it has fewer than seven hundred inhabitants, the village of Bourdeilles is guarded by a partly-medieval, partly-Renaissance château, situated picturesquely on a terrace overlooking the Dronne. From the eleventh century this was the seat of one of the four medieval baronies of the Périgord. Dominating the château is its majestic thirteenth-century keep, octagonal and thirty-five metres high. The entrance is by way of a drawbridge and gateway in the form of a small château, built in the fifteenth century, defended by two round machicolated towers. Inside, the keep separates what are in effect two quite different châteaux: a feudal fortress built in the late thirteenth century and a Renaissance château of

the sixteenth century. Géraud de Maumont, counsellor of King Philippe le Bel built the first. The second was commissioned by Jacquette de Montbron, widow of a seneschal of the Périgord, André de Bourdeille.

Today it displays a collection of Burgundian and Spanish furniture, along with some splendid works of art, including a woodcarving of Jesus from the thirteenth century, a sixteenth-century Entombment comprising eight persons, and the tomb of Jean de Chabannes, who was chamberlain to Charles VIII. The finest room is the *salon doré*, painted in the sixteen-forties by the Italian master Ambroise Le Noble (who as a member of the Fontainebleau school took a French name)

and containing two monumental chimneys and a parquet floor made of walnut. Two curiosities are the gilded bed of the Emperor Charles V and a tapestry depicting his rival François I.

Climb the circular staircase which serves the keep's three storeys for a view of the rest of Bourdeilles, with its fortified seignorial water mill, built like a ship, the long medieval bridge spanning the Dronne, the fifteenth-century seneschal's house and the village's triple-domed Romanesque church which dates from the twelfth century. Bourdeilles' former hospital is notable for a sixteenth-century Pietà – another of the region's remarkable art treasures.

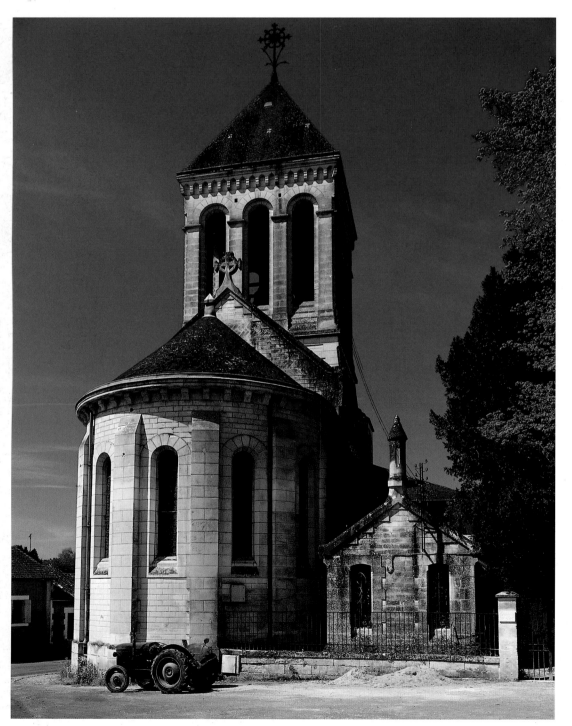

*R*ural and religious Périgord: a tractor parked outside the restored twelfth-century church at Bourdeilles (left), where the humble village houses have been protected by the massively defended fortress since the thirteenth century (above).

*T*he river Dronne flows under a medieval bridge at Bourdeilles (opposite), while above rises the polygonal keep of its château, thirty-five metres high, built for the premier barony of the Périgord in the thirteenth century and flanked by a Renaissance pavilion.

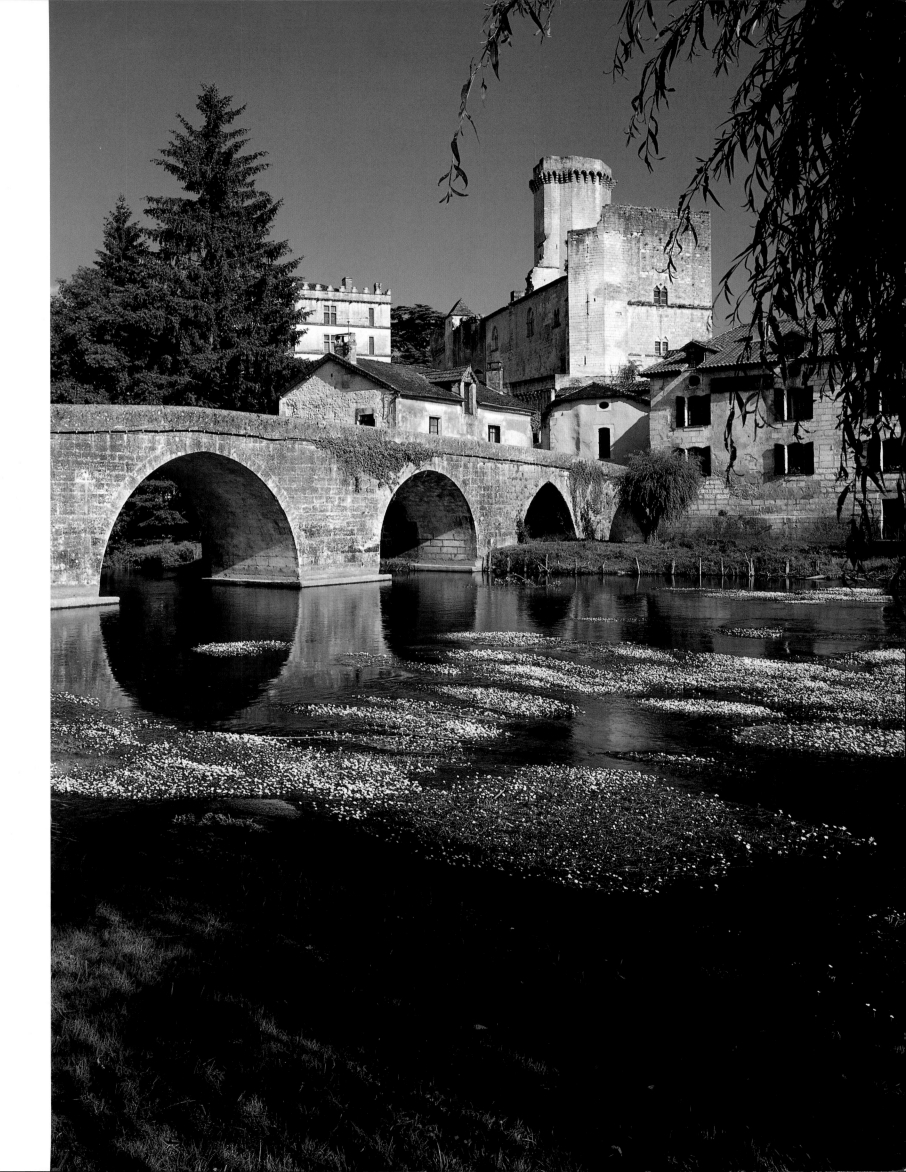

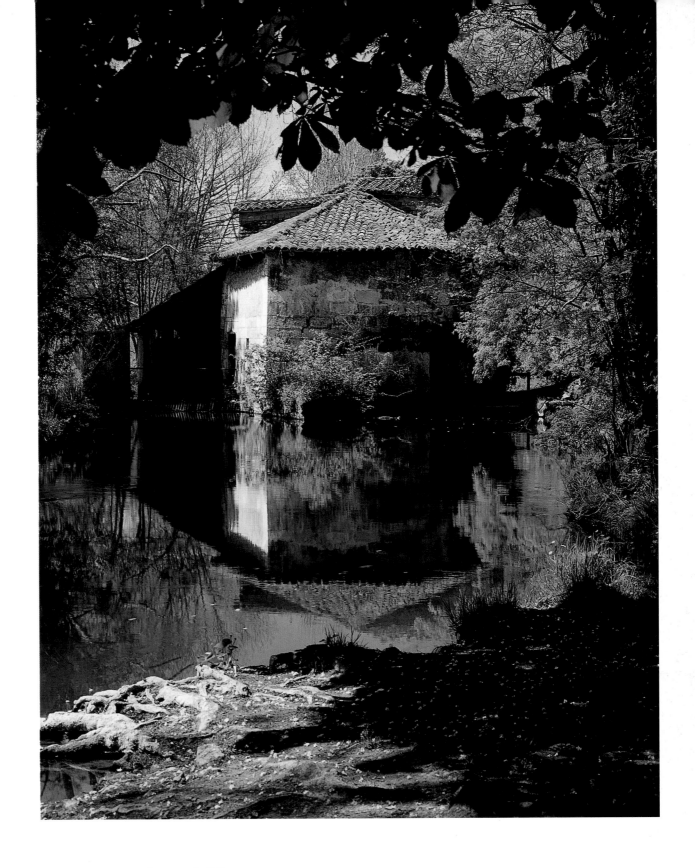

*T*rees, water and ancient buildings –
three of the essential ingredients of
the Périgourdin countryside: two scenes from
the area around Bourdeilles (above *and*
opposite); the old mill is the Moulin de
Rocherel, which stands beside the little river
Euche between Brantôme and Bourdeilles.

Brantôme

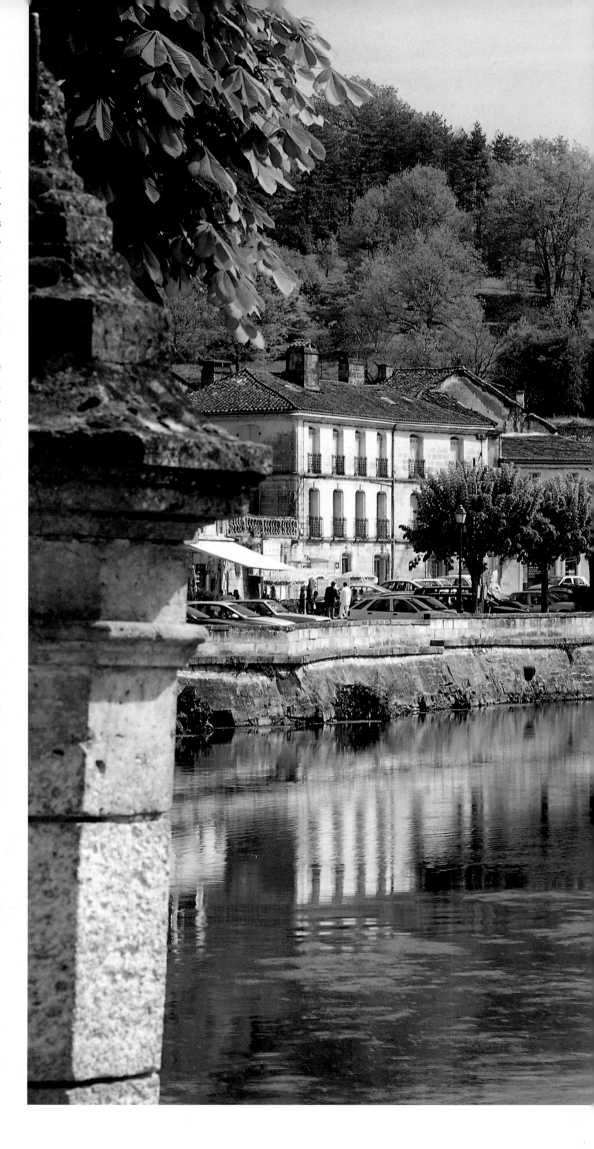

The river Dronne divides to embrace Brantôme, where in the early ninth century Charlemagne founded an abbey for Benedictine monks. He gave the abbey the body of St. Sicaire, reputedly one of the infants murdered on the orders of King Herod in his efforts to kill the infant Jesus. Though sacked by the Normans, the abbey of Brantôme flourished and its present buildings mostly date from the twelfth and thirteenth centuries. The magnificently soaring belfry is older, remaining from the first rebuilding in the eleventh century.

Well restored in the nineteenth century by the architect Paul Abadie, the Romanesque, two-aisled abbey church retains some delightful fifteenth-century vaulting, and its baptistry houses a thirteenth-century bas-relief of the martyrdom of the Holy Innocents and a fourteenth-century carving of the baptism of Jesus. Its square choir, vaulted like the nave, is lit by delicate Gothic windows.

Behind the abbey are caves which served the monks as wine cellars and kitchens, but even here they did not forget their religious calling, and have left us a sixteenth-century bas-relief carving of the Crucifixion (Christ crucified watched by his mother, St. John and others) and another from the same century of the Last Judgment. Their fifteenth-century cloister survives in part, with a beautiful fourteenth-century chapter house and an eighteenth-century refectory.

The rest of Brantôme is equally beguiling. The monks' lodgings, in part eighteenth-century but housing a superb seventeenth-century staircase, now serves as the town hall. The abbot's garden, with its Renaissance pavilion is today Brantôme's civic garden. A fourteenth-century dog-leg bridge crosses the river from the abbey to the rest of the village. Here you enjoy narrow shady streets opening on to squares and flanked by Renaissance and medieval houses.

Brantôme is given shape and character by the river Dronne, here viewed from the former Benedictine abbey.

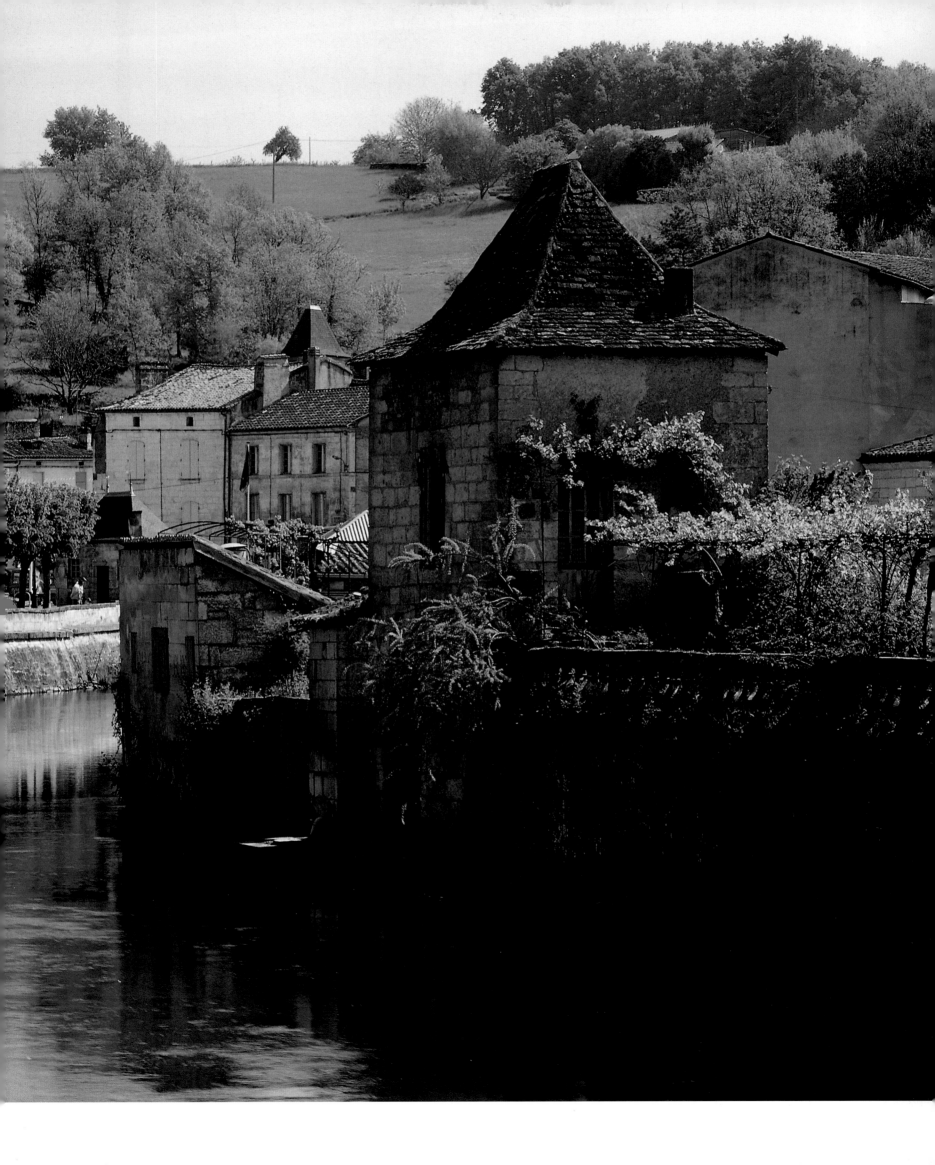

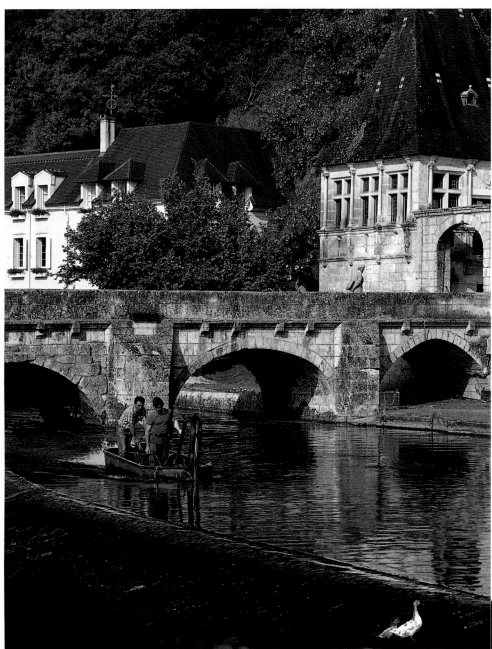

*W*eed cutting on the Dronne (left) frees the weir below Brantôme's bridge which has spanned the river since the fourteenth century, one of many ancient structures, which also include the abbey's *original* pigeonnier (below).

*A*round a bend in the river Dronne rises the abbey church of Saint-Pierre (opposite) *built in the twelfth and thirteenth centuries, but the belfry which rises beyond it dates from the eleventh century.*

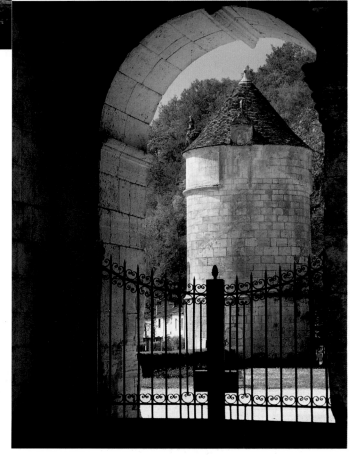

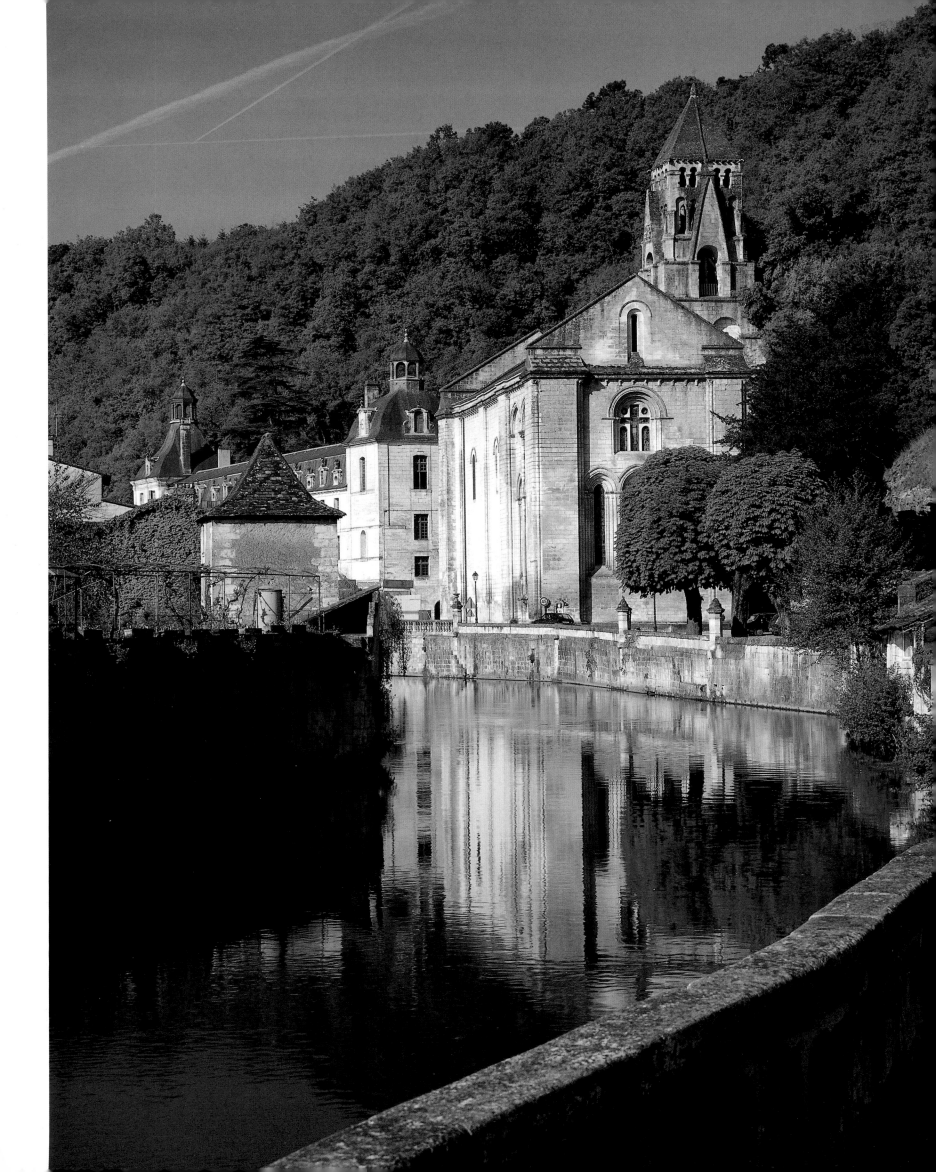

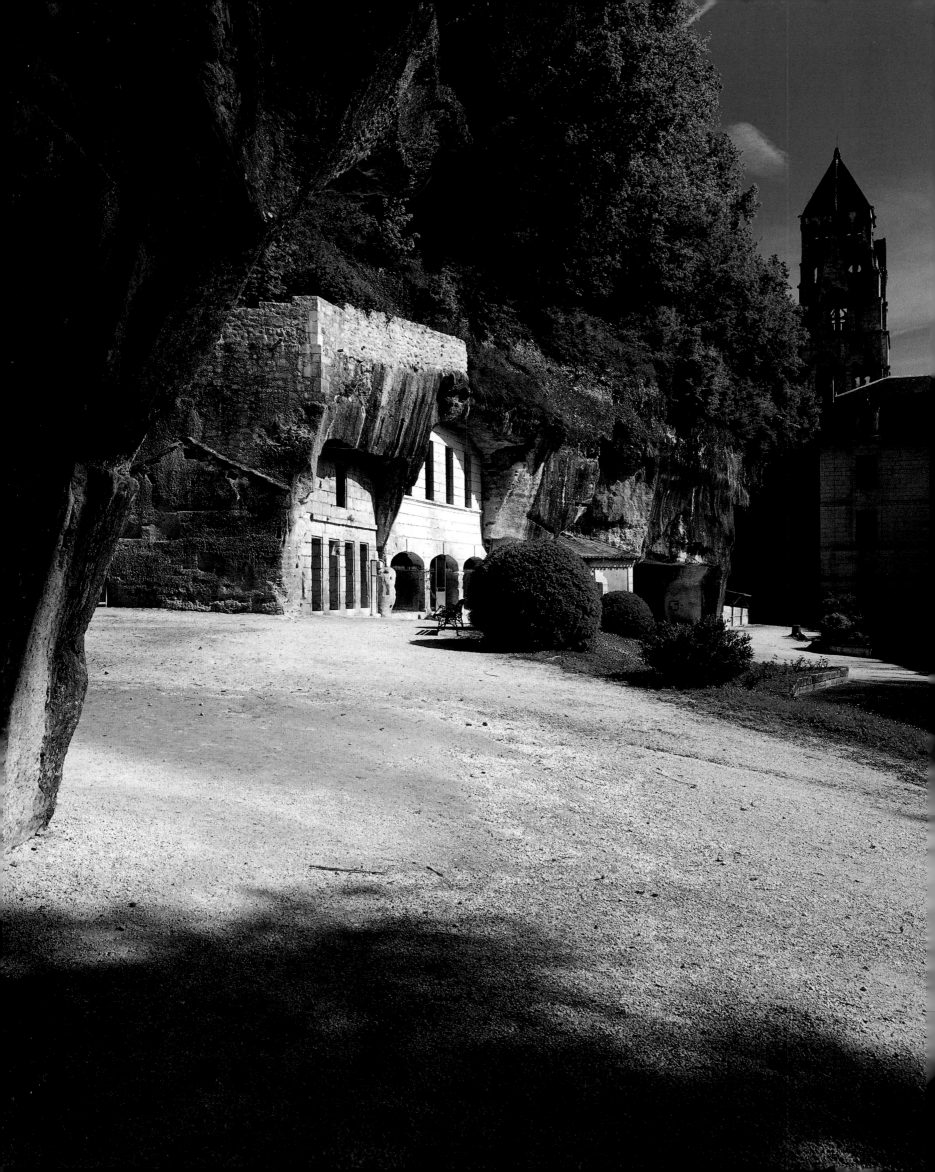

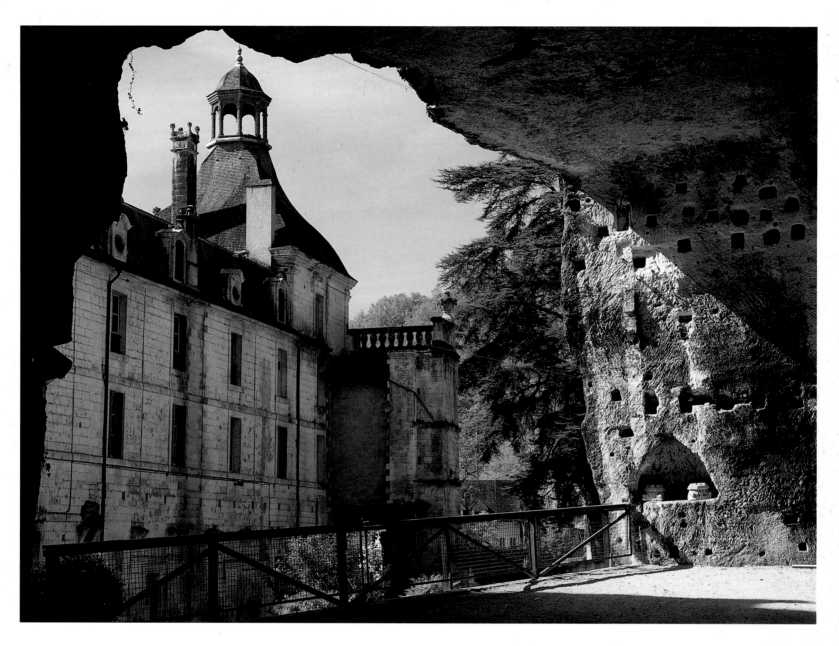

*S*ome of the monks of Brantôme
formerly lived in troglodyte cells,
and would long ago have had a view
similar to this of the more elegant of the
abbey buildings (opposite). Another view
of the abbey, also from a cave cell (above),
reveals the Renaissance wing. The 'Cave
of the Last Judgment' (right) is named
after the scene carved on the left by the
monks of Brantôme; beyond, there is a
sculpted Crucifixion.

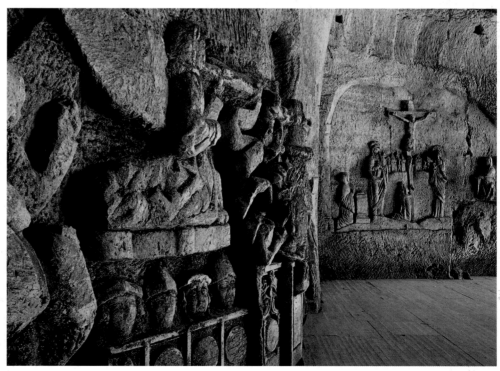

*A*way from its river and abbey, Brantôme's curving streets are lined with delightful medieval and Renaissance houses (below).

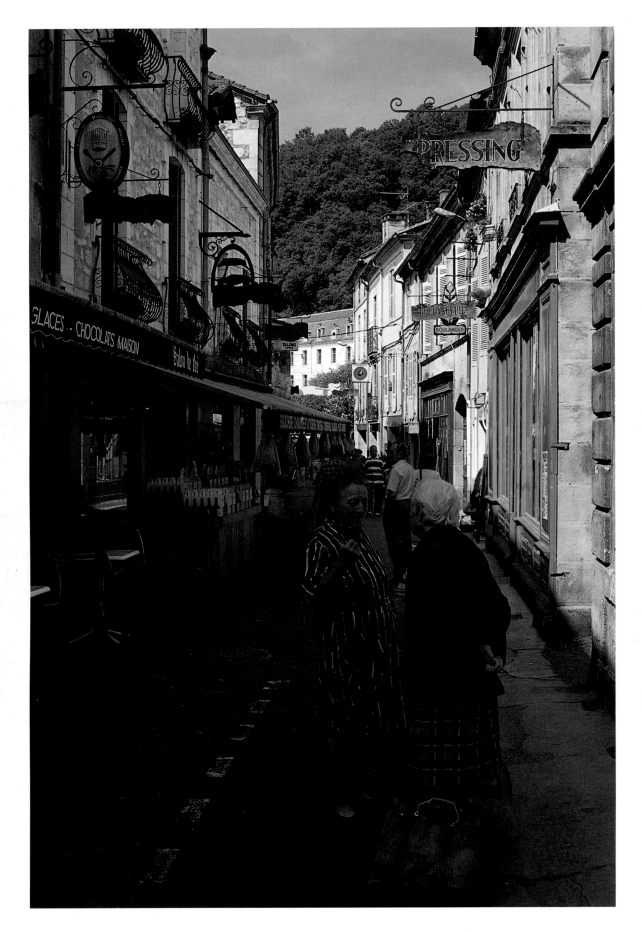

*T*he bustle of the market (top, above *and* opposite) *testifies to the vigour of this small town.*

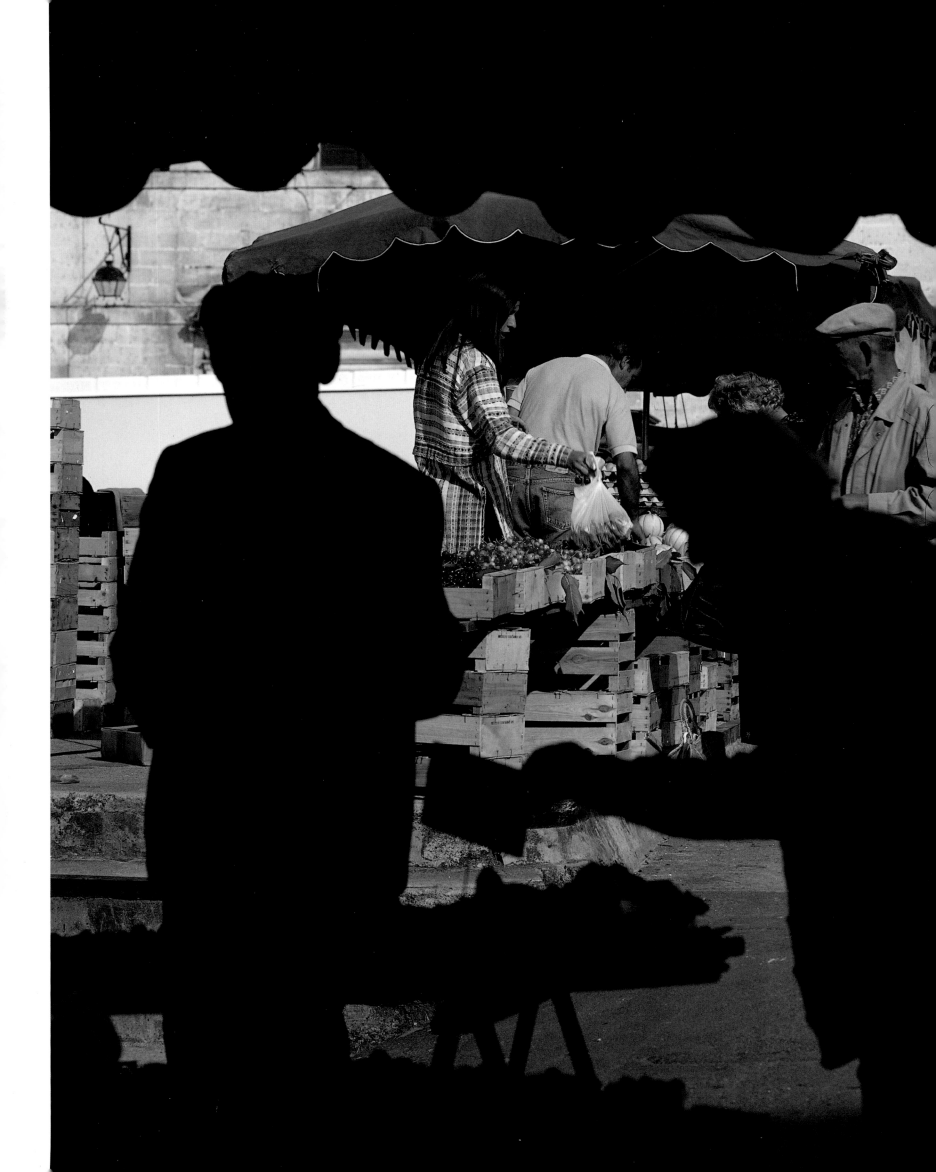

Bussière-Badil

Lying at the northern tip of the Périgord, Bussière-Badil brings into the architecture of the Dordogne elements more characteristic of neighbouring *départements*, something particularly seen in the architecture of its marvellous church. Notre-Dame once served a Benedictine abbey of which we first hear in 1028, and the church, too, dates from the eleventh century. Its west façade, built in a style much favoured by the Cistercians, has a beautiful triple-vaulted portal, surmounted by Romanesque statues and by a fifteenth-century rose window with twelve openings. The exquisitely sculpted animals and foliage of the portal resemble far more those of the Angoulême region than of the Périgord.

Similarly, the octagonal belfry which rises above the crossing is far more reminiscent of Limousin architecture than Dordogne belfries. Once inside the elegant, five-aisled nave, however, the Périgourdin style asserts itself, especially in the twenty-eight decorat-ed capitals and its dome set on fourteenth-century spherical triangles (or pendentives). Fifteenth-century ogival vaulting graces the crossing. The choir is simpler, but equally elegant.

The Benedictine abbey was down-graded to a priory in the fourteenth century and disappeared in the sixteenth. Meanwhile its church had been fortified. It still houses a sixteenth-century Christ and a gilded Virgin of the same era. As for the rest of the village, an eleventh-century keep survives from the former fortress; seventeenth- and eighteenth-century houses are still in use; the Vieux-Château dates from the fifteenth and sixteenth centuries; and the village receives cool water from two monolithic granite fountains, a reminder that the Périgord is a place of underground streams and rivers.

Not far away is the *lieu-dit* of Petit-Bois, where you come across the remains of a Gallo-Roman villa.

To the north of Bussière-Badil lie rich pastures (above) *populated by herds of cattle, most of which boast a resident bull* (below right). *But apart from the apparent belligerence of the latter, Bussière is a peaceful place and a delightful setting for a stroll after evening worship* (opposite).

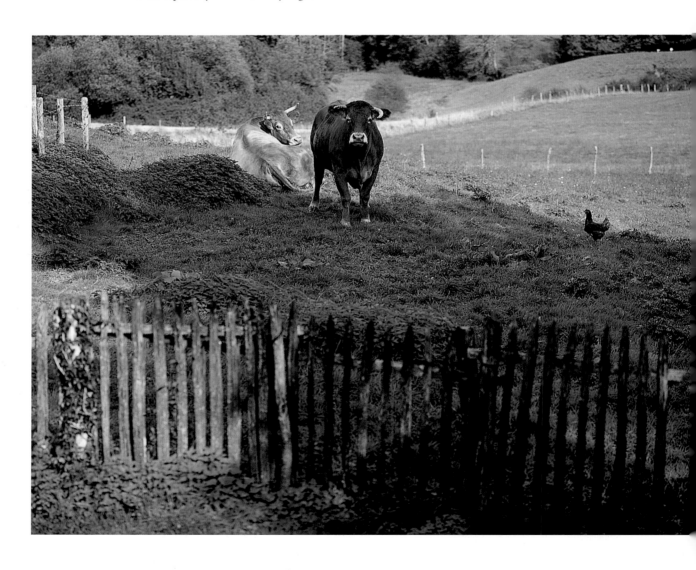

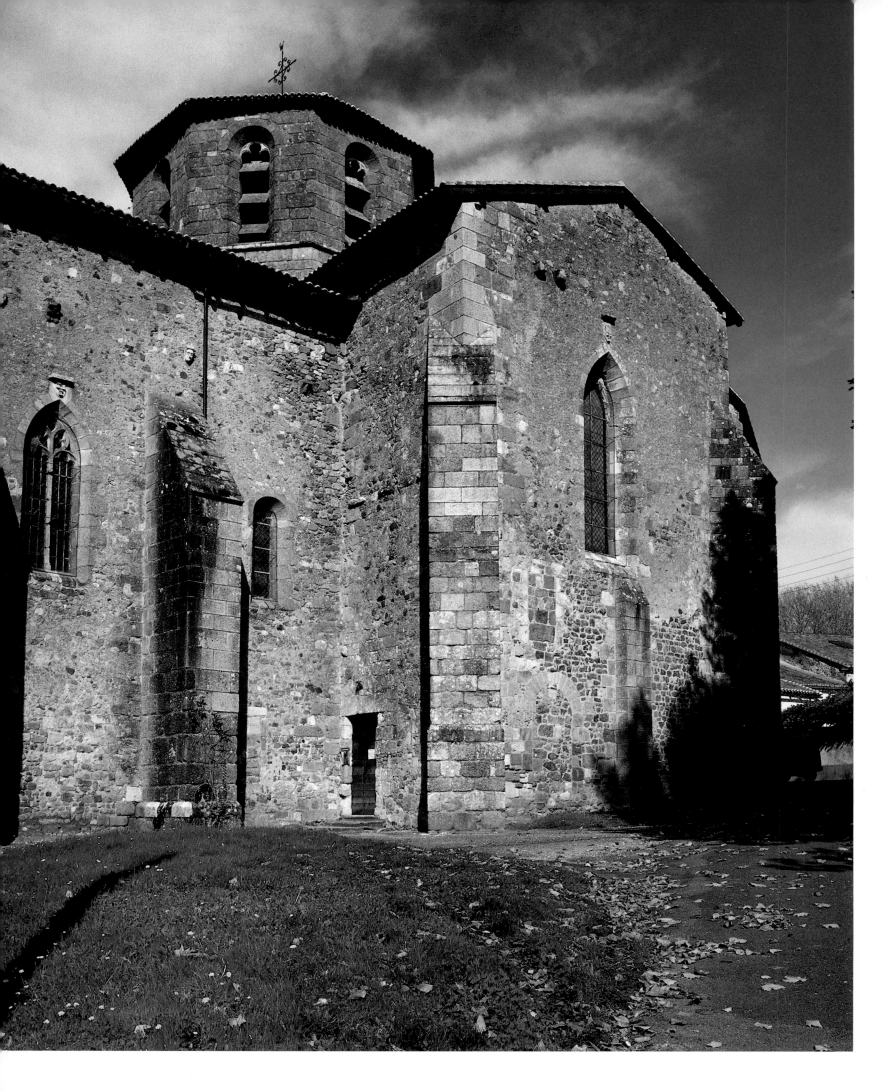

*T*he octagonal belfry reveals the architectural affinities of the Périgord Vert with the Limousin; the church of Notre-Dame at Bussière-Badil (opposite) dates back to the twelfth century, though its rose window was pierced only in the sixteenth.

*T*wenty-eight Romanesque capitals (below) ornament the church of Notre-Dame; its massive, cool interior (right), divided by simple Romanesque arches, invites peaceful meditation.

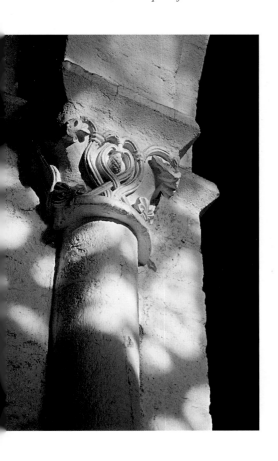

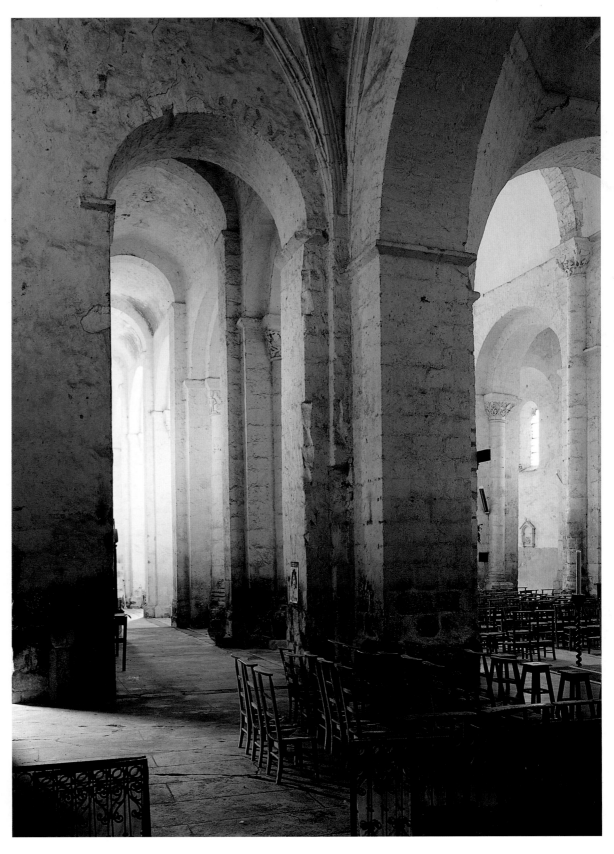

*T*he spirit of the Périgord Vert: a squat church tower overlooks the kitchen gardens of the village (opposite).

*T*he agricultural and horticultural traditions are continued in these assiduously cultivated allotments and gardens outside the main village of Bussière-Badil (left *and* below).

Overleaf:
Cattle graze placidly near Bussière-Badil.

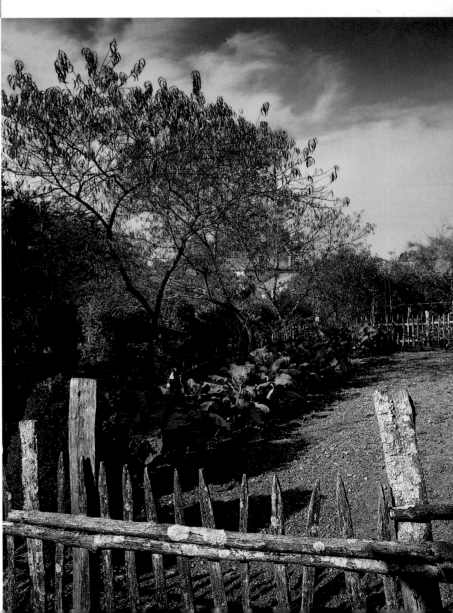

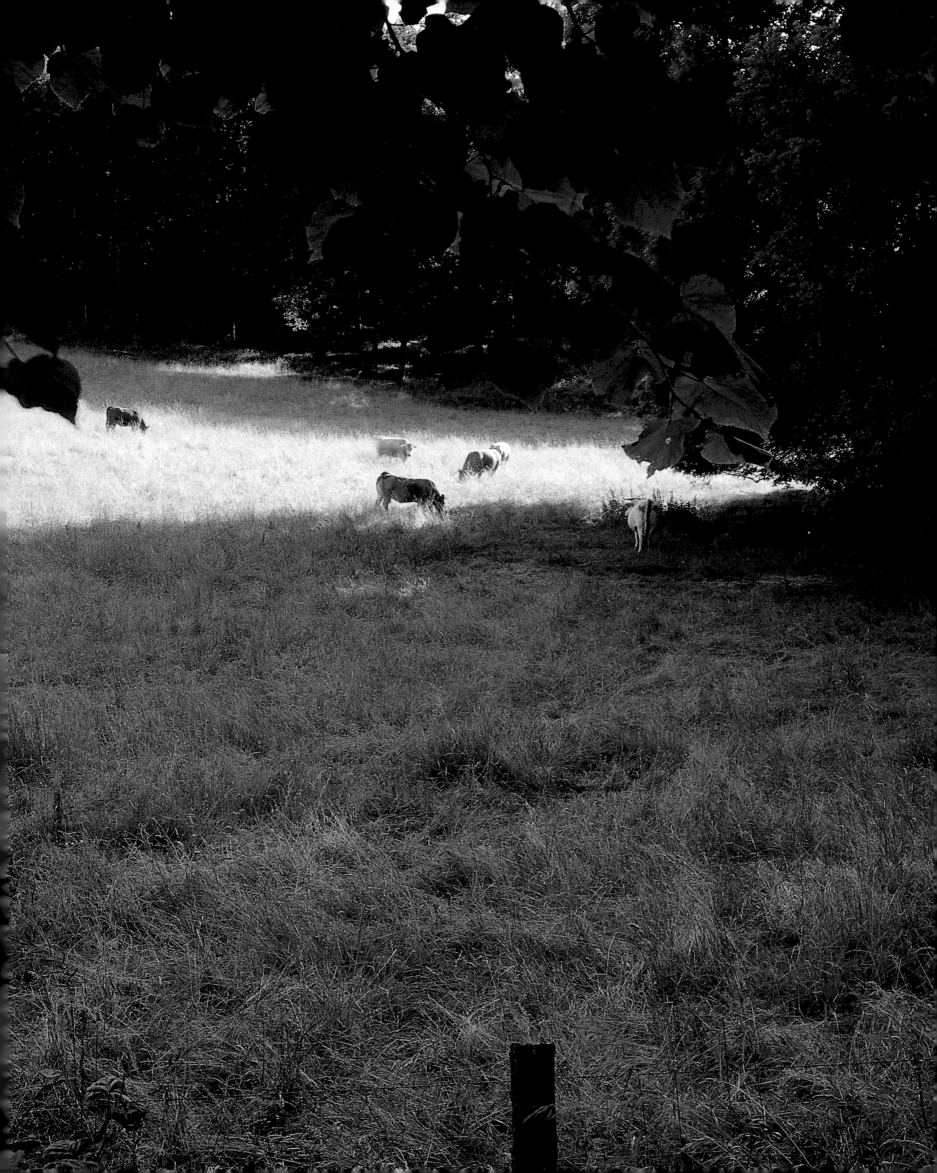

Excideuil

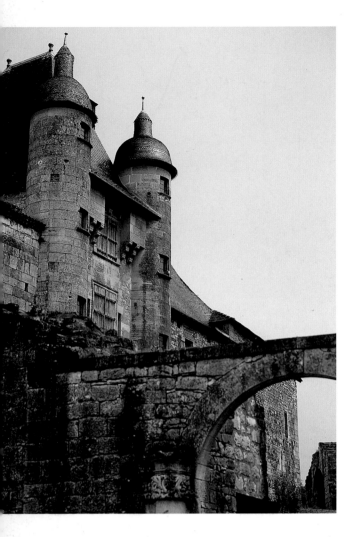

Although small, Excideuil was once the capital of the Périgord Vert, and its old fifteenth- and sixteenth-century houses cluster around a church that was once the chapel of a Benedictine priory. A fragment of its porch still recalls the church's Romanesque origin, whereas the porch on the south side is fifteenth-century flamboyant Gothic, and inside you discover a Romanesque statue of St. John the Baptist, a sixteenth-century Pietà and a splendid seventeenth-century reredos.

The whole village is dwarfed by Excideuil's château, which rises on a limestone cliff. What makes the château particularly attractive is the piquant contrast between the medieval fortress, with its two enormous square keeps, built in the twelfth century, and the turreted Renaissance daintiness of the wing adjoining it – built by François de Cars in the late sixteenth century. Excideuil château is still enclosed by its medieval ramparts.

In the Middle Ages Excideuil was defended by walls and five massive gates, but none of this stopped Richard Coeur de Lion's depradations in 1182 (though he failed to take the village), nor later attacks by the English during the Hundred Years War.

Excideuil has by no means slept since its citizens built their church and château. In the nineteenth century it was the home of Marshal Bugeaud, who was sent to Algeria in 1836 to bring to heel the rebels of Abd El-Kader. He became governor of the colony in 1844, before returning to France and dying of cholera in 1849. Bugeaud cared much for the industrious peasants of his own country and helped them to modernise their farming methods. He gave some of his fortune to improving the water supply of Excideuil, and the market square boasts a fountain donated by him. In the nineteen-sixties the Algerians returned a statue of Bugeaud, which now graces the centre of Excideuil.

A reminder of the Périgord's turbulent past: the once mighty fortress of Excideuil (left) still towers over the narrow streets of the village, like the aptly named Rue de Repos. Beyond the street the belfry of Excideuil's Romanesque church, which once belonged to a Benedictine priory, is just visible (below and opposite).

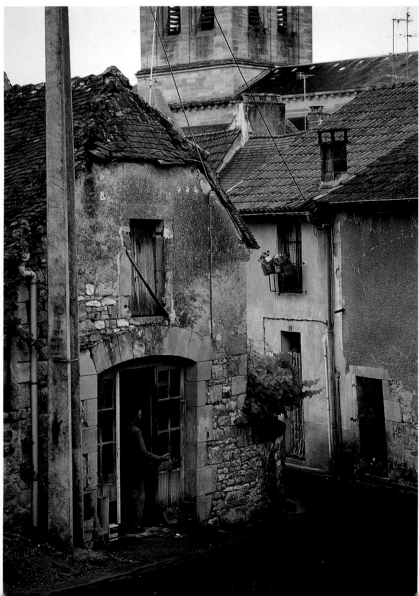

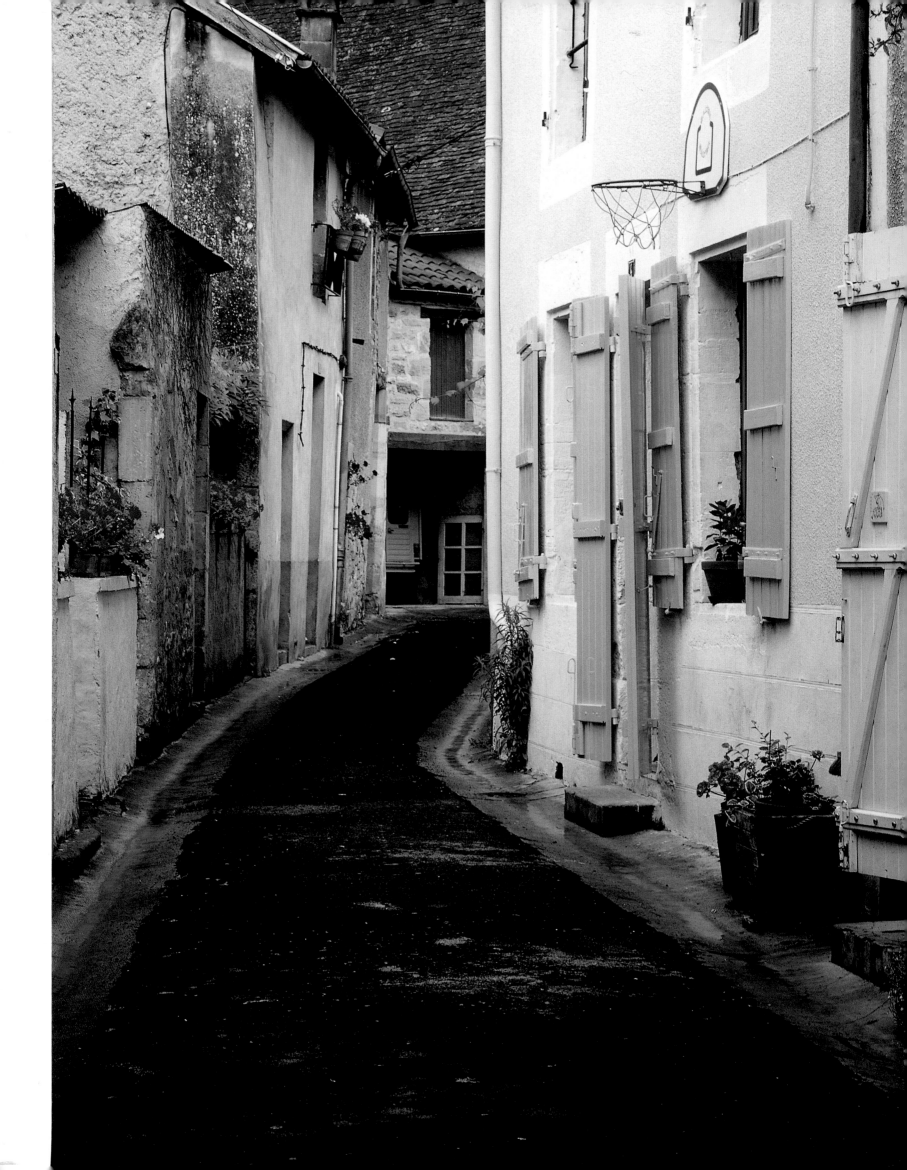

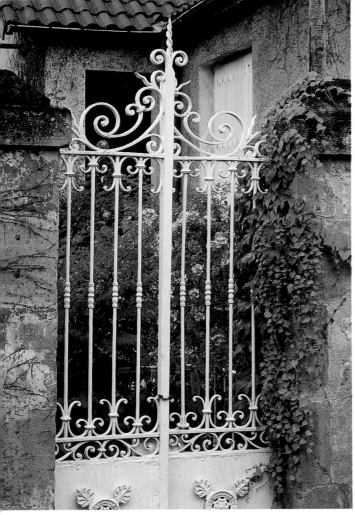

*G*ates and fences in the Rue
Giraud-Deborneil and Rue
Saint-Germain (this page *and*
opposite) *display elegant
craftsmanship in ironwork;
beyond can be glimpsed the
burgeoning gardens so typical of
this part of the Périgord.*

Javerlhac-et-la-Chapelle-Saint-Robert

The château of Javerlhac is best viewed from the bridge that crosses the river Bandiat. Its two towers, dating from the sixteenth century, make a romantic sight, one vast and round, the other polygonal and machicolated with a pointed cap, while the main lodgings are rectangular.

Next to it there rises an impressive twelfth-century Romanesque church, slightly quaint in that its twin aisles are asymmetrical. It houses two fourteenth-century tombs, and the whole is topped by a couple of cupolas. A symbol of civic pride and former wealth is the village's dove-cot, which contains no fewer than 1,500 nests. Javerlhac also boasts a mill and its river is shaded by weeping willows.

The glory of the tiny hamlet of La-Chapelle-Saint-Robert, four kilometres to the east, is its early twelfth-century Romanesque church, all that remains of a Benedictine priory founded in the tenth century by the monks of Viegeois. According to legend, one of its priors was a disciple of St. Robert. The façade has a fine porch flanked by two false bays. Its square belfry is massive and handsome, with blind arcading. Inside, the capitals are sculpted with human beings, horses, elephants and foliage, and support a vaulted, triple-aisled nave. A dome rises above the crossing, while the capitals of the apse are sculpted with palms, pineapples, eagles and doves.

The neighbourhood of Javerlhac-et-la-Chapelle-Saint-Robert once abounded in forges, most of them created in the eighteenth century on behalf of the entrepreneurial Marquis de Montalembert, and some of them still survive. To see the finest, take the shady path alongside the river as far as the tiny hamlet of Forgeneuve, where an elegant eighteenth-century bridge crosses the Bandiat.

The hamlet of Forgeneuve (a reference to the forges which once proliferated in this region) lies just to the north of Javerlhac-et-la-Chapelle-Saint-Robert; its ancient mill blends well with the verdant countryside.

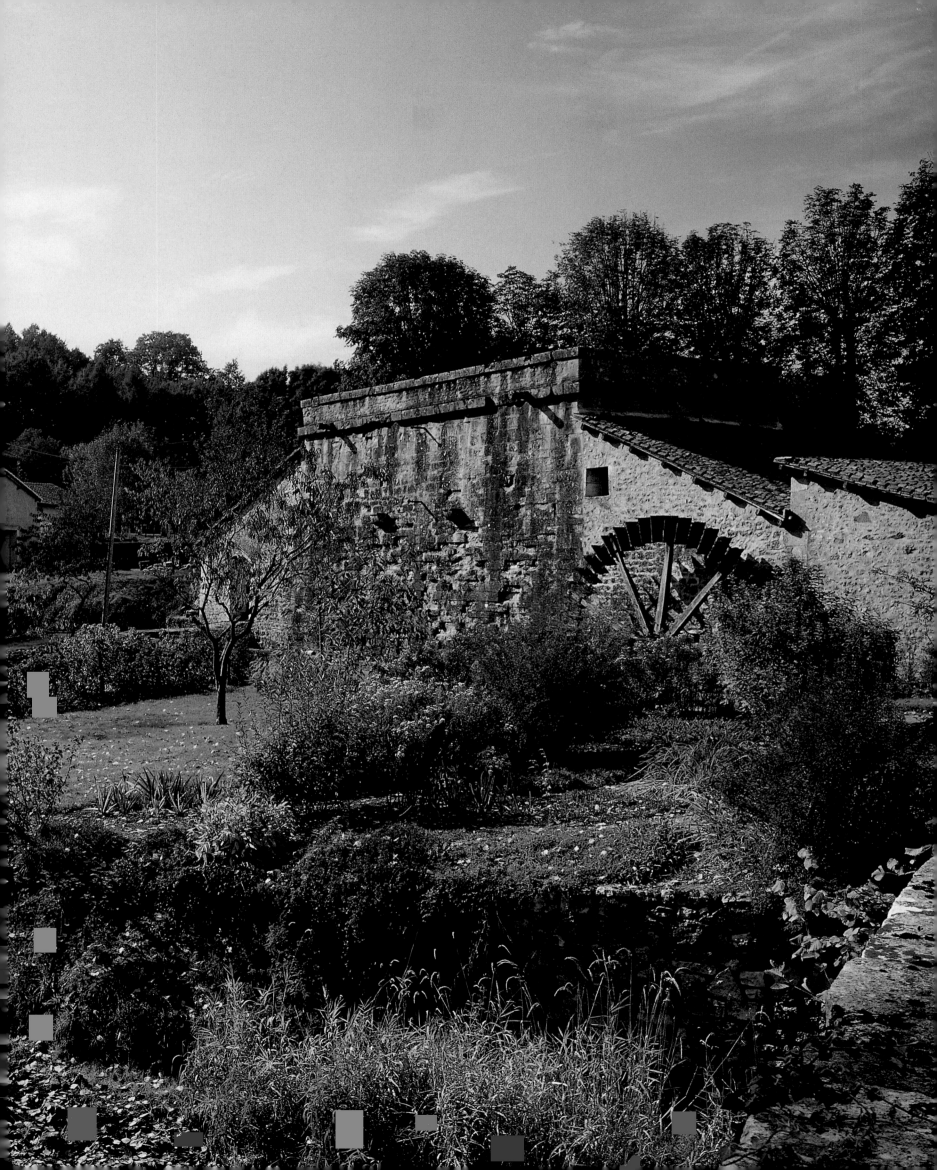

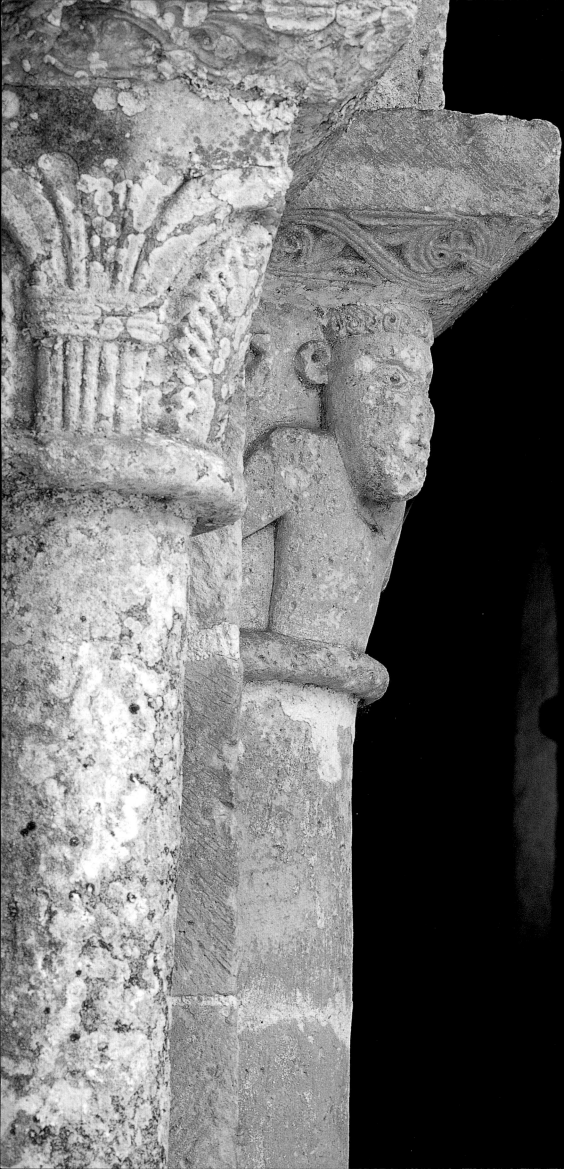

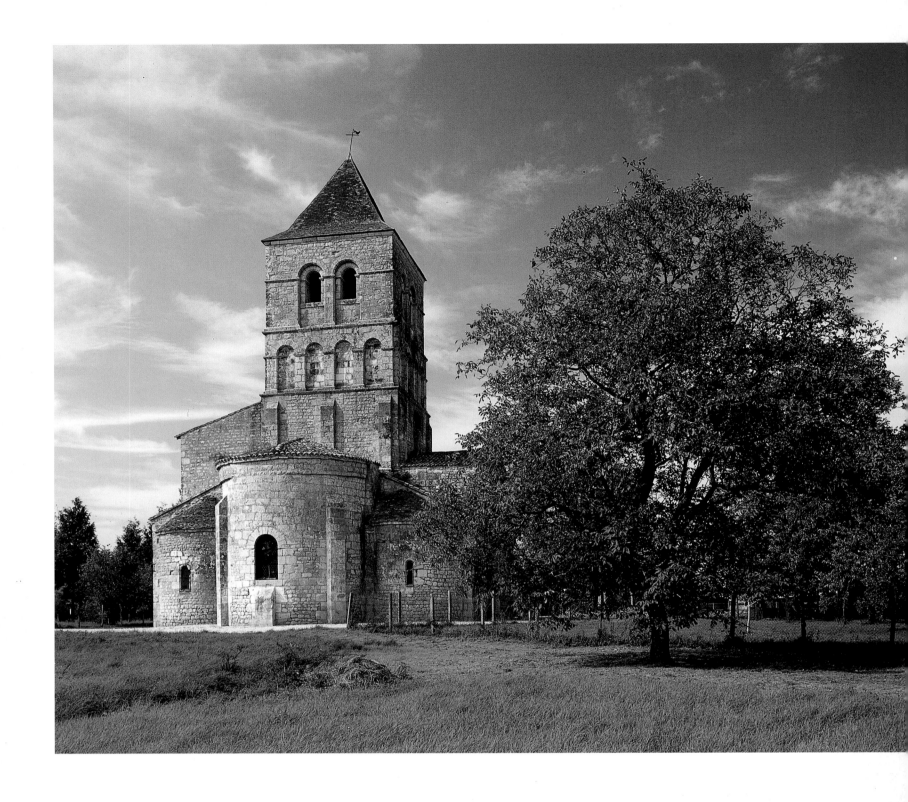

\mathcal{T}*his detail is taken from the*
simple, yet elegant porch
(opposite) of the former priory
church of La-Chapelle-Saint-
Robert, which is further
distinguished by a square belfry
with blind arcades and a pointed
roof in the traditional form of
the Périgord.

*T*he garden of the Château at
Javerlhac (below) *constitutes
a unifying element for secular and
ecclesiastical symbols of power: a
sixteenth-century tower of the
Château de Javerlhac twinned with
that of the village's Romanesque
parish church* (right). *The time-
honoured Périgourdin combination
of greenery, water and aged masonry
is repeated in this picturesque tableau*
(opposite) *of an old mill by the river
at Javerlhac.*

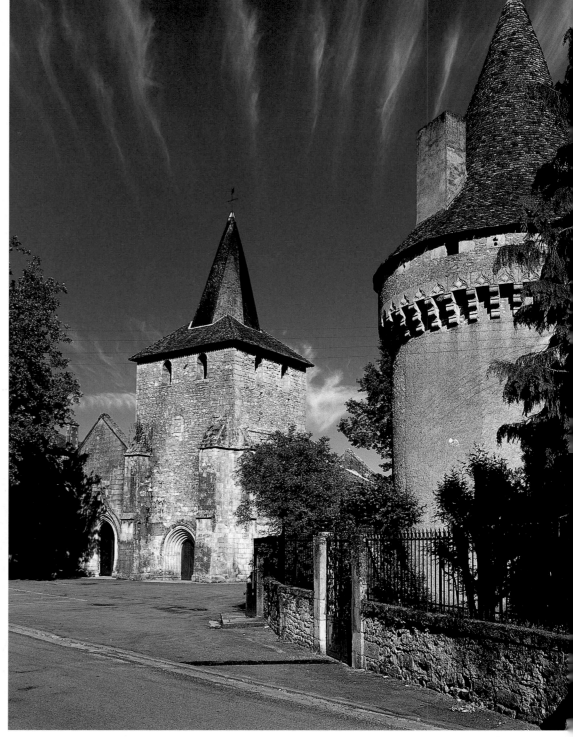

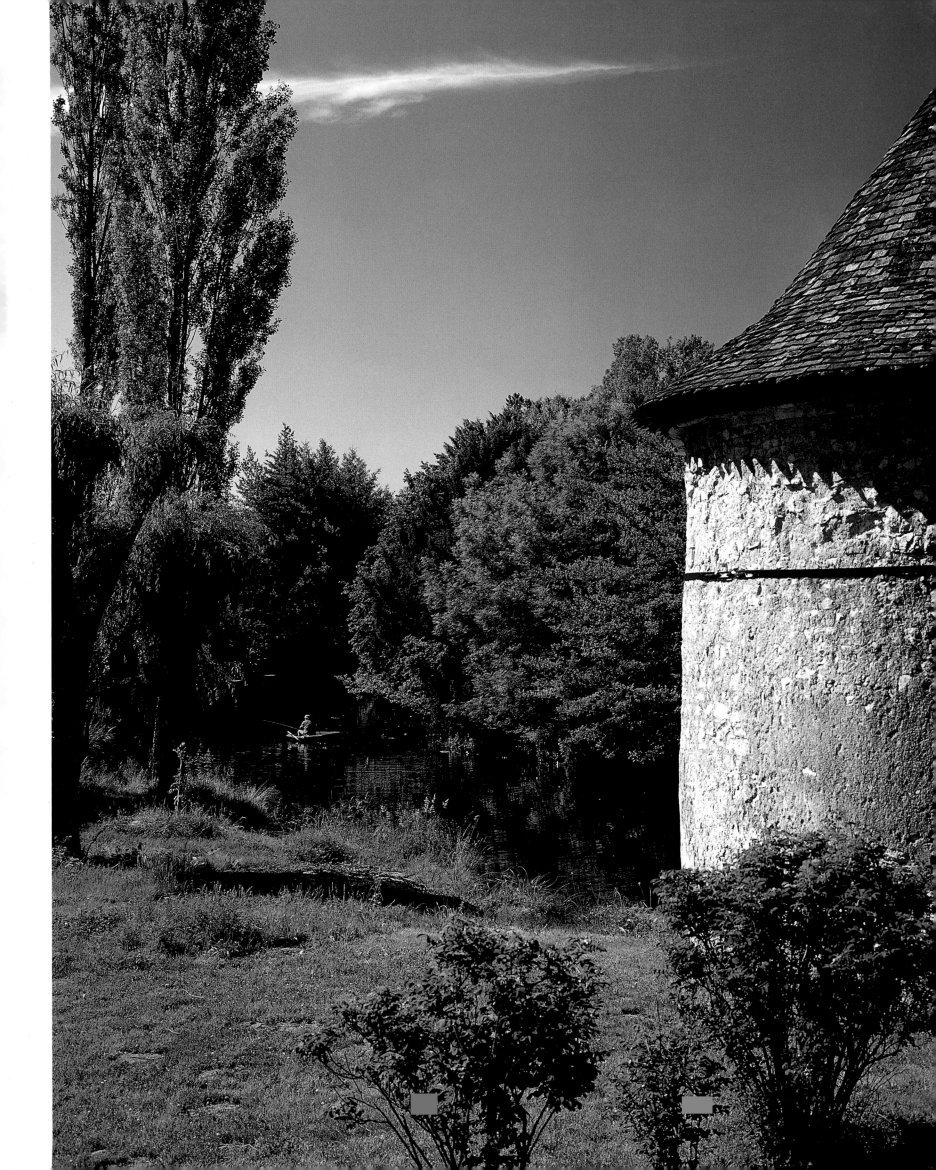

Jumilhac-le-Grand

Among many contenders, the château of Jumilhac-le-Grand best qualifies as the fairy-tale castle of the Périgord. It began life as a fortress built by the Knights Templars in the thirteenth century. When the Chapelle de Jumilhac family acquired this in 1579, Antoine Chapelle, who had become rich on the profits of his forges and had financed the campaigns of Henri IV (who ennobled him in 1597), tranformed it into a Gothic château, adding a delightfully capricious

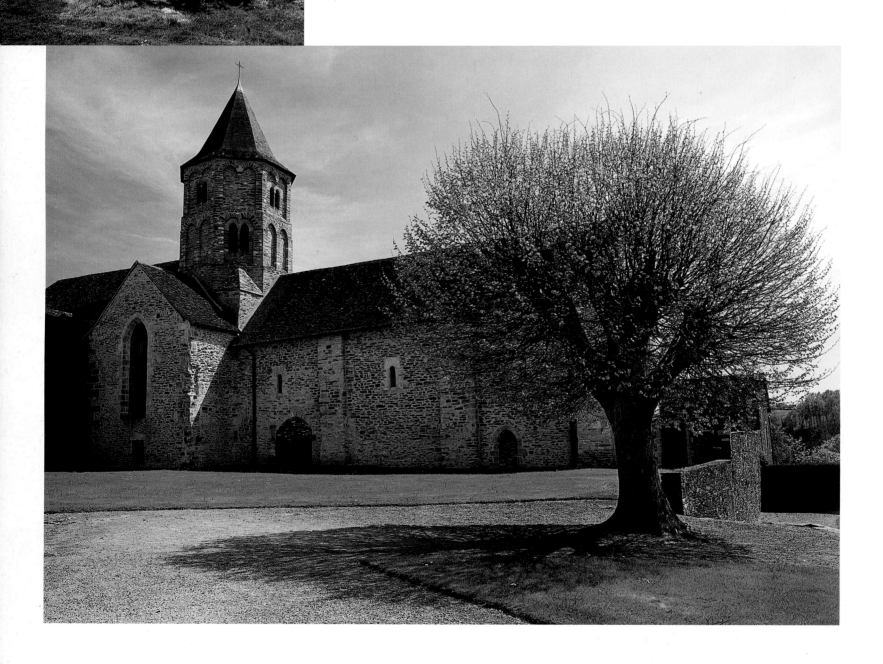

and complex skyline, with pointed and pepperpot turrets all roofed in slate. His forged metal workers then topped the turrets with such fanciful figures as an avenging angel, the sun and moon, Cupid, swooping birds and cabbages.

The central logis still dates from the fourteenth century, and two classical wings were added in the seventeenth century. Inside the château are more delights, particularly the elaborate chimneys and especially the great salon, dating from the seventeenth century and boasting a magnificent wooden chimney, panelling, parquet flooring and an elaborate ceiling. In another room unsophisticated frescoes depict the story of *la fileuse* ('the spinner'), Louise d'Hautefort, who was allegedly imprisoned here by her jealous husband Antoine II de Jumilhac, and spent her days spinning.

Jumilhac's château possesses a splendid terraced garden from which the view over the river

Isle is equally splendid. Beside the garden stands the thirteenth-century parish church of the village. Formerly the château chapel, it is exceptionally rich, with a double-storeyed octagonal belfry and a porch with sculpted heads. Its furnishings are even richer and include a Baroque altar, seventeenth-century statues (one of course St. Antoine), a gallery for the nobility and a choir with a sixteenth-century ogival ceiling.

In front of the château some of the humbler houses of Jumilhac-le-Grand line the massive, tree-shaded village square.

A grove of espaliered apple trees near Jumilhac-le-Grand (left) *makes a brave display of the agricultural prosperity which sustains this historically powerful village. Its parish church* (below) *was formerly the private chapel of the château* (opposite), *a striking building with blue-slated pinnacles.*

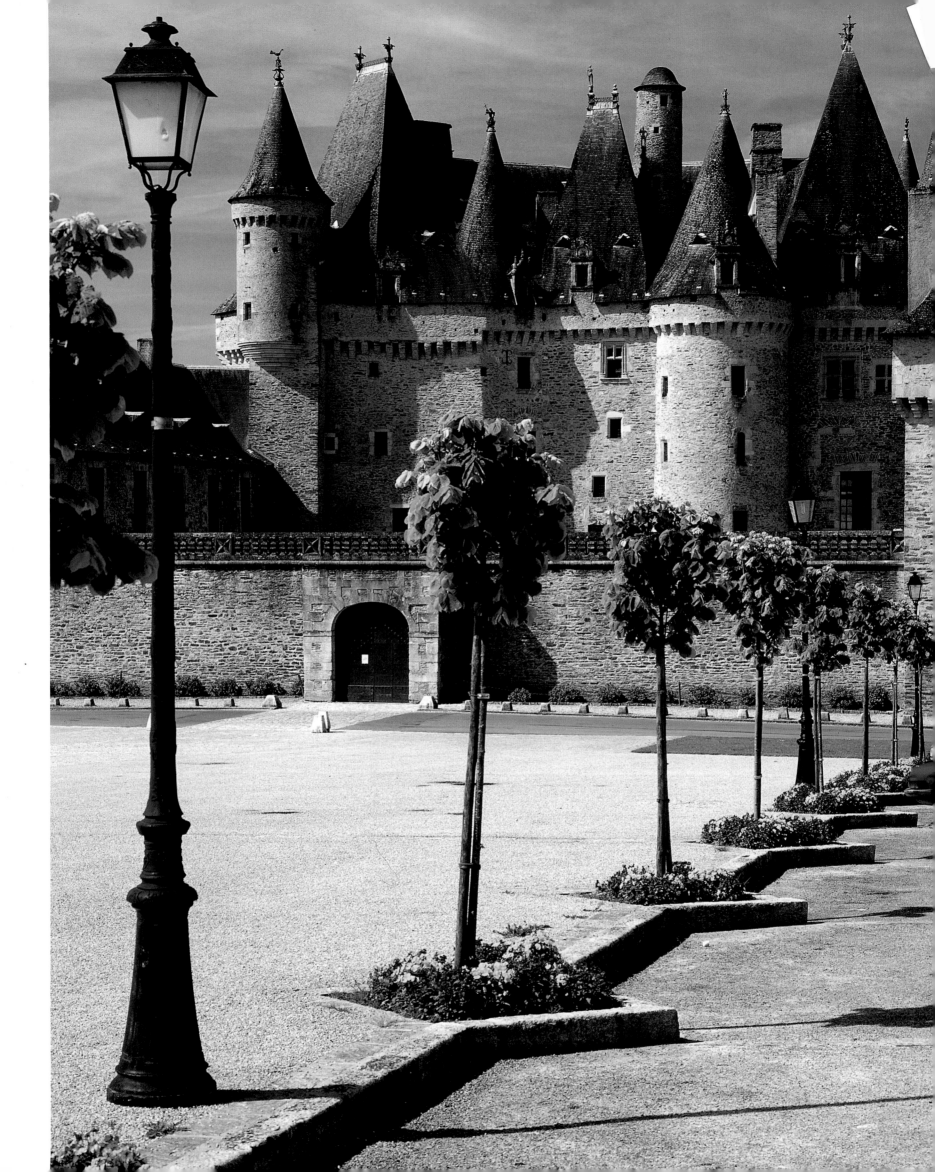

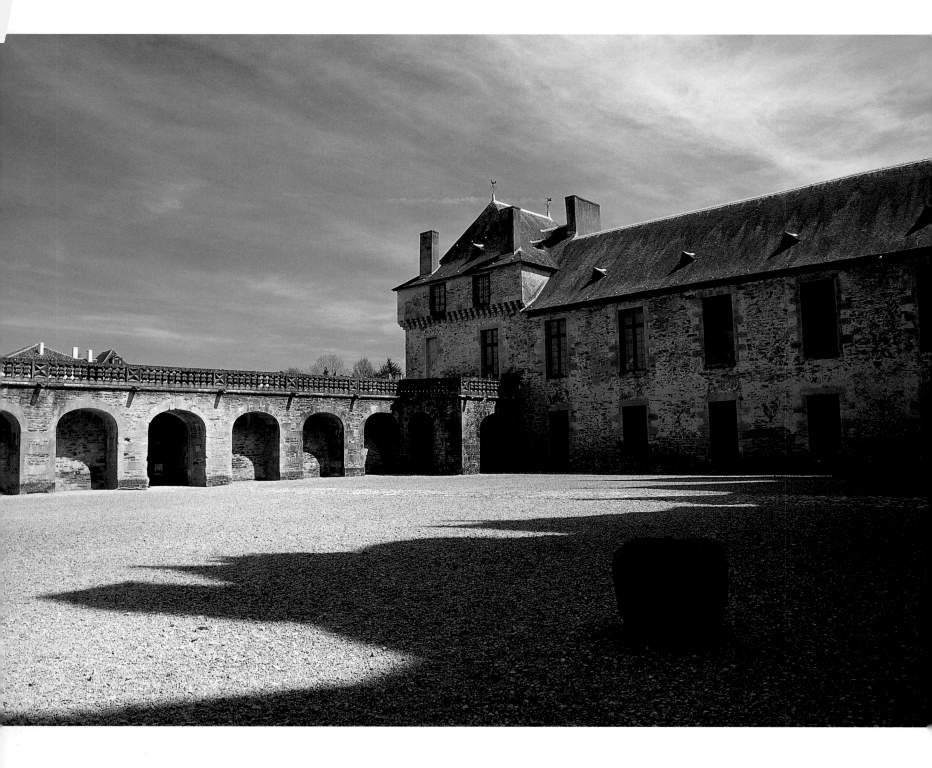

*T*he complex intercourse of
stone, light and shadow in
the spacious courtyard of the château
at Jumilhac-le-Grand (above),
flanked by graceful though slightly
stern buildings; within the château
(opposite) *the architectural charms
of the Périgord are fully displayed:
the sturdy door of the château; its
winding staircase; a paved* salon.

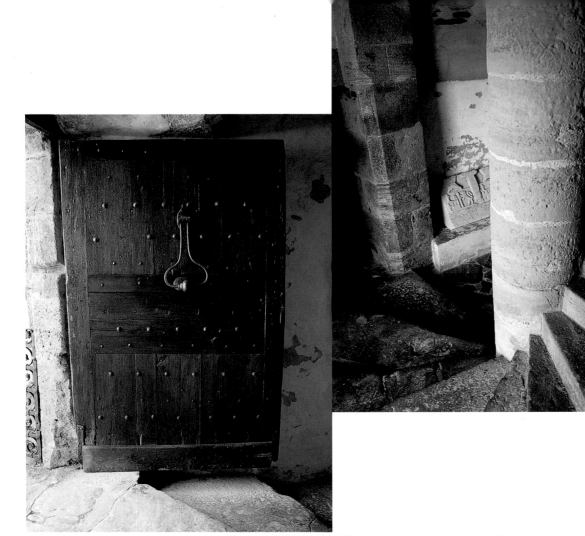

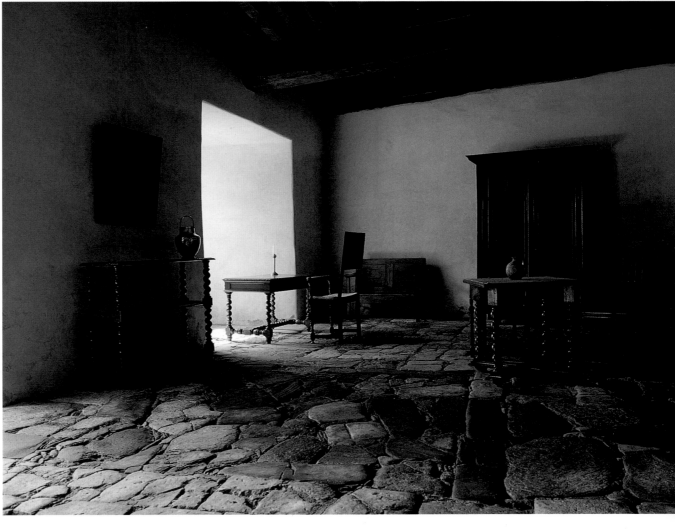

Mareuil-sur-Belle

The village of Mareuil-sur-Belle is renowned for the troubadour Arnaud de Mareuil, who was born of a lowly family in its fortress around 1150. He travelled France singing, dicing and drinking and finally married a beautiful fat woman named Guiaumette Monja for whom he wrote some of his finest love poetry. Ezra Pound judged Arnaud one of the greatest singers of courtly love of the Middle Ages.

Today's château at Mareuil is not the one Arnaud was born in, though it still in many respects resembles a fortress, standing in a plain and once defended by a ring of moats (now filled in) which were formerly fed by the river Belle. The present château was built for Geoffroy de Mareuil in the fifteenth century. Still standing are the irregular defensive walls, with their towers, one of them square, the rest horseshoe. The drawbridge is also defended by a couple of impressively sturdy cylindrical and machicolated towers, while the sculptures over the entrance make only a cursory concession to the decorative arts. A further fearsomely feudal element is the powerful square keep.

This was the seat of one of the four medieval baronies of the Périgord (the other three being Beynac, Bourdeilles and Biron). In spite of the awesome aspect of their château and the warlike centuries through which they lived, the barons of Mareuil and their families led cultivated lives. The chapel of their château is an unexpected flamboyant Gothic masterpiece, two kneeling angels sculpted on its tympanum. Its ceiling has complex ogival vaulting.

Outside the château the village church fared less well. Romanesque and enlarged in the fifteenth and sixteenth centuries, it was ruined by the English and set on fire by the Huguenots; yet it has preserved its twelfth-century dome, over which towers a square belfry, as well as its Renaissance doorway and its eighteenth-century pulpit and reredos.

The fifteenth-century Château de Mareuil still retains its defensive aspect – massive walls, towers and the original keep.

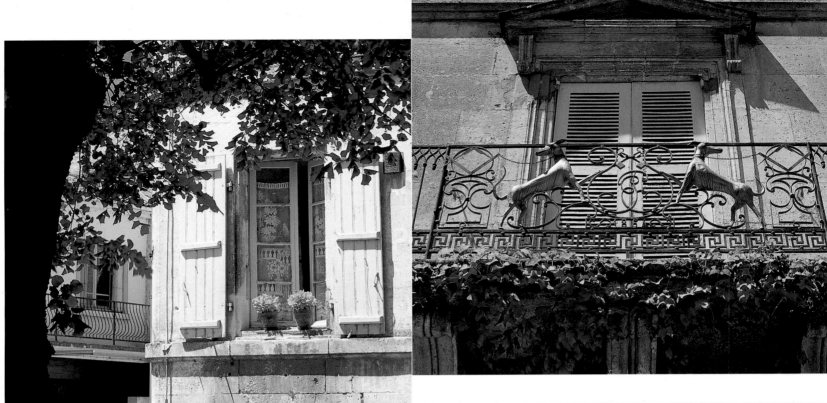

*M*areuil is the quintessential
 Périgourdin village:
shuttered windows in the Rue du Château
(above left); an exquisite wrought-iron
balcony in the Rue Pierre-Degail (above
right); and the tree-shaded, flower-
bedecked Place des Promenades (right).
A warm Périgourdin afternoon brings out
the washing over a garden near the
market-place (opposite).

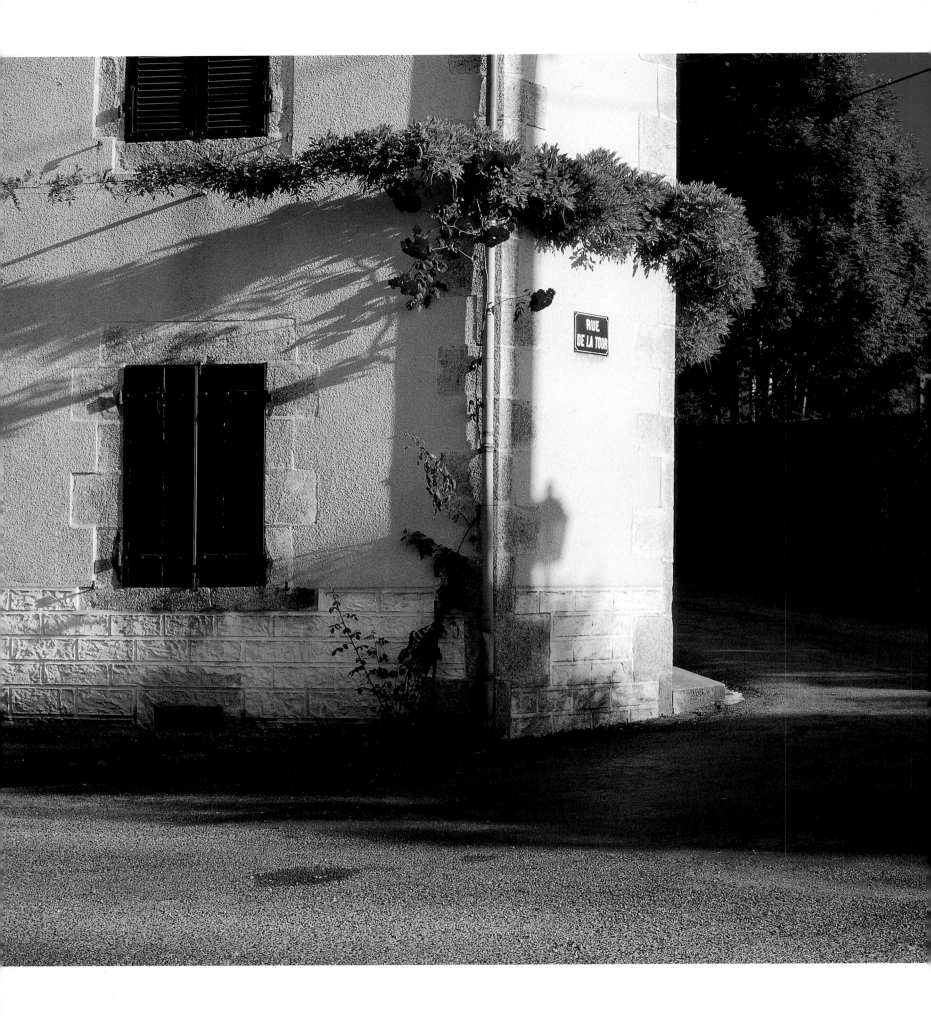

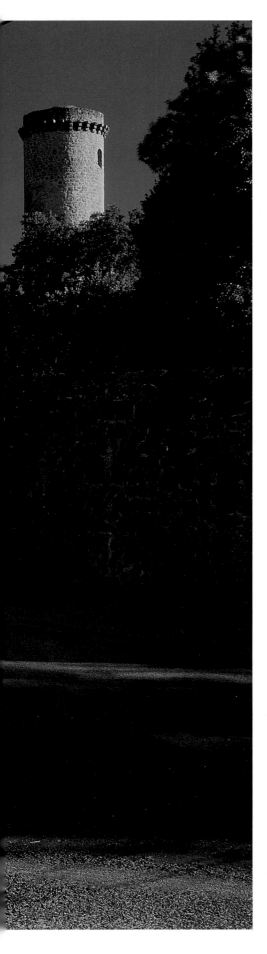

Piégut-Pluviers

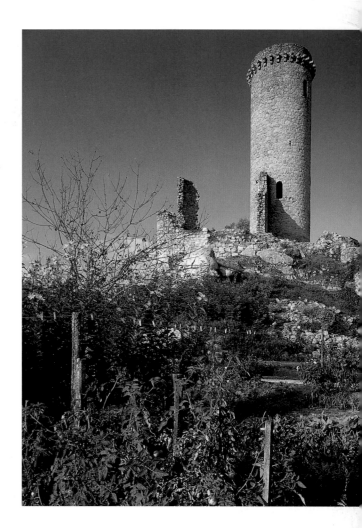

As you approach Piégut-Pluviers you see in the distance its superb round keep, built of granite, set on a hillock, seven metres wide and rising some 23 metres high, its machicolations still intact. This keep and the ruined walls that surround it are all that remain from a twelfth-century fortress built by the viscounts of Limoges and destroyed by Richard Coeur de Lion shortly before his death in 1199.

The village that it dominates was known in Gallo-Roman times as Podium Actium, and at the nearby *lieu-dit* of Chez Noyer you can see traces of a Roman road twelve metres wide with its fosses on either side, as well as the remains of a Gallo-Roman forge.

The church at Piégut dates from the nineteenth century, but it houses a sixteenth-century Pietà which was once an object of pilgrimage, as well as a painted statue of Jesus, carved out of wood in the seventeenth century. Pluviers has a Romanesque church, begun in the twelfth century, finished in the fifteenth and restored in the nineteenth. Its pride is its rich reredos, and if the church is locked, you can obtain the key at the bar opposite. Pluviers also boasts a fountain which was itself once the centre of religious devotion. Pushing back in time, in the same commune seek out the menhir of Fixard, as well as the neolithic burial ground of La Butte-du-Collège.

Another fascinating prehistoric site can be enjoyed five kilometres south of Piégut-Pluviers at Saint-Estèphe, whose vast 30-hectare lake has made the village an important centre of tourism. This is the celebrated 'Roc Branlant' (swinging rock), so-called because even though the enormous stone measures three by three metres, an adult can push it so that it oscillates north and south. Locals call it 'the nutcracker', because it is so brilliantly balanced as to be able to do exactly that.

Peaceful Rue de la Tour (left), *at Piégut-Pluviers, derives its name from the powerful castle keep whose circular form* (above) *still dominates the village. This is all that remains of a château razed in 1199 by Richard Coeur de Lion.*

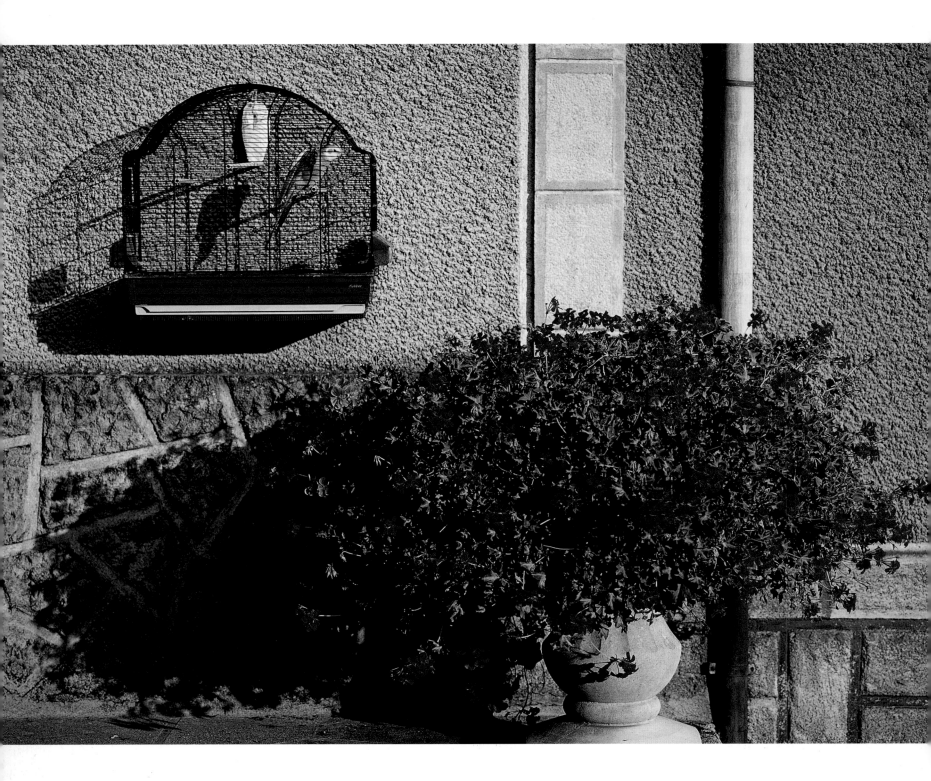

A caged parrot contentedly basks in the warm sunshine above an exuberant vase of flowers – a strange tableau of colour and light close to the church at Piégut-Pluviers (opposite).

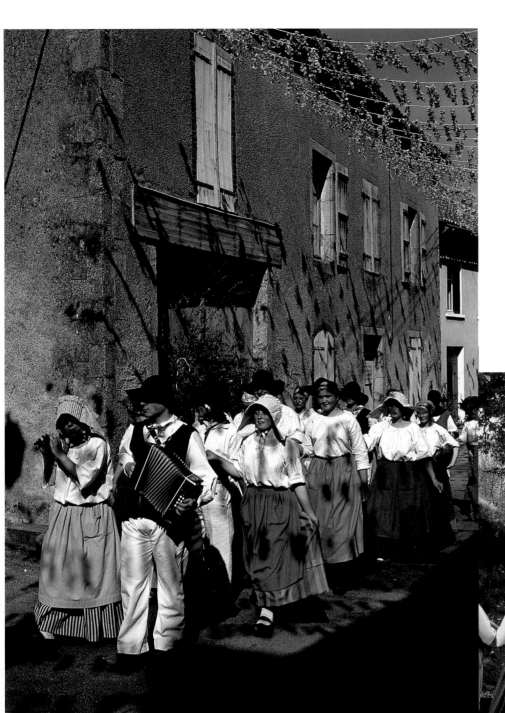

*T*he May flower festival brings out the traditional costume of the Périgord Vert (left *and* below), *where religious and other occasions are still observed with a deeply-felt fervour. Woods and water* (overleaf) *are very much the constant themes of this part of the Périgord: here, the Grand Étang near Piégut-Pluviers, a place of recreation for tourists and locals alike.*

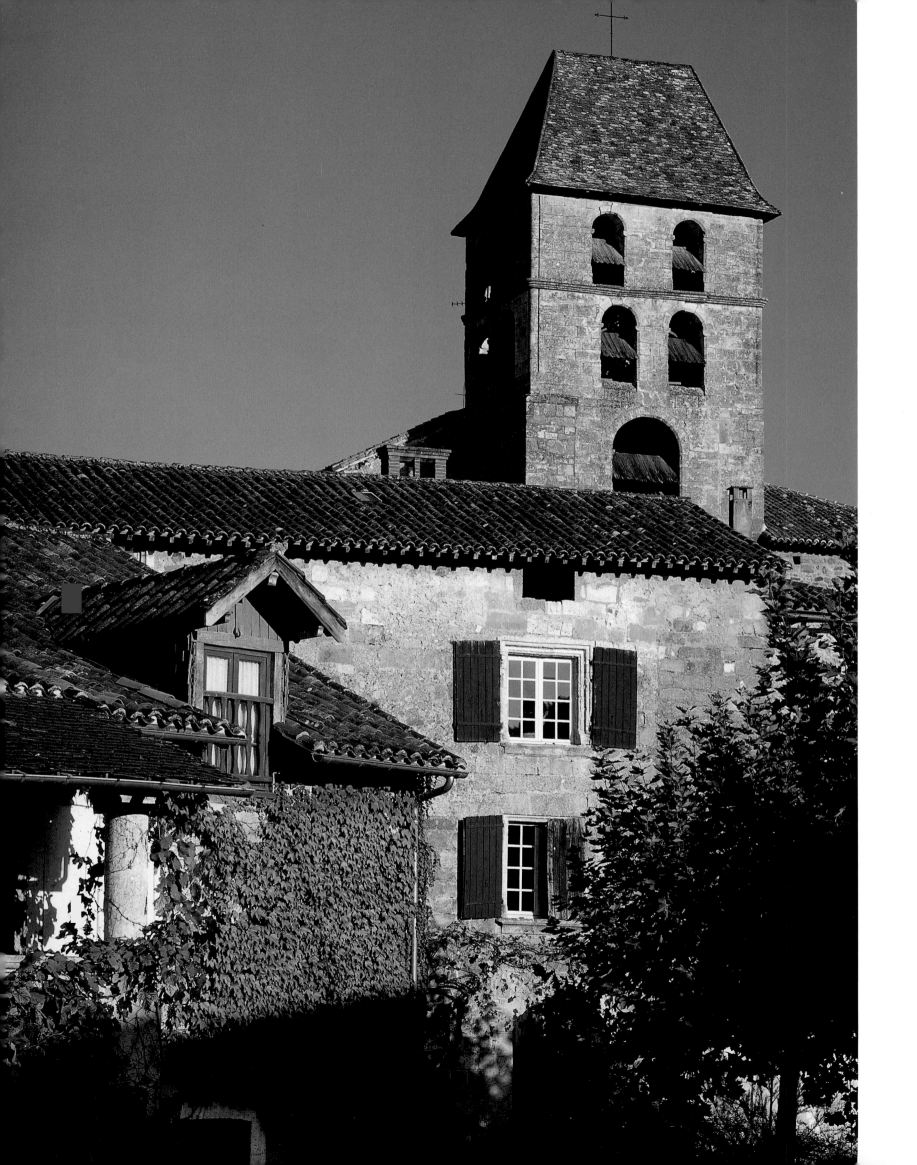

Saint-Jean-de-Côle

The heart of this village is almost outrageously charming, the ensemble of the central square especially so, one side closed by the Château de la Marthonie, another by the remarkable church and its priory buildings, the whole enhanced by a lovely market-hall at the east end of the church.

Château de la Marthonie was built in the fifteenth century for Mandot de la Marthonie, counsellor to the Queen Mother when King François I was in Italy. Building continued over the next three centuries, so that the château has quite distinct aspects. From the earlier epochs derive the living quarters and the circular tower on the south side and the two square towers on the north side. Later eras contributed the classical wing, with pilasters and mansard roofs enlivened by decorated dormer windows, while the classical arcaded gallery opening on to the court of honour and the staircase of honour dates from the late seventeenth century.

Like the houses of the village, the church of Saint-Jean-Baptiste is covered with brown tiles. Built out of granite and once the chapel of an Augustinian priory, it was begun at the end of the eleventh century for Raymond de Thiviers, Bishop of Périgueux. Its plan is unusual, for Saint-Jean-Baptiste is almost completely circular. The dome, twelve metres in diameter, would have been the largest in the region, but it proved beyond the builders' capacities and repeatedly fell down, to be replaced in the end by a wooden ceiling covered by the same brown tiles of the rest of the village. Outside the apse are medieval carvings – Daniel in the lions' den; drunken Noah; God creating man; angels; the Annunciation. The cornice has seventy-five medallions depicting wrestlers, animals, birds and masks. Inside, the furnishings date from the Grand Siècle, while the sacristy (like the square belfry) dates from the seventeenth century. The priory retains two arcaded wings of a sixteenth-century cloister.

Some of the village houses (occasionally half-timbered) date from the Middle Ages, while a Gothic bridge spans the Côle, close by the former abbey's water-mill.

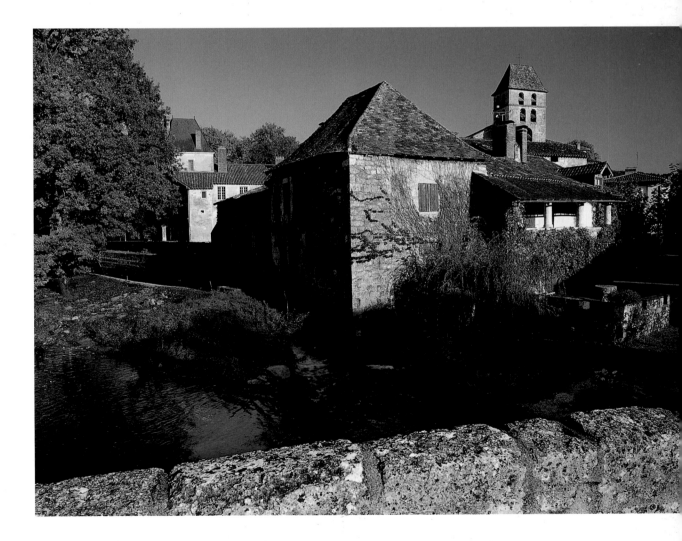

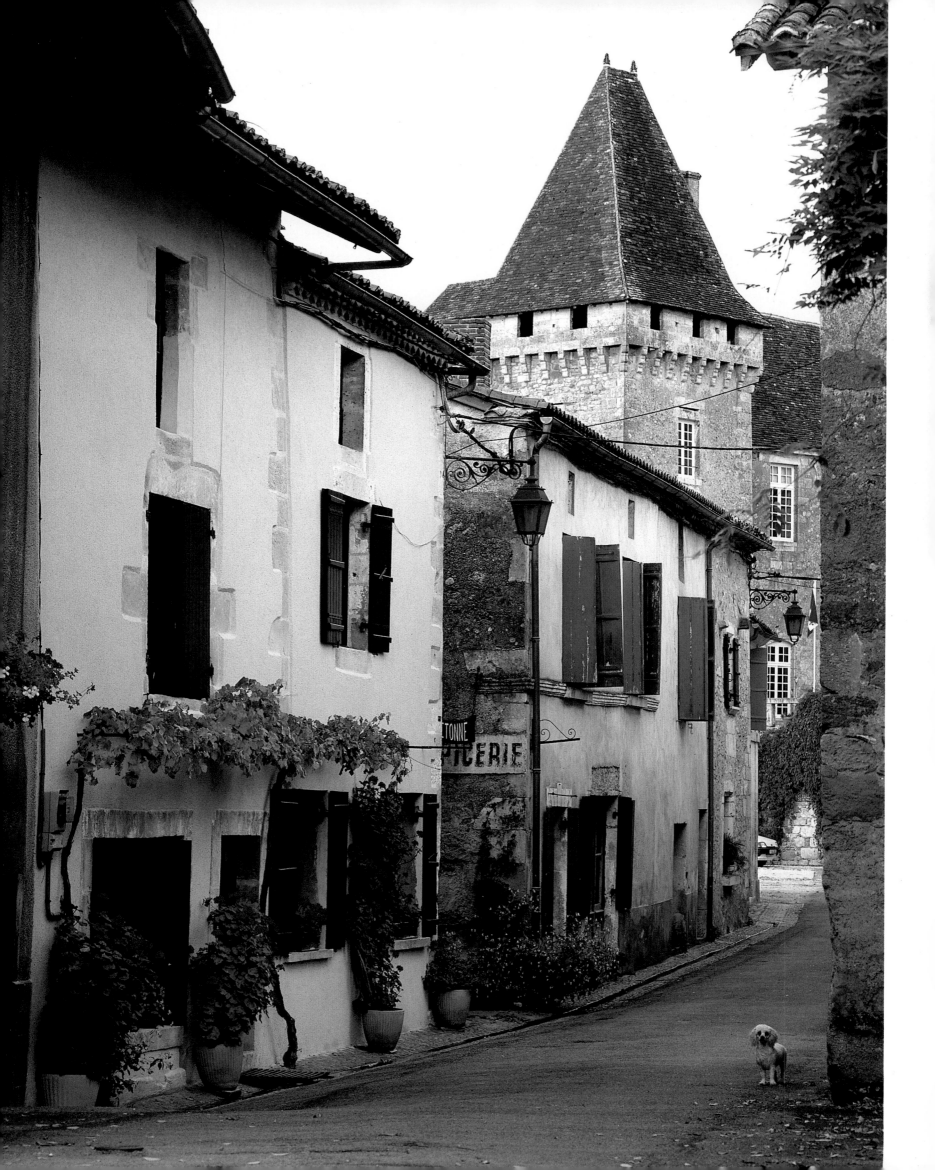

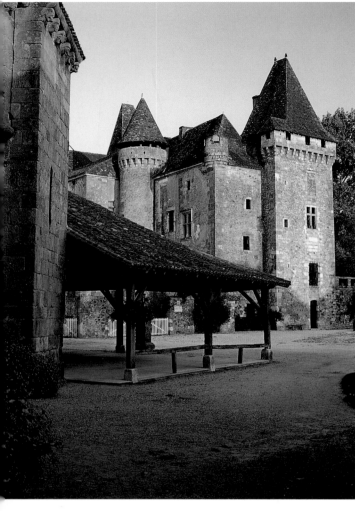

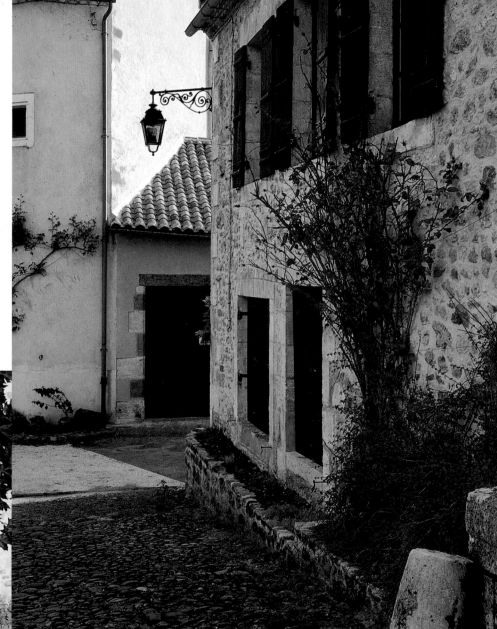

*T*hese charming vignettes of the village demonstrate the rich architectural heritage of the Périgord: the Château de la Marthonie; the covered market-hall; and the south-east end of the twelfth-century village church, its granite wall enlivened at the top with carvings (opposite *and* above). The village also has less spectacular delights: the village well and quiet streets of charming houses (left *and* above).

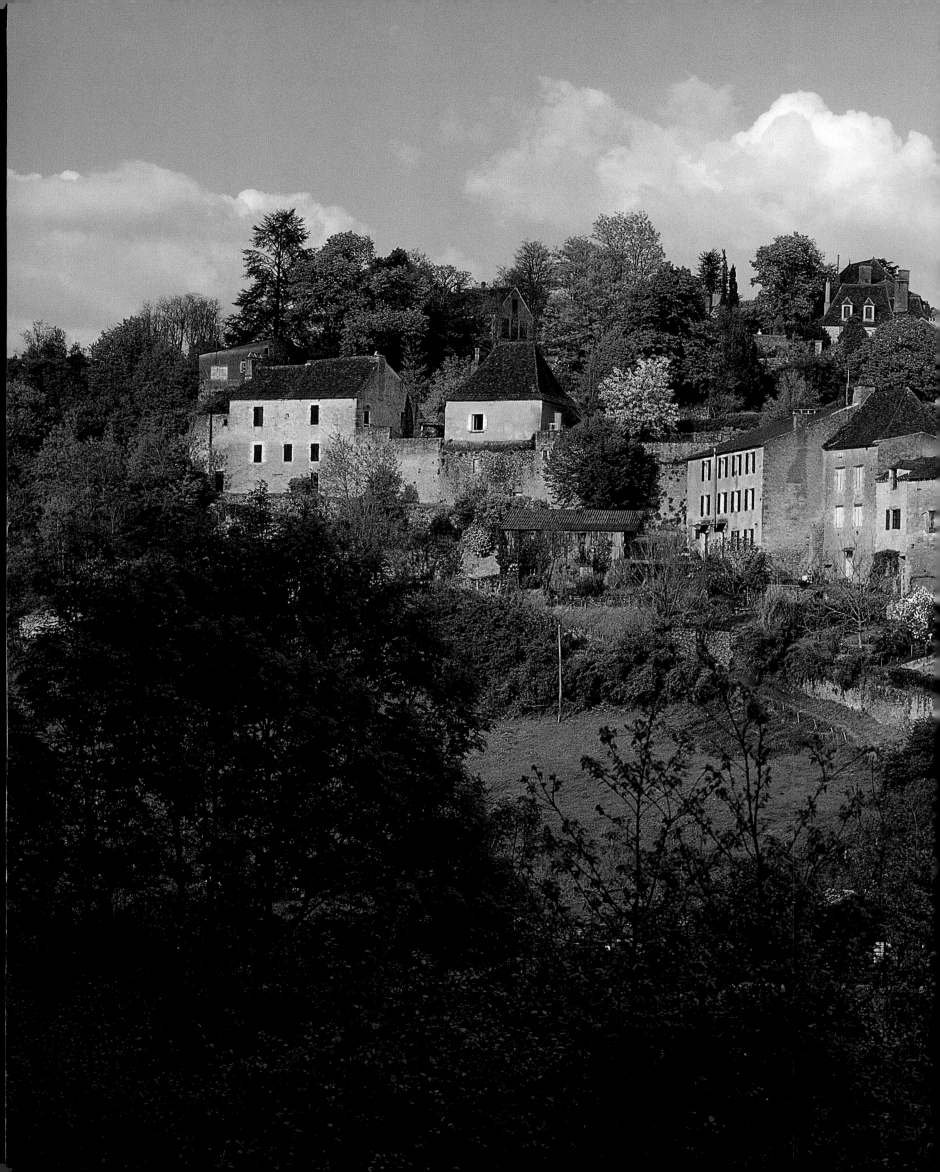

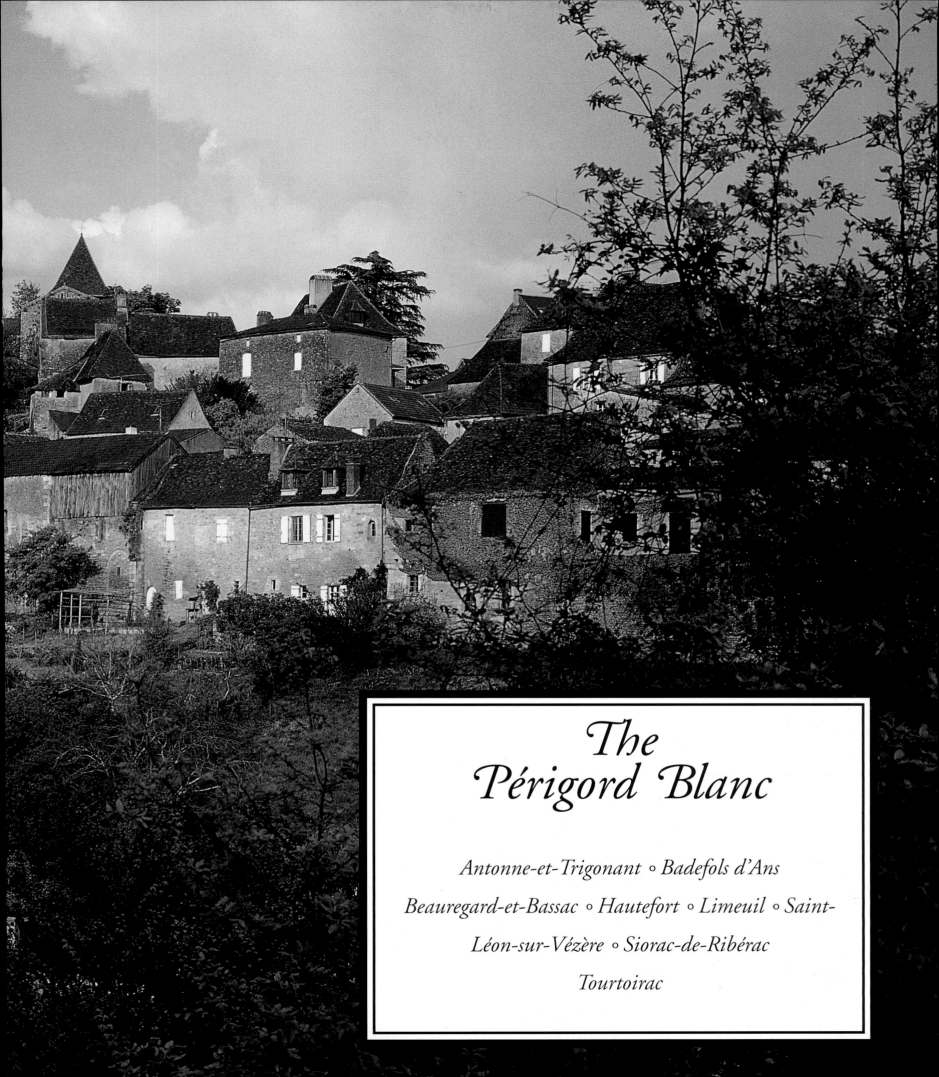

The Périgord Blanc

Antonne-et-Trigonant ○ Badefols d'Ans

Beauregard-et-Bassac ○ Hautefort ○ Limeuil ○ Saint-

Léon-sur-Vézère ○ Siorac-de-Ribérac

Tourtoirac

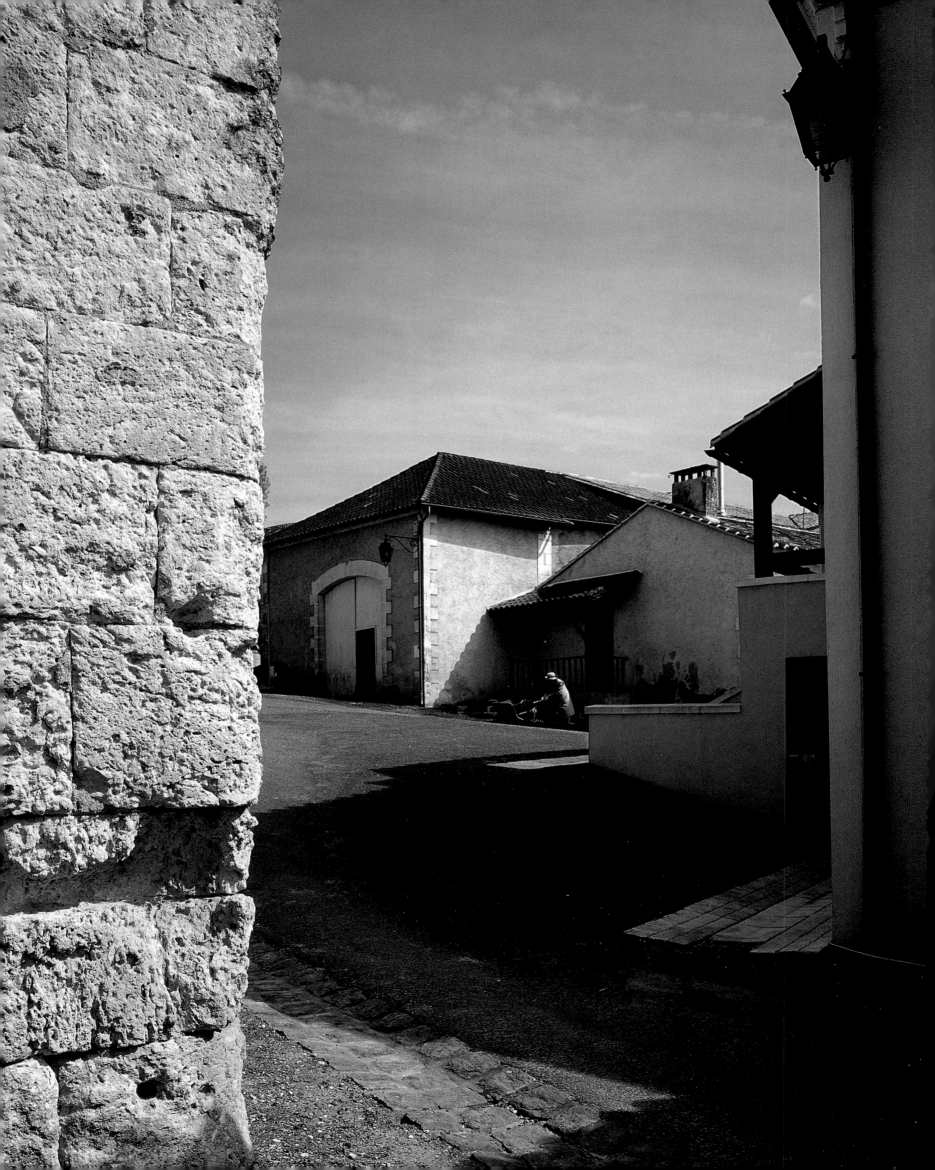

Comprising some of the most open countryside of the *département* of the Dordogne, the area of the 'white' Périgord stretches from Périgueux to the regions south of Ribérac (as far as Montpon-Ménestérol in the lower valley of the river Isle). Here, the rivers Auvézère and Isle slice through plateaux of extensive fields of cereal crops, alternating with undulating hills and warm valleys, ideal for maize and strawberries. (Vergt is the strawberry capital of France.) A few lakes dot the region, such as those around Montpon-Ménestérol or the Étang du Coucou between Hautefort and Nailhac, where you may also come across an old windmill. And since forests do not respect man-made boundaries, the Périgord Blanc also embraces part of the Double forest.

No one crop dominates the region. Walnut trees, ancient oaks and chestnut trees flourish around many of the villages, and the countryside is often sweetened by fruit trees cultivated by assiduous market-gardeners. Maize and tobacco are also grown, the tobacco leaves dried in large barns, whose unadorned walls contrast with those of the appealing houses of the villagers and farmers. Pigs and fowl are a staple source of income, their flesh succulently served in the local restaurants, where the cooking is often done in oil from the local walnuts.

Among the many enticing towns and villages of this region are Mussidan, set at the confluence of the Isle and Crempse and noted for its ceramics, Sorges, resting in the valley of the river Beauronne and renowned for its truffles, and Savignac-les-Églises, a village in the Isle valley which, as its name indicates, has two lovely churches, one twelfth-century, with a fifteenth-century Gothic nave, the other housing a fourteenth-century Descent from the Cross carved in stone.

The Périgord Blanc is centred on the capital of the Dordogne, Périgueux, whose majestic cathedral, brilliantly restored in the nineteenth century by Paul Abadie and Jacques-Emile Boeswillwald, rises beside the river Isle. Périgueux has its share of Roman and Gallic monuments; but so do many of the entrancing villages of the Périgord Blanc, such as Badefols d'Ans, near which is the site of a Roman camp, or Saint-Léon-sur-Vézère, where you can still make out the Gallo-Roman wall on which its parish church was later built. Traces of a Roman aqueduct remain at Saint-Laurent-sur-Manoire, south-east of Périgueux. Some villages, such as Sergeac, are also sought out for their prehistoric remains.

The churches of the Périgord Blanc abound in treasures of religious art: medieval Madonnas; twelfth-century frescoes; most unexpectedly a Descent from the Cross by the Italian master Annibale Caracci in the Gothic church of Antonne-et-Trigonant.

A particular treat of this region is the formal garden of Château Hautefort, the château itself another marvel, rising as it does above a village with fewer than 1,500 inhabitants. Garden and château mirror each other in classical harmony, while other châteaux of the Périgord Blanc, such as the ruins of that at Limeuil, speak of a more savage age.

Another once savage part of the Périgord Blanc is the Barade forest, like the Double inhospitable in the past and likewise transformed. At its heart is the tiny village of Bars, whose Romanesque church has a belfry with four bays and houses an eighteenth-century sculpted and gilded reredos. In the Barade forest Eugène Le Roy, the Zola of the Périgord, set his finest novel, *Jacquou le Croquant*, which he published in 1899, depicting the life of the Périgourdin poor in the early nineteenth century who (as Jacquou's mother puts it) 'live in hell in this world'.

Preceding pages
A witness to the turbulence of the region, the strategically important village of Limeuil stands at the confluence of the Vézère and the Dordogne; it was successively fought over by the French and the English in medieval times, then suffered further indignities during the Hundred Years War.

Light, shade and rugged masonry all contribute to a feeling of peace and security at Siorac-de-Ribérac (opposite).

Antonne-et-Trigonant

As you approach the village of Antonne you climb to a terrace overlooking the river Isle to discover a fascinating château which was built for Jeanne de Hautefort, widow of Jean de Saint-Astier, between 1497 and 1604. Château des Bories marks a turning-point in the lordly dwellings of the Périgord. The Wars of Religion had raged for the past thirty-five years, and defensiveness was still the first priority of any château; yet the owners of powerful fortresses were now humanizing them a little. Château des Bories was defended by a moat whose traces you can still see, and other fortifications stretched to the edge of the river. The central part of the château is flanked by two massive, machicolated round towers, topped by pepperpot roofs, while behind the steeply sloping roof of the main building rises a square staircase tower. But even these towers are pierced not with slits but with the same graceful windows that lighten the rest of the château.

Inside, the gentler aspect of the fortress is still more apparent. The staircase, with its ogive-vaulted landings, is splendidly decorative as well as useful. Unexpectedly, the kitchen has deft vaulting which springs from a central pillar, as well as two chimneys (one reserved principally for baking bread). In the great gallery, with its Louis Treize furniture, is a Renaissance fireplace. Yet its military aspect proved vital, for Château des Bories was besieged both in the seventeenth and the eighteenth centuries.

The commune of Antonne-et-Trigonant, four kilometres north-west, rejoices in two other châteaux: fifteenth-century Château de Trigonant, with its two towers; and the secluded seventeenth-century Château de Lanmary. The Gothic church of Trigonant is worth a visit for its treasures: the reredos, the pulpit and Descent from the Cross painted by the Italian master, Annibale Caracci.

The circular towers and machicolations of the Château des Bories dominate a distinctly agricultural setting above the river Isle close to Antonne-et-Trigonant.

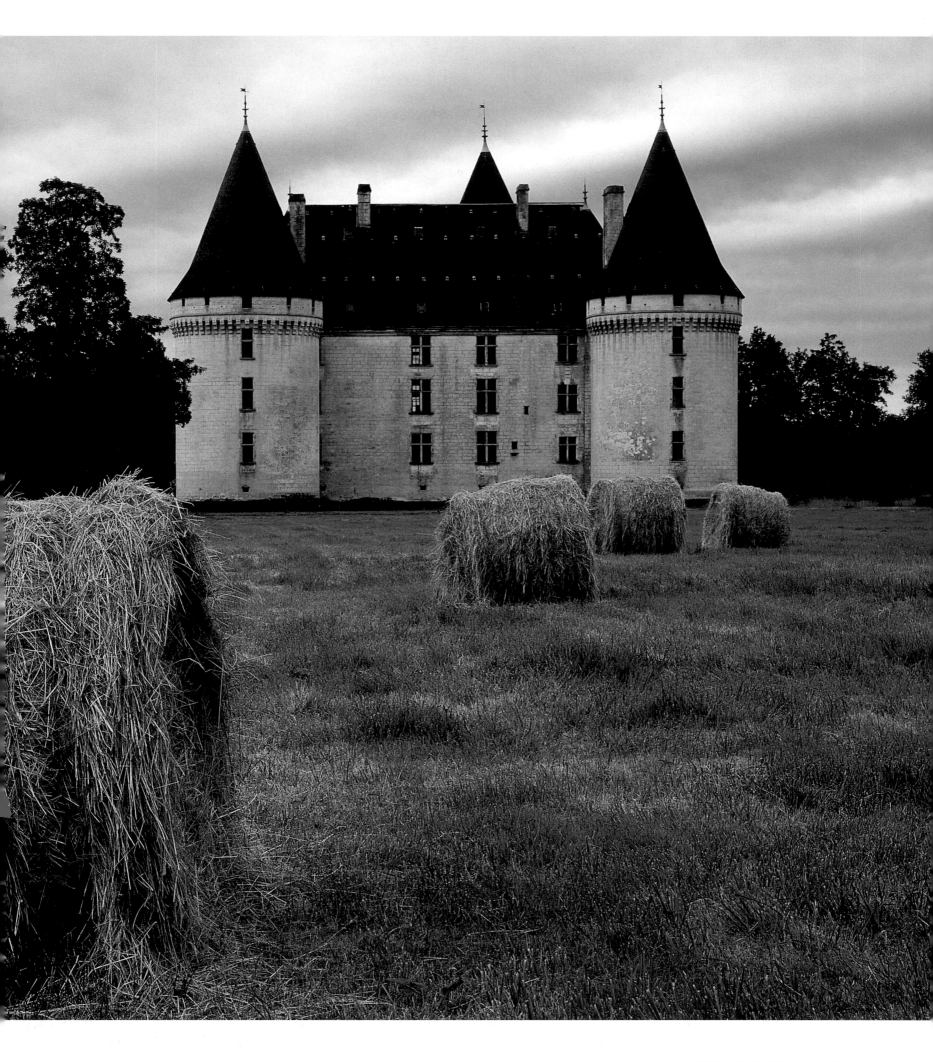

*D*etails of the fine late
fifteenth-century
stonework of the Château des
Bories at Antonne (left *and*
above); *the château is beautifully
situated on the tiny river
Isle* (opposite).

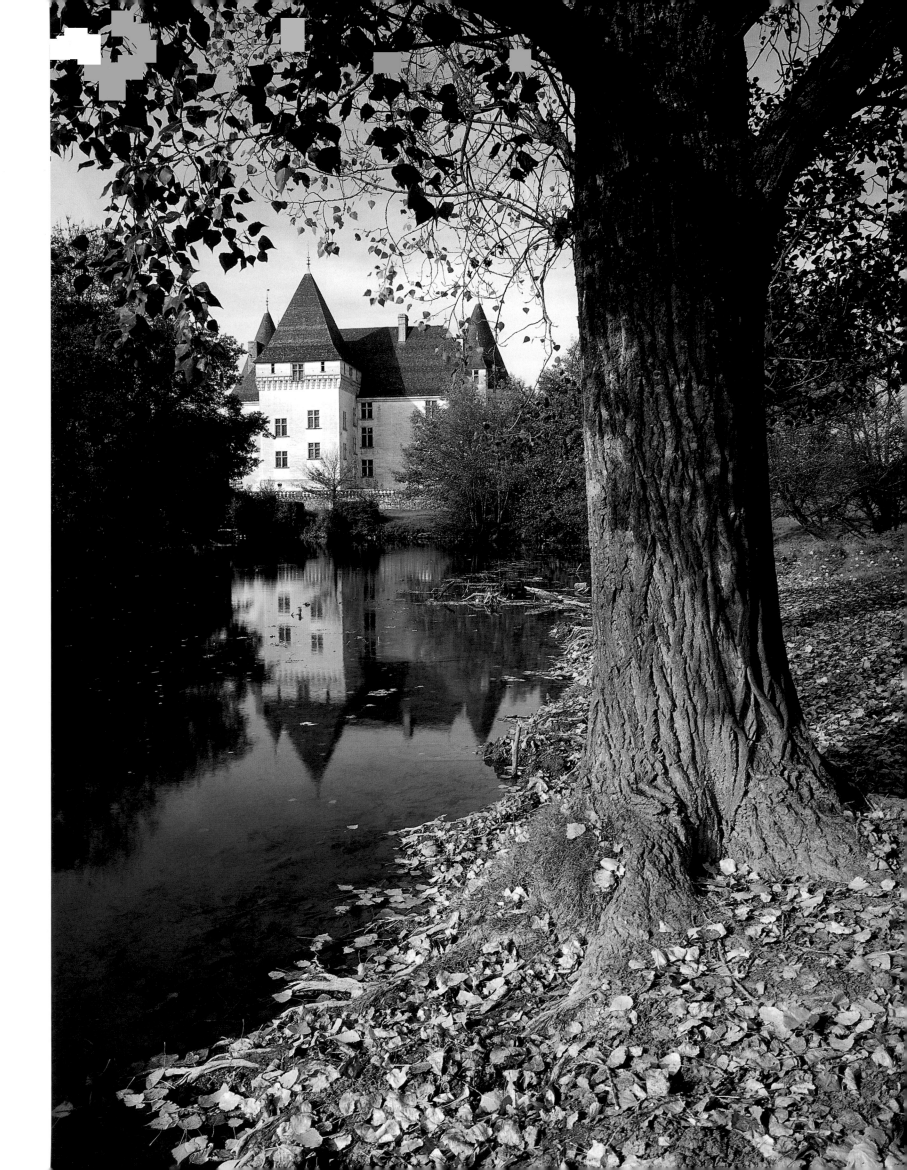

Badefols d'Ans

In the fourteenth century a daughter of the lord of Hautefort married the lord of Ans in Flanders, hence the curious name of this Périgourdin village (as well as a whole row of villages ending 'd'Ans' along the valley of the Auvézère). No doubt in part because Badefols d'Ans is close to the Limousin border, the delightfully irregular château which dominates the village is powerful. And the builders took care to find a position with a splendid panorama, not so much to enjoy the view as to be able to spot the approach of potential enemies.

The oldest part of the château is the keep, with its later machicolations. The huge square towers date from the fourteenth and the fifteenth centuries. Only at the time of the Renaissance were windows pierced in the walls, and in the eighteenth century a more elegant building with a mansard roof was added to the existing fortress.

When retreating German troops set fire to the château in 1944, the walls survived the flames, and the whole has now been meticulously restored. The cruciform village church is dedicated to St. Vincent. Romanesque with Gothic elements, it has a square belfry and a seventeenth-century entrance. Inside, its Baroque reredos was created in the seventeenth century. An agreeable feature of this church is the variety of its vaulting: the square choir and a chapel to the south with round vaulting; other chapels with ogival tracery; and the north chapel vaulted like a star. A cupola at the crossing completes the ensemble.

Six kilometres south-west, at the *lieu-dit* Moulin-à-Vent near La-Chapelle-Saint-Jean (with its prehistoric site and Roman camp) is one of the highest points of the whole *département*. Moulin-à-Vent is 354 metres above sea level, and the panorama is superb.

*S*cenes of peace and undeniable charm sum up the Périgord Blanc in the village of Badefols: a quiet street curves towards the tower of the château (above right); ironwork in the form of gates and balustrades (left *and* opposite) provides exquisite detailing amid the stonework and wood shutters of the village's gentle, unassuming streets (right).

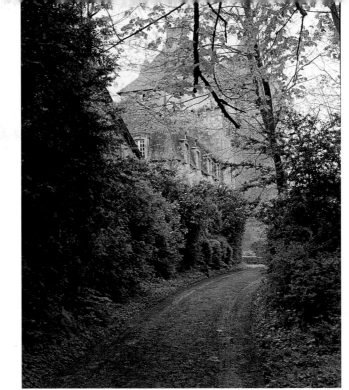

*M*any Périgourdin
 villages seem literally
invaded by the surrounding
countryside, sometimes to such a
point that the very buildings seem
organic in origin (opposite).

*P*eace and calm are the
 virtues of this village: a
winding drive leads up to the
medieval château (above right);
houses and barns alike (above and
right) have a timeless, engaging
decrepitude, as though they – like
the countryside – go back to eras
beyond the memory of man.

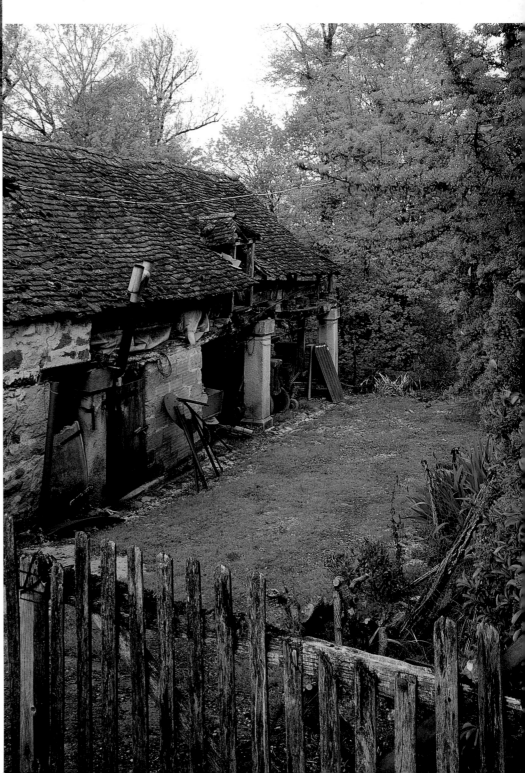

Beauregard-et-Bassac

The word *bastide* originally signified any kind of French stronghold, but in the thirteenth century it became increasingly to be applied exclusively to a new kind of fortified settlement, created either on behalf of the rival kings of France or England in their effort to secure their hold on Aquitaine. Citizens were attracted by a measure of self-government, by grants of land and by the right to hold markets – hence the superb market-halls which often grace the *bastides*. Within a space of 150 years some six hundred were founded, and three hundred or so remain.

Beauregard-et-Bassac is an English *bastide* founded in 1268 on behalf of King Edward I. It perches beguilingly on a hill, which added to its defensive capacity. Its finest feature is the thirteenth-century market-hall. Beauregard has also preserved a Renaissance house which once belonged to the politician and diplomat Talleyrand (Charles Maurice de Talleyrand-Périgord) and the fortified sixteenth-century Maison Pimport, which was later transformed into a mill.

The church of Beauregard is Gothic. Bassac's church is finer, Romanesque, with a porch decorated with sculpted capitals, a rustic reredos and a miracle-working statue of the Virgin Mary.

The whole commune of Beauregard-et-Bassac is worth exploring for its prehistoric remains, particularly a neolithic dolmen. There are also a couple of *cluzeaux*, underground refuges, specially prepared by the citizens for use in time of trouble.

Bastides are almost invariably surrounded by fertile land, the result of their citizens' industry over the centuries, and today the valley of the river Crempse, over which Beauregard-et-Bassac looks, is rich both in tobacco and in strawberry fields.

A sixteenth-century château-mill at Beauregard-et-Bassac lends architectural splendour to the landscape of cultivated fields and surrounding woodland.

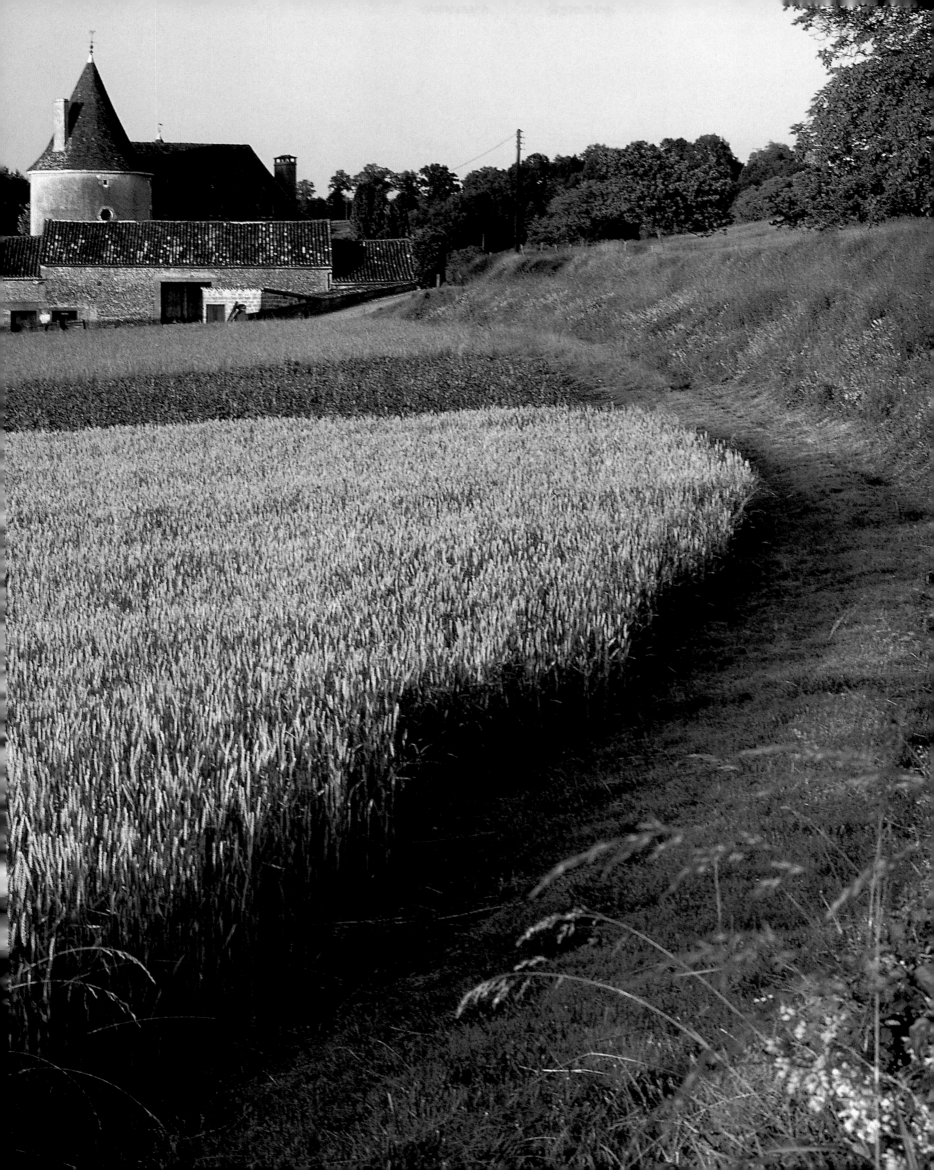

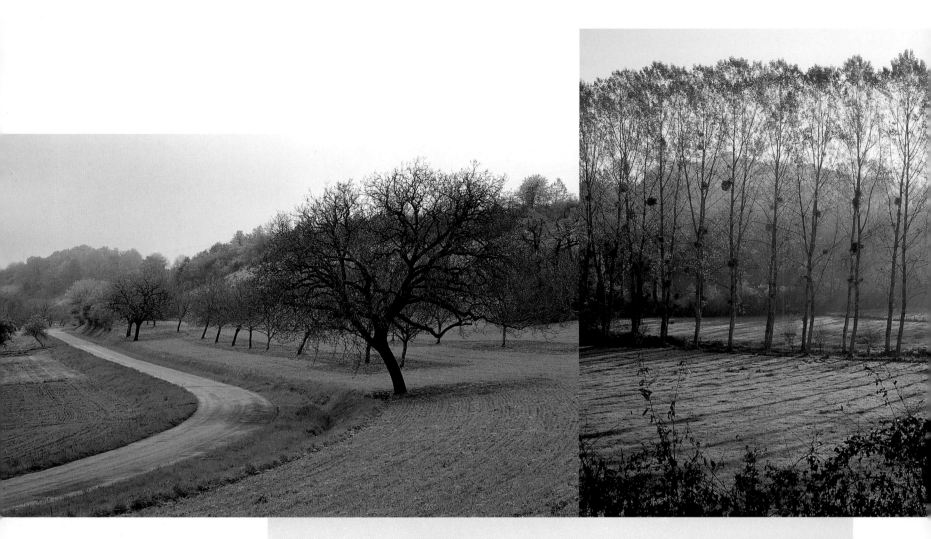

*T*rees, practical and fruit-bearing *(above) or elegantly ornamental like these poplars near Hautefort (above right), caught in the morning light, lend great variety to the Périgourdin landscape. The same landscape, supremely accessible, also embraces buildings and architectural elements which it seems to envelop and make its own (right).*

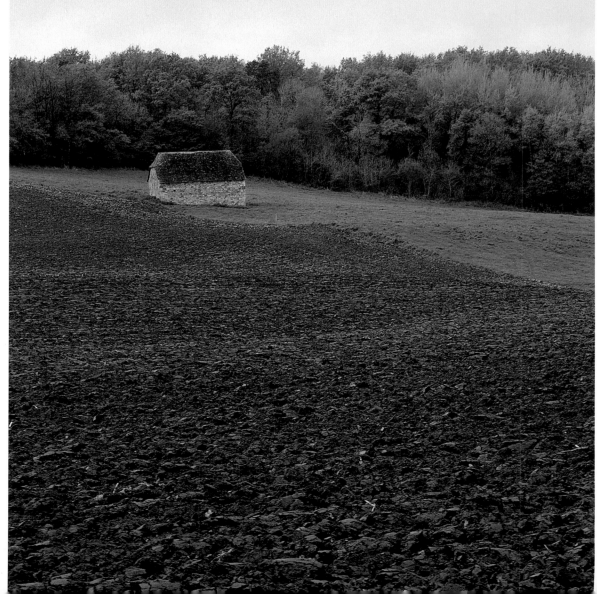

Hautefort

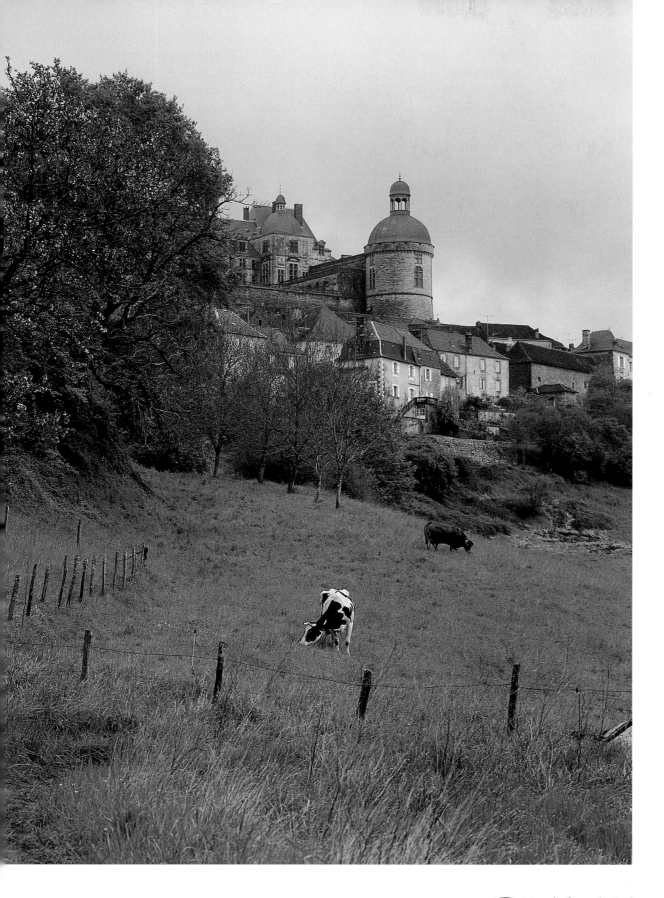

Périgord's finest classical château rises magnificently above the crouching houses of the village and the slopes of surrounding pasture land.

Visible long before you reach the village is the most magnificent classical château in the Périgord. There has been a château at Hautefort at least since the ninth century, but the defensive gateway, with its dry moat and drawbridge, through which you reach the courtyard of honour of the present building, dates from the sixteenth. The seventeenth-century masterpiece, however, is the work of two architects, the Périgourdin Nicolas de Rambourg and his successor, the Parisian Jacques Maigret; their patron was Jacques François, Marquis of Hautefort.

Born in 1610, Jacques François de Hautefort commissioned the rebuilding of his château in 1630. It was finished forty years later. The principal building, an immense rectangle, is enlivened by two square pavilions capped with slate-covered domes. Tall windows topped with triangular lintels, dormers with curved windows and wide bays display a classical symmetry. The side aisles stretch towards two round towers, whose machicolations hint at the Middle Ages, while their slate-tiled domes, topped by lanterns, are again harmoniously classical. It is possible that the western tower is contemporary with the entrance wing of the château; the eastern tower was completed in 1670.

The formal gardens of the Château Hautefort are among the finest in France, the flowers and plants enhanced by clipped yews and box trees as well as pergolas, the whole complemented by a park of some 40 hectares.

The village of Hautefort, its houses roofed either in slate or brown tiles, also benefited from the generosity of Jacques François, who commissioned Jacques Maigret to built a hospice for eleven old men, eleven boys and eleven young girls (their number symbolizing the age of Jesus at his crucifixion). Maigret's hospice, in the form of a Greek cross, is domed like the château. The four arms of the cross served as living quarters, gathered around a central chapel which is now the parish church of Hautefort.

Virtually every street, alley and quiet corner of Hautefort is overlooked by one or other aspect of the majestic château (above and right). Even the great castle's immaculate classical garden provides another vantage point for a survey of the dwellings of the village below and the rolling landscape beyond (opposite).

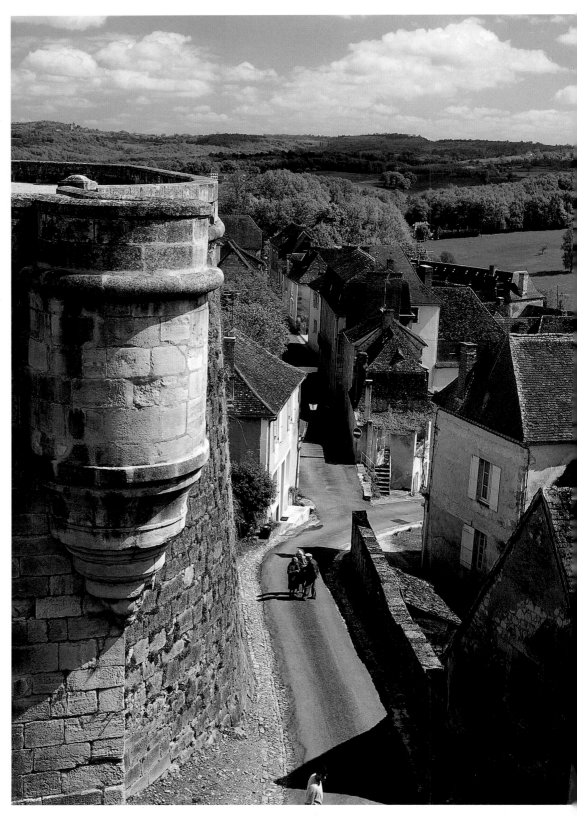

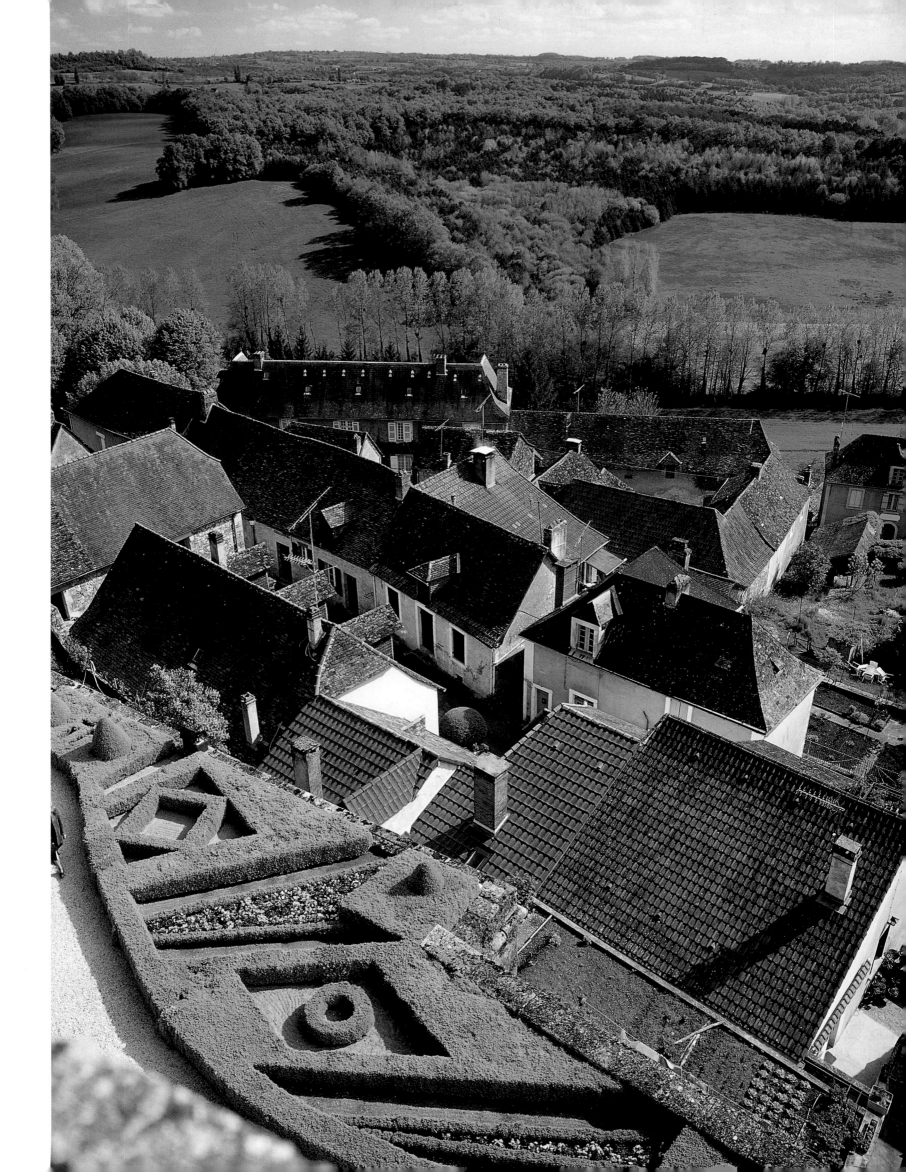

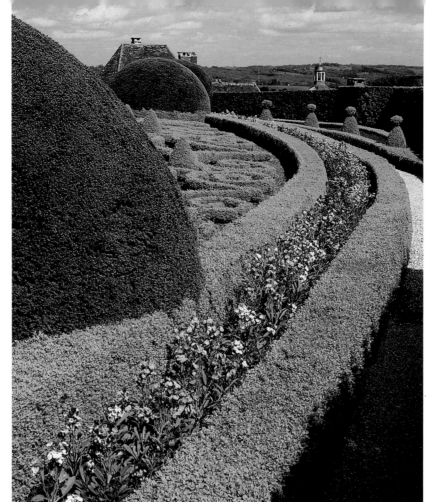

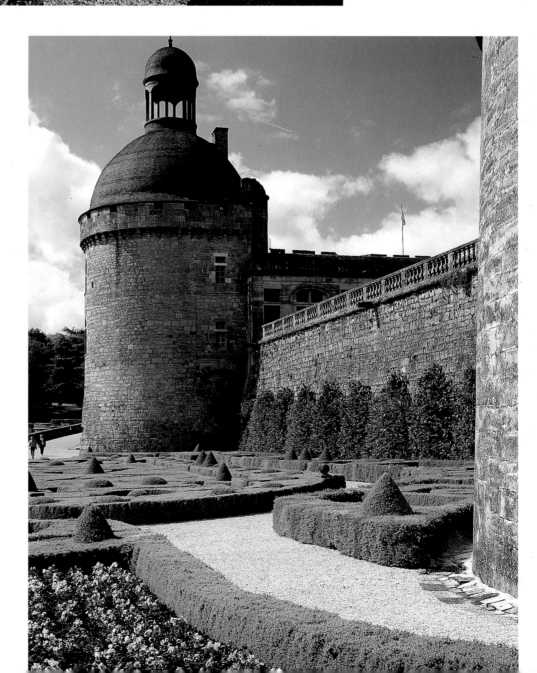

The formal gardens of the Château of Hautefort provide a wonderful viewing platform over the surrounding countryside; here we look south-eastwards towards Badefols d'Ans (opposite). The ordered formality of the gardens (left and below) are in dramatic contrast to the rugged masonry of castle tower and wall.

Limeuil

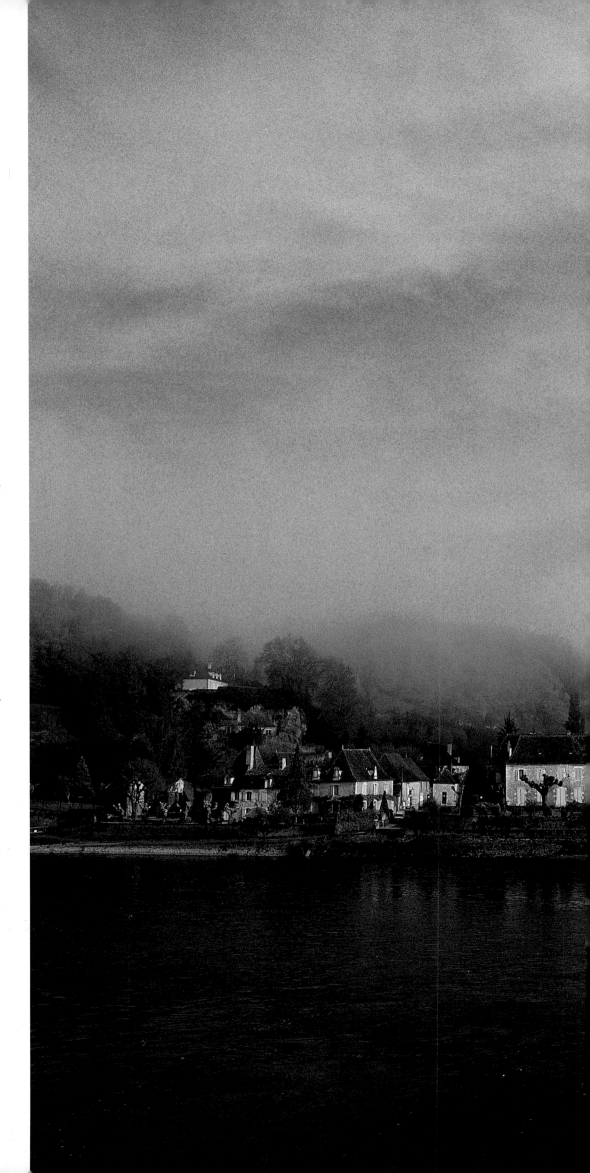

Perched on a little hill at the confluence of the rivers Vézère and Dordogne, Limeuil was once of considerable strategic importance and much battled over during the Hundred Years War, the Wars of Religion and the seventeenth-century revolts of the *croquants*. Traces of its defences still remain: three fortified gateways and vestiges of its once mighty ramparts, dating from the fifteenth and sixteenth centuries. Of the thirteenth-century château scarcely anything remains, save the base of the keep, the well and a few solitary stones. This spot, claimed the nineteenth-century novelist Eugène Le Roy, afforded the finest of all views of the Périgord.

Limeuil's cobbled streets climb between an ensemble of exquisite sixteenth- to eighteenth-century stone houses, their windows ornamented, their doors embellished with emblems, their gables sculpted, their walls covered in ivy and roses. Some of them, with ample curved windows, once were the homes of weavers. Among them you come upon an eighteenth-century former convent. The nave of the parish church was built in the nineteenth century, but its choir is five hundred years older and houses an eighteenth-century reredos. Its proudest treasures are a Gothic Madonna and Child, sculpted in the fourteenth century, and a seventeenth-century Black Virgin and Child.

The English occupied Limeuil in 1194, and in that year Richard Coeur de Lion and King Philippe-Auguste of France founded a church to expiate the murder in 1170 of Thomas Becket, Archbishop of Canterbury, at the instigation of Richard's father, King Henry II. Richard wished to dedicate the church to Becket, but today its dedication is to Saint-Martin-de-Limeuil. Romanesque, it stands close to its cemetery, the Latin inscription over its doorway appropriately begging God's forgiveness. The keystone of the archivolt is sculpted with a lion pursuing a goat, and inside are some fascinating traces of fifteenth-century wall-paintings.

Dawn at the confluence of the Dordogne and the Vézère: the village of Limeuil peers eerily through the valley mist.

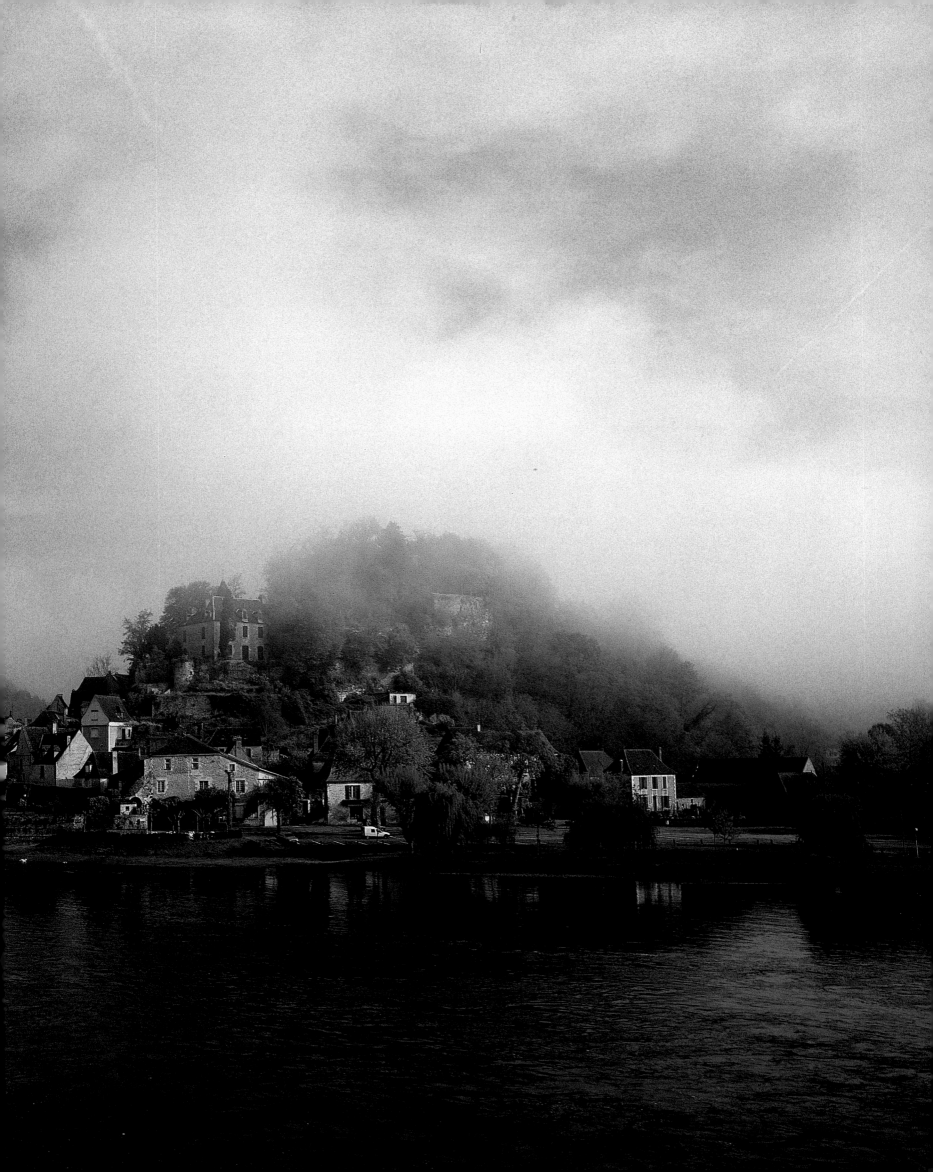

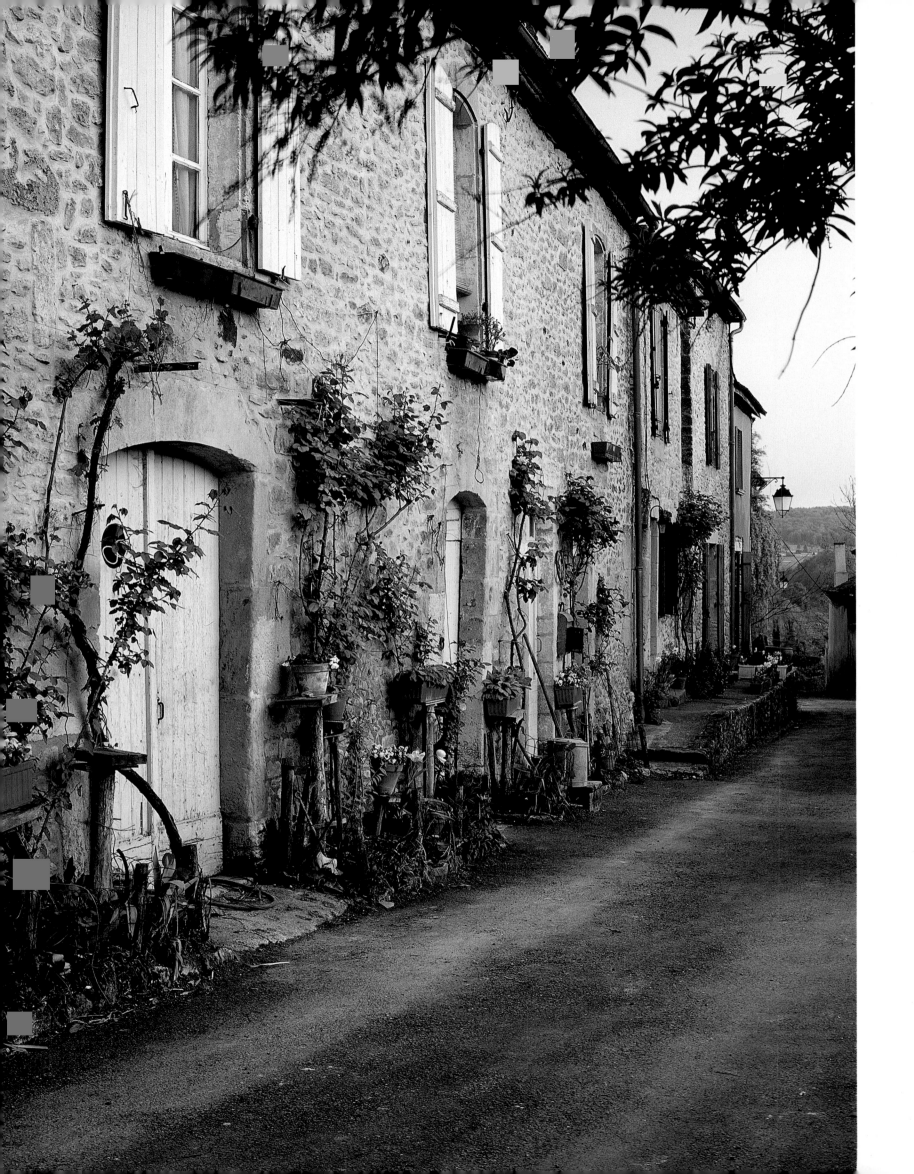

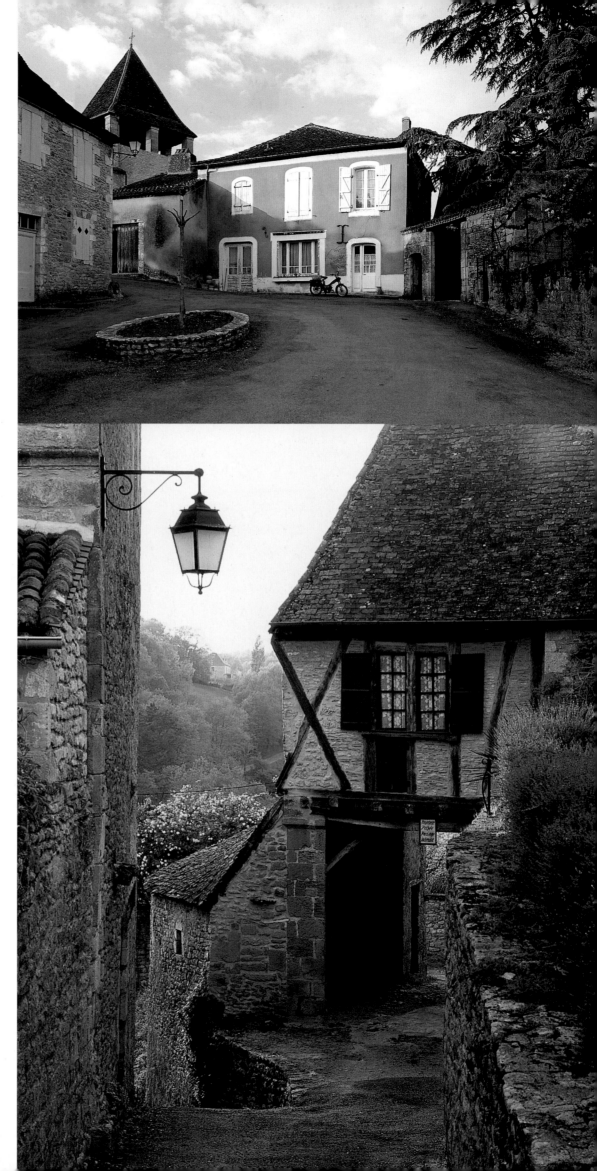

*T*hese charming, west-facing houses flank one of Limeuil's steep streets (opposite).

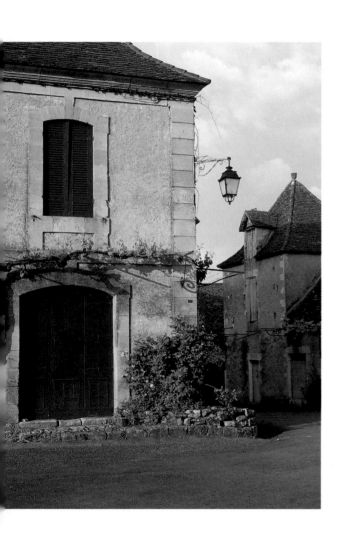

*A*spects of the variety of a Périgourdin village: a classical house (above); the square and the twelfth-century church of St. Martin (above right); and an entrancing corner with a half-timbered house roofed in traditional lauzes (right).

Saint-Léon-sur-Vézère

This bewitching village sits beside a meander of the willow-bordered river Vézère. It developed around a Benedictine priory which disappeared during the Wars of Religion. Its eleventh-century parish church of Saint-Léonce, one of the oldest in the Périgord, is built on a Gallo-Roman foundation, the ancient stones clearly visible in the wall along the river bank. The round apse, whose stones grow smaller as the wall rises, is flanked by two smaller apses, all three wearing pointed hats made of the heavy stones known as *lauzes*. The nave too is roofed in *lauzes*, as is the belfry, whose lower storey is delicately pierced with two lights, the upper with three.

Inside the church is a sixteenth-century Virgin and Child, and the ceilings of the apses are painted with frescoes dating from the twelfth to the seventeenth century. Of the earliest you can make out three heads of Apostles, while one of the fifteenth century depicts Jesus surrounded by symbols of the four Evangelists.

Saint-Léon-sur-Vézère boasts two châteaux: Château de la Salle, whose square, *lauze*-covered keep dates from the fourteenth century, and the riverside Château de Clérans, which was built a hundred years later. Close by is Château de Chaban, built in the sixteenth and seventeenth centuries and approached through a long alley of cypresses.

The cemetery of the village has been classified as an historical monument of the first order, for it possesses rare eight-hundred-year-old wall-niche tombs as well as a 'lantern of the dead'. And the fourteenth-century cemetery chapel is noted for an inscription in Occitan which recounts the story of an archer who in 1233 loosed an arrow at the crucifix and then fell dead, his head twisted round. In 1890 the Société Historique et Archéologique du Périgord excavated a tomb here and discovered a skeleton whose cranium was indeed turned back-to-front.

A peaceful scene in a herb garden in Saint-Léon-sur-Vézère (above); a canine denizen of the village (right) exudes a proprietorial air over his garden.

Another canine villager guards the superb church of Saint-Léon (opposite) whose triple-lobed apse and square tower, the whole topped with stone lauzes, *are typical of the finest Romanesque churches of this part of the Périgord.*

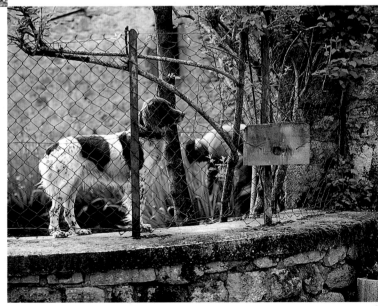

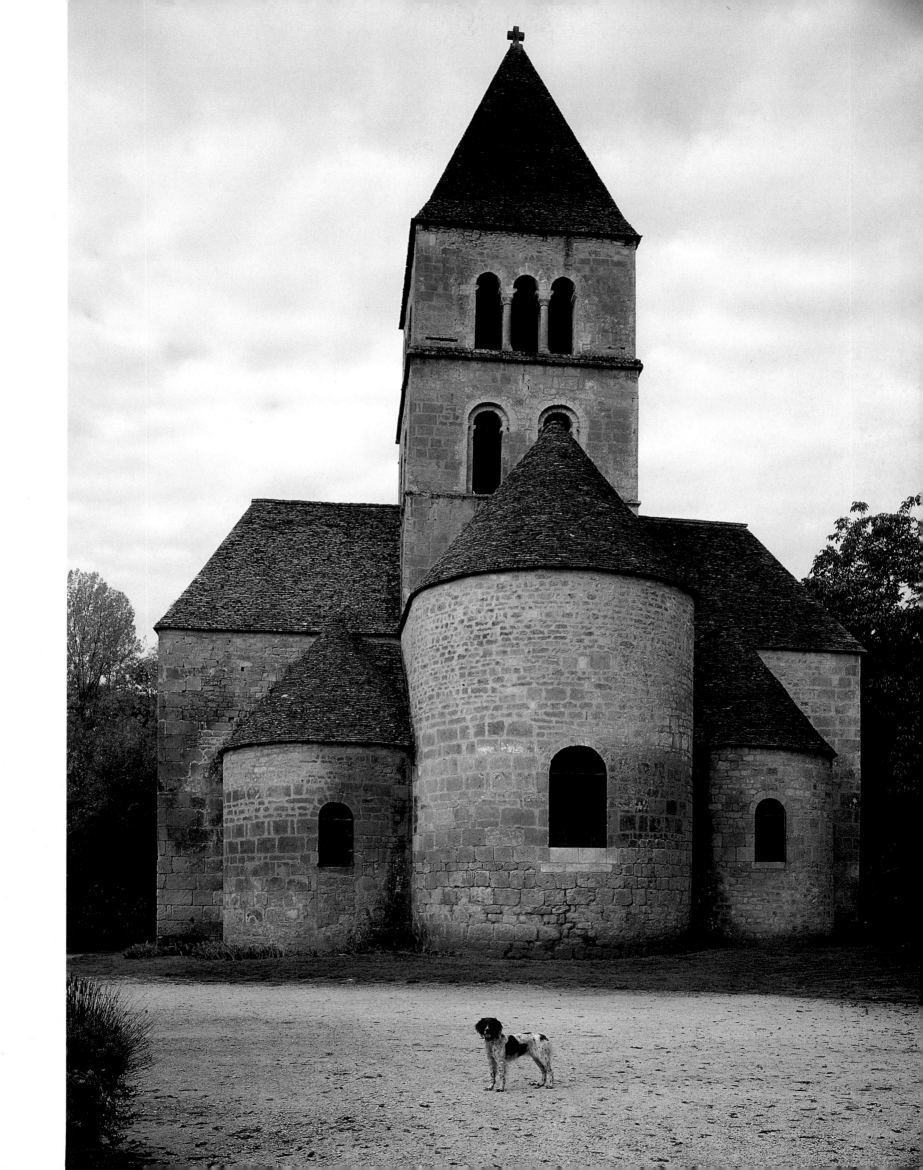

A typical Périgourdin scene: a solitary stone shelter in a field outside Saint-Léon-sur-Vézère brings a note of human occupation to a powerful landscape (above). Saint-Léon is notable for its variety of large houses, many of which, like this example (right), could be classified as part farmhouse and part château.

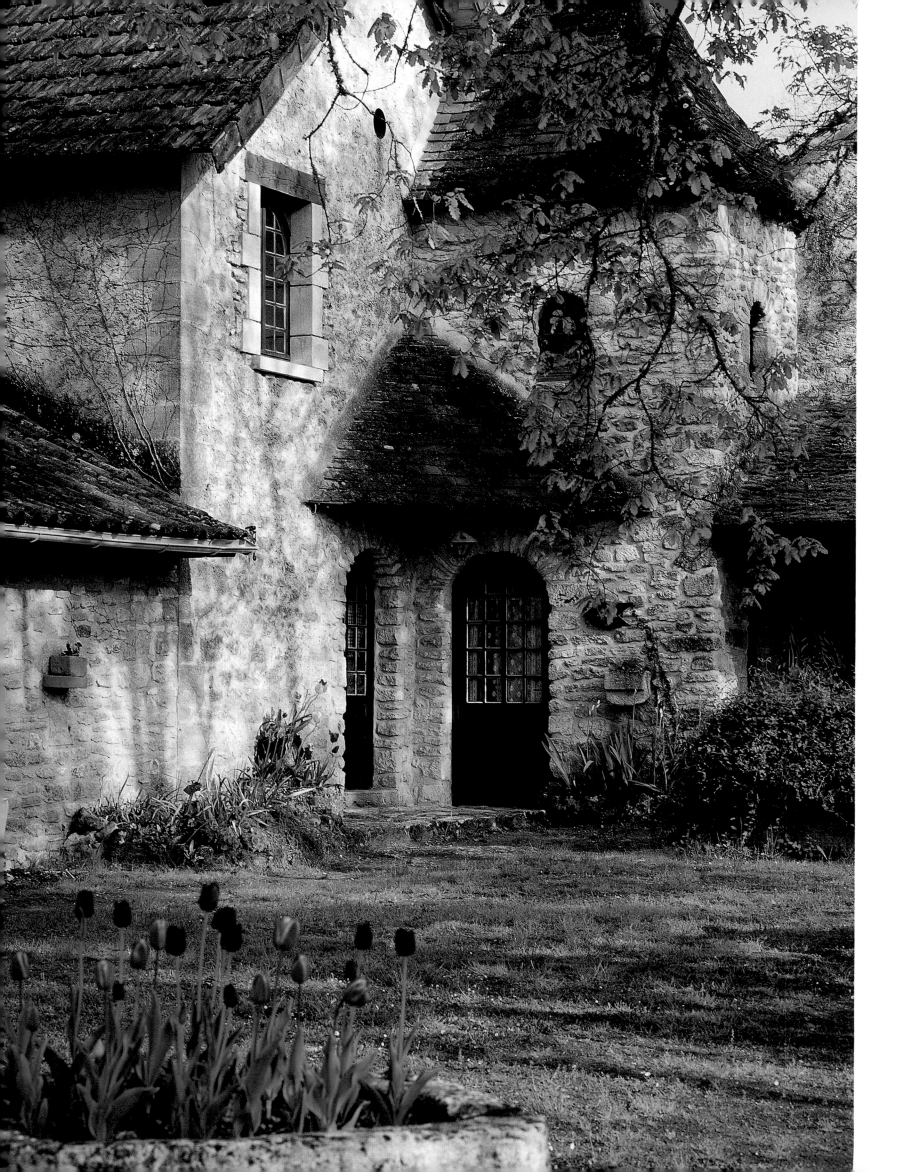

*S*pring tulips adorn the lawn of one of Saint-Léon's agreeably weathered manor houses (opposite).

*T*he oldest part of the village (right *and* below), *close by the church, boasts numbers of elegant, secluded houses which express a sense of long establishment and a village life settled for many years.*

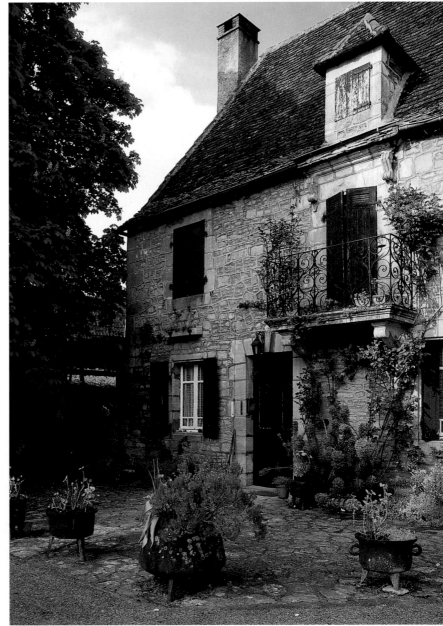

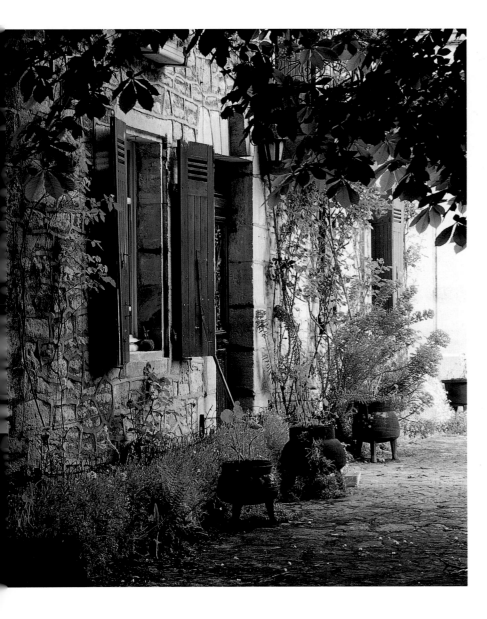

Siorac-de-Ribérac

Some five kilometres from Ribérac on the way to Bergerac you turn right to discover the seductive village of Siorac-de-Ribérac, set on a hillside. In the thirteenth century this tiny spot was the seat of an archpriest, which may account for the way the church of Saint-Pierre-de-Siorac dominates the rest of the village. Romanesque, the church dates back to the twelfth century, but its subsequent architectural history speaks of the turbulence of the Périgord in the Middle Ages. Saint-Pierre has two belfries. The simple, square one, from whose summit stubby stone fingers hold up a flat roof, was built in the twelfth century. Two centuries later Siorac-de-Ribérac added another belfry to its parish church, this one grimly defensive, its walls scarcely pierced, capable of sheltering the population under attack.

Yet Saint-Pierre also displays gracious touches. Its cornice is ornamented with projecting modillions.

Inside, the cupola of the church rises from pendentives above the single nave. Wall-paintings depict the arms of the lord of Chapt de Rastignac. The eighteenth-century reredos is enchanting. And most notable of all, the font is carved out of an ingeniously re-used Gallo-Roman capital.

The hazardous nature of life in past centuries is further evidenced by the numerous subterranean refuges which surround Siorac-de-Ribérac. Today its aspect is peaceful, its houses ornamented with pillars and doors decorated with nails.

Beautifully sited on the river Rissonne, Siorac-de-Ribérac also sits on the edge of the Double forest, which stretches over 50,000 hectares between the rivers Dronne and Isle and was once the haunt of brigands and fugitives, its marshlands the source of pestilence. Today its lakes increasingly attract tourists for fishing, swimming and windsurfing.

A gentle slope leads up to Siorac-de-Ribérac (below), which stands above the valley of the river Rizonne.

Both blessing and protecting the village, the twelfth-century church (opposite) has two towers, one fortified and added in the fourteenth century, the other contemporary with the rest of the building, a graphic illustration of the historical need to reconcile religious and secular security.

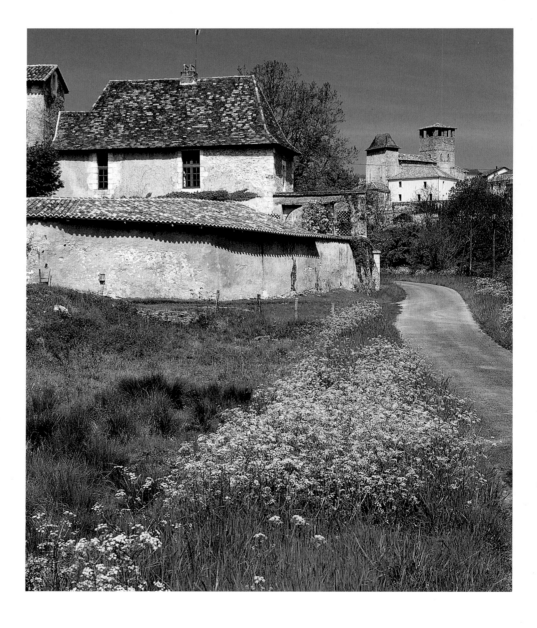

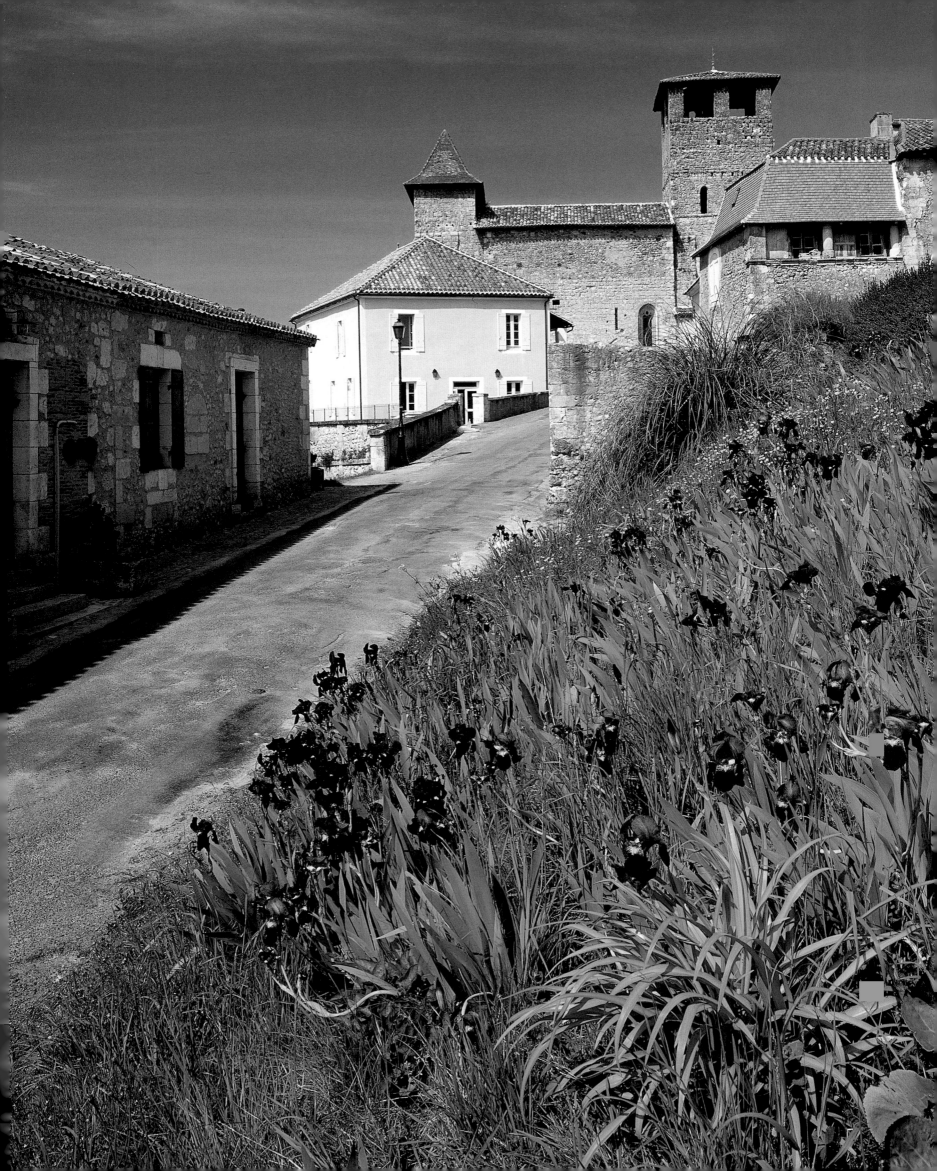

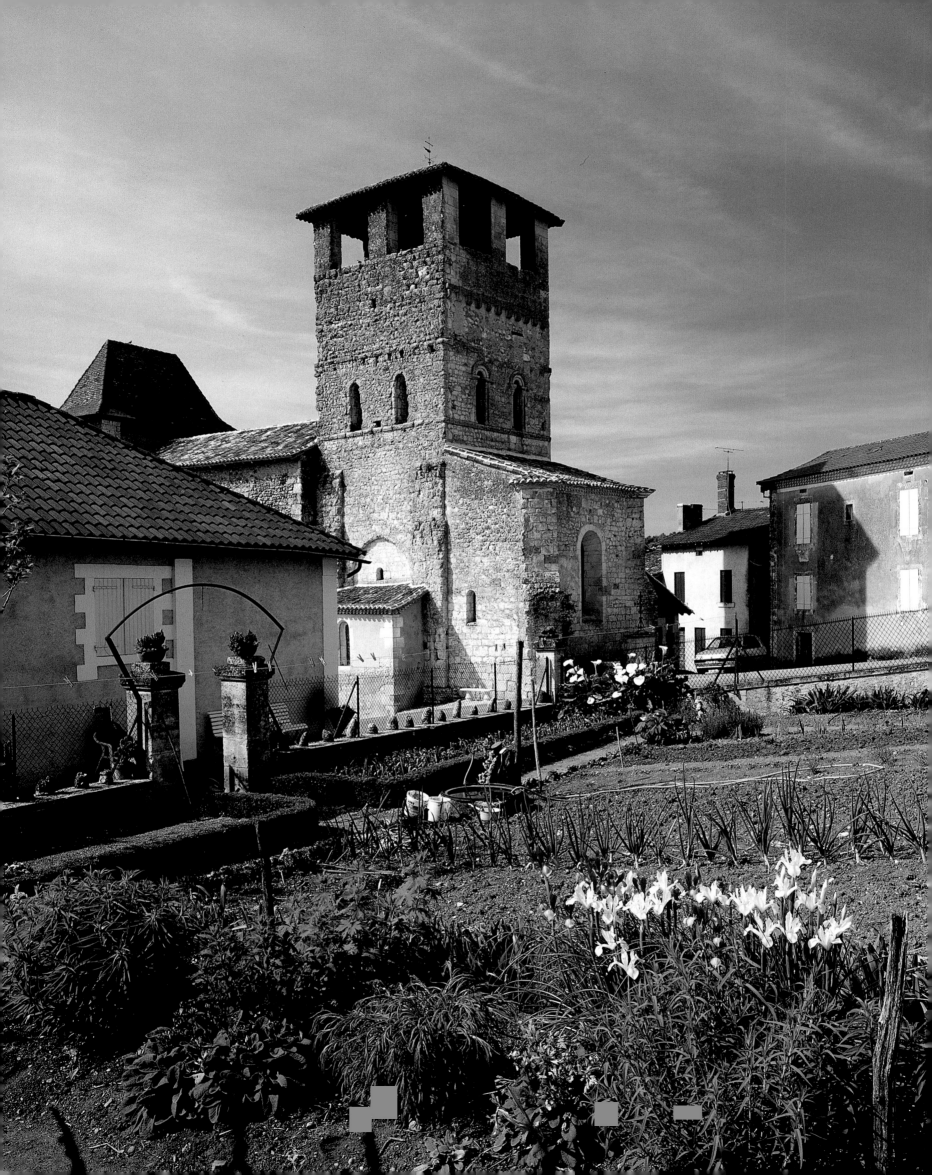

*I*nside the village, gardens and flowers bring the countryside closer and flourish beneath the somewhat forbidding exterior of the church (opposite).

*A*lthough from the outside the church of Siorac-de-Ribérac seems menacing, inside it offers peace, with its rows of chairs for the faithful (below) and its peaceful Lady chapel (right).

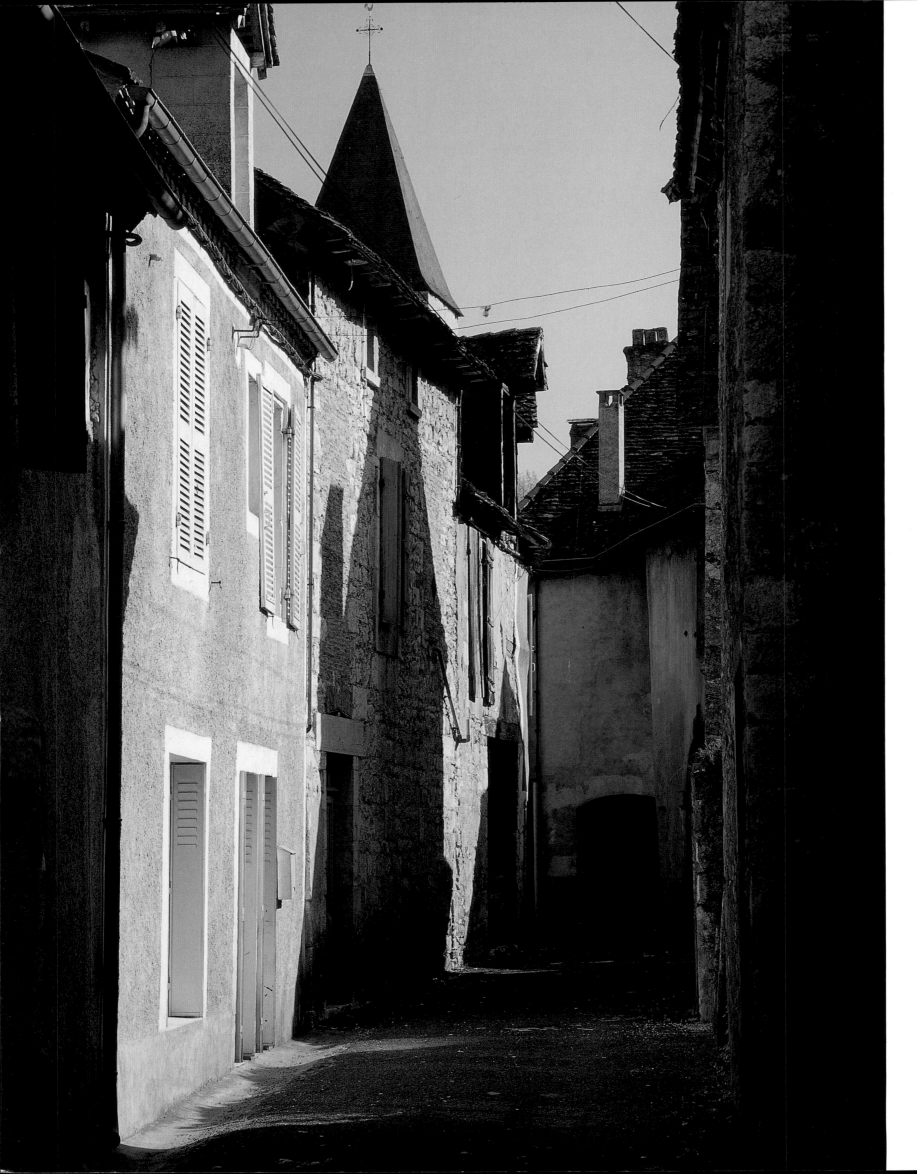

Tourtoirac

In the verdant valley of the Auvézère, Abbot Richard of Uzerche founded a Benedictine abbey in 1025 around which the village of Tourtoirac developed. The abbey prospered and boasted thirty-five monks in the thirteenth century, but began to decline and, after being savaged by the Huguenots in the sixteenth century, the monks soon departed. The remains of their abbey, however, are still an architectural delight.

The massive Romanesque abbey church (with a few Gothic elements) has five aisles and a huge belfry towering above the cupola. A second belfry at the west end gives this church a curiously grim aspect, but the interior of the church becomes more playful. Naïvely sculpted capitals depict Adam and Eve and a sacrificial Lamb. In the choir are the remains of fifteenth-century frescoes. On leaving the church by its thirteenth-century porch, do not miss the *enfeu*, a rare, fourteenth-century wall-niche tomb.

The beautiful gardens of the present presbytery surround a Romanesque chapel; the cellars incorporate the remains of what was once the monks' chapter-house, as well as a Romanesque cloister whose carved capitals depict monks trimming their beards. Still intact are a fragment of the fourteenth-century wall that once surrounded the abbey, and the abbot's lodgings, built in the seventeenth century just before the abbey was abandoned.

Tourtoirac has some imposing houses, many of them with turrets and Renaissance windows, as well as the manor of Roumailhac, which was finished in 1617 and a couple of later manors (de Goursat and de la Farge). And a piquant curiosity in the cemetery is the tombstone of the self-styled King Orélie-Antoine I of Patagonia and Araucania, chiselled with a crown. Orélie-Antoine I was in fact Antoine de Tounens, a Périgourdin born in 1828. When Spain lost her American colonies, he went to Patagonia and in 1860 was elected king by the rebellious tribes in the south. The Chileans expelled him, and he died at Tourtoirac in 1878, a simple citizen of the Périgord.

*T*hough a place of narrow streets and winding lanes, Tourtoirac does boast some substantial town houses (opposite). In the countryside around are a number of notable manor houses, including the home (right) of Antoine de Tounens (above). De Tounens, Périgourdin by origin, became the self-styled king of the tribes of Patagonia in 1860.

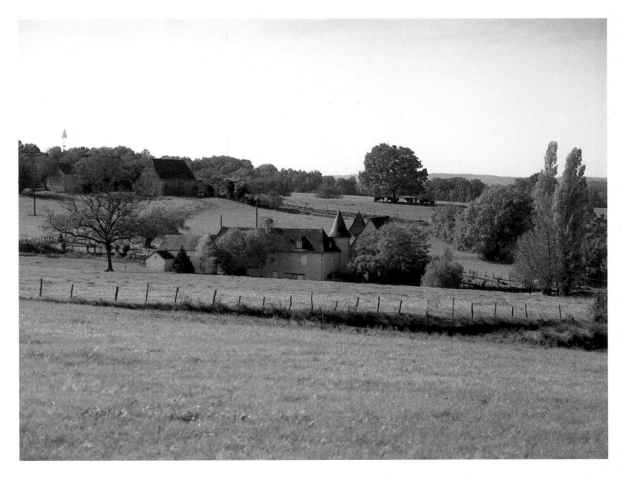

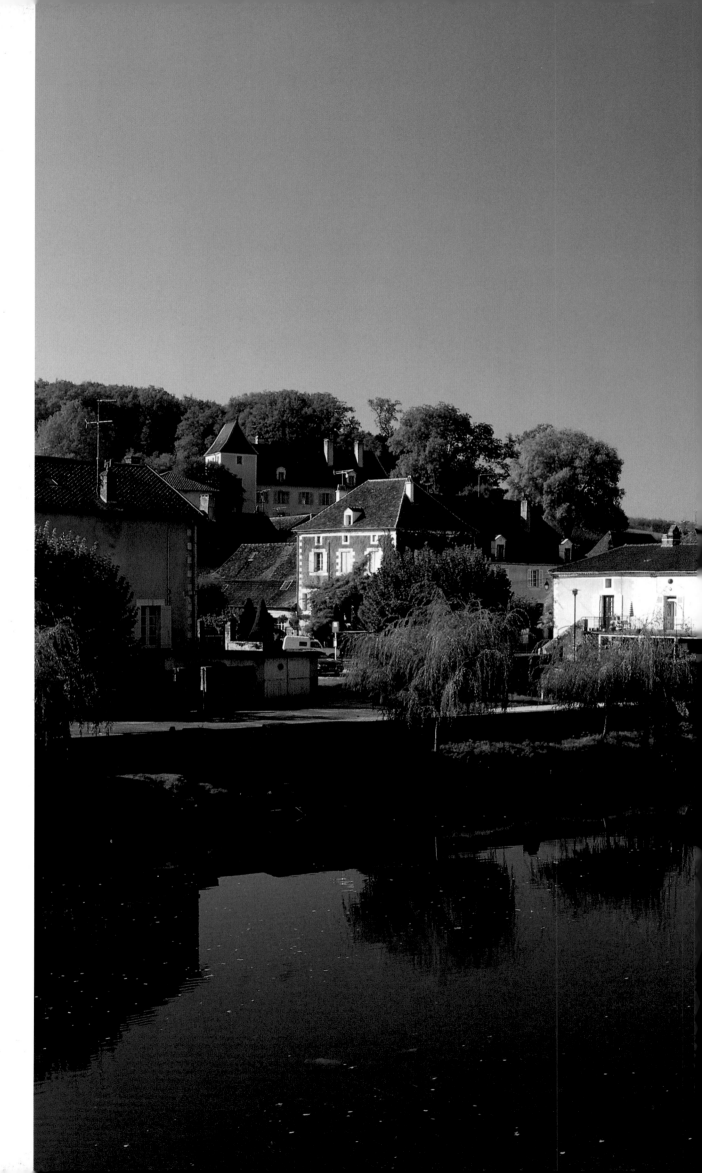

Trees shade the outskirts of Tourtoirac – a peaceful spot, perhaps, to peruse the pages of the local newspaper, Sud-Ouest Dordogne.

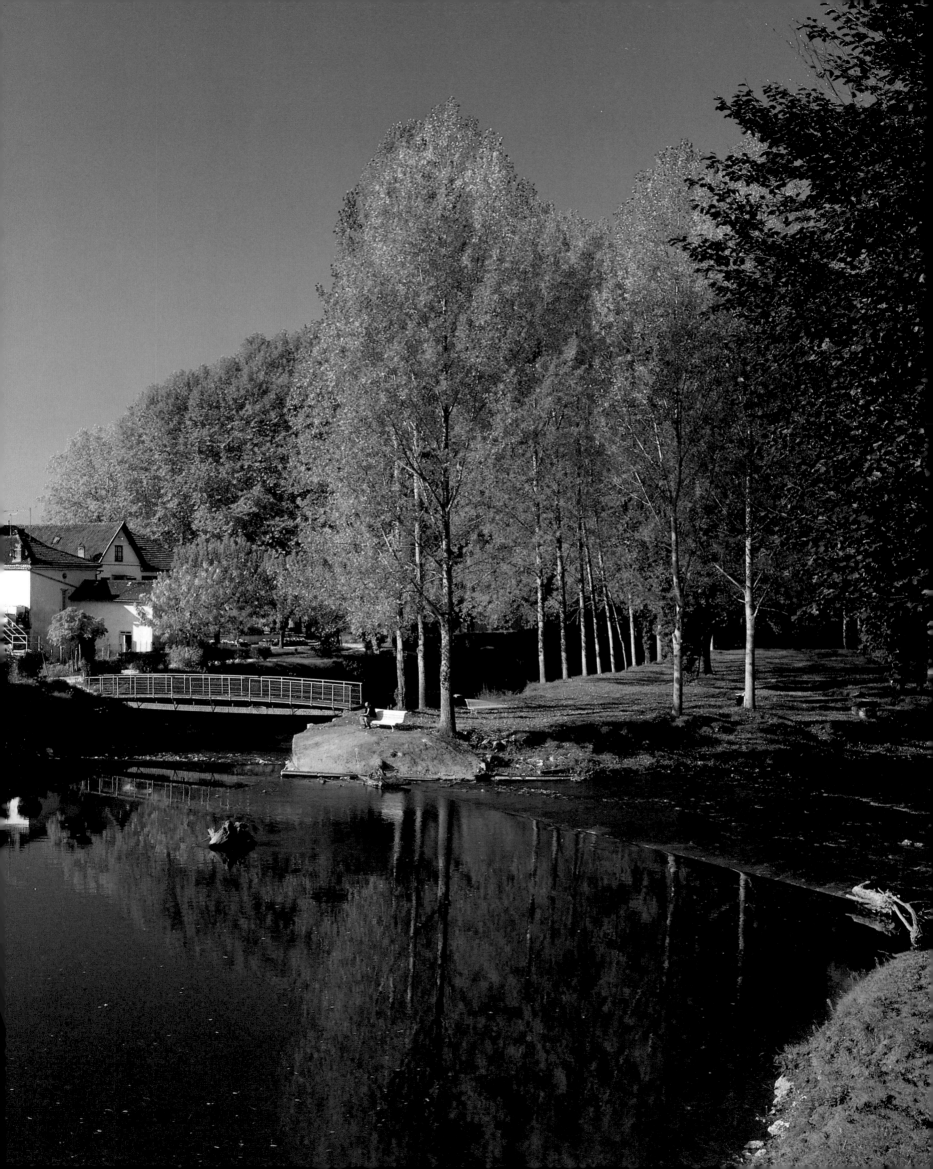

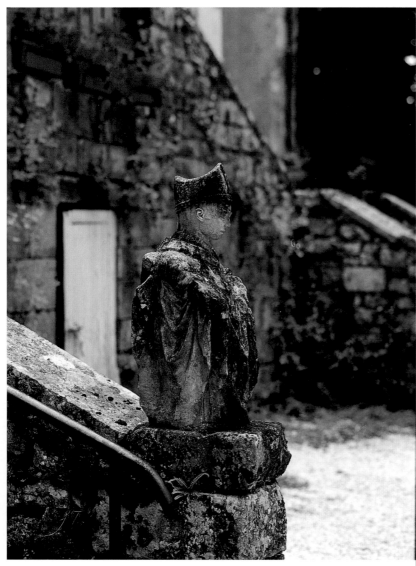

*T*ourtoirac is notable for its many fine medieval houses, the upper storeys of which often protrude over the narrow streets (opposite).

*T*he statue of an abbot (above) stands in the remains of the former presbytery; in the cellars are the carved capitals of monks trimming their beards. Another sign that Tourtoirac was once a centre of intense religious activity: a closed shrine on one of the roads to the village (right).

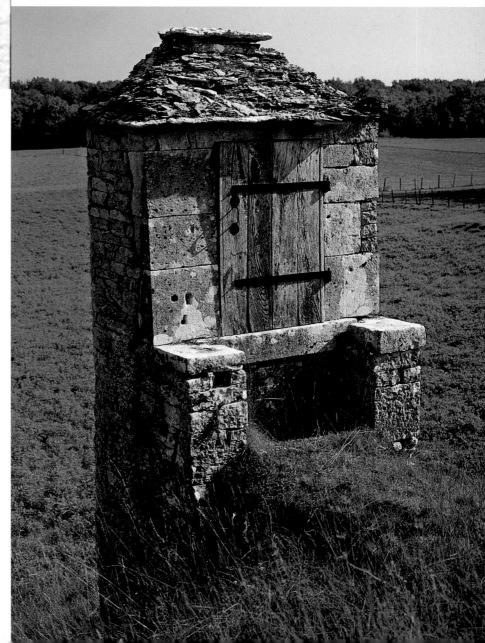

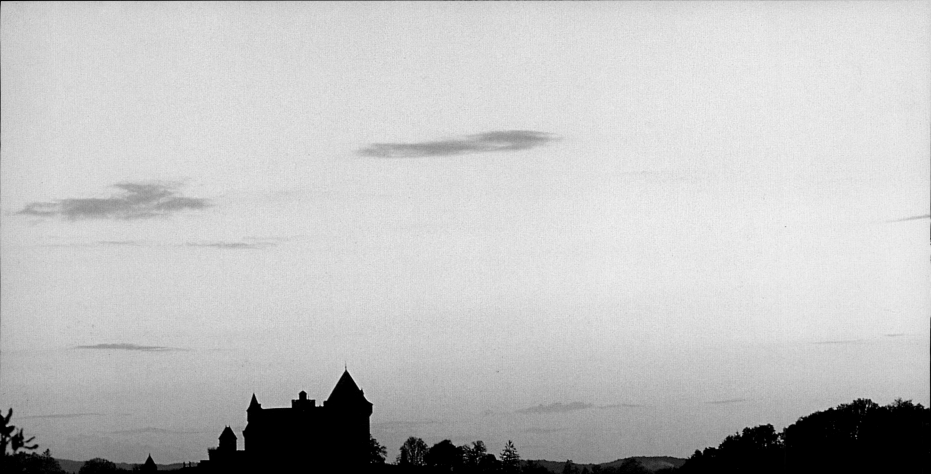

The Périgord Noir

Besse ◦ Beynac-et-Cazenac ◦ Biron ◦ Cadouin

Castelnaud-la-Chapelle ◦ Cénac-et-Saint-Julien

Domme ◦ La Roque-Gageac ◦ Monpazier ◦ Montfort

Rocamadour ◦ Saint-Amand-de-Coly

Salignac-Eyvigues ◦ Villefranche-du-Périgord

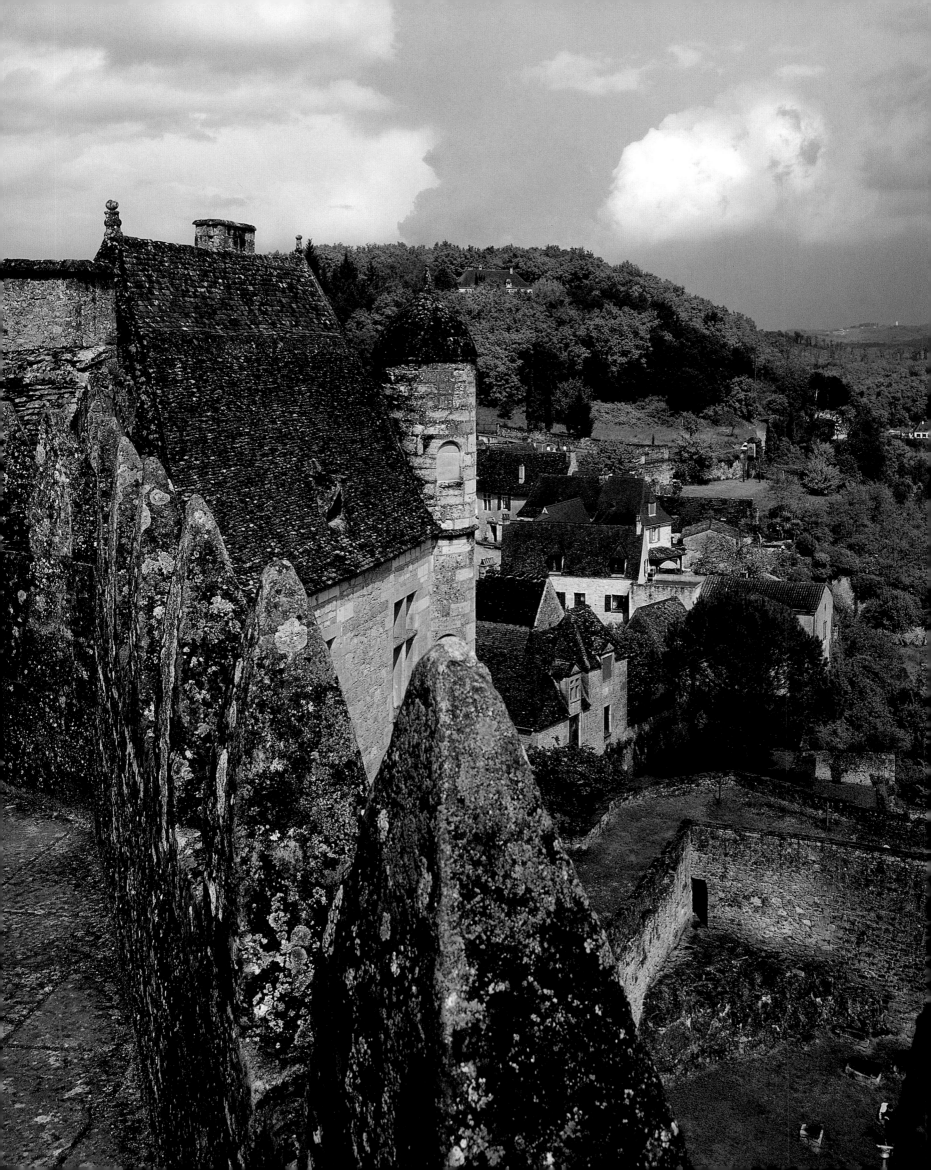

The river Vézère flows from the Périgord Blanc into the region known as the Périgord Noir, through remarkable prehistoric sites: Les Eyzies, which the French call the capital of prehistory; Saint-Cirq-du-Bugue, where the 'cave of the sorcerer' contains ten engravings (including one of a dappled horse and another of a fat man), carved 15,000 years ago; Le Bugue, set on the right bank of a curve in the river and possessing a cave discovered only in 1951 which exhibits drawings of bison, bears, horses, auroch and wild goats, all done around 15,000 BC; and Limeuil, where the Vézère joins the river Dordogne and where in 1909 two brilliant, clerical prehistorians, the Abbés Breuil and Bouyssonie, excavated a cave on whose walls some 200 reindeer and horses were engraved 10,000 years before the Christian era.

This southernmost part of Périgord, ranged around the medieval town of Sarlat, has been known as the Périgord Noir for centuries. Here the foliage of oaks and chestnuts turn dark as the sun sets. Here are grown truffles, the 'black diamonds' of French cooking. Some historians, however, believe that the region is known as 'black' because of its often sinister history, with vicious nobles cruelly terrorizing humbler folk and occasionally each other. Not surprisingly, this part of the Périgord has the finest fortified church in the whole *département*, built by the monks who once inhabited the village of Saint-Amand-de-Coly.

In this part of the Périgord the landscape varies remarkably. It includes the vast Bessède forest, the alluvial plains of the rivers Dordogne and Vézère and also the scenic cliffsides which the rivers have dug over the centuries. Sometimes the countryside consists of steep, uncultivable rocky slopes. Elsewhere, avenues of poplars flank the rivers, and lush fields are cultivated like patchwork quilts. Beneath walnut trees waddle geese, force-fed to produce *foie gras*.

Above riverside villages rise such superb châteaux as Biron, Beynac, Montfort and Castelnaud, and many other exquisite villages, such as Salignac-Eyvigues, are guarded by powerful, ancient fortresses. Lesser rivers are overlooked by equally delightful architecture. Medieval Belvès, with its seven belfries, perches on a hill above the valley of the Nauze. Little Saint-Cybranet, with its gabled houses, is washed by the Céou, as is even tinier Bouzic. The Périgord Noir also embraces some of the finest *bastides* of the *département*: Domme, Monpazier, Villefranche-du-Périgord.

From yet earlier times date *les bories*, curious stone cabins at the corner of fields, their rounded roofs covered in stone *lauzes*, built to shelter peasants and shepherds. Most remarkable of all is the ancient Gallic village of Breuil, some eleven kilometres from Les Eyzies-de-Tayac, which still includes a group of small stone houses unchanged since the Neolithic age.

It is hard not to imagine prehistoric men and women relishing as we do this exquisite region, but we have more to enjoy than they had. The Périgourdin novelist Albéric Cahuet accurately eulogized the river Dordogne as he watched it flow past the remarkable perched village of La Roque-Gageac in the Périgord Noir. 'When the sun is setting, you should contemplate the lovely curve of this river, as it cradles one of the most beautiful countrysides of the whole world. On the right the rocks could be those of Greece; to the west, perched high on its hill, Castelnaud resembles a château of the Rhine. Opposite us bristles a clump of oaks. On the other side of the river is the sweetness of the French landscape and richness of our Dordogne walnuts, while a centuries-old church speaks of the history of this earth, this water and this sky.'

Preceding pages

The dark waters of the river Dordogne slice through the heart of the Périgord Noir; along its banks are ranged such gems of villages as Montfort.

The Périgord Noir has an embarrassment of fine châteaux, like that of Beynac (opposite), *most of them built as strong points and therefore enjoying spectacular views over the surrounding countryside.*

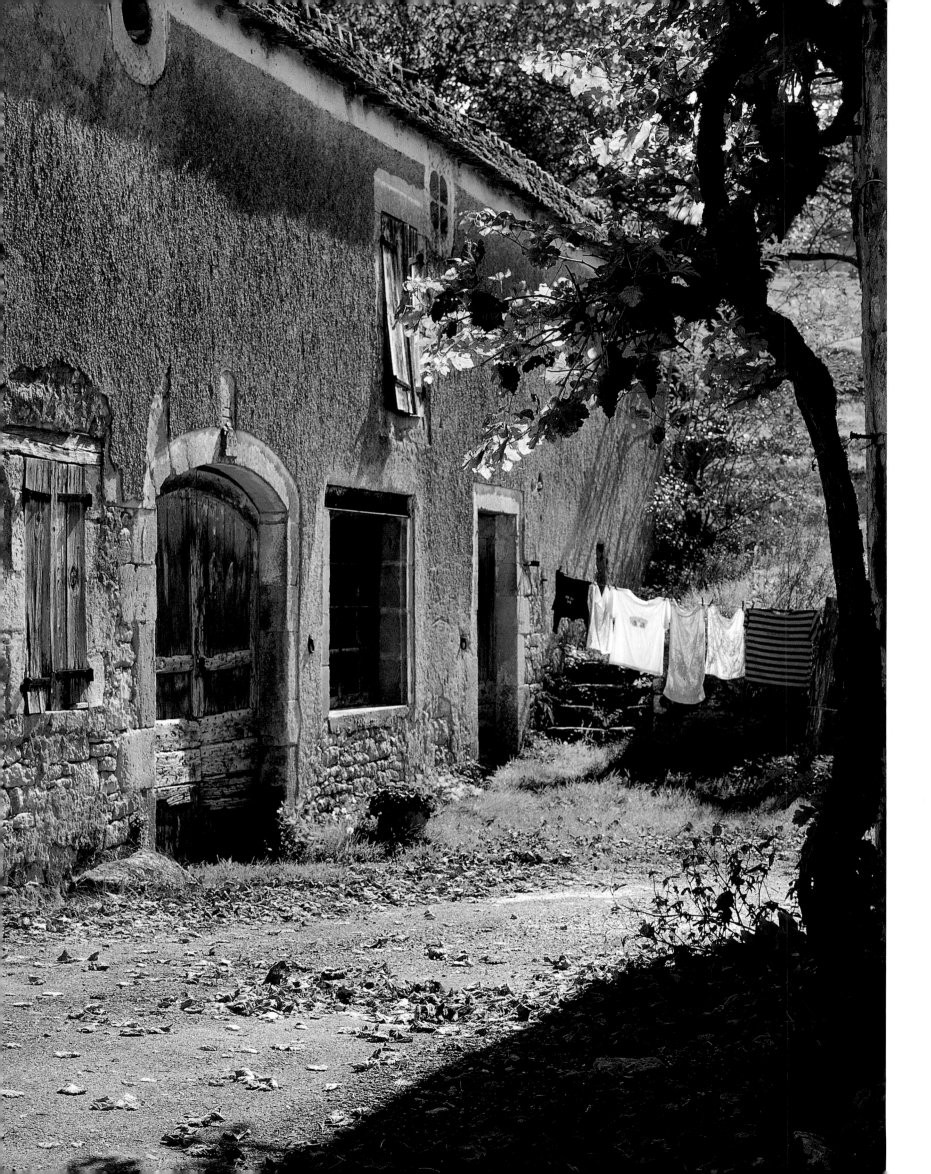

Besse

Few people live in Besse, which rises out of the enormous, rich Bessède forest, and few visit here one of the most diverting ensembles of Romanesque religious sculpture in south-west France. The village is delightfully haphazard, its flower-bedecked, ochre stone houses (some of them with balconies and outside staircases) climbing the side of a hill. The sculptures belong to a *lauze*-roofed church which was once the chapel of a Benedictine priory taken over by the Augustinians in the thirteenth century. Built in the eleventh century, it was enlarged in the mid twelfth century and its transept and apse date from the fifteenth. The apse is Gothic. The rest of this fascinating building looks like a malevolent fortress. Inside are distinct traces of sixteenth-century wall-paintings.

The eleventh-century carvings on the porch are stunning. They depict the seven deadly sins, earthly paradise, the Lamb of God, the Madonna and Child, St. Michael overthrowing the dragon and a hunting scene portraying St. Eustache, to whom Christ appeared between the antlers of a deer. Here is the Christian message of redemption: Adam and Eve depict sinfulness; the prophet Isaiah predicts the coming of the Saviour, his lips purified by an angel's censer; St. Michael the Archangel weighs souls; and a redeemed soul rises to heaven in the care of angels. Both Isaiah and Michael seem to be dancing. Not content with depicting all this, the Romanesque sculptors added sailors, lion-tamers, animals, monsters and acrobats, a veritable menagerie of human life.

Above the village rises a château built in the mid sixteenth century on behalf of Gabriel de Gaulejac and enlarged in the next century. Its furnishings are rich and include a self-portrait sent by the poet Lamartine to his admirer Gabrielle de Sanzillon.

Prats-du-Périgord is four kilometres north-west of Besse. ('Prats' is the Languedoc word for 'meadow'.) Its Romanesque church, with a belfry/keep, was fortified in the fifteenth century and shelters a seventeenth-century painted reredos. A typical example of the mixed styles of the Périgord, its Renaissance château encompasses a fourteenth-century keep with a round tower.

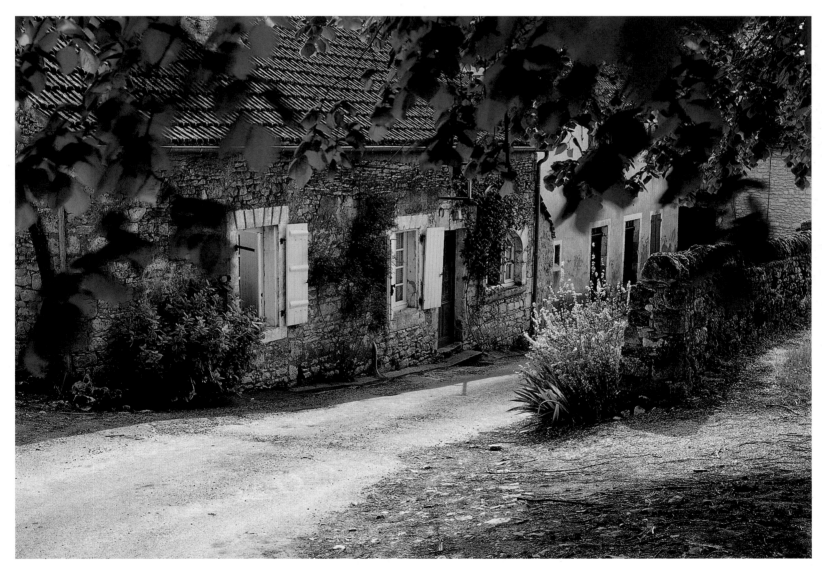

Besse is utterly unpretentious, a place of people going quietly about their daily lives and activities (opposite).

The homes of Besse are made even more beguiling by the variety of their building materials (above), *combining stone, plaster and wood in dwellings which look as though they may well have grown from the very soil of the village.*

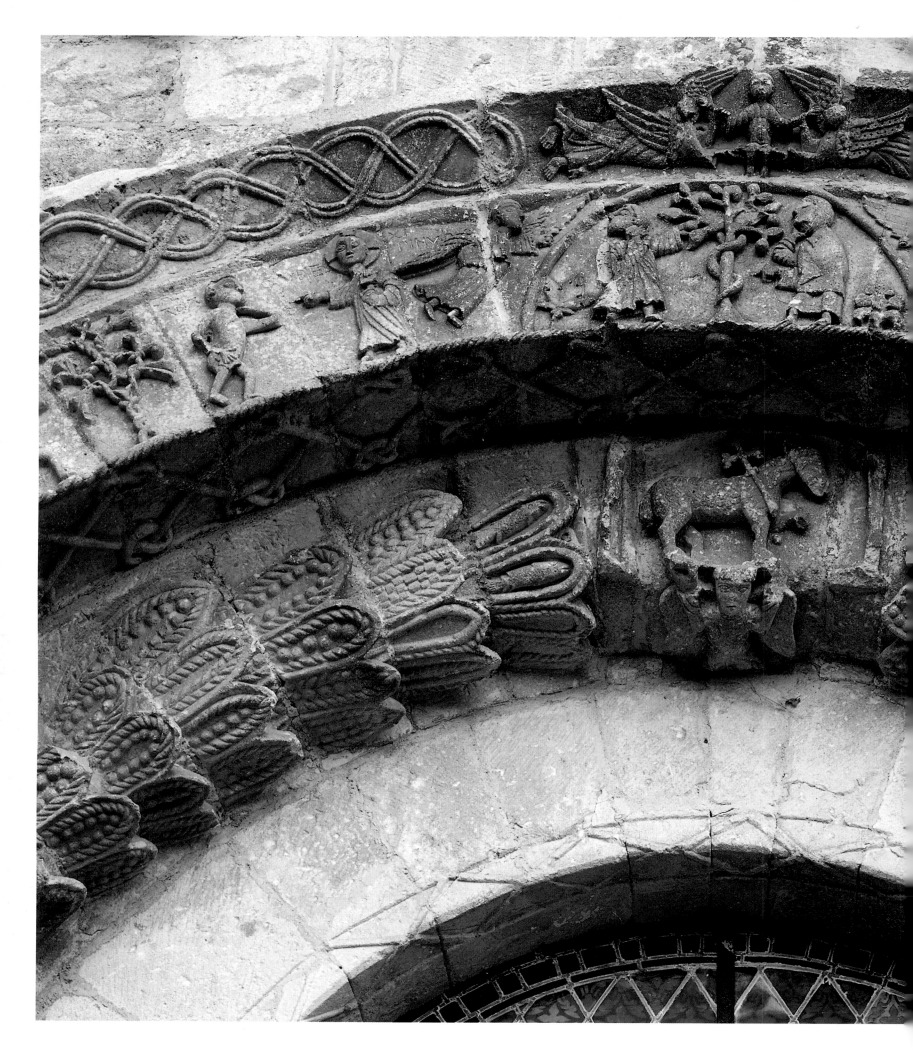

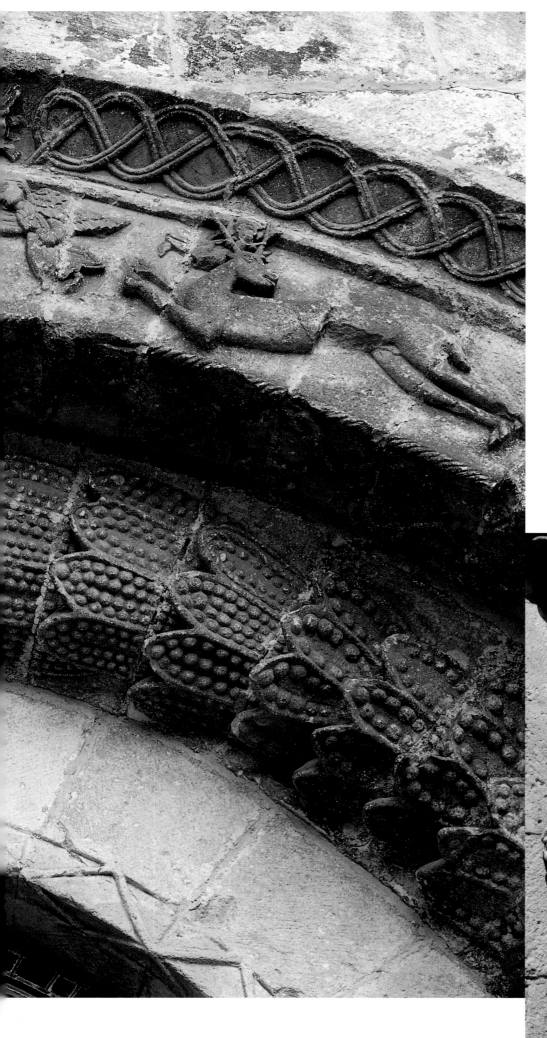

An unexpected, remarkable treasure at Besse:
the Romanesque porch of its fortified church
(left *and* below); *sculpted in the early twelfth century, the
upper arch centres on a six-winged Seraph, one of God's
Biblical attendants. Below the Seraph is a scene from the
Garden of Eden, with the Annunciation on the left and,
on the right, St. Michael on his horse pursuing the dragon.
Beneath the Garden of Eden scene is the image of the
Lamb of God.*

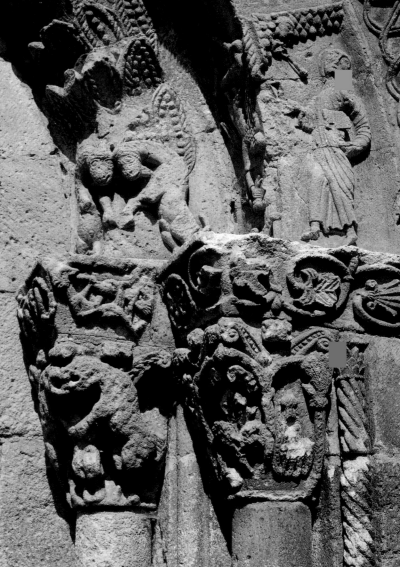

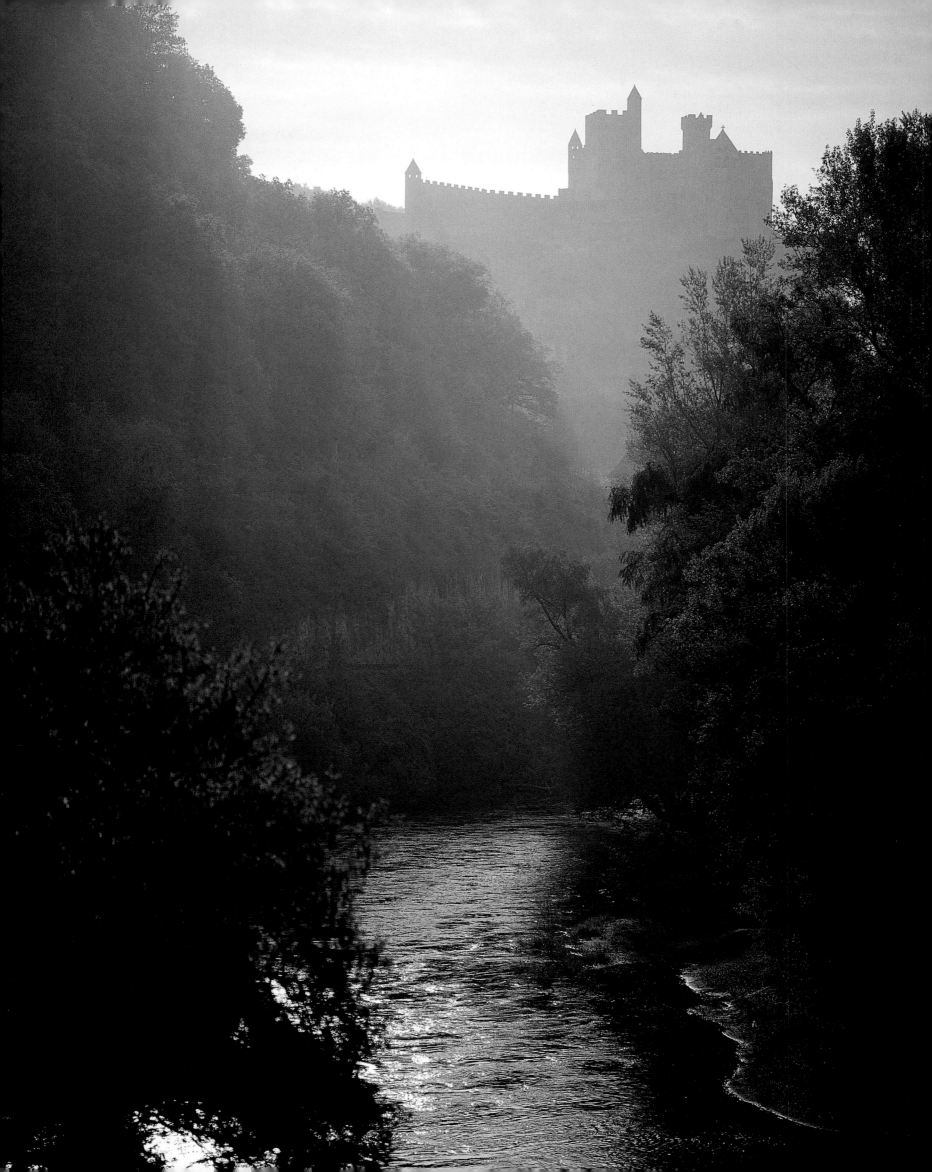

Beynac-et-Cazenac

Without doubt the most formidable fortress of the four baronies of the Périgord, Château Beynac high on its cliff dominates the river Dordogne and can be seen long before you reach the village. The château we know today was built after the implacable Simon de Montfort, in 1214 during the Albigensian crusade, destroyed a previous one because its lord was an ally of the Cathar heretic Raymond of Toulouse.

Impervious to attack from the river and boasting two sets of defensive walls, on its vulnerable northern side Château Beynac is defended by two glowering keeps, both consisting of battlemented towers and a turret and joined by a curtain wall. Inside the château the majestic vaulted great hall dates from the thirteenth century. Its neigbouring oratory is embellished by animated fifteenth-century frescoes depicting a Pietà, several members of the Beynac family and the Last Supper, with the quaint addition of St. Martial,

apostle of the Périgord, as a waiter. The furnishings of the château include a graceful seventeenth-century staircase.

The cliff on which Château Beynac rises offers exceptional views of the Dordogne valley and especially of four other châteaux: Fayrac, La Malartie, Marqueyssac and Castelnaud, the last an English stronghold during the Hundred Years' War when Beynac remained resolutely French. At the edge of the cliff stands the Romanesque, *lauze*-roofed former château chapel, now Beynac's parish church, and below the houses of the village line the riverside and straggle picturesquely up the cliff.

Cazenac, a hamlet four kilometres from Beynac, merits a visit for its fifteenth-century Gothic church (rising in the cemetery) and for its memorable view of the château and the western aspect of the magnificent Dordogne valley.

Dawn breaks over the river Dordogne (opposite), gently outlining the walls and towers of the château at Beynac against the morning sky. The same walls and turrets appear in sharper relief (right), dominating the village and giving a point of focus for its more humble dwellings.

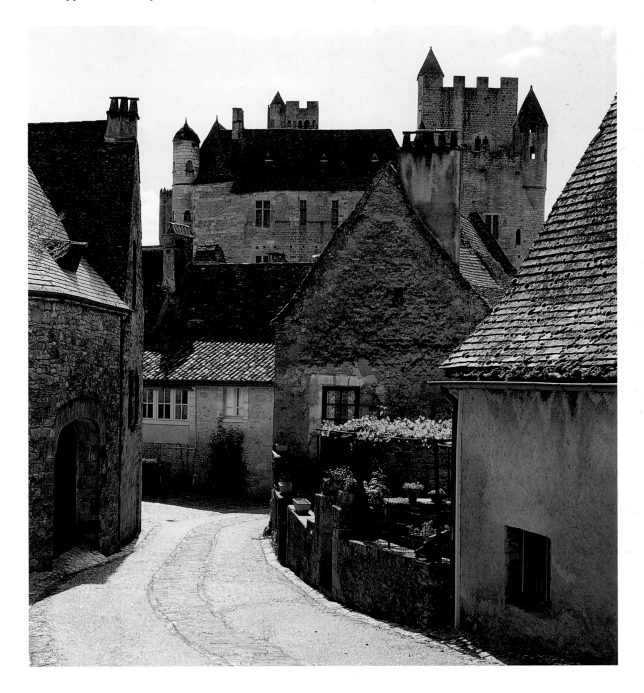

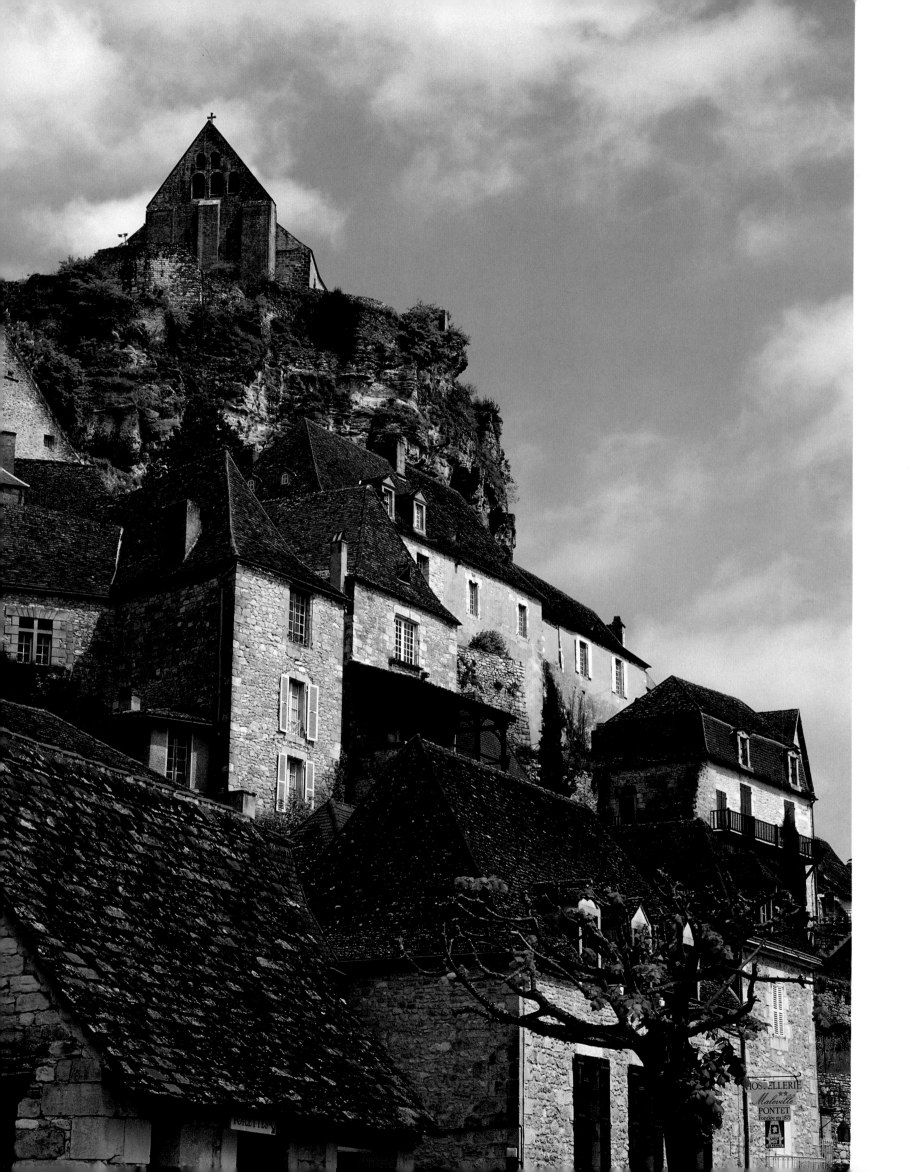

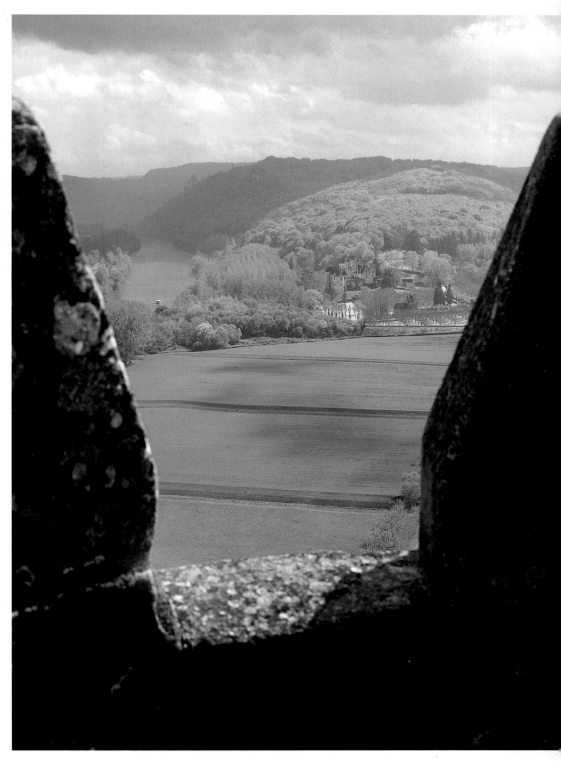

*D*ominating the valley of the Dordogne, the powerful château of Beynac rises high above the steeply stacked houses of the village (opposite); one of the great strong points of the region, the ruggedness of the château's position testifies to its importance in the warring thirteen-hundreds. The views from its battlemented walls (above and right) of the village and surrounding countryside are among the most spectacular of the region.

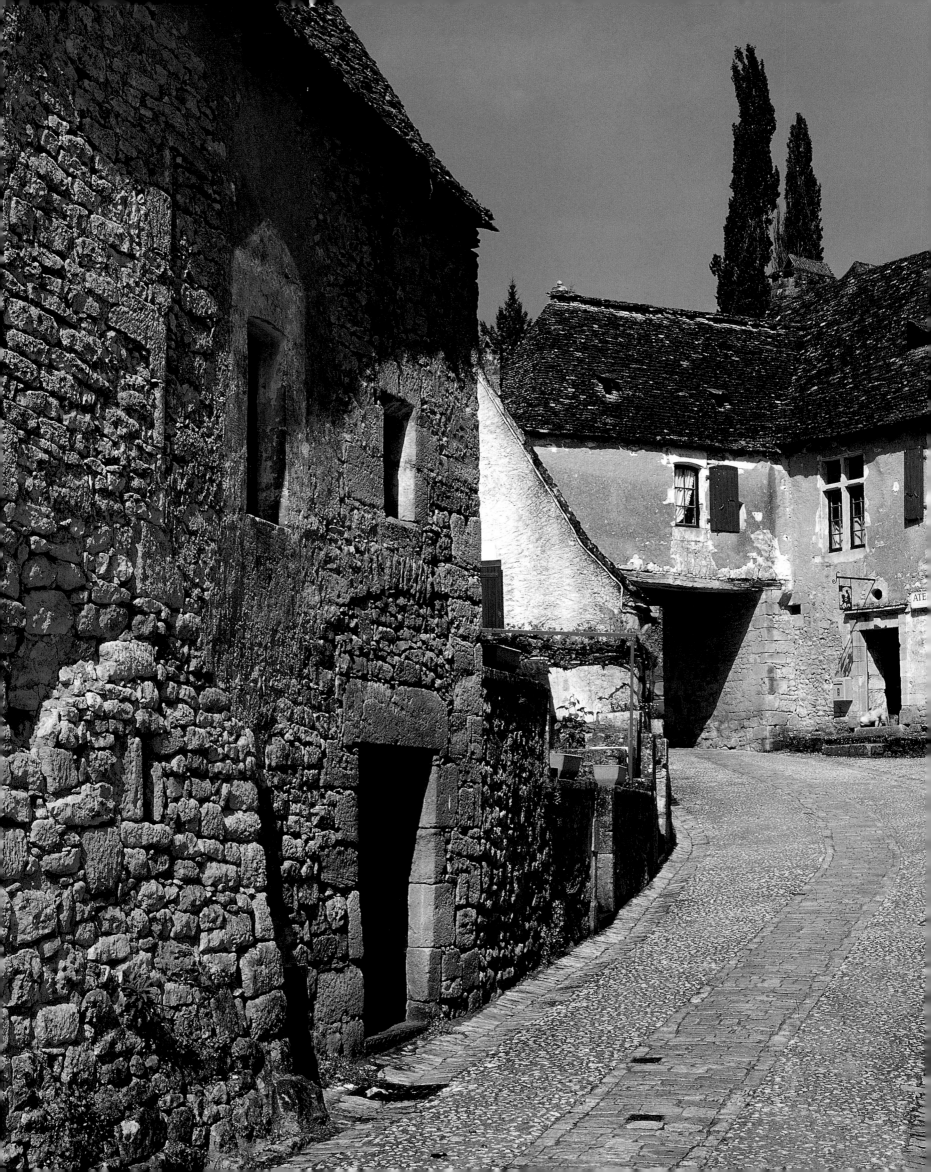

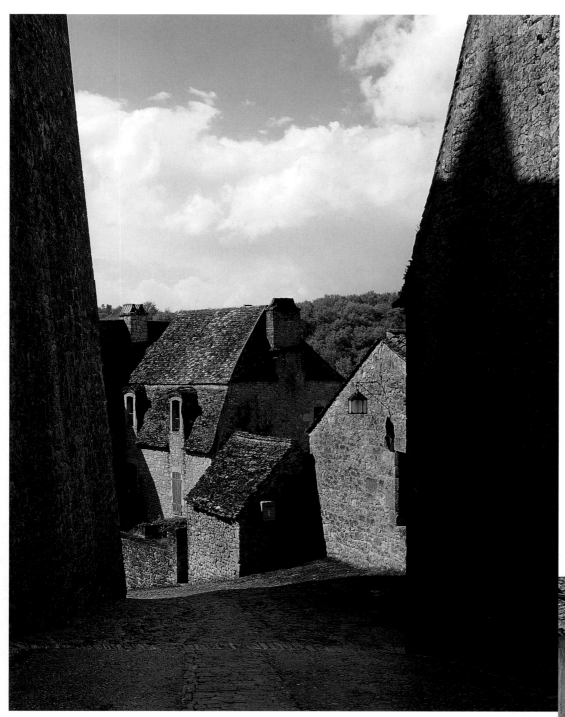

N arrow paved streets rise through the
village of Beynac (opposite *and*
left) *while the houses cluster defensively on
its hillside, their sturdy structures
indicating that this was a place built to
withstand attack. But Beynac has a gentler,
agricultural side* (below): *a quiet corner
with a traditional farm cart.*

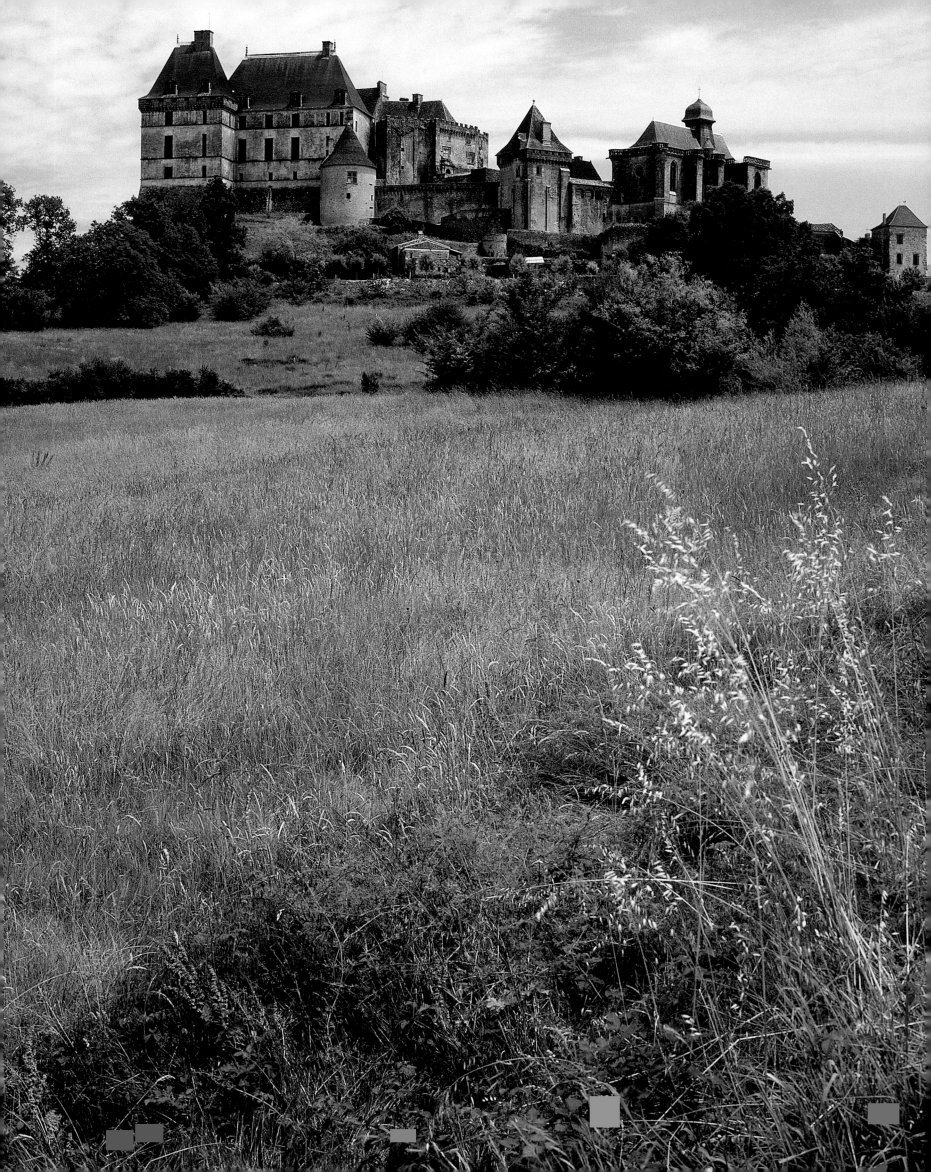

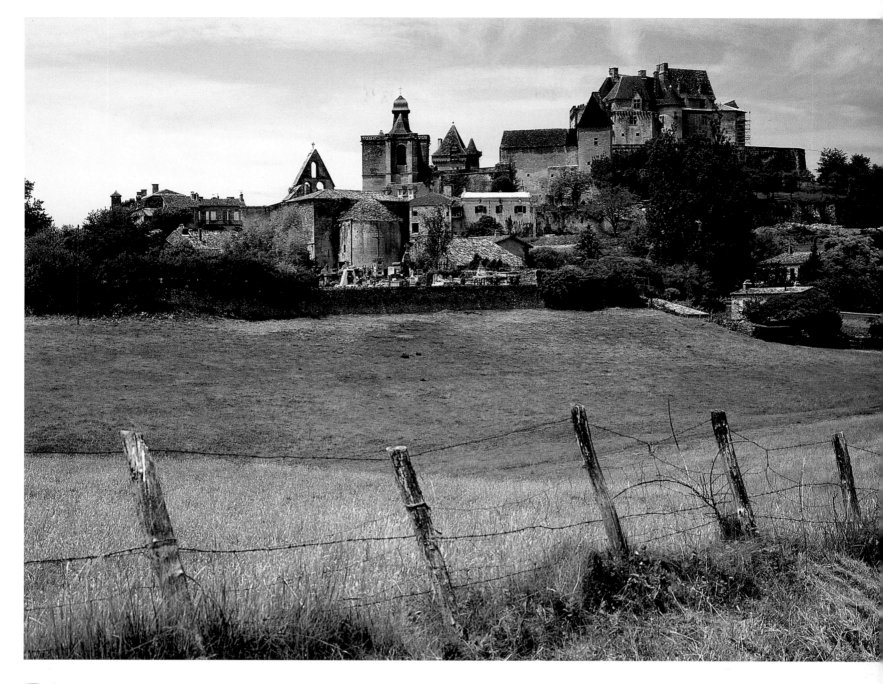

Biron

Fittingly, as the seat of the chief of the barons of the Périgord, Château Biron is the largest fortress in the *département*, its bulk visible from thirty kilometres away. Château Biron was built over eight centuries (and remained in the hands of the Gontaut family from the twelfth century till 1938), perfectly illustrating the contention of the distinguished Périgourdin André Maurois that, 'variety in unity is the definition of a work of art.'

The square tower which defends the entrance was begun in the thirteenth century and rebuilt in the fifteenth and again in the sixteenth. Beside it is a triple-arcaded Renaissance loggia, which leads to the pearl of the château, its chapel, a congenial mixture of flamboyant Gothic and Renaissance architecture. The chapel is in two parts, the ogivally-vaulted upper chapel built for

the nobility, the lower chapel designated for the villagers (who could reach it directly). Two exceptional sixteenth-century tombs occupy the upper chapel: that of Bishop Armand of Sarlat, his sepulchre carved with Virtues; and that of his brother, Pons de Gontaut-Biron, sculpted in hope of his own resurrection with scenes of the raising of Lazarus and the appearance of the risen Jesus to his disciples.

A Grand Siècle staircase leads through a Renaissance gateway to the courtyard of honour, which is dominated by a twelfth-century keep, La Tour Anglaise. On one side of the courtyard rise living quarters begun in the twelfth century and rebuilt in the fifteenth. On the other stands an imposing classical wing begun in the seventeenth century, inside which is the château's huge kitchen. At the end of the courtyard you

reach a delicately columned eighteenth-century porch which offers a fine view of the surrounding countryside.

Below the château the tiled houses of the village of Biron cluster idyllically around its ancient market-hall.

Château Biron from the west (opposite): its double defences, its Romanesque keep, its Renaissance loggia on the left, its sixteenth-century chapel on the right all go to make it one of the most fascinating architectural gems of the whole Périgord.

Viewed from the south-east (above), the château seems to overwhelm the houses clustering below.

A village wedding party (left and below) approaches the Mairie of Biron for the civil ratification of the church ceremony.

The Château Biron is an extraordinary mixture of architectural styles, having been built over several centuries; here the Renaissance and Classical predominate (opposite).

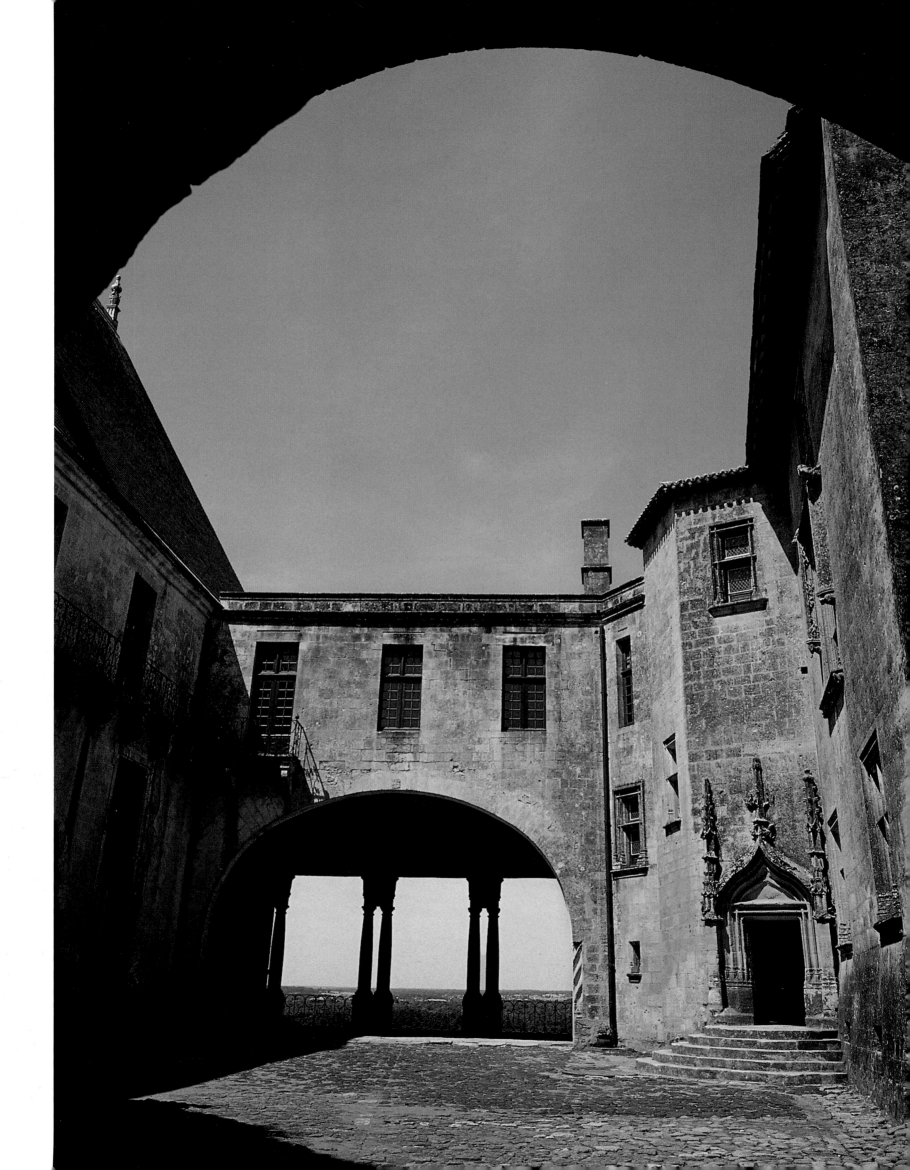

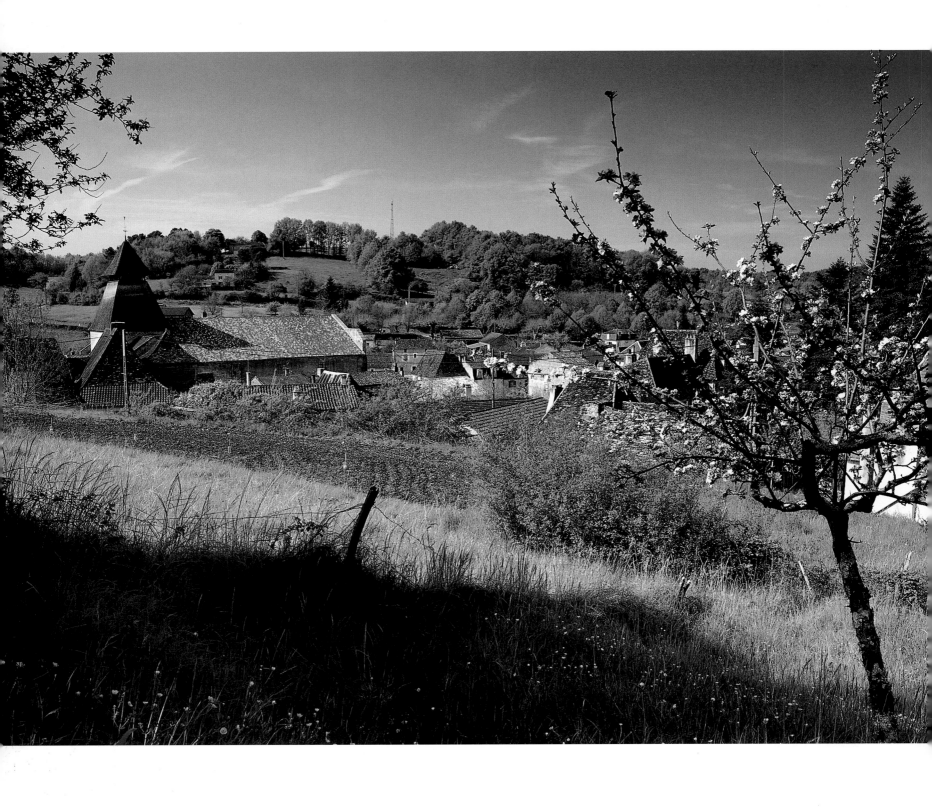

Cadouin

An eighteenth-century market-hall, its roof held up on massive stone pillars, occupies the main square of the village of Cadouin, next to its celebrated abbey. The abbey, founded in 1115 at the heart of a forest, was taken over by the Cistercians four years later. The abbey became rich because of the pilgrims who flocked to see what was said to be the kerchief that covered the head of the dead Jesus and was proved a fake only in 1934. Such wealth paid for the lavishly sculpted decoration of Cadouin, which bears little connection to the usual austerity of Cistercian architecture.

The cloister (begun in the fifteenth century and finished in the sixteenth), with its flamboyant Gothic tracery blending with Renaissance details, centres on a garden with a well and is the most elaborate part of the abbey, its vaults and pillars richly decorated. Gothic pinnacles on two of its entrances are matched by Renaissance medallions and pillars on the two others. Of its two galleries, brilliant Renaissance carvings ornament the west gallery, representing Biblical themes (the stories of Job, Lazarus and Samson and Delilah) and profane ones (traders squabbling over a goose, Aristotle with a prostitute). The sculptures of the vault depict the sacrifice of Abraham, the flight into Egypt and the Last Judgment. The north gallery, where the monks would rest, has fifteenth-century frescoes and fine carvings.

The abbey church and its sacristy both date from the twelfth century and boast more carvings, as well as sixteenth-century frescoes and a sixteenth-century woodcarving of the Madonna and Child.

Touchingly, the lovely apse of Cadouin church, with its softly-painted capitals and its fresco of the Resurrection, still bears twenty-three plaques thanking the holy kerchief for its miraculous help, the last dated 1923 with the touchingly simple message 'Merci S. Suaire de Cadouin'.

The view looking north towards the abbey church and village of Cadouin (opposite); in great contrast to the grandeur of its famous church and abbey, the domestic dwellings and gardens (right and below) of the place have an air of bucolic familiarity which makes this village one of the most immediately appealing in the Périgord.

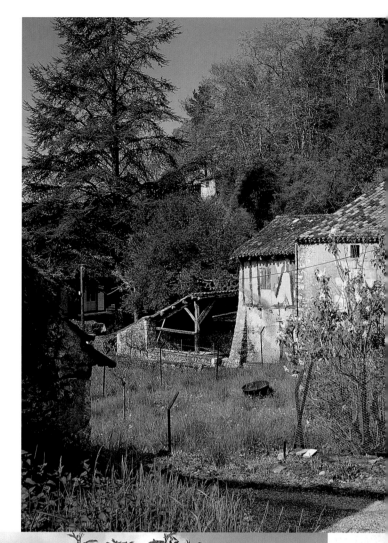

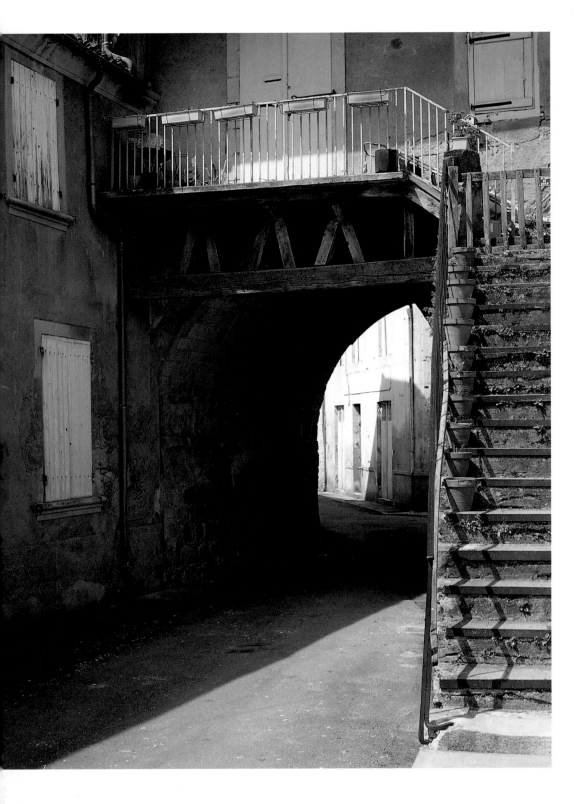

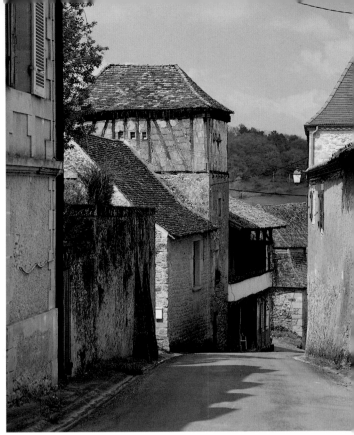

*E*very corner of Cadouin seems to
hold some fresh architectural
delight: light and shade under the Porte
Saint-Louis (left); the ancient houses on
the Rue Luc (above); beside the abbey
entrance the massive roof and pillars of
the market-hall (below).

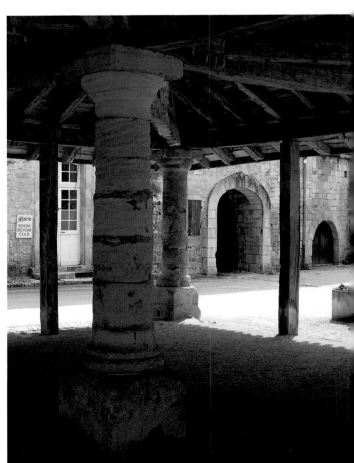

*L*ight and shade, bursts of colour and greenery, soften the lines of Cadouin's traditional architecture: the imposing Villa Marguerita (above); a wisteria threatens to envelop the hand-hewn stones of a house in the Rue Porte Saint-Louis (right).

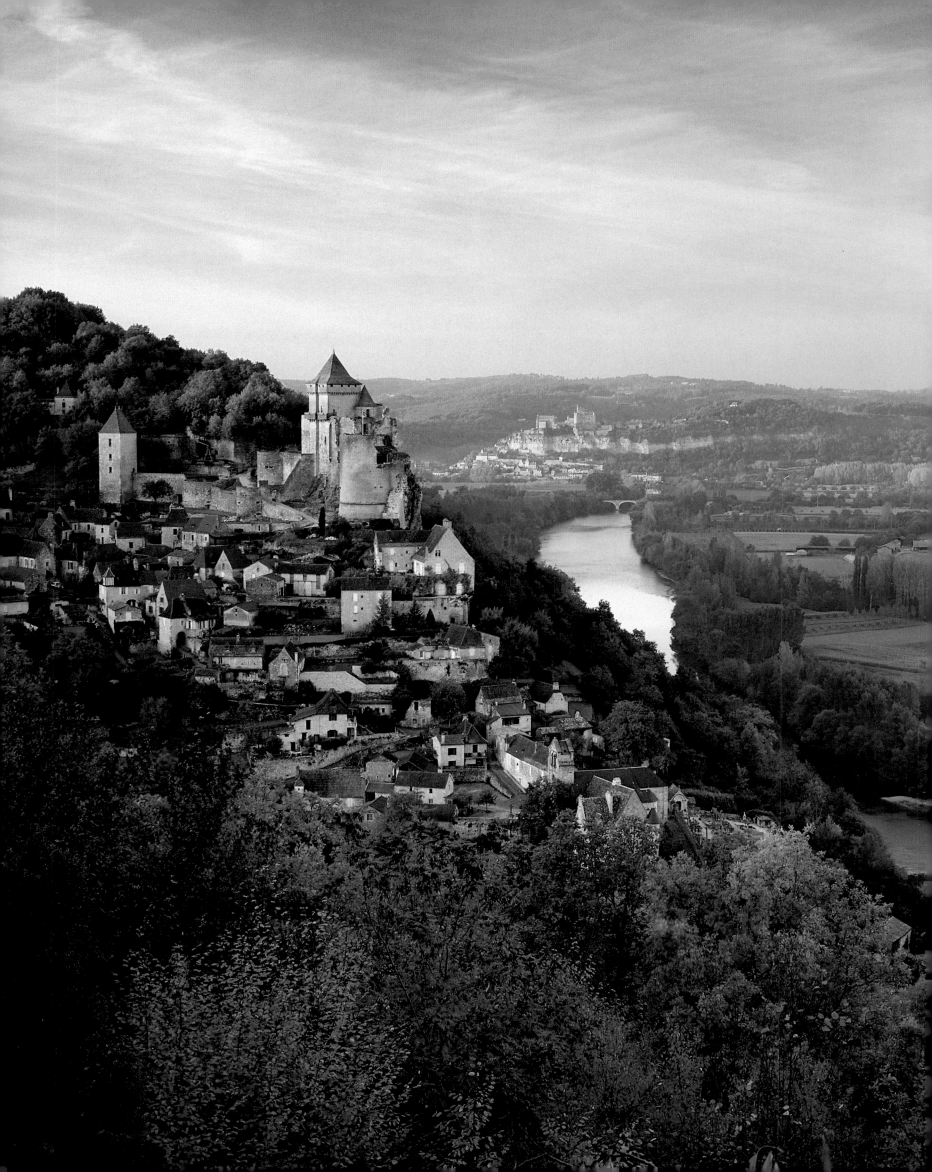

Castelnaud-la-Chapelle

Looking across the Dordogne towards its implacable enemy Château Beynac (as well as to the cliffside village of La Roque-Gageac), feudal Château de Castelnaud dominates the confluence of the rivers Dordogne and Céou. Below it rests a village of traditional Périgourdin houses, sometimes ornamented with sculpted decoration, some of them covered with stone *lauze* roofs, others with simple, pretty balconies, many of them mingling with half-dismantled medieval fortifications.

Château de Castelnaud was begun in the late twelfth century, from when dates its massive, square machicolated keep which is flanked by an enormous round tower. Fifteen years after Simon de Montfort had taken the château in 1214, the French king Saint-Louis was forced to cede Castelnaud to the English, and although it changed hands many times, for the most part the English hung on to it until 1463. In the fifteenth century they further strengthened the château with walls four metres thick. A fortress so high also needed a well scores of metres deep. With the advent

of artillery, the lords of the château strengthened its fortifications in the hope of evading destruction by the new weaponry.

Then the lords of Castelnaud, the Caumont family, grew weary of the stern fortress, preferring their sprightlier château at nearby Les Milandes. Château de Castelnaud went into decline. Eventually its roofs fell in and by the beginning of the seventeenth century its stones were being used for building elsewhere. By the nineteenth century it was a veritable quarry, providing the raw material for local housing.

In 1969 an important restoration was put in hand, bringing back dignity as well as visitors to the great château, some of whom may also seek out the Romanesque church of La Chapelle with its classical doorway. And connoisseurs of châteaux, exploring the plateau to the south of Castelnaud, delight in discovering a complete contrast: eighteenth- and nineteenth-century Château de Lacoste with its park, its neo-Gothic chapel and its stunning panorama of the Dordogne valley.

At Castelnaud-la-Chapelle the imposing château dominates both its village and the river Dordogne (opposite); in the distance can be seen the rival château of Beynac.

The steep site of the village by the river produces an effect of rising and falling within it: sudden vistas of roofs (below right), or glimpses of the fifteenth-century defences of the château sharply rising against the sky (below left).

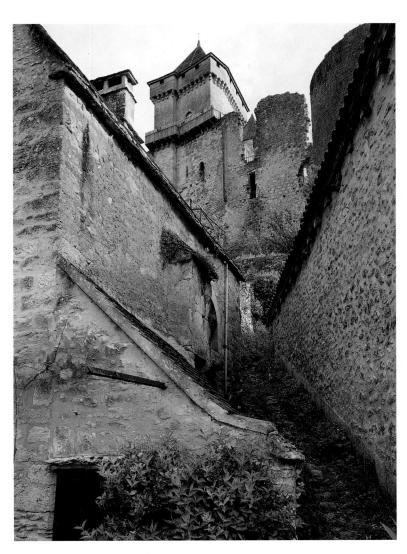

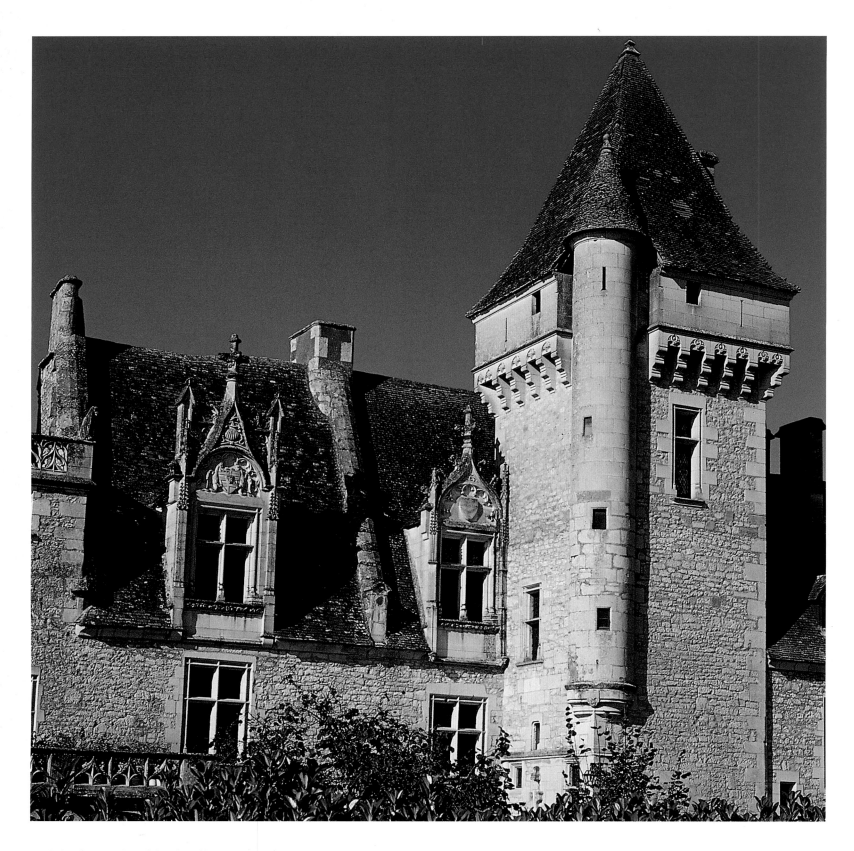

Close by Castelnaud-la-Chapelle is the Château des Milandes, here revealing its flamboyant Gothic aspect (opposite). The sterner aspect of the tower of the château at Les Milandes makes a strong contrast with the elegant dormer windows of a residential wing (above). It was here that Josephine Baker founded her home for orphans.

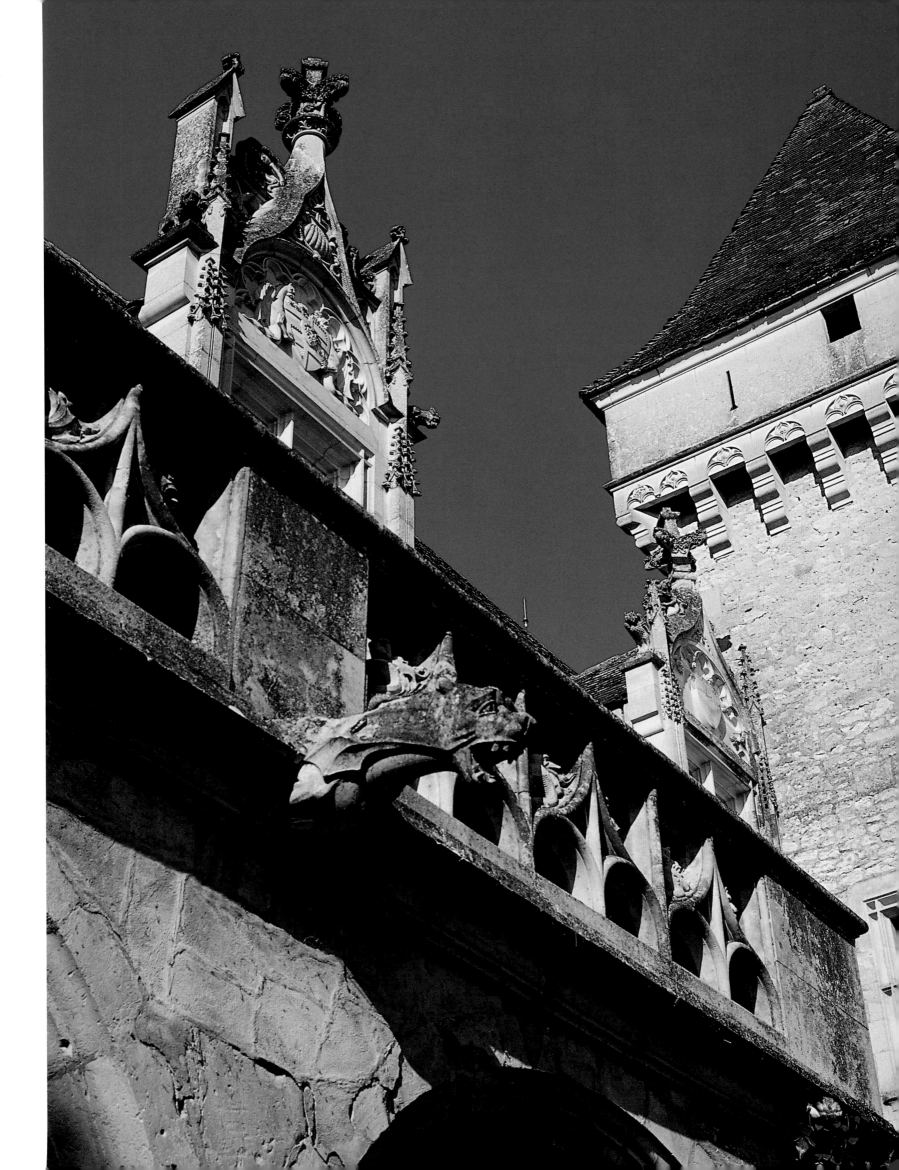

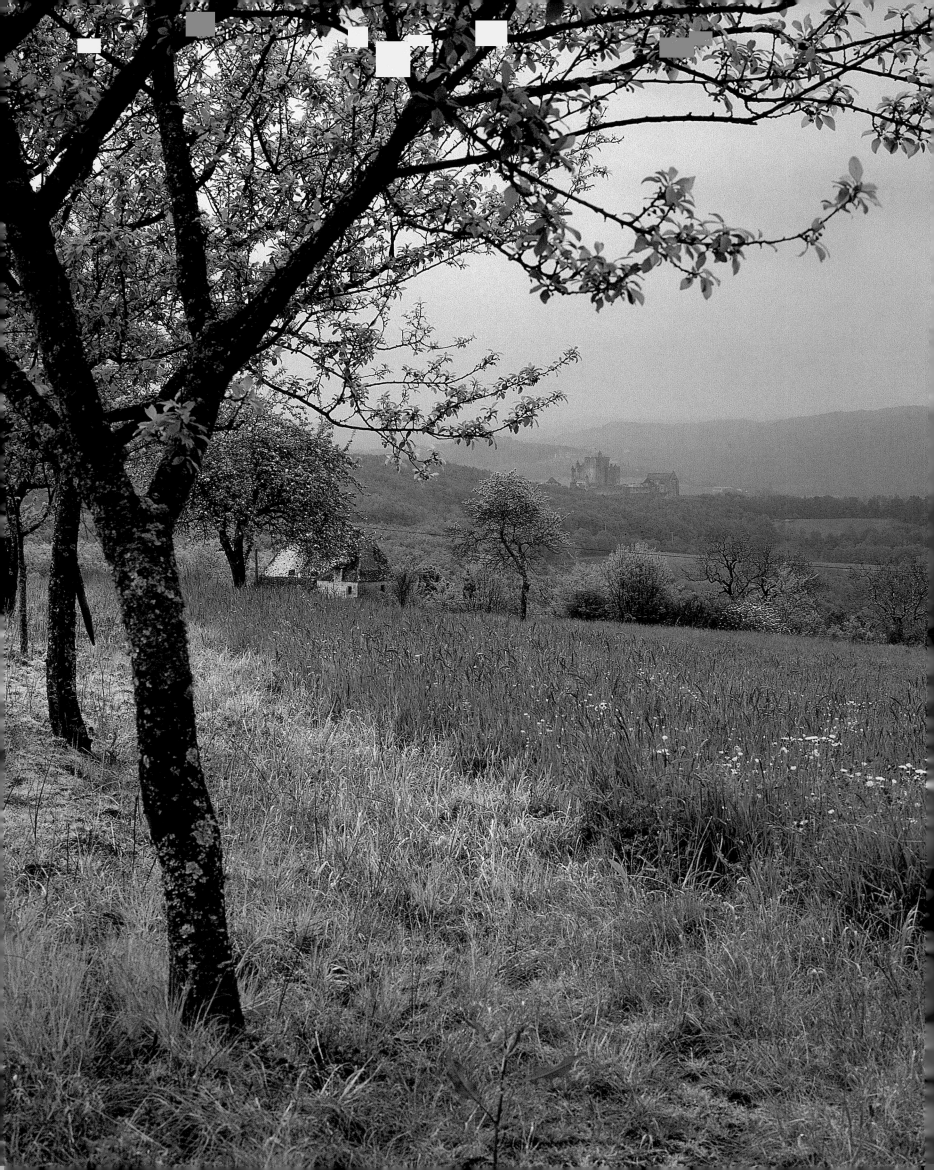

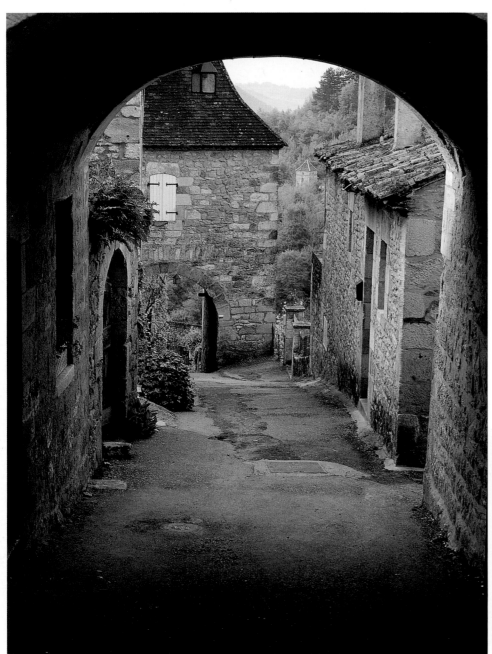

An idyll of the Dordogne: Castelnaud is a warren of houses and gardens (left and below), all sheltering beneath the mighty ramparts of the castle. Around the village stretch delightful vistas of meadows and hedgerows (opposite).

Cénac-et-Saint-Julien

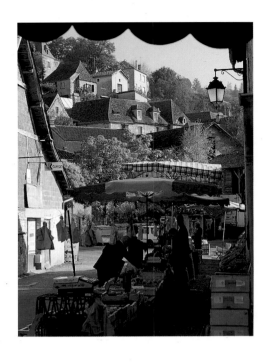

The charms of Cénac-et-Saint-Julien reveal themselves slowly. Set beside a swiftly flowing river Dordogne, it seems to comprise just five streets, three of them rising up towards the *bastide* of Domme. Then you spot that the village is threaded by ancient alleyways, and possesses a ruined eighteenth-century pigeon house, as well as numerous seventeenth- and eighteenth-century manor houses (*gentilshommières*), the finest dignifying itself with the name Château Thouron.

As you walk uphill, you come across a Romanesque church, its apse separated from the rest by pillars, its doors usually locked. The street rises to a delightful park. Sleepy Cénac-et-Saint-Julien has one of everything – one bank, a post office, a little supermarket, a locally famed bakery, a newsagent which doubles as an ironmongers – save in one respect: remarkably, it boasts a second Romanesque church, this one magnificent.

Just outside the village, Saint-Julien's church of the Nativity dates from the twelfth century, though its porch employs material from a nearby Gallo-Roman villa. It began life as a priory church attached to the celebrated Cluniac abbey of Moissac. Its Romanesque apse is carved inside and out with a magical collection of twelfth-century sculptures – Daniel in the Lions' Den; Lazarus rising from his tomb (while two women recoil from the stench); rabbits, monkeys, salamanders and birds of prey; the Nativity; Jesus censed by angels; a snake amidst a couple of sinful, naked women; a pig eating two human heads; flowers and patterned mouldings; a contortionist; and a twelfth-century musician with a drum between his legs.

The lively village of Cénac lies downhill from the great bastide of Domme. In spite of this apparent dependence, there is both vigour and elegance here (right), with flourishing produce stalls (below) and some fine, substantial houses (opposite).

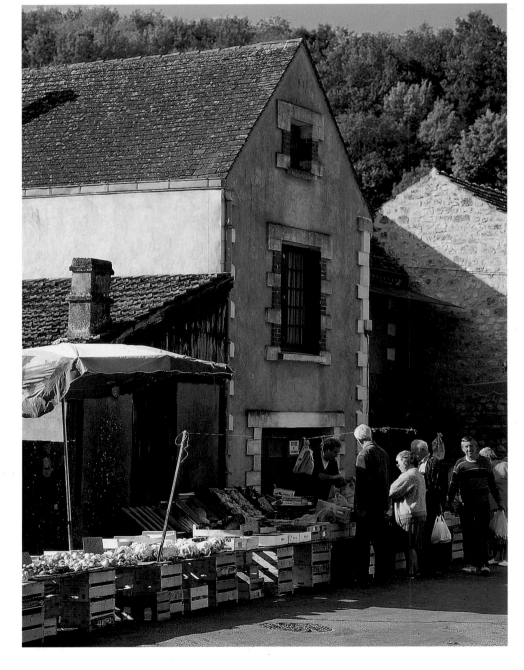

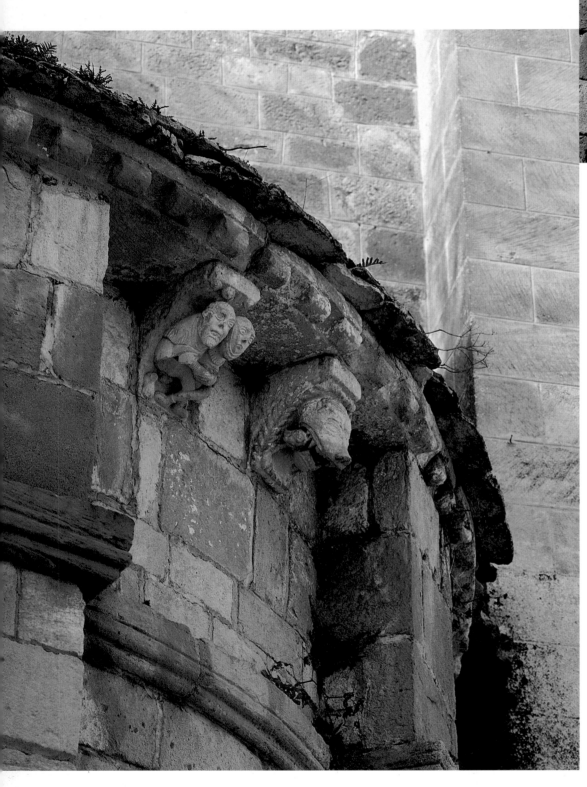

*B*izarre figurative sculptures embellish the exquisite Romanesque apse of the church at Cénac-et-Saint-Julien (above and left). Its warm stones and lauze roof (opposite) contrast with the harsher lines of machine-cut stones of the restored west part.

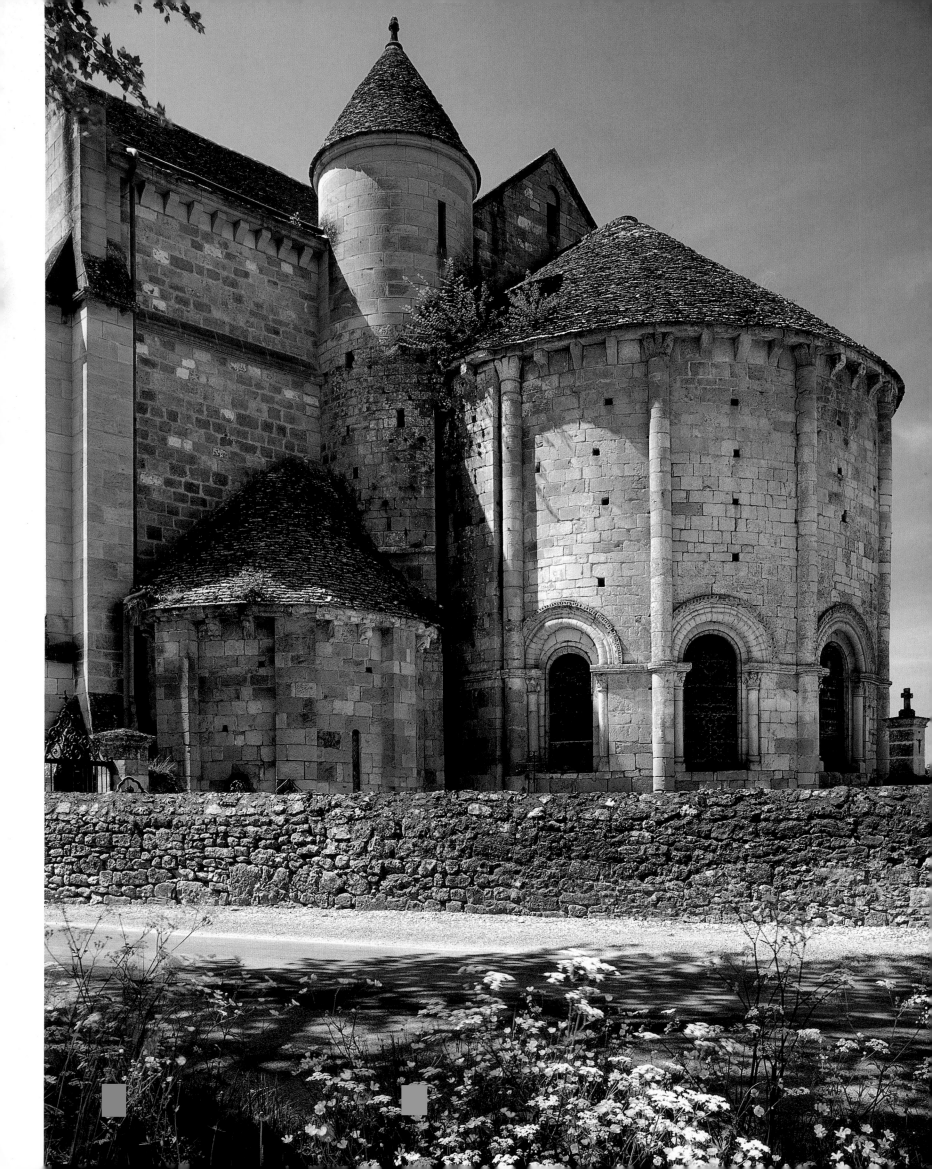

Domme

Perched on a hill high above the Dordogne valley, Domme is undoubtedly the finest French *bastide* in the Périgord. Yet building it proved very difficult. Philippe the Bold founded this *bastide* in 1281, but the problems of transporting materials up the steep hill and apparently the fact that those expected to build it were paid only in leather money meant that work dragged on slowly and Domme was finished only in 1307.

Domme's fortifications include four gates, the finest the superb Porte des Tours, built at the end of the thirteenth century and defended by two enormous semicircular towers. Although the triangular site meant that the usual grid-pattern of a *bastide* could not be absolutely followed, for the most part Domme's exquisite streets cross each other at right angles. The ochre stone of the neighbourhood lends enormous charm to the houses, which in the Grand'Rue have ogival vaults and ancient doorways, along with the occasional sculpted Renaissance window.

In the Place de la Rode (i.e. 'roue', where miscreants were broken on the wheel) the oldest house in Domme still stands, its inscription declaring that this was where the king's leather money was minted. From the Place de la Rode the Grand'Rue climbs up to the central square and the *bastide's* seventeenth-century hall, its balcony supported on stone pillars. En route the Rue des Consuls leads off right to the former town hall, its façade thirteenth-century.

In front of the hall rises the fine Maison du Gouverneur, built in the fifteenth and sixteenth centuries and enlivened with turret and corbel. During the Wars of Religion the parish church was burned down, and the present building, just beyond the Place de la Halle, is undistinguished, save for its Renaissance porch. Walk past it and you reach the *barre* (or bluff) of Domme, with a magical vista. As Henry Miller wrote, 'Just to glimpse the black, mysterious river at Domme from the beautiful bluff at the edge of the town is something to be grateful for all one's life.'

Most dramatic and best preserved of the French bastides, Domme is a place of endless perspectives – streets rise steeply to its ramparts and cliffs (opposite), which in turn permit magnificent views across the valley of the river Dordogne, like this one from the famous local viewpoint of the Belvedere de la Barre. It is a place of historical anecdote: the oldest house (left) was originally the local mint, where leather money was made in the thirteenth century to pay the workers who built the original bastide.

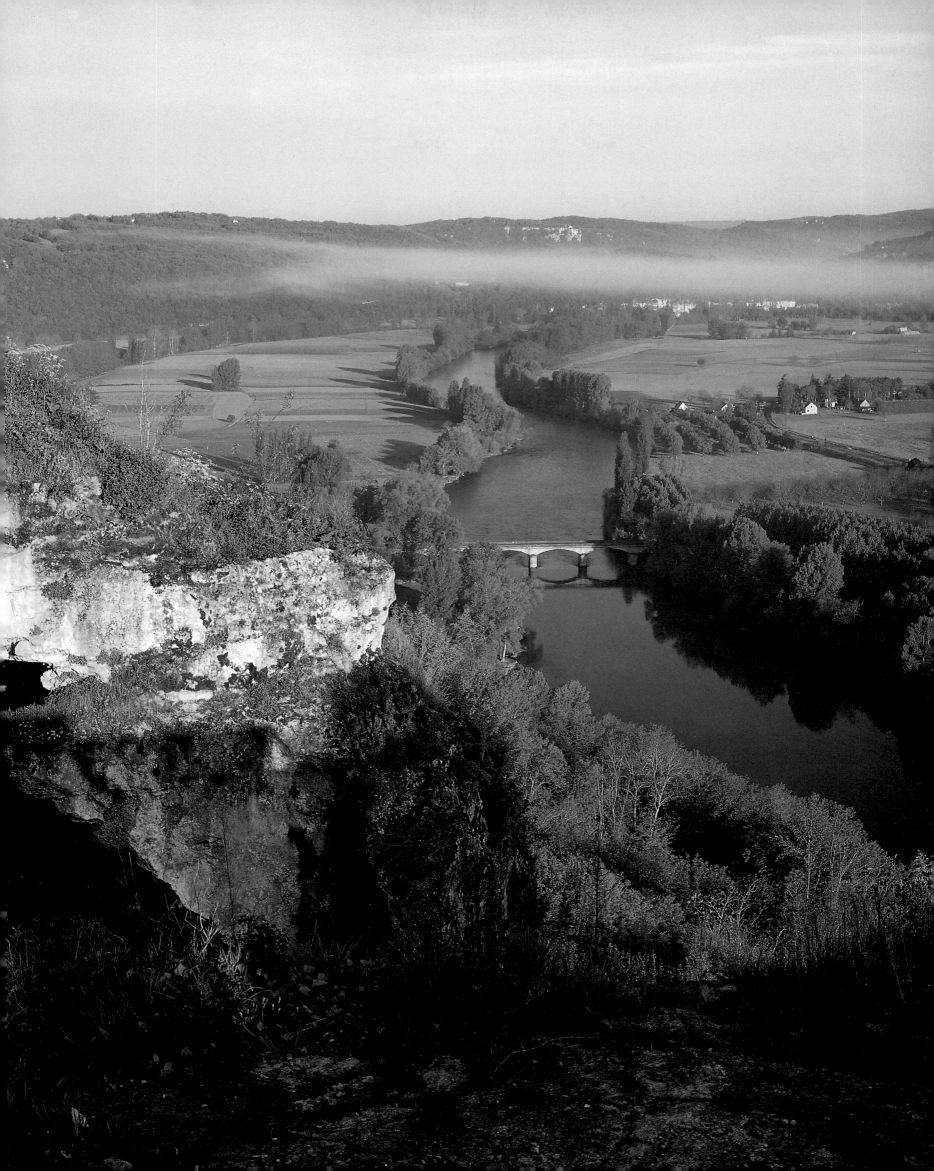

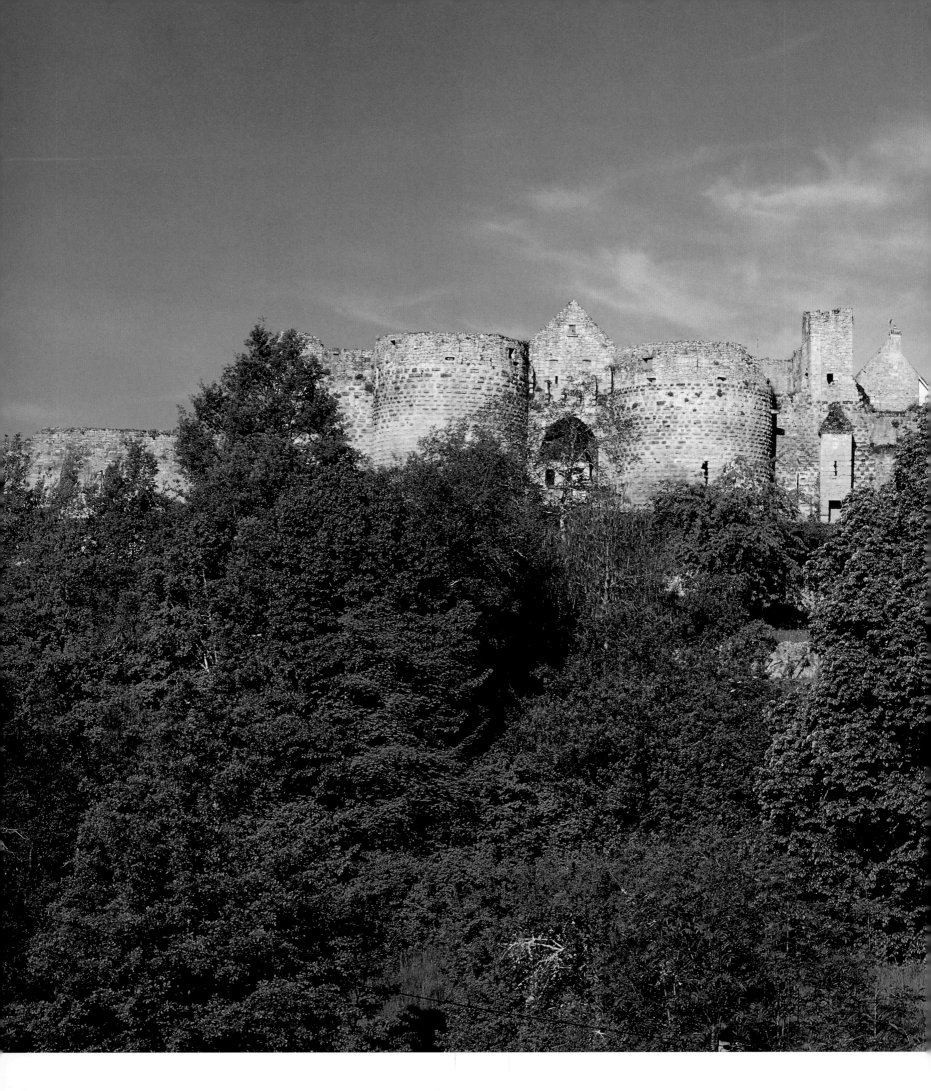

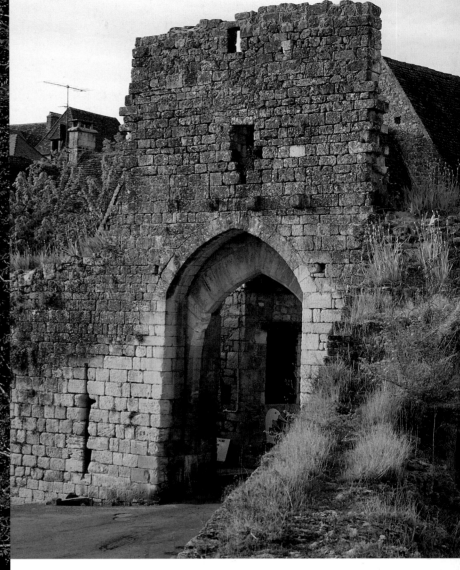

*T*he massive fortifications of Domme
(above) *were the fruit of long and
arduous building, lasting almost thirty years,
as Philippe the Bold sought to make the place
impregnable to the invading English. Key
parts of the defences were the four massive
gates, of which the finest is the well-preserved
Porte des Tours (left).*

omme's original function may have been military, but the present-day village has many a gentle aspect. Well-worn streets (opposite) wend their way to the upper reaches of the village – and truly breath-taking views. Fine domestic architecture is abundant (below), including such beautiful details as this elegant dormer window (left) which protrudes from the roof of a house on the Place de la Rode, once the scene of brutal executions.

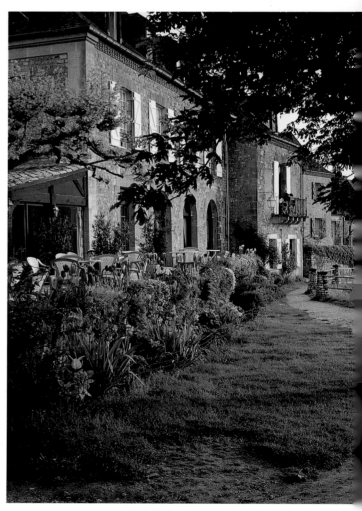

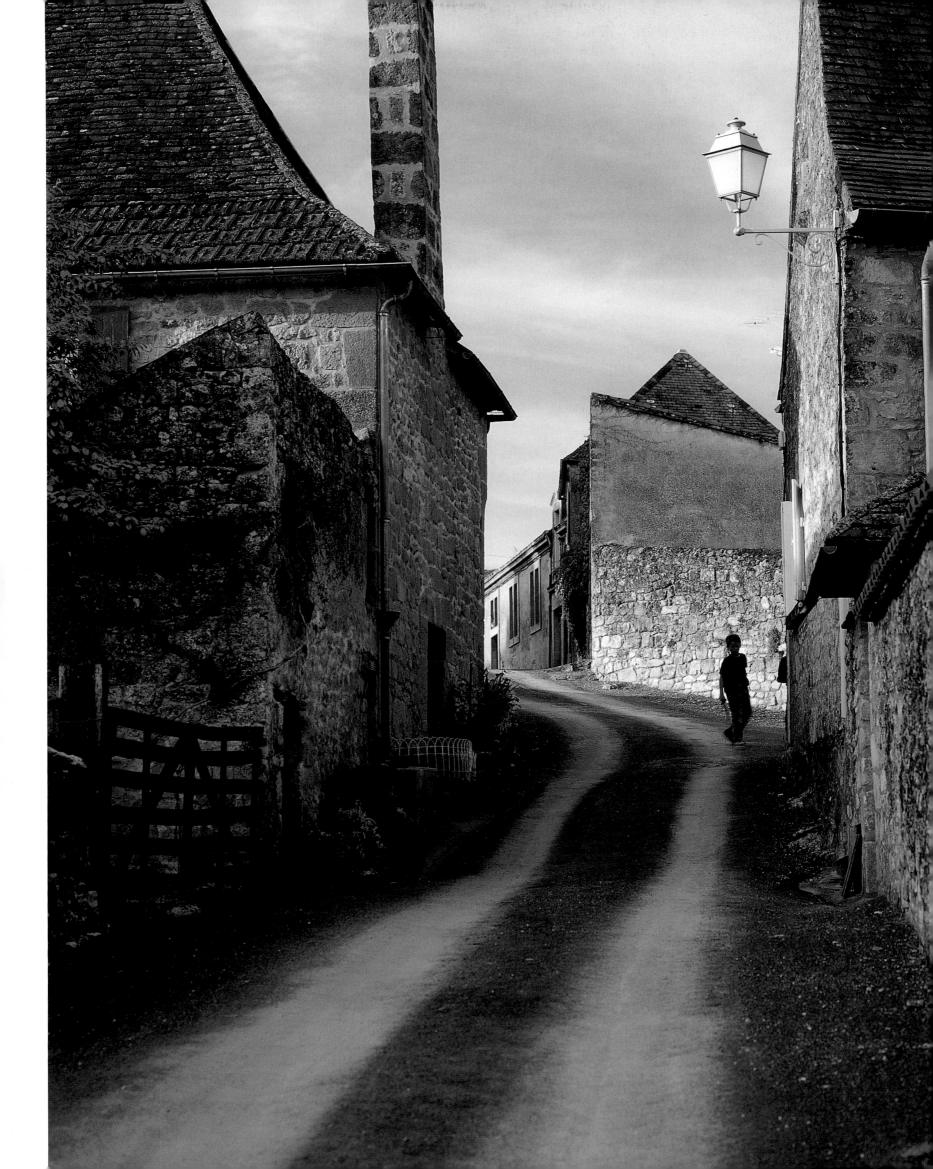

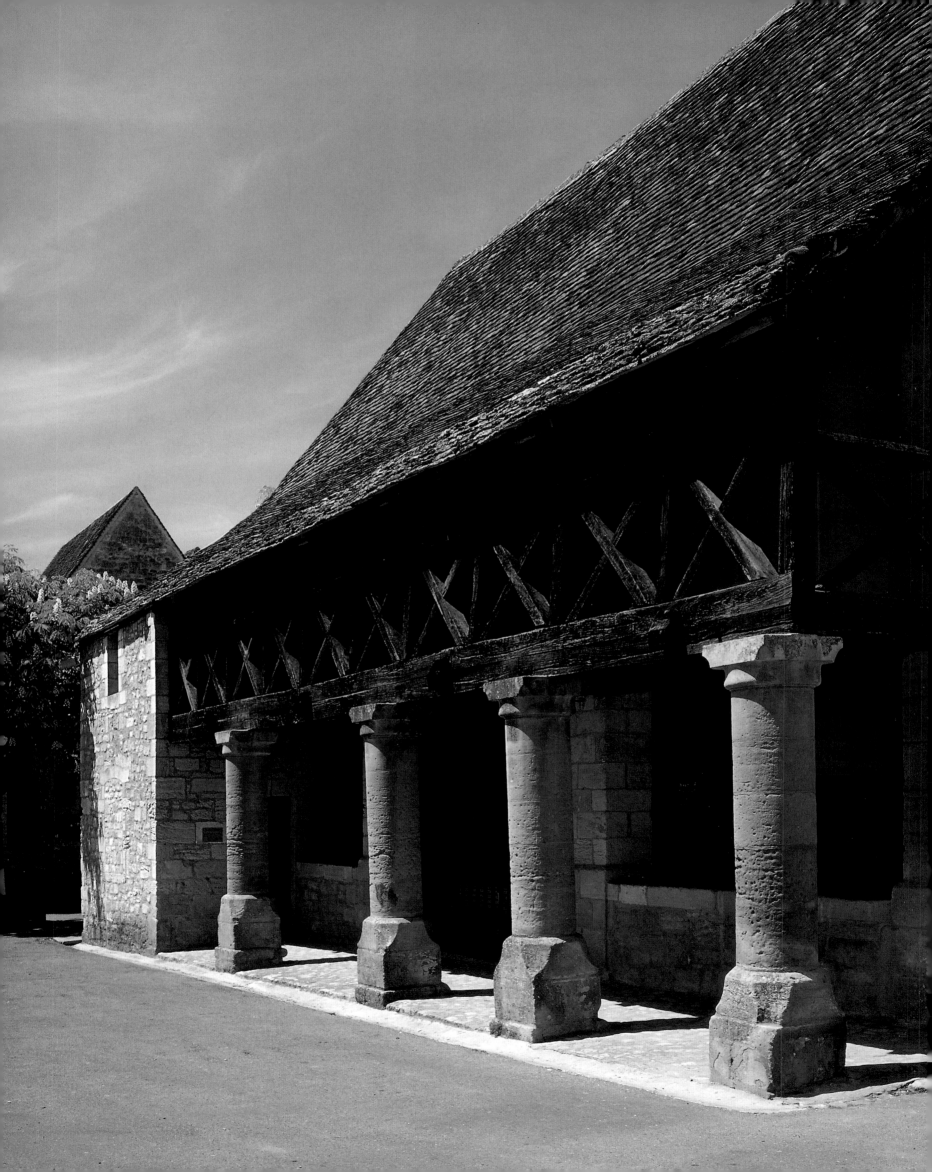

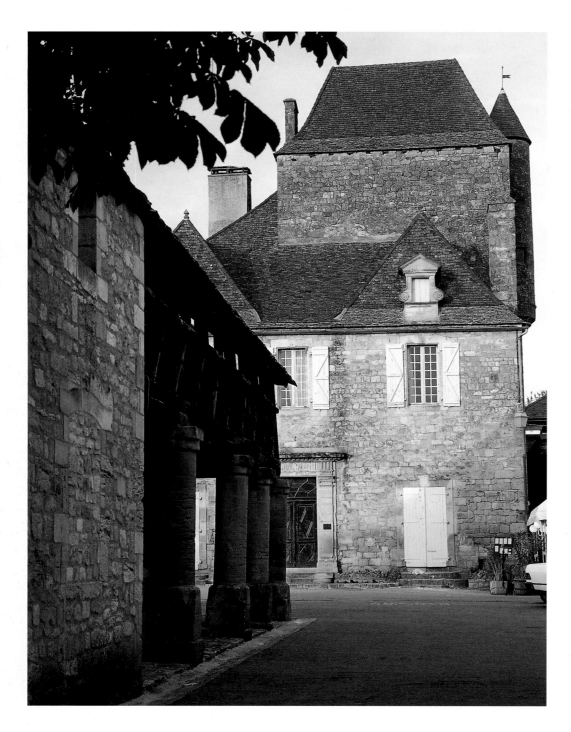

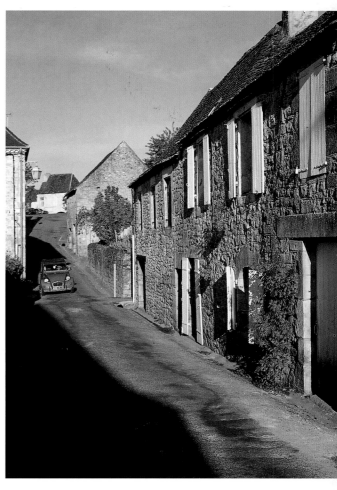

*I*n common with other bastides of the *Périgord, Domme possesses a fine market-hall* (opposite), *built in the seventeenth century on the main square. And wherever the visitor is led there is superb architecture, domestic and small-scale in parts* (right), *but with sudden intrusion of the monumental* (above).

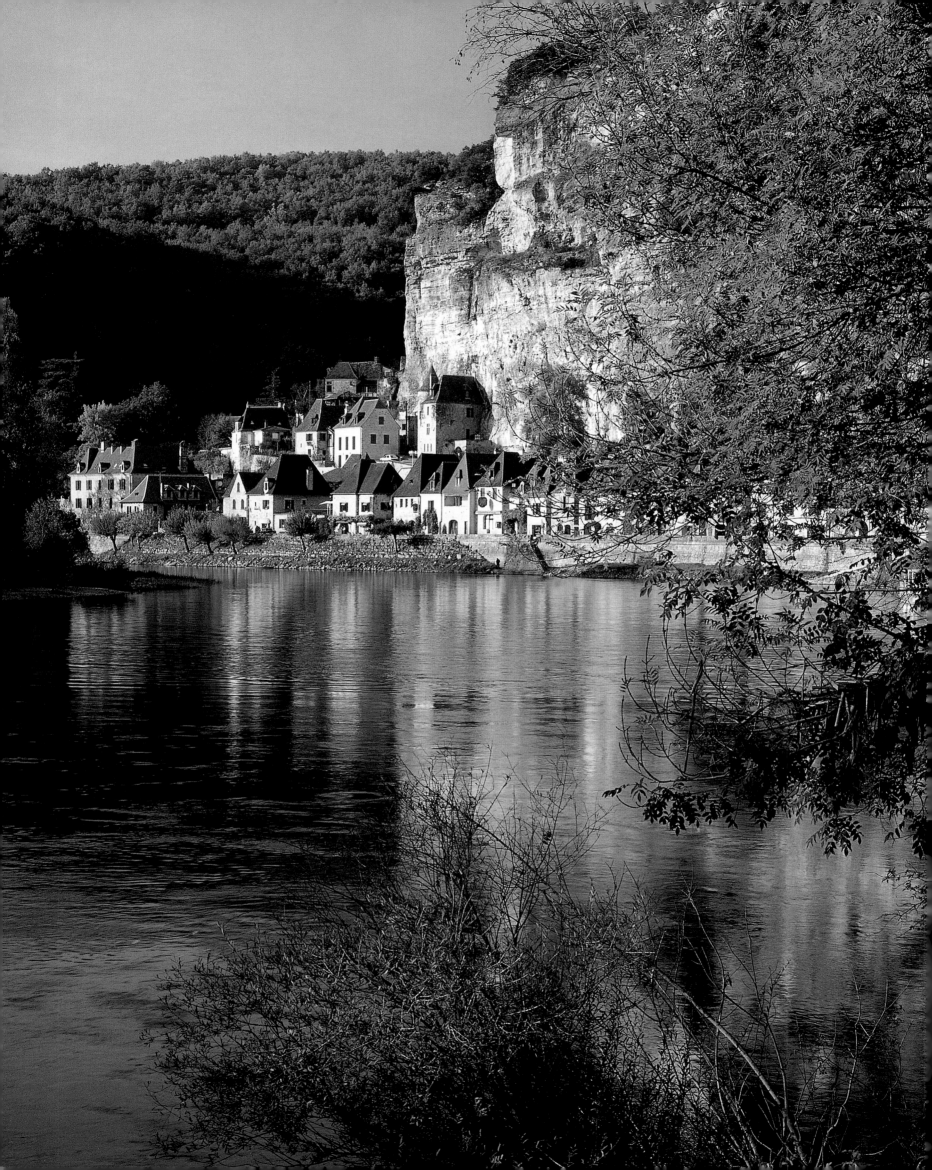

La Roque-Gageac

The enclosed position of the village immediately on the river creates a micro-climate in which exotic plants can flourish in the local gardens (left *and* below).

One of the most spectacularly sited of all Périgourdin villages, La Roque-Gageac nestles beneath its ochre cliffs beside the river Dordogne (opposite).

Beguilingly reflected in a curve of the wide river Dordogne, the medieval village of La Roque-Gageac is set against an impressive cliff to which many of its houses cling. Throughout the centuries it was preyed on by the English and by Huguenots alike and resisted every attempt by both sides to destroy its homes and châteaux. Its latest sufferings occurred in 1957, when part of the cliff fell down, demolishing several houses and killing several inhabitants. You can still see a different hue in the texture of the cliff where the offending rock came apart.

Little streets rise up the cliff side to the upper part of La Roque-Gageac, where you discover some troglodyte homes and also its sixteenth- and seventeenth-century church, with a stone roof, a wall-belfry and, inside, a seventeenth-century Pietà. The climb is worthwhile, if only for the superb view from outside the church.

La Roque-Gageac is defended by a château at each end of the narrow road which borders the river. Château de la Malartie was built in the nineteenth century, but in the style of the sixteenth century. Château de Tarde is a genuine fifteenth- and sixteenth-century building. Here too is a former hospice of the Knights Hospitallers, as well as the ruins of a fortress (tower and walls still partly intact) which once belonged to the Bishops of Sarlat.

The unusual micro-climate created by this site, with its steep cliff and the river, has made La Roque-Gageac a village of palm trees and cactuses, while the river itself is here flanked by green oaks and tall pines. Outside the village, the farmers cultivate tobacco. Today, traditional flat-bottomed boats which once transported wine along the river as far as Bordeaux now offer trips to tourists.

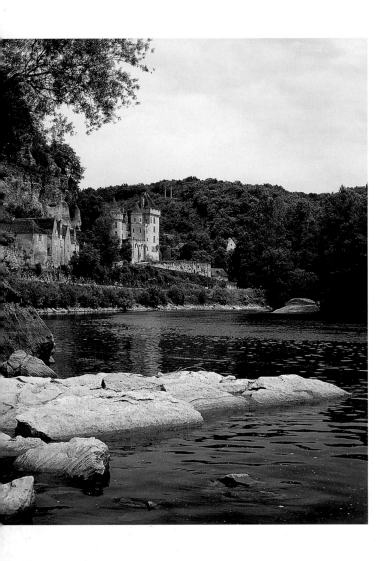

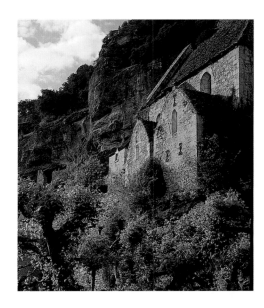

In days gone by, La Roque-Gageac was a centre of the local wine trade; its flat-bottomed boats (below) were used to transport the produce of local vineyards further down the river. Although many of the village's buildings are strung out along the river – here seen from the west – other structures cling to the cliff itself, sometimes with disastrous consequences (right).

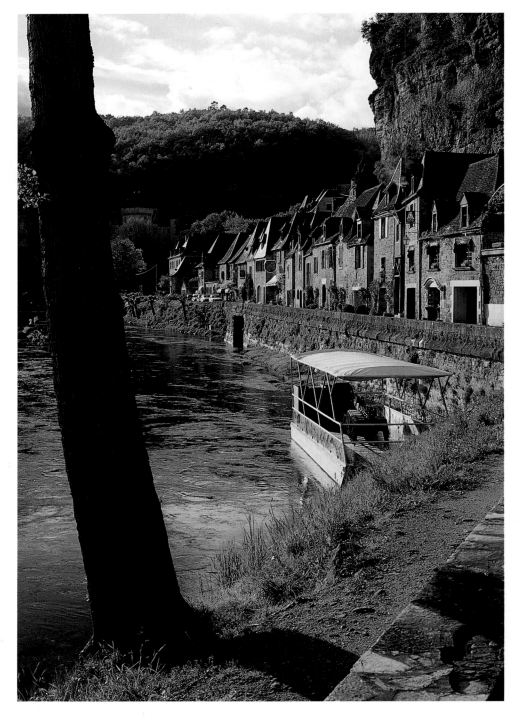

The fine gardens of the village often afford beguiling vistas along the river, whether of more houses and exotic gardens (opposite) or of the river bank and its more traditional foliage (overleaf).

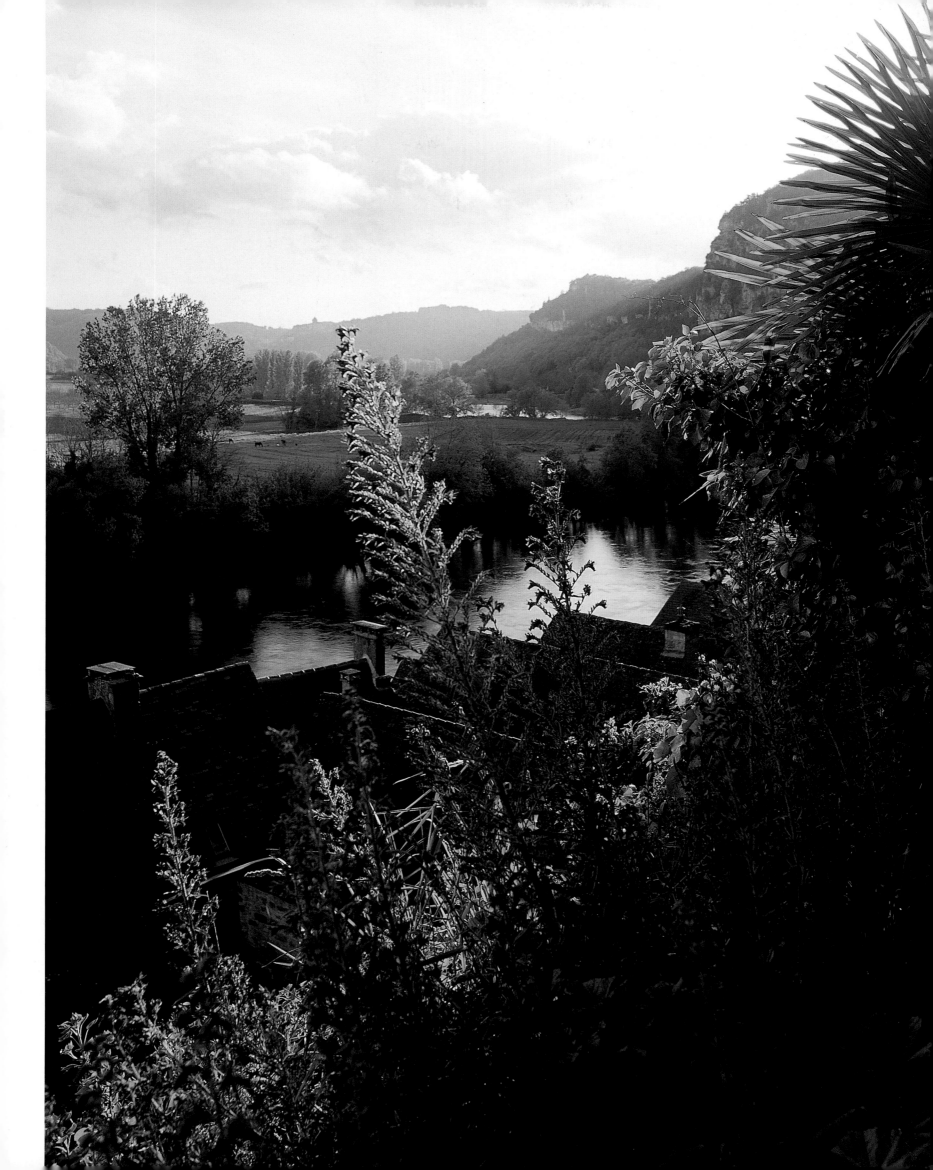

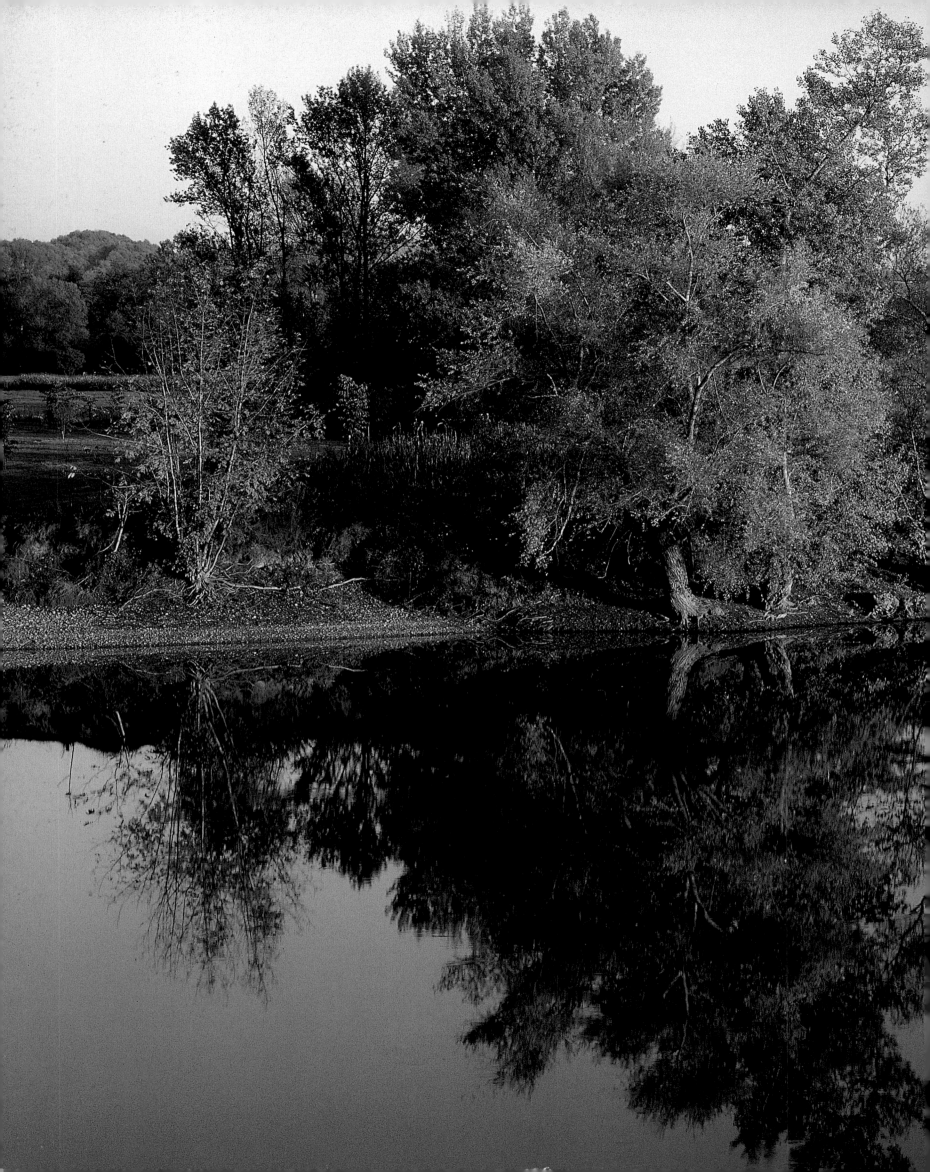

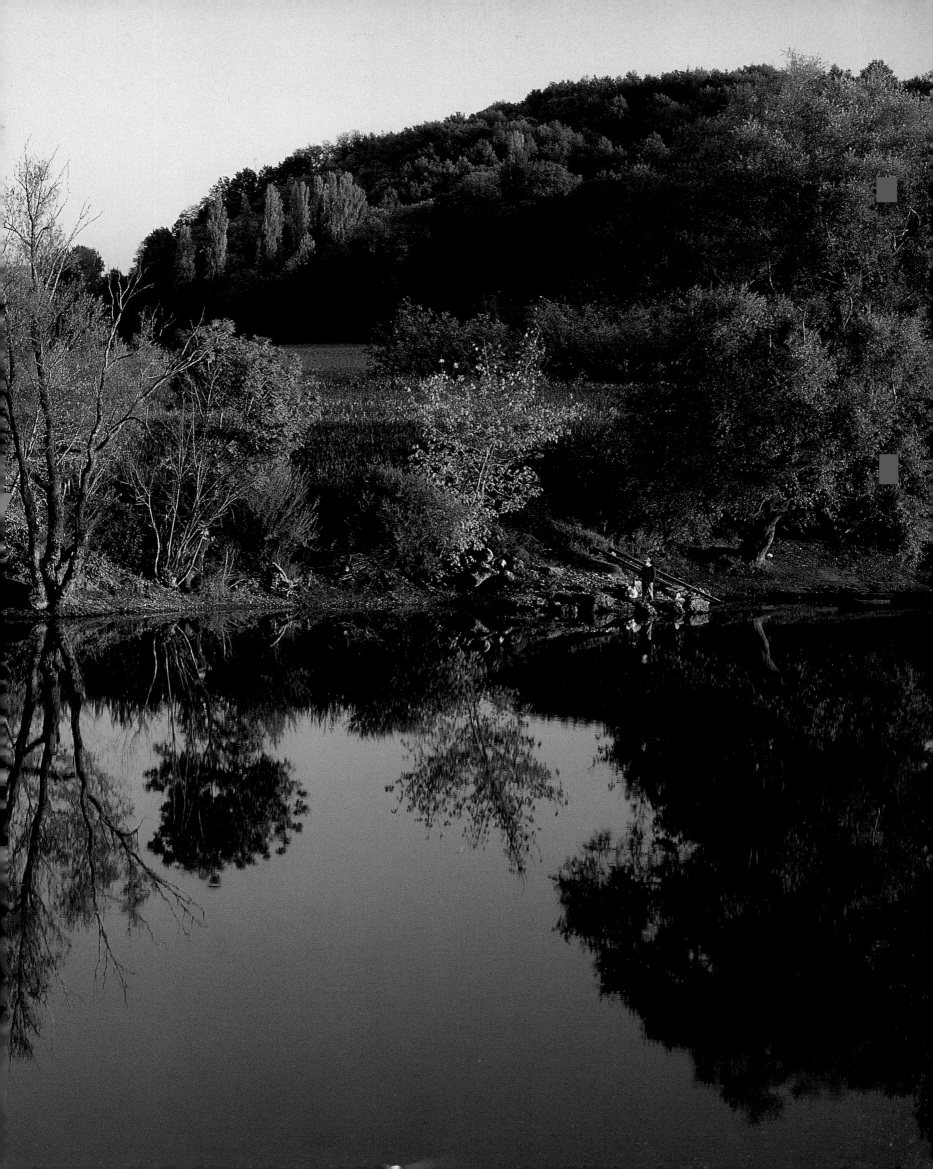

Monpazier

On a plain above the river Dropt lies the almost perfectly preserved and most entrancing *bastide* in the Périgord. Jean de Grailly, seneschal of the English King Edward I, founded Monpazier for his master in 1284, on a gentle hill known as Mont Pazerii. His aim was to control the route from southern France .

The seneschal attracted men and women to this new *bastide* by offering them space for a house with its garden, as well as cultivable land outside Monpazier, provided that they swore allegiance to the English king. They built the *bastide* within six years. It centres on a market square whose every house dates from the thirteenth century, each one of the same dimensions (eight metres wide and twenty metres deep), yet all of them individual in design. Tiny passages separate the houses, as a precaution against the spread of fire and also to allow the escape of drainage. To one side of this market square stands Monpazier's sixteenth-century market-hall, its pantiled roof supported on exquisite fretted woodwork made out of seasoned Dordogne chestnut. Ochre arcades, delightfully irregular, surround this market square, sheltering citizens from excessive heat and excessive cold, as well as giving shade to shops. The rest of the *bastide* is set out in a strict grid pattern.

As you walk from the main square (Place des Cornières) to the parish church of St. Dominic, you pass the former three-storeyed, Gothic house of the canons, where once tithes were collected. St. Dominic itself was founded in 1279, though its choir was completed only in 1506, its choir stalls date from the fourteenth century and its square tower and west portal from the sixteenth. Don't miss the inscription over its doorway, added at the time of the Revolution: 'The French people recognize the existence of the Supreme Being and the immortality of the soul'.

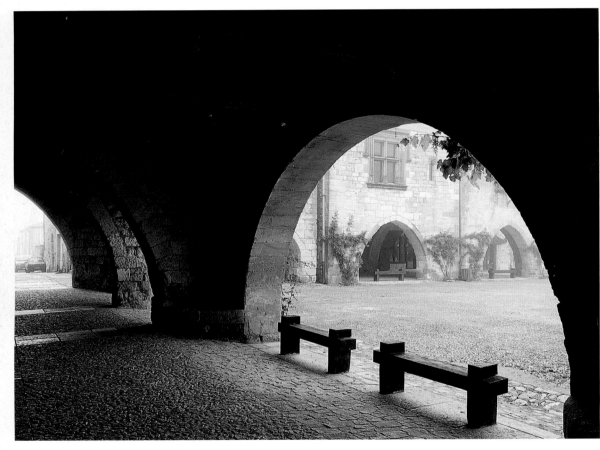

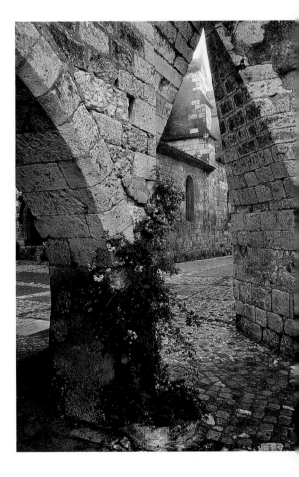

Landmarks old and new (top) *– a prehistoric standing stone and a First World War memorial. Low-arched arcades surround the main square of this finely preserved* bastide (above)*, offering shade in summer and shelter in winter. Summers are often extremely warm – any early morning mists* (opposite) *soon burn away to give long fine days.*

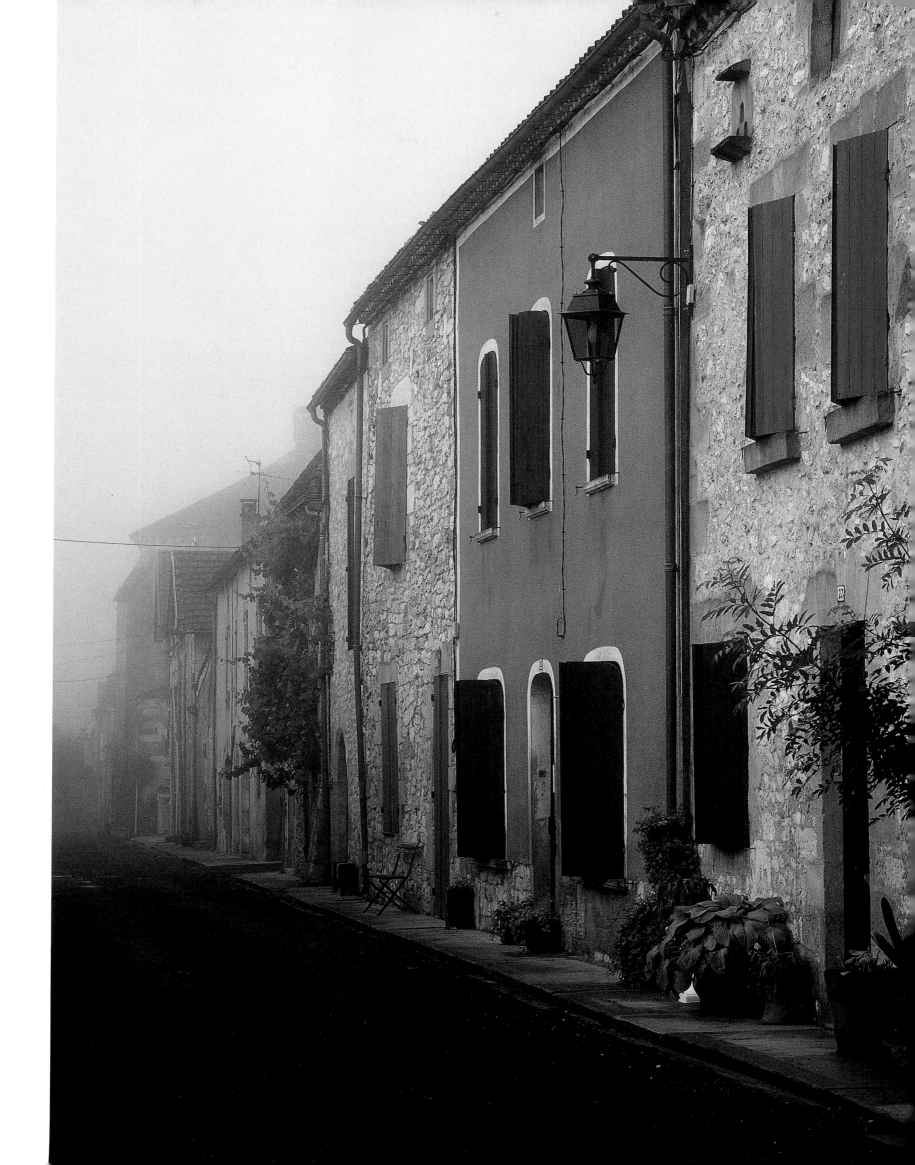

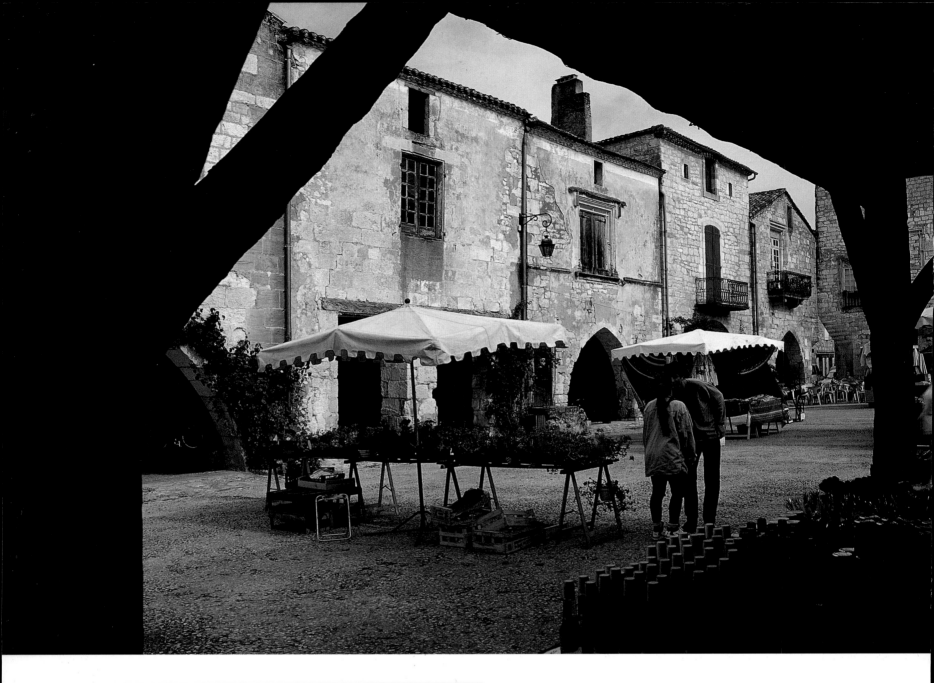

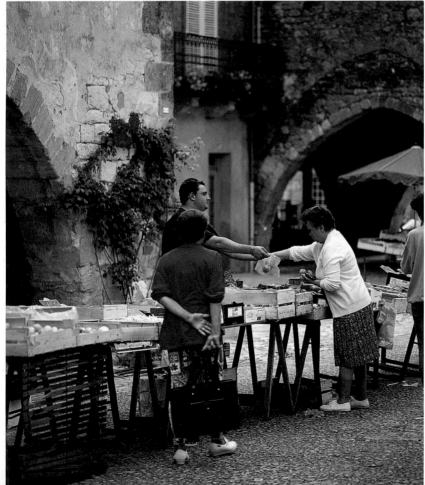

*T*he central square of Monpazier has been traditionally a place for market trading (above *and* left). *Other produce is sheltered by the pantiled roof and chestnut pillars of the sixteenth-century market-hall (opposite); market days also provide a useful opportunity for the exchange of local gossip and news and, of course, for the sale of traditional crafts.*

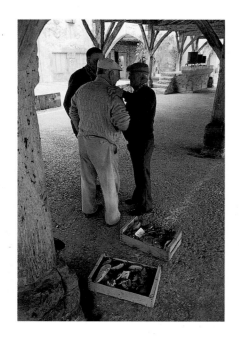

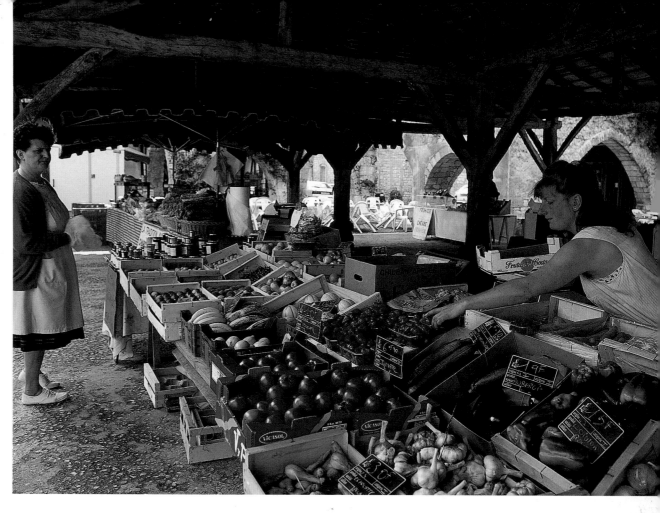

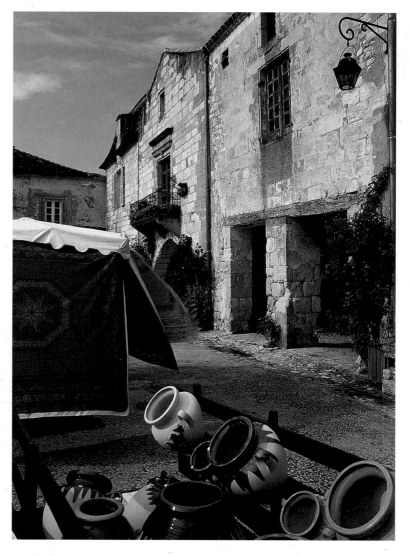

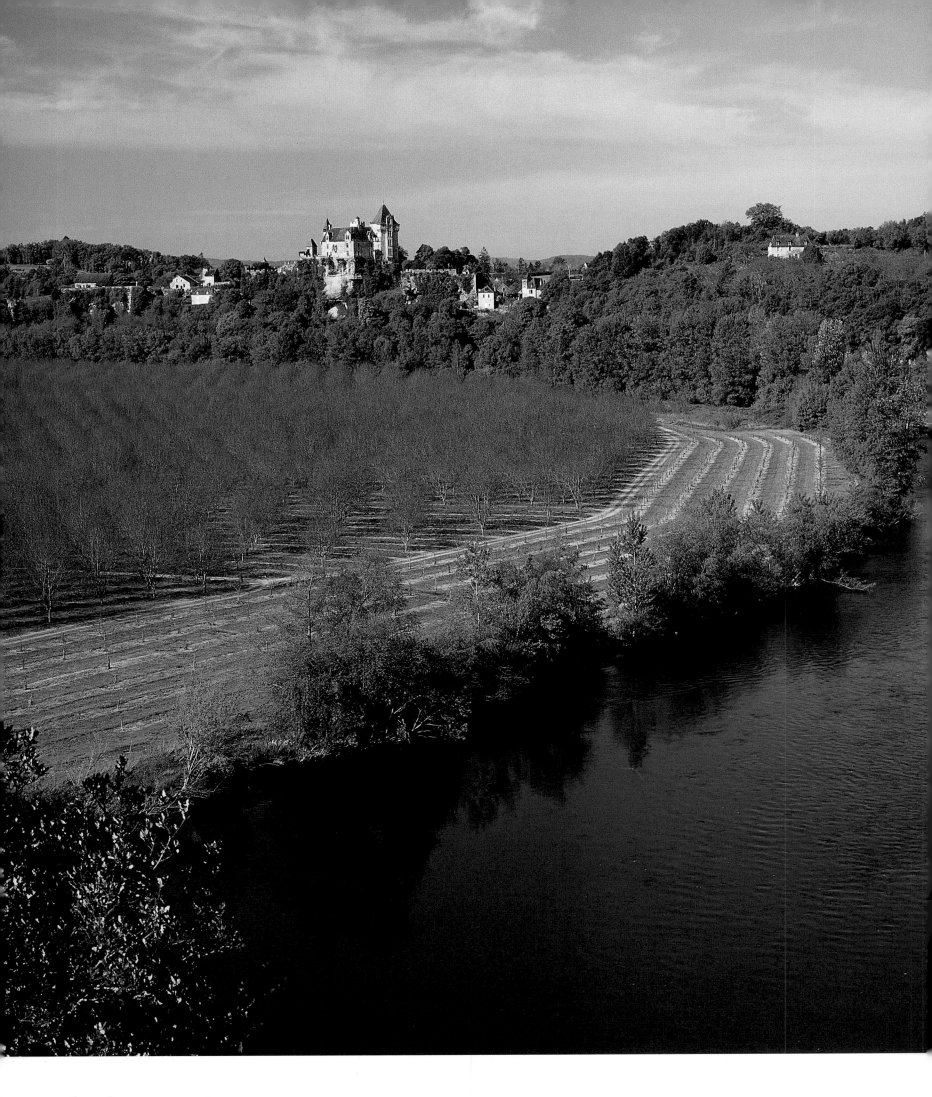

Montfort

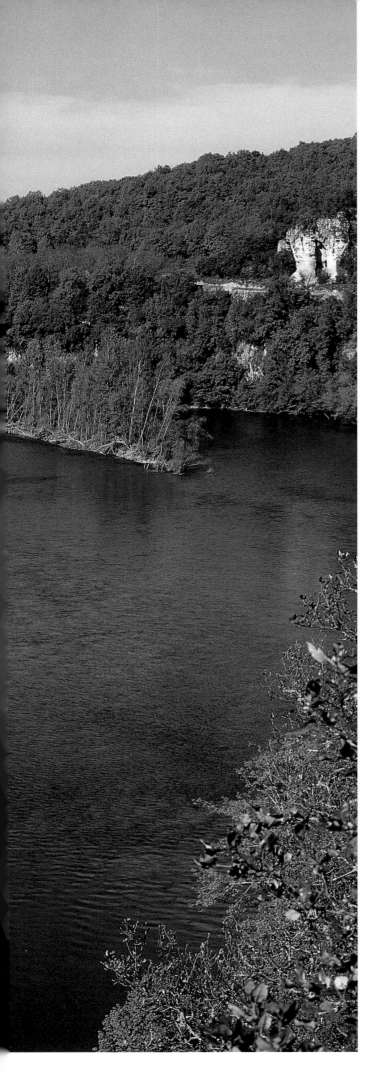

Château Montfort rises spectacularly from a cliff that itself rises sheer from the Dordogne and is pierced with holes in which birds of prey often nest. The château and village of Montfort are named after Simon de Montfort, who in 1214, during the wars of the Catholics against the heretic Cathars, captured a former fortress here and demolished most of it. (Montfort then belonged to Bernard de Casnac, who was a Cathar.)

This stunningly romantic château was subsequently twice partly razed. During the Hundred Years War the English took the stronghold only after besieging it three times. During the sixteenth-century Wars of Religion, when Montfort was a bastion of Protestantism, its owners successfully resisted a royal command that once more Château Montfort should be destroyed. The eirenical Henri IV revoked the command when the Wars of Religion came to an end.

The château and village stand above one of the two great loops or *cingles* of the Dordogne, where the river curves beautifully from the tiny, exquisite hamlet of Turnac as far as and beyond the village of Montfort. Today's château still retains vestiges of the fourteenth and fifteenth centuries, though it was greatly (and excellently) restored in the nineteenth. Its medieval base blends entrancingly with the Renaissance and classical elements which rise above it, while dormer windows, turrets and machicolations, as well as the battlemented walls which surround a formal garden, are equally captivating.

Montfort village is largely made up of traditional Dordogne houses, some of them with the original stone roofs. And because the river Dordogne curves so majestically here, from whatever direction you approach Montfort, its château reveals itself in extravagantly improbable, equally diverting aspects.

Château Montfort (left) is seen here from the Cingle de Montfort, the great loop made by the river Dordogne at this point.

The château rises high above the river (below), viewed here from close by the hamlet of Turnac on the opposite bank.

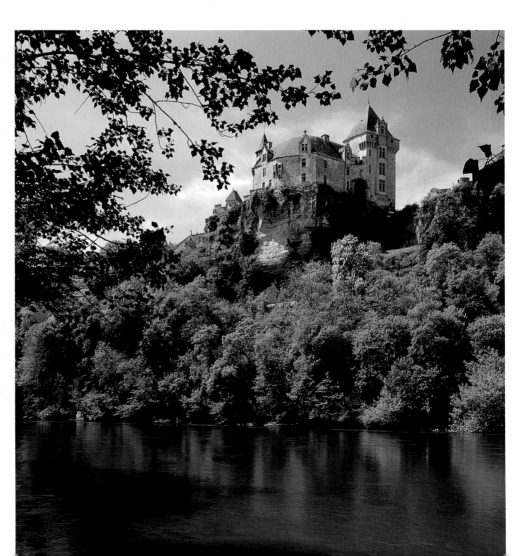

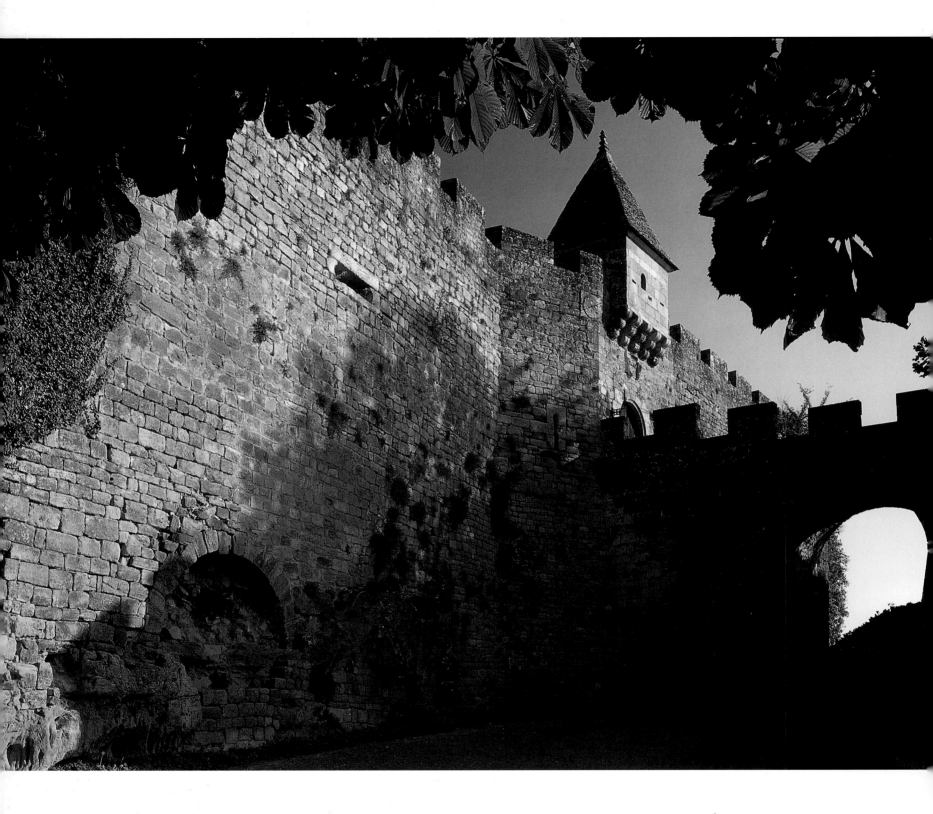

The complex defences of Château Montfort (above); earlier versions of the castle were not sufficiently strong to prevent its taking by Simon de Montfort, after whom it is named.

Old parts of the château (opposite) *still survive amid later Renaissance and Neoclassical additions, all restored in the nineteenth century.*

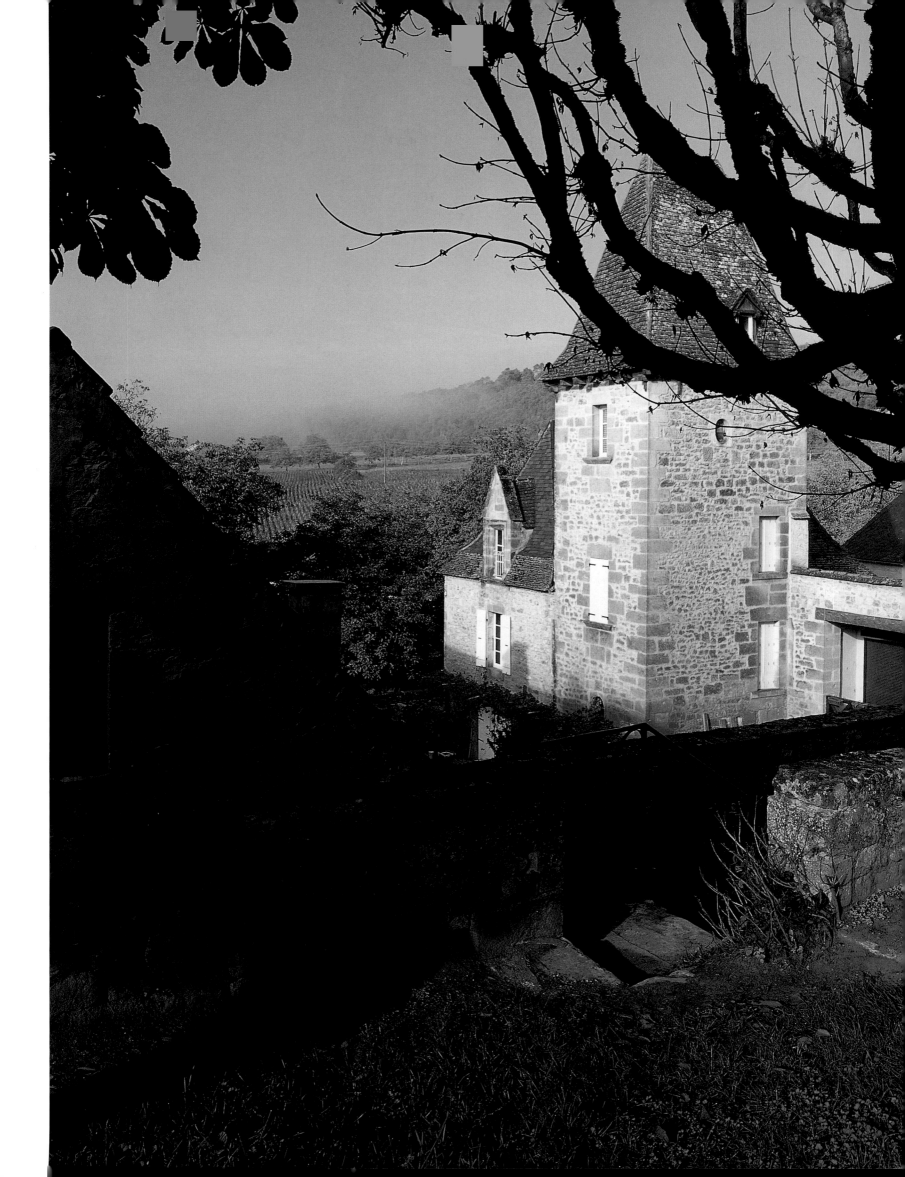

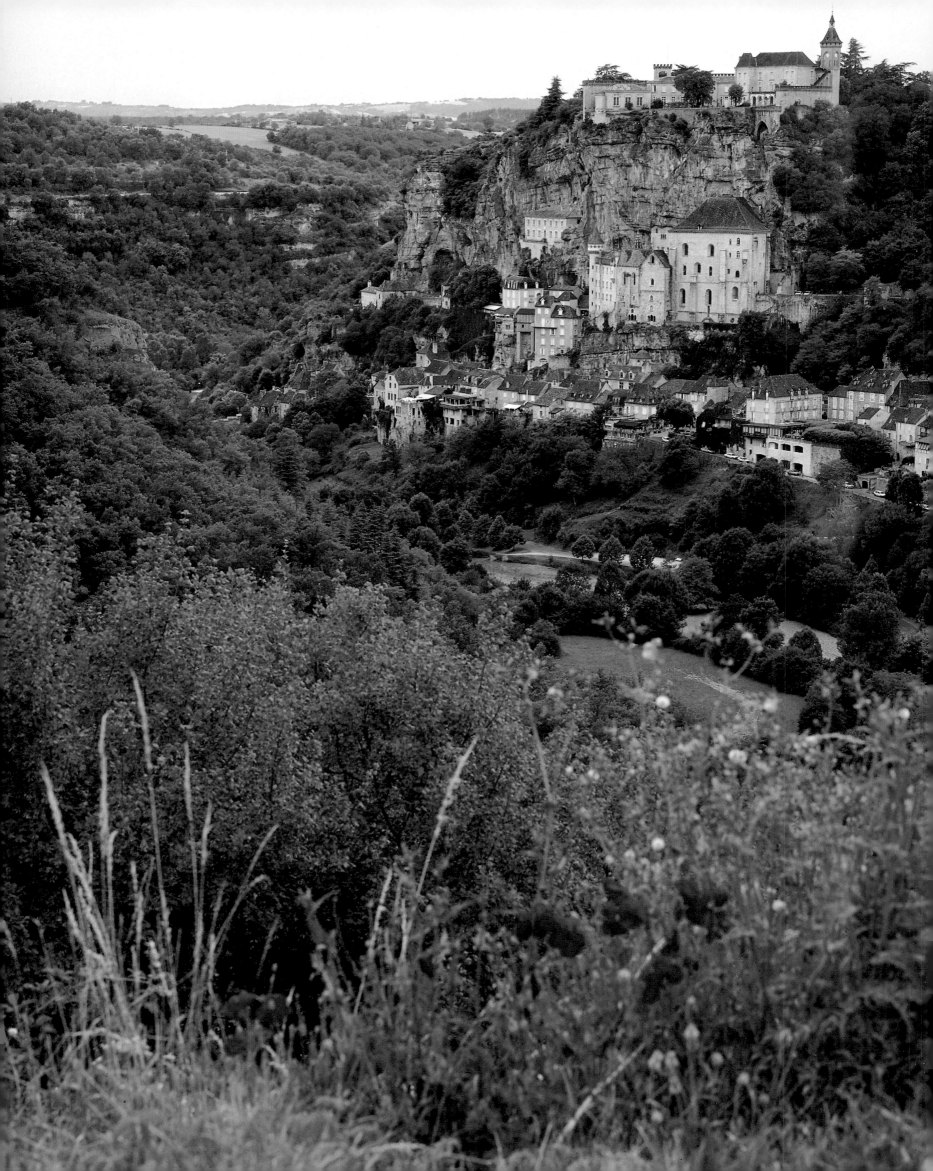

Rocamadour

In 1166 the body of a holy man was discovered near the altar of a chapel in one of the most spectacular villages of France. Just south of the Périgord, Rocamadour is situated where the gorge of the river Alzou cleaves through cliffs some 120 metres high, which in part overhang the shrines below and the village, some of whose houses are medieval, some Romanesque.

Initially the uncorrupted remains of the holy man were identified as those of St. Amadour, but as miracles began to be worked at his shrine and increasing numbers of pilgrims arrived it was concluded that he could be none other than Zacchaeus, publican and friend of Jesus, who according to legend sailed to France with Jesus's mother and St. Mary Magdalen to avoid persecution. During the Wars of Religion the Protestants set fire to his corpse. But Rocamadour also possessed a twelfth-century statue of the Madonna and Child, blackened with age, and in time this Black Virgin of Rocamadour became the focus of renewed pilgrimages.

Over the centuries seven churches were built in this once obscure hamlet. Some of them possess superb works of religious art, especially the twelfth-century frescoes in the semi-troglodyte chapel of St. Michel and the eighteenth-century reredos in the chapel of St. Anne, while the late twelfth-century basilica of Saint-Sauveur, with its double nave, is particularly imposing. To visit these shrines you follow a tortuous route, with no fewer than 216 steps. The ashes of St. Amadour lie in the crypt of the church named after him. The Black Virgin is housed in the chapel of Notre-Dame, which was rebuilt in the eighteenth century. As Freda White wrote, 'Her dark face wears a one-sided smile, proud and secret.'

Rocamadour was fortified, and some defensive gateways remain, as does its château and l'Hospitalet, once a hospice for pilgrims. To quote Freda White again, 'Seen from the Hospitalet, the churches, the impending cliff, the straggling old village below, the gleam of the winding river, make a superb view. You feel it must truly have been a holy place for pilgrims to have come to this savage cleft.'

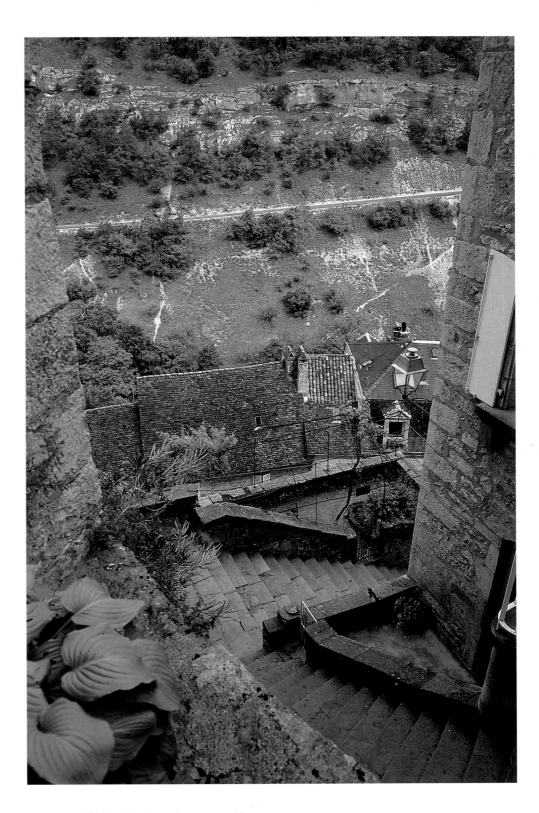

*A*lthough a short distance outside the strict departmental boundary of the Dordogne, Rocamadour enjoys such a spectacular site (opposite) *that it must be included in any itinerary of the area. Fine churches and houses line stepped streets which plunge vertiginously down the cliffside* (above).

Possessor of no less than seven churches, Rocamadour presents the visitor with gems of ecclesiastical architecture at virtually every turn of its steep streets and alleys (this page). *Its greatest treasure, however, is the statue of the Black Virgin in the chapel of Notre-Dame* (opposite).

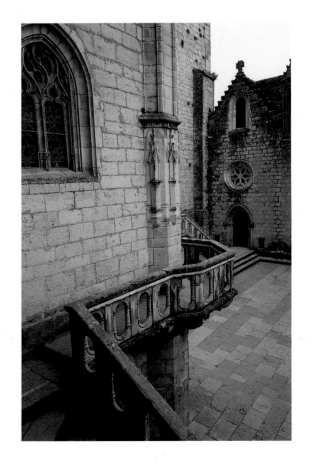

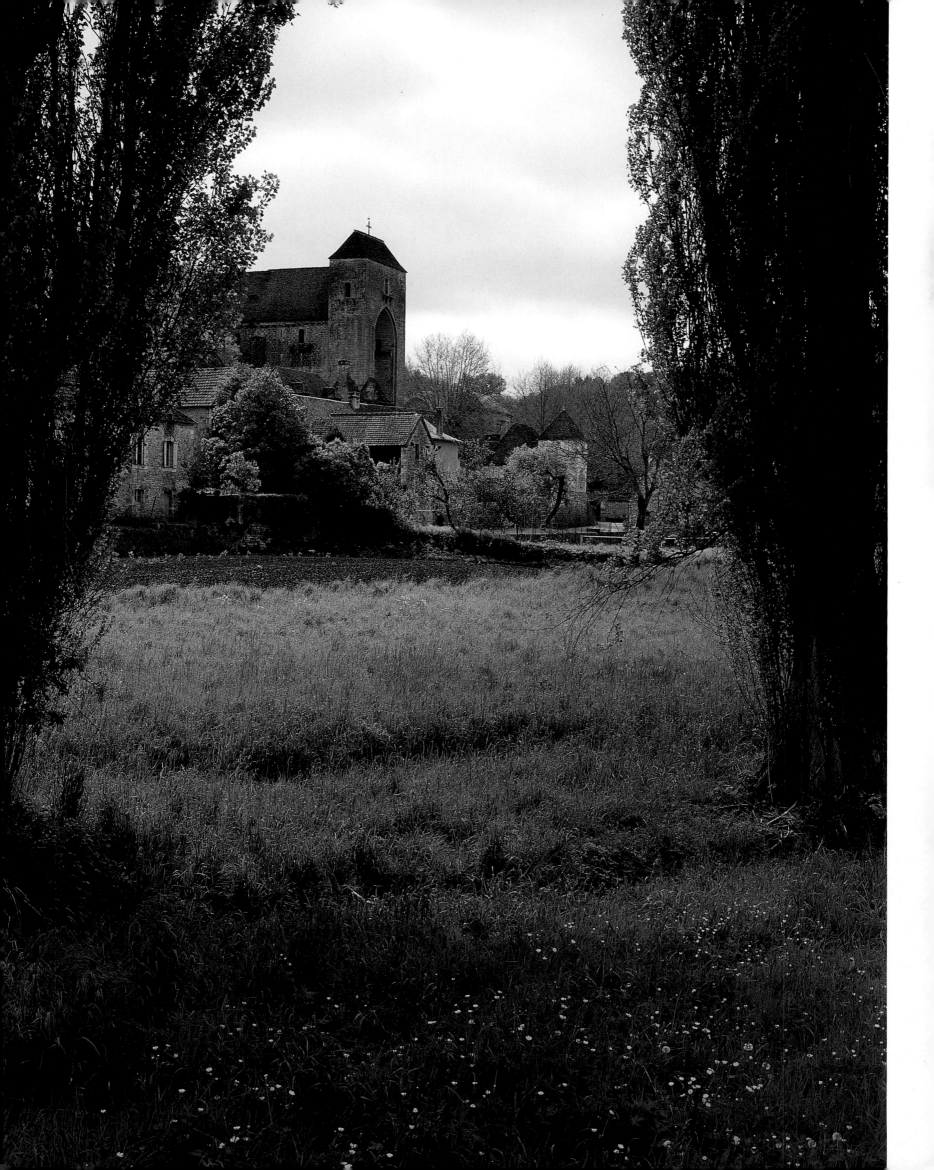

Saint-Amand-de-Coly

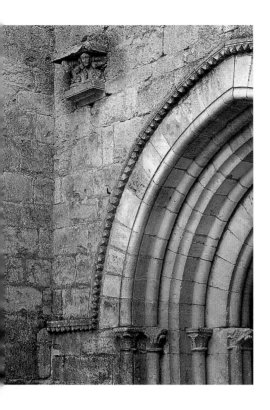

The early twelfth-century church of Saint-Amand-de-Coly is a startlingly brutal reminder that no-one, religious or lay, could feel safe in the medieval Périgord. Its belfry is in fact a formidable keep, rising almost thirty metres above the village it shelters. High up is the sole opening of this belfry/keep. Under attack, this church could shelter every single villager. In some places its walls are four metres thick. Inside, beams enabled the villagers to retreat up into the belfry, while high up around the nave and choir runs a walkway to enable them to rain missiles down on their besiegers outside the walls.

Yet the church remains a house of God. Saint-Amand-de-Coly grew around an Augustinian monastery, and its church displays Augustinian architectural sobriety. Here are exceptionally fine sculptures, again reminding us of the fragility of human life,

for one represents a beast half-dragon, half-bird and another depicts a lion devouring two men. There are also fragments of Romanesque frescoes. The Augustinian monks built a church here which is acoustically perfect, so that today it is the ideal venue for numerous summer concerts.

Around it is a collection of sweet medieval houses, some of them roofed in stone *lauzes*. You can search out vestiges of the former abbey. Parts of the enormous medieval fortifications still survive. And four kilometres west of the village is the picturesque Château de la Grande-Filolie, in truth half a farmhouse as well as a château. A delightful jumble of styles, it comprises a fifteenth-century lordly retreat, a Renaissance manor house, a chapel, a round tower with a pointed dunce's cap and an especially elegant square staircase tower.

*O*ne of the most formidable fortified churches in the Périgord lends a brooding presence to this village (opposite).

A glimpse of the church porch (above) and ensembles of dwellings, barns, gardens and a motorcycle speak of the continued rhythms of life in the Périgord (below and right).

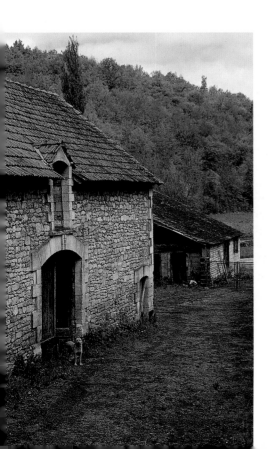

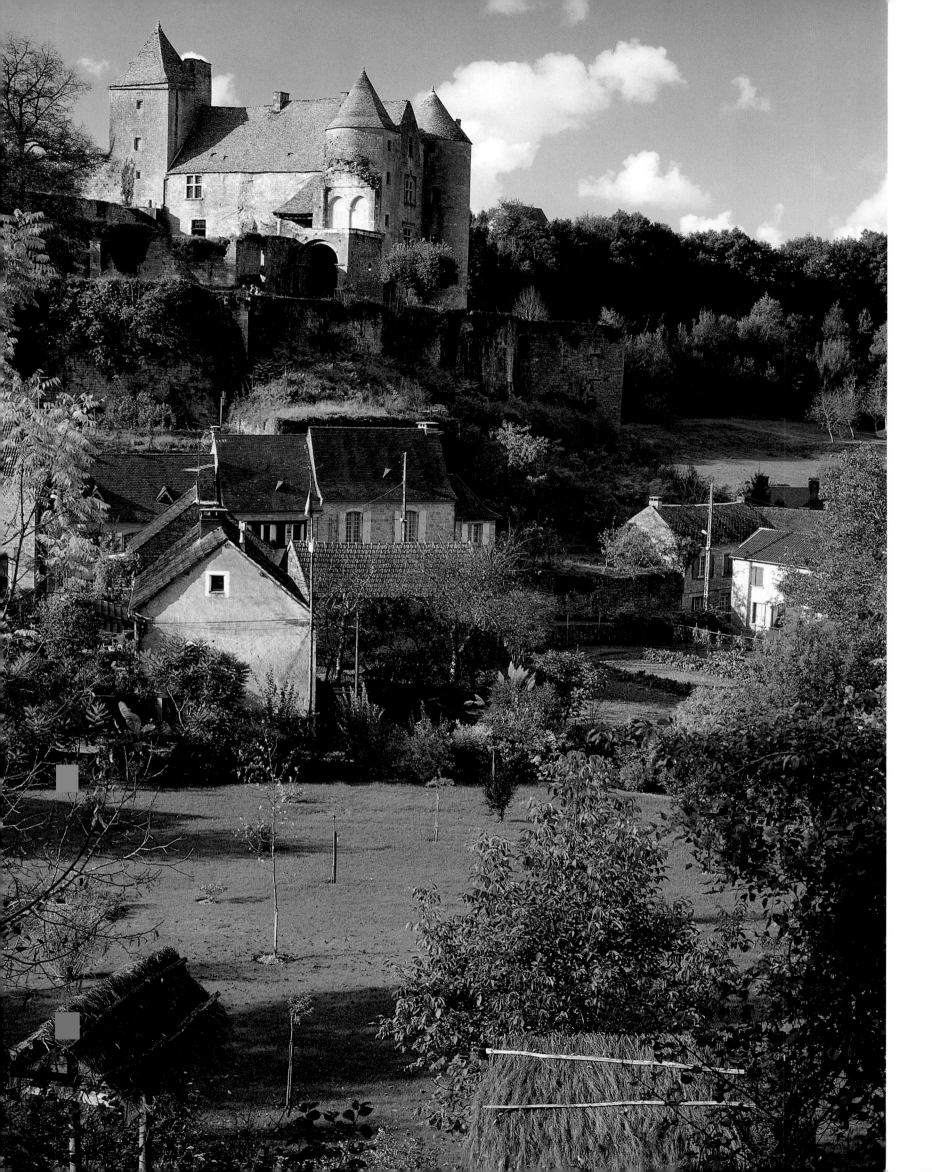

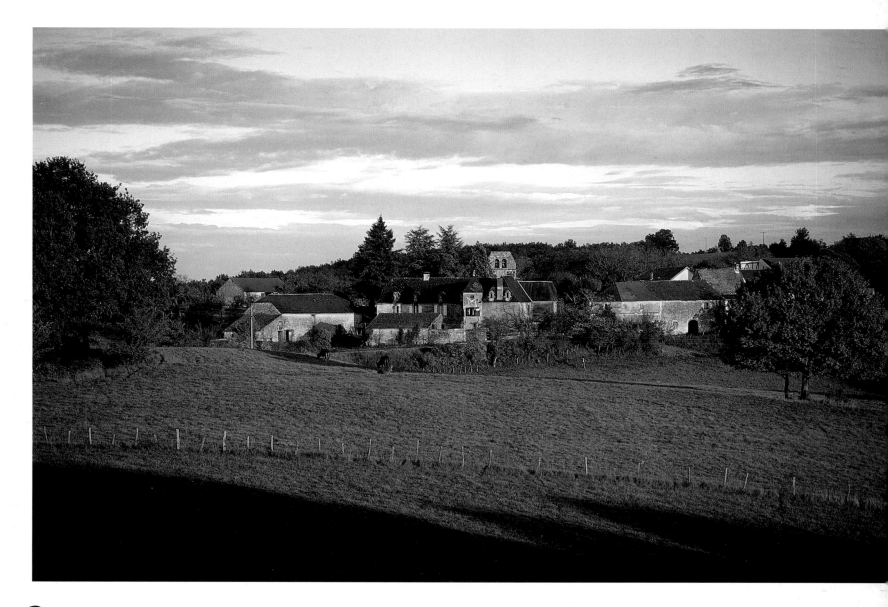

Salignac-Eyvigues

The name Salignac recalls one of the greatest sons of the Périgord, the famous Fénelon, Archbishop of Cambrai and author of the celebrated *Adventures of Télémaque*, whose full name was François de Salignac de la Mothe Fénelon and whose family built the impressive château of the village. One of the oldest fortresses in the Dordogne, picturesquely rising on a hill to one side of the village, the château has preserved substantial thirteenth-century ramparts as well as its square twelfth-century keep. The chapel dates from the thirteenth century. The tall main living quarters date from the fifteenth and sixteenth centuries and are flanked by polygonal and round towers with pointed hats, everything delightfully roofed with stone *lauzes*. Inside, you discover vaulted cellars and a fifteenth-century chimney as well as a portrait of Fénelon.

The village is equally delightful, many of its houses dating from the thirteenth and fourteenth centuries, as does its market-hall. Salignac has a Gothic parish church, built for the most part in the same centuries, though its south chapel is two centuries older and the belfry modern. Nearby are the ruins of Château de la Veyssière, once an outpost of the Knights Templars, which the English took in 1357.

Eyvigues, which completes the village, is in fact six kilometres south-east of Salignac and has a partly Romanesque, partly Renaissance church with an eighteenth-century reredos, a seventeenth-century château and a fourteenth-century former convent – the counterpointing of the religious and secular.

A similar distance south-west of Salignac reveals a particular delight: the gardens of the manor of Eyrignac. The manor was built by the premier consul of nearby Sarlat in the seventeenth century and the gardens created in the next. Abandoned and allowed to fall into ruin, they have been lovingly restored to their former exquisite formal state, with clipped hedges, green lawns, terraces, box-trees and yews.

A remarkably intact medieval survival, the château of Salignac-Eyvigues perches high above the village, its medieval ramparts and keep still presenting a formidable aspect (opposite).

The hamlet of Eyvigues (above), *about six kilometres from Salignac, boasts a church of very mixed styles, ranging from Romanesque to Renaissance.*

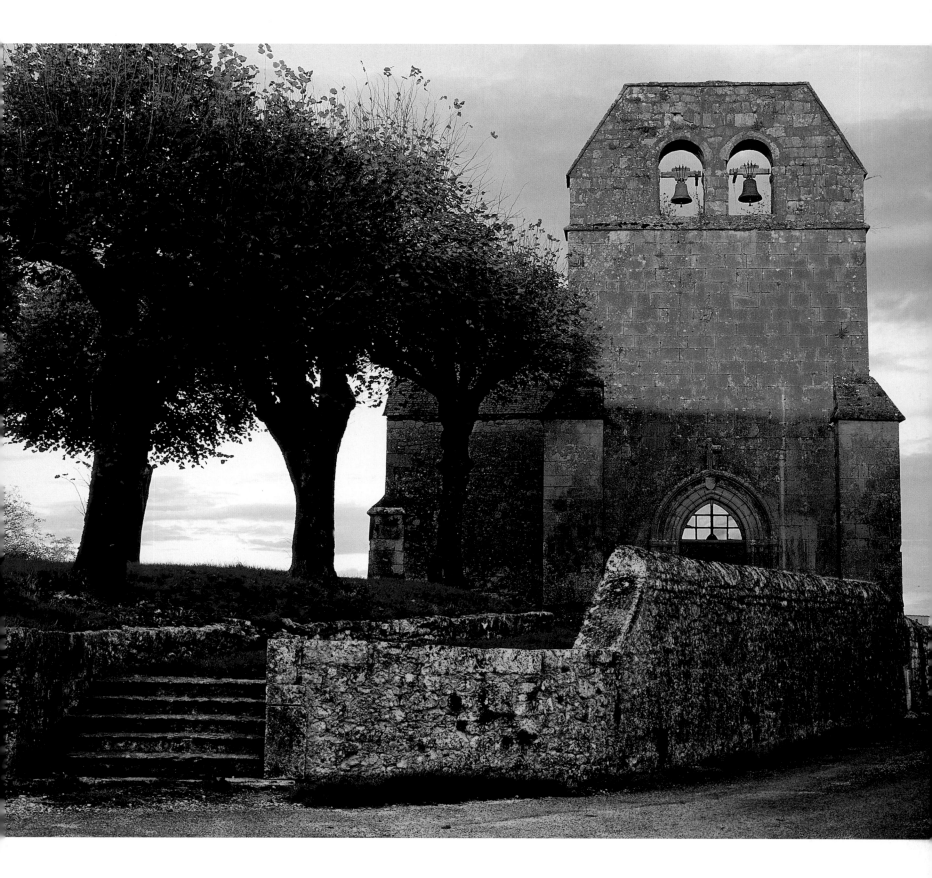

*A*heraldic beast guards this
house in Eyvigues (opposite);
another of the characteristic wall-belfries
of the Dordogne provides more than
adequate housing for the frugal two bells
of the village church (above).

Villefranche-du-Périgord

Anxious to defend the the frontier between the Périgord and the provinces of Quercy and Guyenne, Alphonse de Poitiers, brother of the French king Saint Louis, commissioned the seneschal of Agenais, Guillaume de Bagnols, to found a *bastide* here in 1261. Villefranche-du-Périgord is thus the oldest *bastide* in the Périgord. It developed into one of the finest after passing into the hands of Edward II of England in 1287. Fought over for centuries by the English and the French and then besieged by both Protestants and Catholics during the Wars of Religion, its peaceful aspect today belies its savage history – a history typical of every Périgourdin *bastide*.

Overlooking the river Lémance, Villefranche-du-Périgord is sited in a great forest of oaks, pines, walnuts and chestnuts which covers some 10,000 hectares of the Périgord and the Quercy. Its Place du Marché is a classic *bastide* market square, with a fret-work of beams, supported on powerful stone pillars, upholding the roof of its market-hall. Under the shade of the hall you can still see the ancient measures for grain and other produce: One side of the square is arcaded. Nearby is the fountain which served the *bastide* from its foundation.

The nineteenth-century church has a bizarrely Spanish-style façade. A more interesting building was once the home of the White Penitents (a religious order catering for humble folk, as opposed to that of the Blue Penitents, catering for the nobility), with a Latin inscription over the lintel declaring, 'If God be for us, who can be against us.'

Villefranche-du-Périgord has retained the grid-pattern of streets favoured by *bastides*, some of them lined by ancient half-timbered houses. Other houses have little towers – a sign of past prosperity. Among the old towers of the village, the name of the Tower of the Consuls is a reminder of the former governors of the *bastide*. A census made for the Black Prince in 1365 revealed some 1800 inhabitants, more than twice as many as live here today.

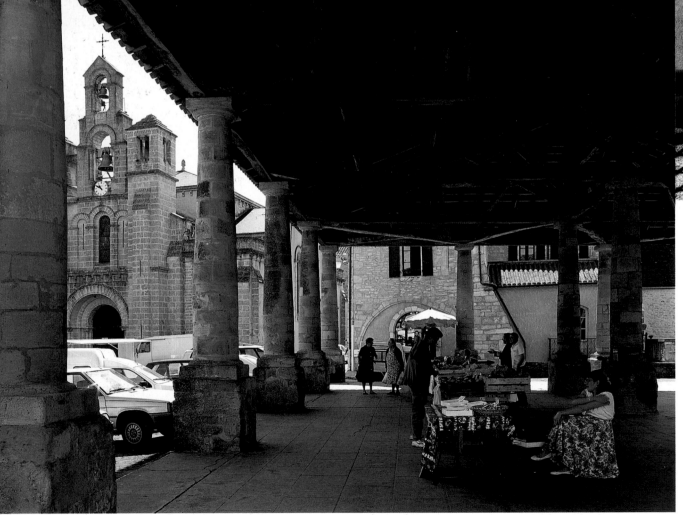

Like other Dordogne bastides, Villefranche is the possessor of a particularly fine market-hall (left), here sheltering the foreground to the quaint nineteenth-century church.

Homely details (top and above) abound in this strikingly well-kept village, a model of order typified by the figure of a satisfied customer making her way home from market (opposite).

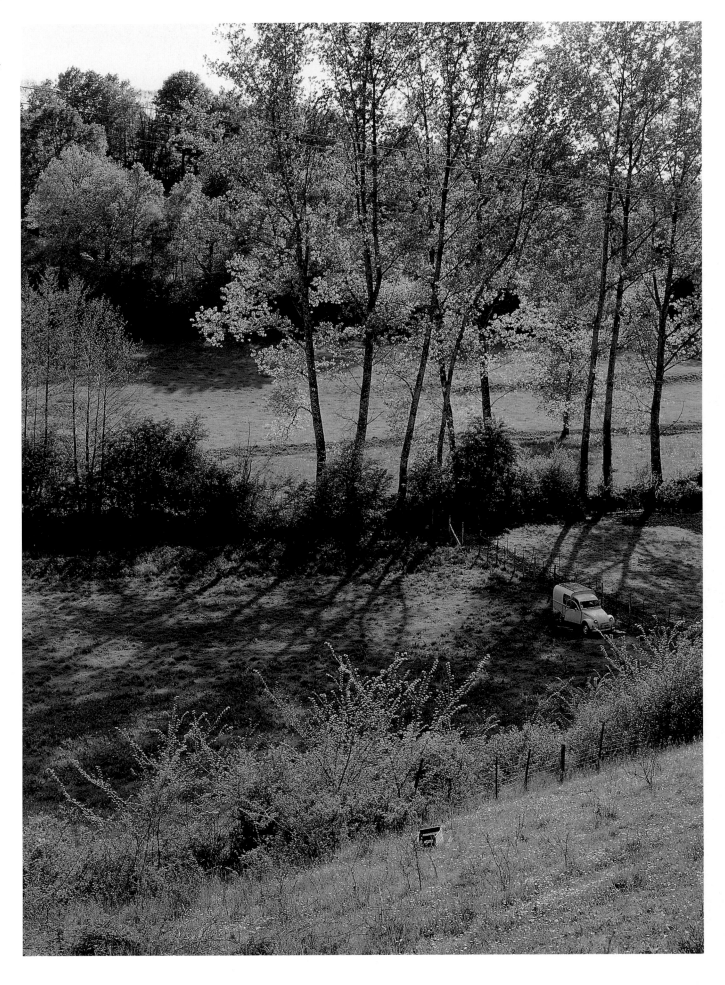

*O*pportunity for relaxation after hard work in the potager (right *and* opposite); the mixture of natural growth and cultivation characterizes the surrounds of many a Périgourdin village.

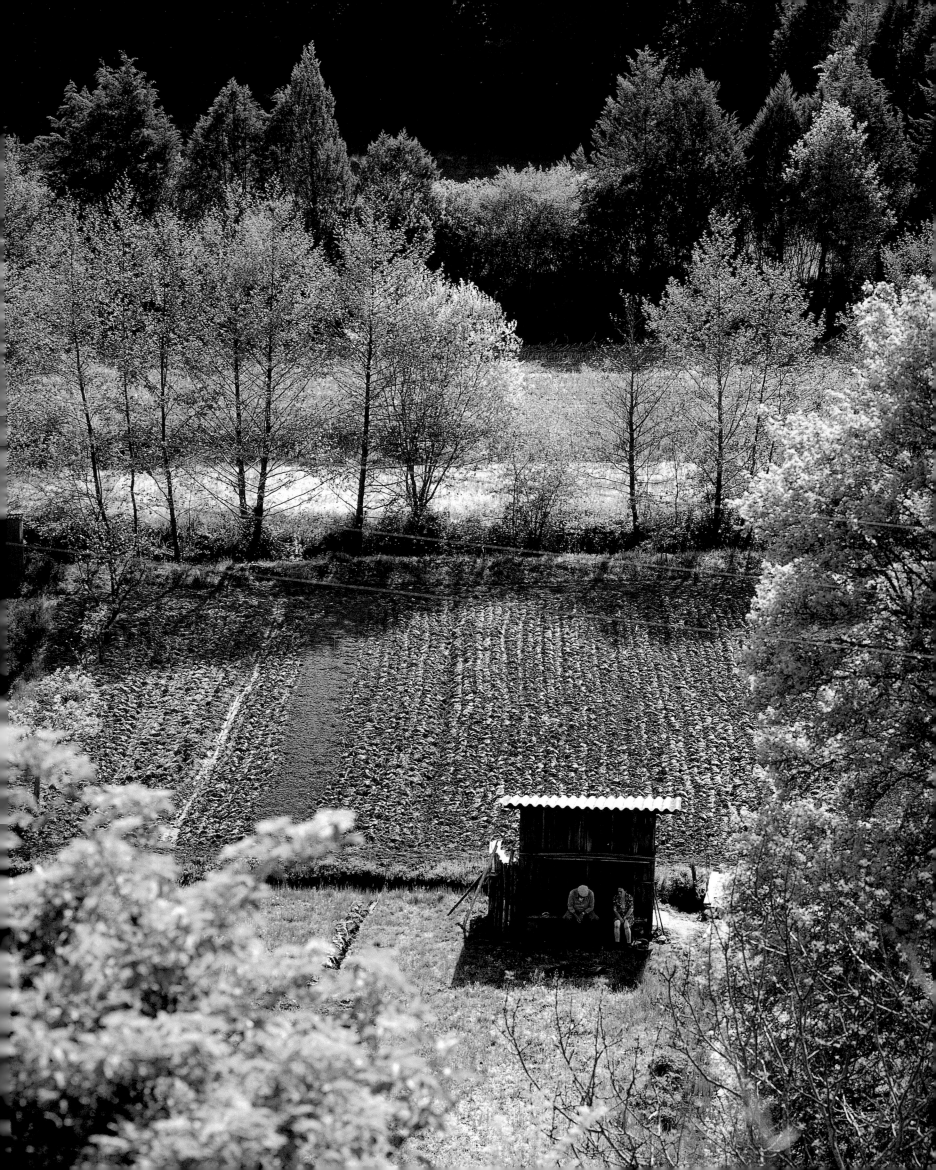

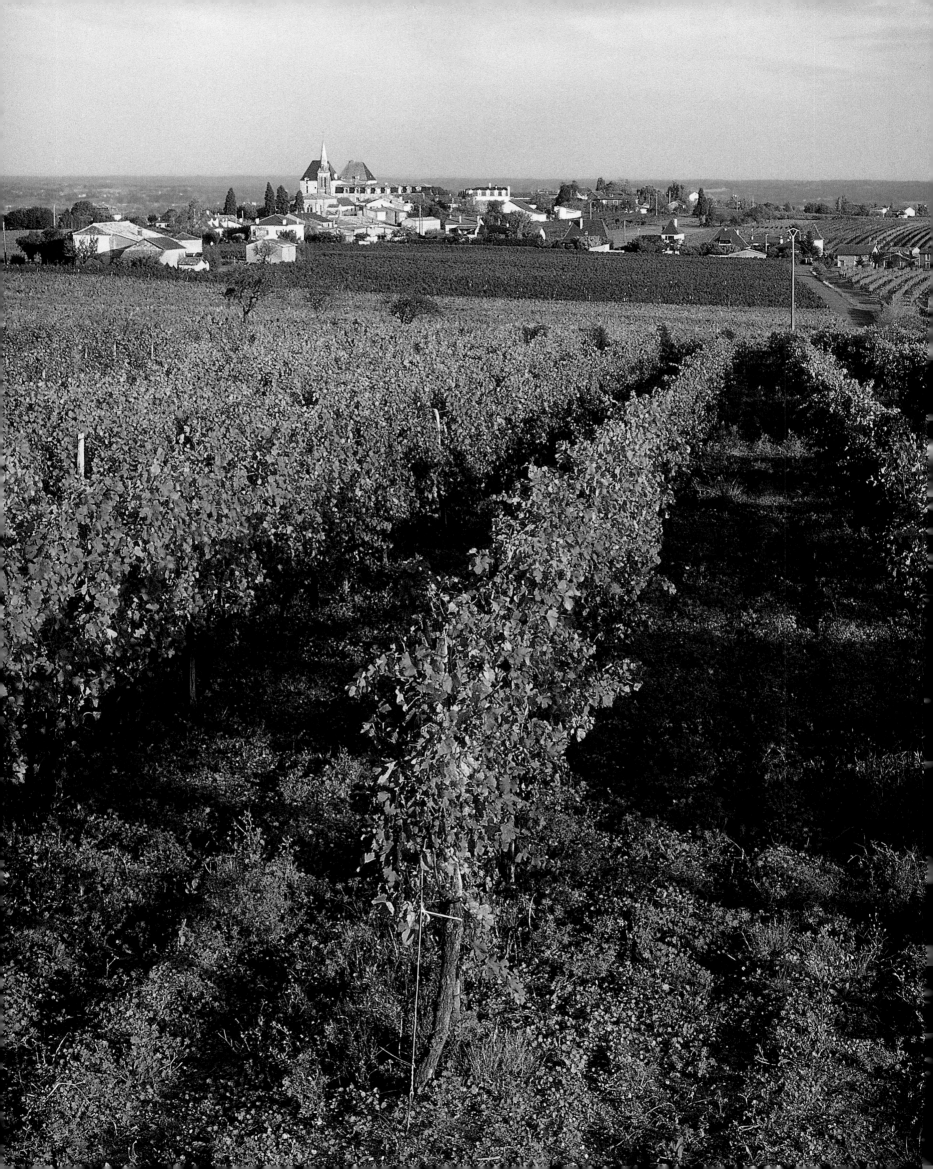

The Périgord Pourpre

Beaumont-du-Périgord

Eymet ∘ Issigeac ∘ Lanquais

Saint-Michel-de-Montaigne

Trémolat

Its name created only recently, the Périgord Pourpre (which has surreptitiously attempted to claim some of the finest towns and villages of the Périgord Noir) designates the thirteen cantons of the south-west of the *département* of the Dordogne, a region of substantial vineyards and medieval fortified towns.

'Pourpre' derives from the deep purple of much of the wine produced around the capital of the Périgord Pourpre, Bergerac. But superb white wines are also produced in this region, some of them sweet as alcoholic honey. On either side of the river here vineyards cover 36,000 hectares. Those wines denominated 'Bergerac' can be red, white or rosé. The whites are both dry and *moelleux*.

Undoubtedly the greatest red wine of the region is Pécharmant, made from grapes grown north of the river Dordogne on some 170 hectares of the land west of Bergerac. Its principal grape is Cabernet-Sauvignon, to which the *vignerons* add Cabernet-Franc and Merlot grapes, as well as a quantity of the red Malbec grape. Robustly full-bodied, Pécharmant can be laid down for up to seven years or more and magnificently complements game and red meats.

Monbazillac is the rich, sweet white, created from grapes grown on some 2,700 hectares of land south of the river Dordogne around Château Monbazillac. Built in 1550, the château with its pepperpot towers, dormers, turrets and machicolations is worthy of the wine. Its outhouses are reserved for visitors who wish to taste and buy. The château also displays local crafts, as well as housing a Protestant museum, for this region was longtime staunchly Huguenot.

Many other wine-producing *caves coopératives* welcome visitors, especially if they telephone in advance. West of the Pécharmant vineyards are those producing the straw-coloured Rosette, while south of the river grow the vines which produce the sweet and *liquoreux* wines bearing the *appellation* of the perched village of Saussignac, whose château has magnificently vaulted cellars.

The Périgord Pourpre offers, however, much more than these delicious wines. Among the almost perfectly preserved fortified *bastides* here are Eymet, Beaumont-du-Périgord and Villefranche-de-Lonchat. Sigoulès, a picturesquely perched village whose *cave coopérative* is the second largest in Aquitaine and sells wine to over a dozen countries, has developed a leisure centre offering clay pigeon shoots, horse riding and tennis. And Trémolat, where the river Dordogne makes one of its astounding loops, has one of the most impressively fortified churches of the whole *département*.

Further down the river towards Bergerac, you can see from the pattern of its streets that Lalinde was once a *bastide*; its western gateway is still known as the Porte Romane because it was built out of stones which the Romans had quarried. Further downstream the village of Saint-Capraise-de-Lalinde once was an important staging post for the boats that brought produce as far as Bergerac and Bordeaux.

Rural architecture in this part of the Périgord is also distinctively beguiling. Issigeac, for example, which the Bishops of Sarlat made into a holiday village for themselves, boasts half-timbered houses overhanging winding streets. And in the minuscule village of Saint-Michel-de-Montaigne, amongst the Montravel vineyards of the Périgord Pourpre, that most humane sixteenth-century essayist, Michel de Montaigne, lived and wrote in his château, deploring the follies of his era, which had set Catholics and Protestants at each others' throats during the Wars of Religion. Montaigne kept Montravel wines in his cellar, observing that, 'With this wine the good God gave gaiety to mankind and youth back to old men.'

Preceding pages
Part of the vast vineyards around Saussignac, where both sweet whites and full-bodied reds are produced. Rabelais celebrated this area for its wine, whose colour and robustness are referred to in the region's name.

An autumnal scene in the vineyards south of Issigeac (opposite); this area of wine production was considered so attractive by the medieval bishops of Sarlat that they established their summer residence there.

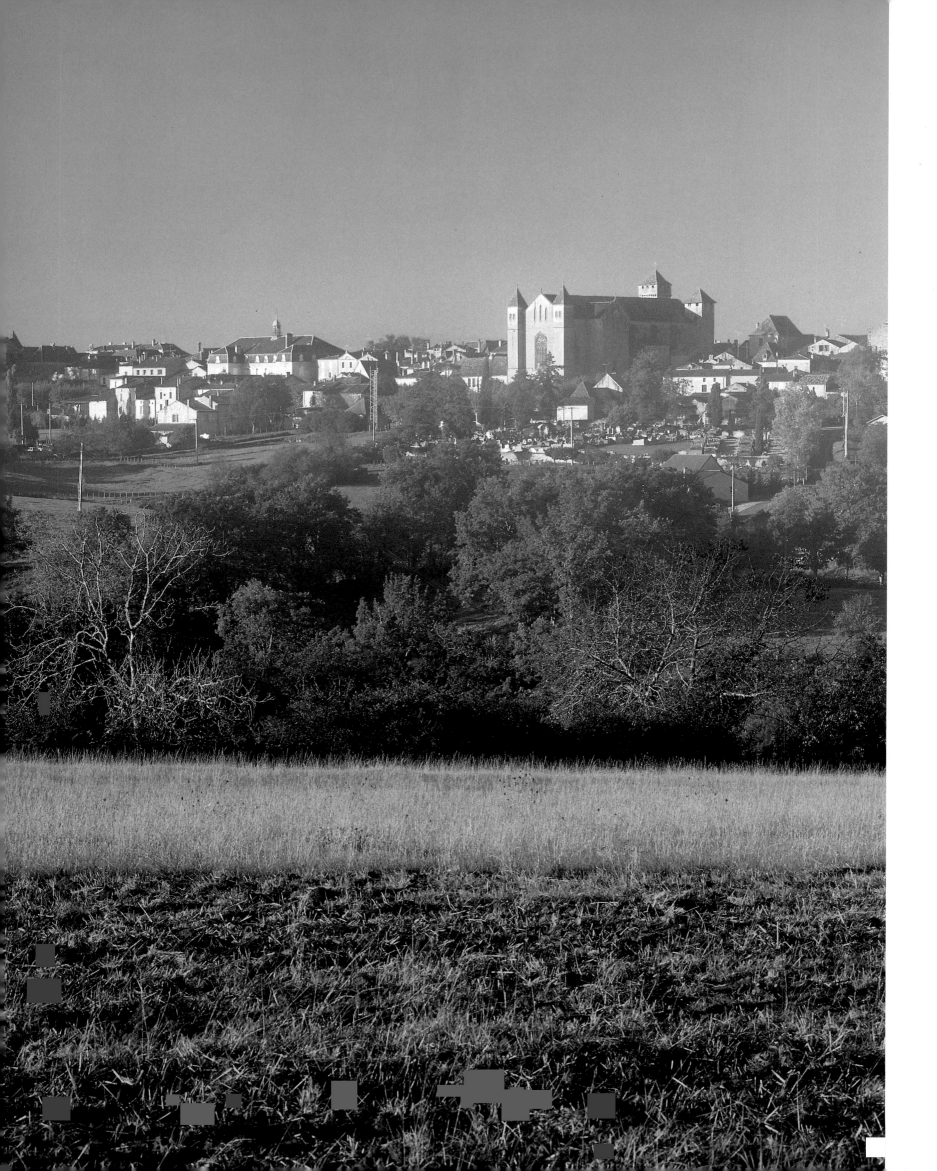

Viewed from the surrounding countryside, Beaumont is entirely dominated by the fortified thirteenth- and fourteenth-century church of Saint-Front (opposite) whose solid form suggests secular rather than ecclesiastical power. Its detailing, however (right and right below), does reveal that its purpose was not entirely defensive.

Beaumont-du-Périgord

When in 1272 Edward I of England ordered his seneschal of Guyenne, Lucas de Thanay, to build the *bastide* of Beaumont-du-Périgord, the king charged him to lay it out not in the usual square pattern but in the form of an H, in memory of his father Henry III. The customary pattern of right-angled streets and a central market square was followed, but the square was remodelled in the eighteenth century and today has three sides. Though the market-hall was demolished in 1864, some of the old arcades still retain their charm. As you wander its streets you meet houses dating from the thirteenth, fourteenth and fifteenth centuries, while the old people's home was built in the eighteenth century as the Convent of the Dames-de-la-Foy.

As its name suggests, Beaumont-du-Périgord is built on a defensive hill. In the past the *bastide* was surrounded by double ramparts pierced by six defensive gates. Today remnants of the ramparts survive, and one of the gates, the massive Porte Luzier, where you can still see the grooves of its former portcullis. Invaders who breached this first defence had next to force their way along a narrow passageway to a second fortification.

Most impressive of all is the church of Saint-Front, as much a fortress as a house of God and one of the finest Gothic military churches in the Périgord. Its four powerful towers resemble keeps rather than belfries, in particular the south tower with its machicolations. Apart from the choir with its great window, the interior is sombre, even harsh, as befits what might have been the last resort of beleaguered citizens. The brick ogival arches are modern.

The sole, but entrancing concession to architectural playfulness is the west end of the church. Its entrance is sheltered by a pointed arch, chiselled with five half-pillars. Above it is a Gothic balcony and a frieze, depicting a siren, a stag hunt, the four Evangelists and the head of a king – which could be that of Edward I or of his father, Henry III.

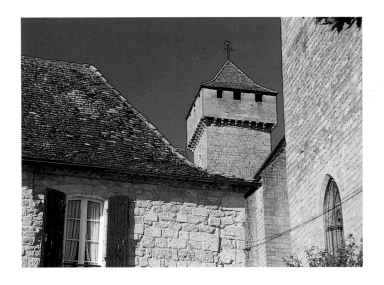

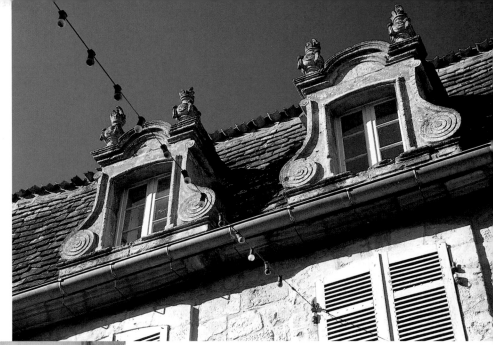

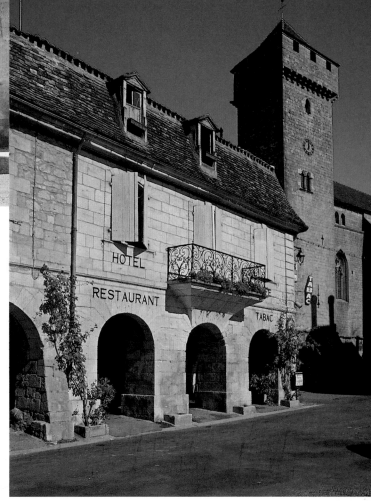

*C*limbing the steeply rising way
from the outside fortifications of
Beaumont-du-Périgord, visitors to the
bastide *face the once-redoubtable Porte
de Luzier* (opposite).

*T*he central square of the bastide
follows the classic pattern of arches
and capacious arcades *(above* and right)*;
fanciful dormer windows in the Rue
Rameau lend a lighter architectural touch
(top right), *although it is hard to find any
view which does not include at least some
evidence of fortification* (top left).

Eymet

In 1256, at the south-western tip of the Périgord in the fertile valley of the river Dropt, Alphonse de Poitiers founded the *bastide* of Eymet around a Benedictine priory. Four years later he granted those who were willing to live here a charter of rights and privileges. The main Place des Arcades, which centres on a fountain monumentally embellished in 1830, is surrounded by noble, white-stone houses carried on pointed arches, and half-timbered houses carried on sturdy wooden pillars. Rue de l'Engin, which leads off the Place des Arcades, celebrates a formidable catapult, an 'engine' capable of throwing stones weighing 150 kilogrammes, which the French in 1377 deployed against the English occupiers of Eymet, who fled in fear, many of them drowning as they tried to ford the Dropt.

In spite of its twisting site, the village has preserved its ancient chequerboard plan, and many of Eymet's houses – either wattle and daub or built of stone – date from the fifteenth and sixteenth centuries. Little streets run off wider ones, with overhead dwellings supported on beams joining the houses on either side. At the north-west corner of the village are the ruins of its former medieval château, the thick walls of its keep dating from the fourteenth century. Three storeys high, the keep has retained intact its turret and gargoyles. In the two lower storeys latrines, chimneys and cupboards set in the walls indicate that this was a home as well as a form of defence.

The successor to the priory chapel at Eymet is the fourteenth-century parish church. Eymet is famous for its conserves, its plums and also its wine. Proximity to the Huguenot stronghold of Bergerac meant that the *bastide* was longtime Protestant. As late as 1659, when the Catholics had raised a crucifix in the Place des Arcades, Eymet's Protestants tore it down, and then parodied a Catholic procession with a pitchfork to represent the cross and a donkey to represent the parish priest.

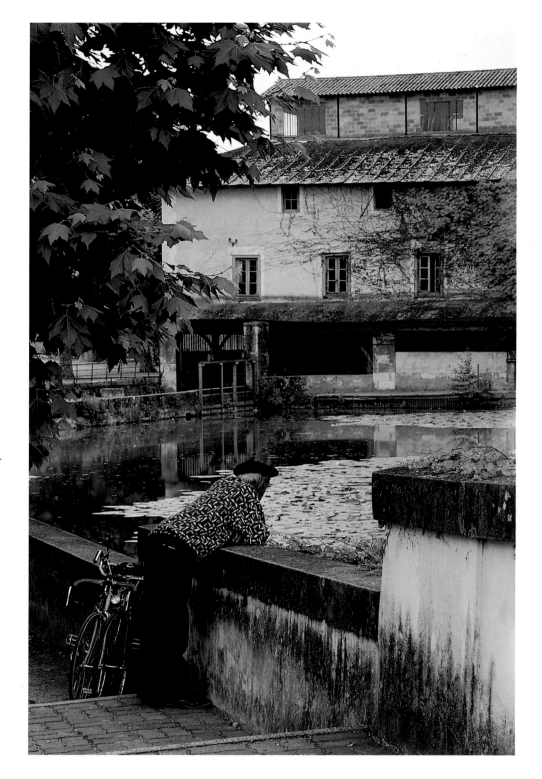

A moment of contemplation is inspired by the waters of the river Dropt which flows through the centre of the village (above).

A tower guards the flank of an Eymet manor house in classic Périgourdin style (opposite).

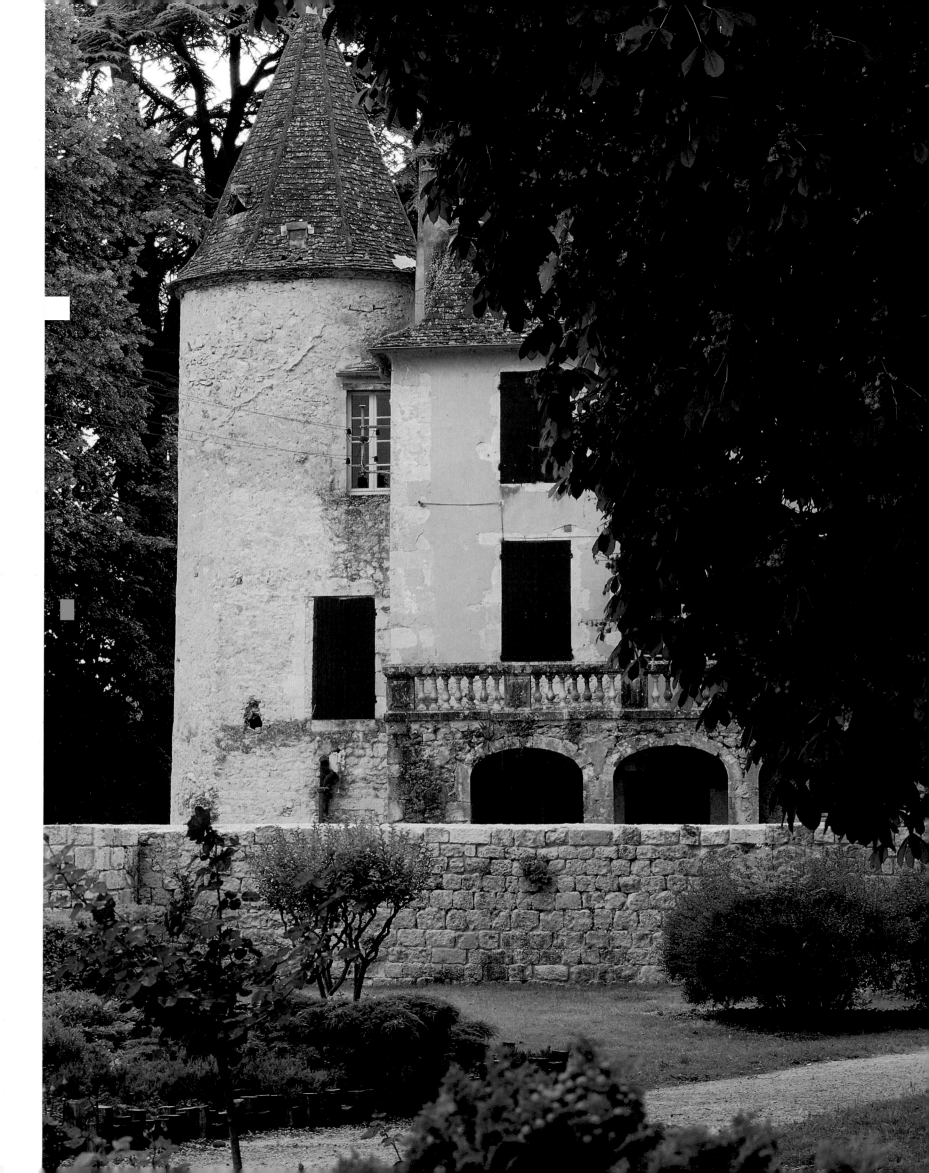

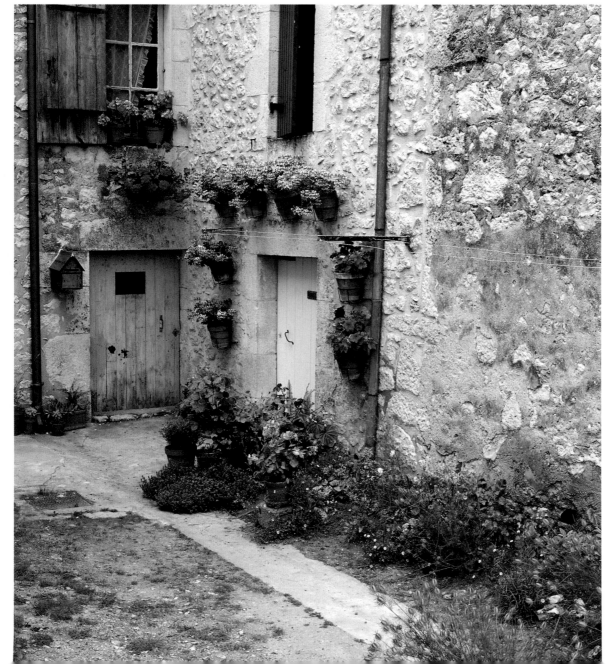

Still retaining its ancient plan, the village of Eymet boasts many houses dating from the fifteenth and sixteenth centuries (opposite). *The crumbling of the traditional materials creates fascinating effects of surface in hidden corners* (left), *while unexpected tableaux* (above) *speak of a leisurely pace of life.*

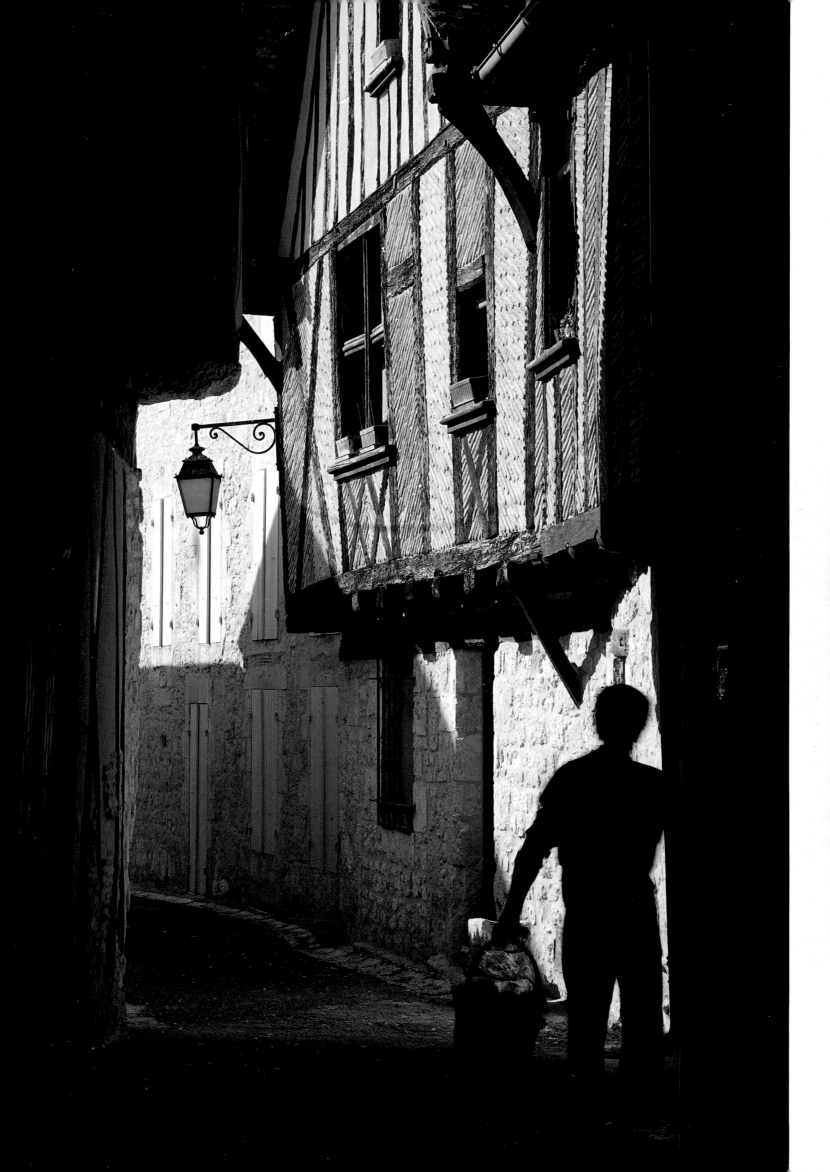

Issigeac

After Archbishop Bertrand de Got of Bordeaux, the future Pope Clement V, had visited Issigeac in 1304, he decided that its priory should be placed under the jurisdiction of the abbey of Sarlat. After the abbots of Sarlat were elevated to the rank of bishop, small wonder that they made this almost-too-good-to-be-true village one of their summer residences. The site alone, by the river Banège, is adorable, with the vineyards of Bergerac to the north. And the bishops were not slow to enhance the attractions of their acquisition.

Issigeac was fortified in the Middle Ages with high ramparts, and some thirteenth-century fragments remain intact. Between 1495 and 1527 Bishop Armand de Gontat-Biron of Sarlat reconstructed the parish church in the Late Gothic style. Rising above the entrance, its sturdily buttressed belfry begins at its base as a square tower and ends as an octagonal one. The four bays of the nave have ogival vaulting springing from columns whose capitals are sculpted with armorials and inscriptions. Inside are seventeenth-century furnishings and statues.

Further evidence of the beneficence of the bishops of Sarlat is the summer palace built by Bishop François de Salignac in 1669 on the base of a former fortress. Stone and brick, this elegant lodging is flanked by a couple of encorbelled, turreted pavilions. A couple of massive, angled pavilions also rise on either side of the sixteenth- and seventeenth-century *prévôté* with its unusual slate roof.

Issigeac's narrow, winding streets reveal overhanging half-timbered and cob houses alongside sculpted Gothic houses (such as the fourteenth-century 'house of the heads'), some of them roofed in stone *lauzes*, others in warm tiles. The local *syndicat d'initiative* has housed itself in the former haughty tithe house.

Effects of light and shade, wood and stone make Issigeac a place of entrancing nooks and crannies: an overhanging, half-timbered upper storey in a side street off the Grand'Rue (opposite); a cluster of houses by the church (below left); and a house with stone arcades below and half-timbering above in the Rue Sauveterre (below).

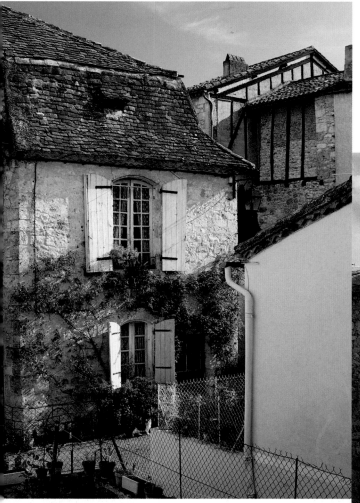

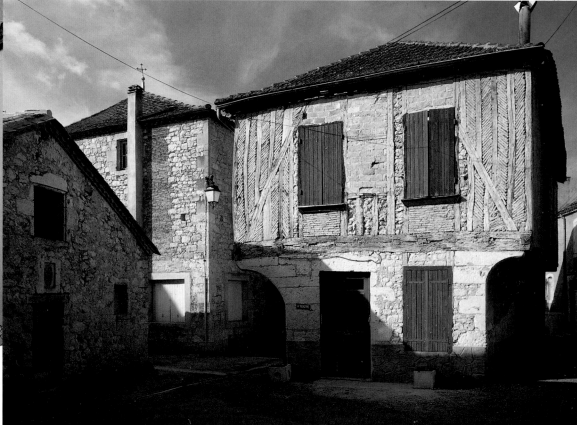

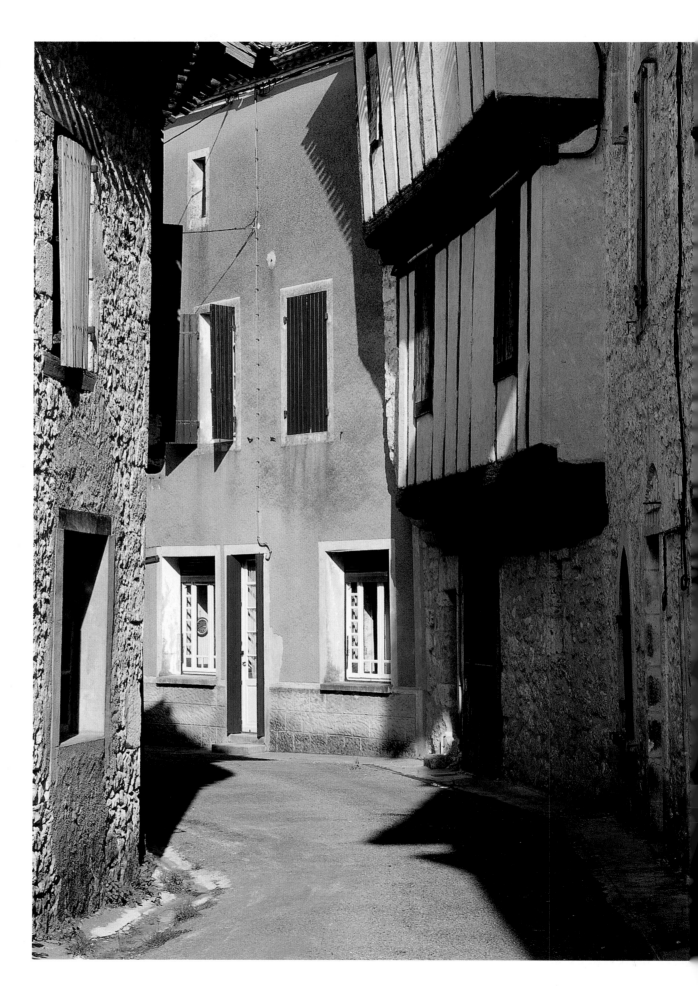

*I*ssigeac provides many shady
 spots and winding lanes like the
*Rue du Cardinal, lined with
charming houses* (right).

*I*ssigeac's well-appointed Gothic
 church (opposite), *with its
octagonal belfry, is graced with
seventeenth-century statues and
woodwork.*

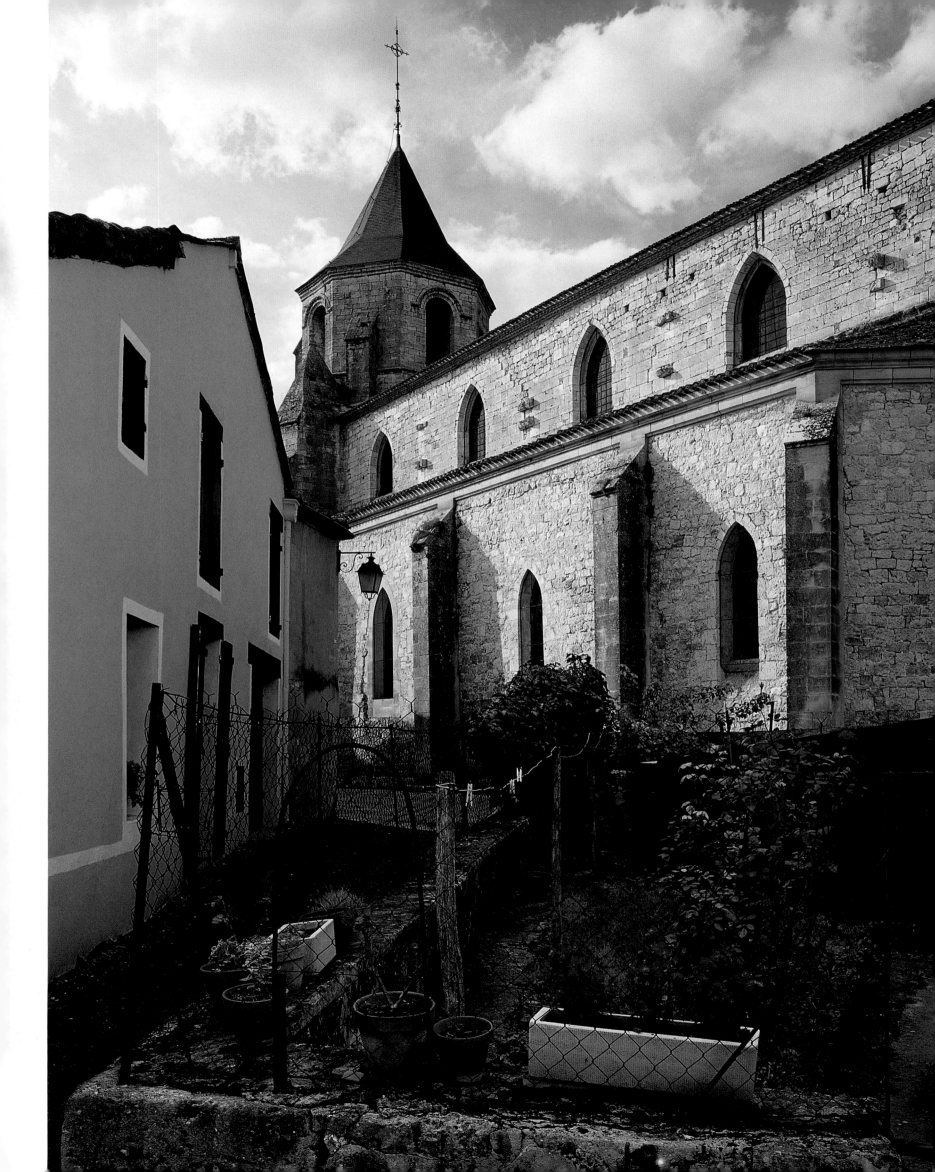

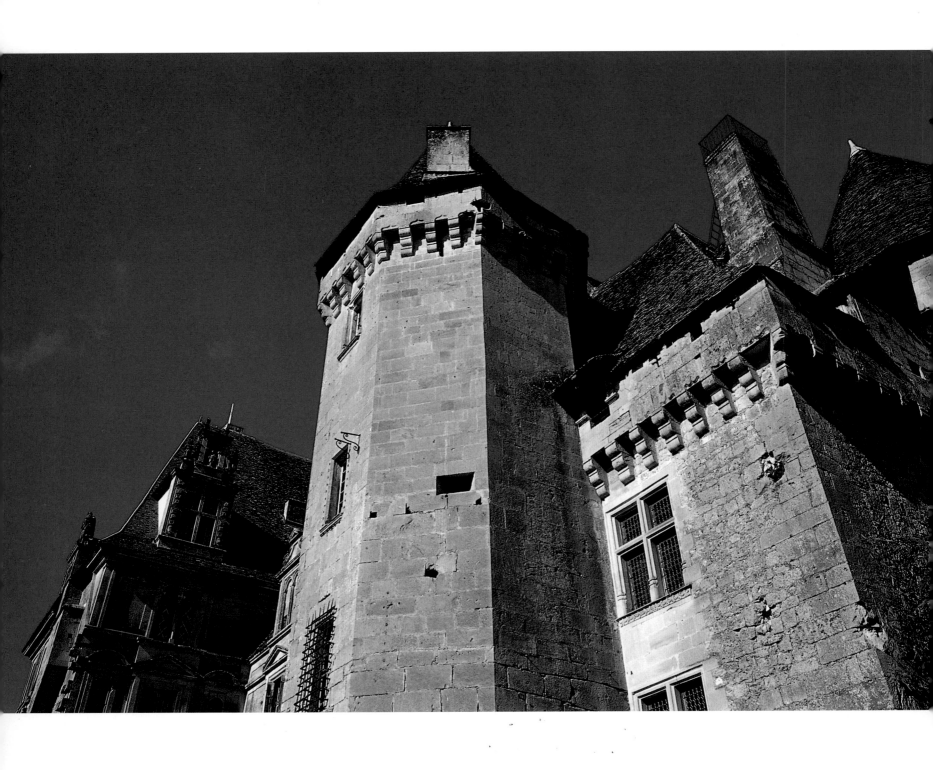

Lanquais

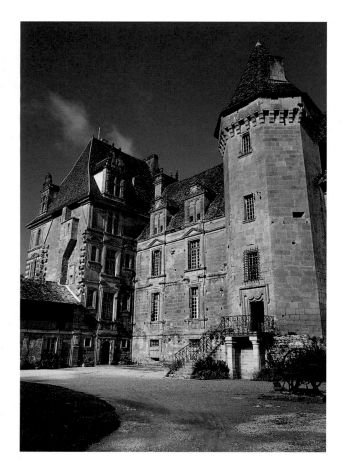

The château dominating the tiny village of Lanquais and the valley of the river Couzeau is a magical contradiction of styles: a defensive fifteenth-century fortress soldered on to a Renaissance palace. The first, slightly sinister part is defended by a powerful machicolated round tower with a pepperpot cap and, on the south wall, also machicolated, by a polygonal staircase tower.

Towards 1570 Galliot de la Tour d'Auvergne decided to replace the old fortress with a Renaissance palace and evidently did not manage to pursue his plan to the final destruction of the old. His model was the Louvre, recently rebuilt by Pierre Lescot, and his architecture a political gesture to show that he sided with the Catholic Valois royal house against the Protestants of the Périgord. The symbolism was not lost on his religious enemies, and the walls of the château at Lanquais still bear traces of the bullets of the Protestants who besieged it in 1577.

Surviving the siege, his château is one of the most elaborate in the Périgord. Triangular pediments on the lower windows are replaced by Italianate on the upper. Massive, sculpted dormer windows top the ensemble, while the gables are carved with magnificent medallions. Even the stone chimneys are elaborately sculpted. Equally sumptuous is the interior, notable above all for its monumental, yet elegant chimneys and its beautiful ceilings. Louis Treize furniture adds allure to the rooms.

Medieval houses, excellently preserved, grace the village, along with an old market-hall, and at the foot of the château is an enormous medieval tithe barn, now used for concerts and exhibitions. A seventeenth-century cross stands next to the restored Romanesque church of Lanquais, with its dome and its wall-belfry.

*O*ne of the most architecturally
complex in the whole of the
*Périgord, the château at Lanquais
dominates its village* (opposite).

*B*egun in the fifteenth century,
the château mixes defensive
*features with the gentler detailing of
a residential Renaissance palace*
(above *and* below right).

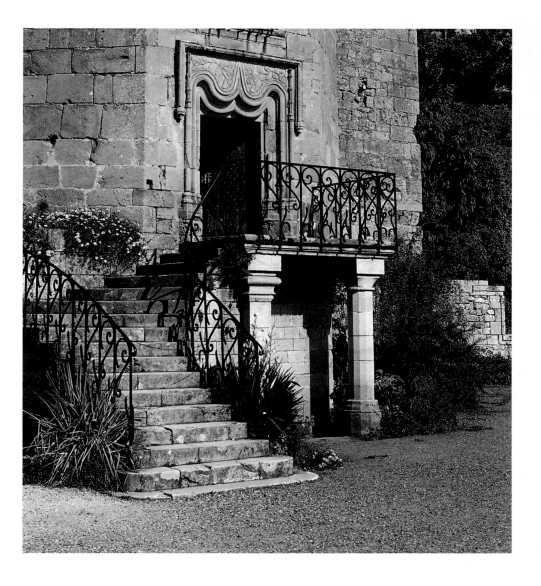

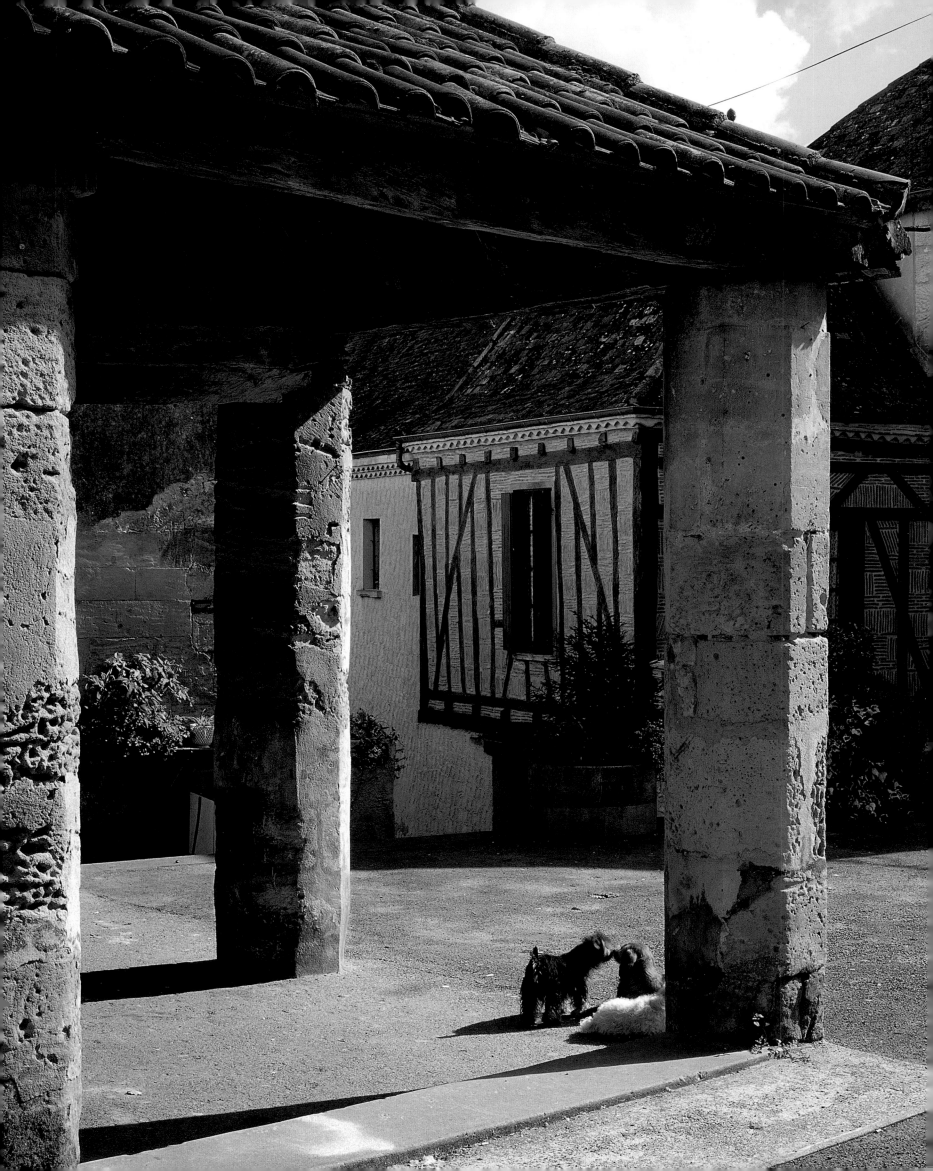

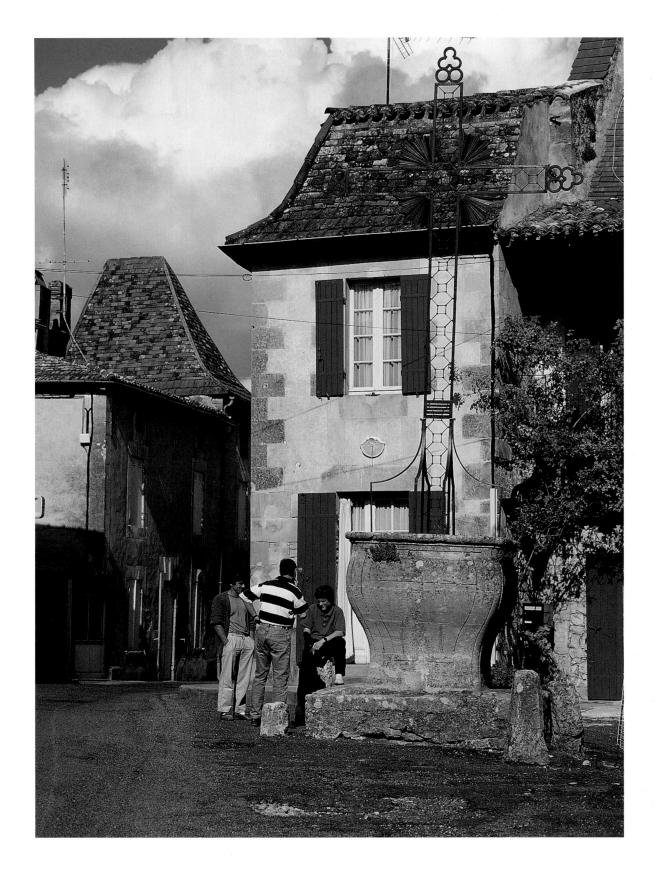

*Q*uiet corners for meetings and conversation in Lanquais: beneath a corner of the market-hall (opposite); *the well-head of the village, a convenient venue for the human inhabitants* (right).

Saint-Michel-de-Montaigne

Surrounded by vineyards whose grapes produce a sweet white wine, Saint-Michel-de-Montaigne once boasted a château in which in 1533 was born the sceptical, liberal Catholic humanist Michel Eyquem de Montaigne. In 1884 a fire destroyed the château and the present one is a nineteenth-century Neoclassical building. Remarkably, the flames spared the tower, with its chapel and library where, after he retired from public life, Montaigne wrote his famous *Essays*. This sage man who hated the religious intolerance of his day, began them in 1572, the year of the Massacre of St. Bartholomew's Day, when he was thirty-nine. Though elected mayor of Bordeaux (in his absence) for an unusual term of two years, he found his peace here, dying in his château in 1592.

A visit to his tower, which is flanked by two small rectangular wings, reveals first the chapel, connected to the next storey, which Montaigne used as a living room, and then to his circular library. Here he had, 'at his fingertips', as he wrote, all his books, arranged on five tiers of shelves. The books are gone, but what remain are the texts he himself inscribed in Latin and Greek on the beams of the library, texts deflating human vanity and taken from Ecclesiastes, the letters of St. Paul, the pagan stoics, epicureans and sceptics – the inspiration of the *Essays*.

Montaigne's heart, as well as several of those of his family, is buried in the Romanesque church of the minuscule village. Its lovely graved porch has eight colonettes. Note also a Templars' cross engraved at the entrance. Dedicated to St. Michael, the church was enlarged in the sixteenth and eighteenth centuries, gaining in the process some ogival vaulting. Masks and foliage are sculpted on its capitals. The pulpit, reredos, confessional and font all date from the Grand Siècle. And in the twentieth century the church was further enriched by a representation of the Way of the Cross by Gilbert Privat.

Montaigne's study window affords us this glimpse of the rebuilt château of Saint-Michel-de-Montaigne (above).

Autumn cyclamen provides a colourful carpet in the woods close by Saint-Michel-de-Montaigne (right).

The round tower (opposite), where Michel de Montaigne was at peace and wrote his celebrated Essays, *had a remarkable escape from fire in 1884, when the rest of the château was gutted.*

The ruins of the Château de Gourdon (overleaf) brood eerily over the landscape between Saint-Michel-de-Montaigne and Villefranche-de-Lonchat.

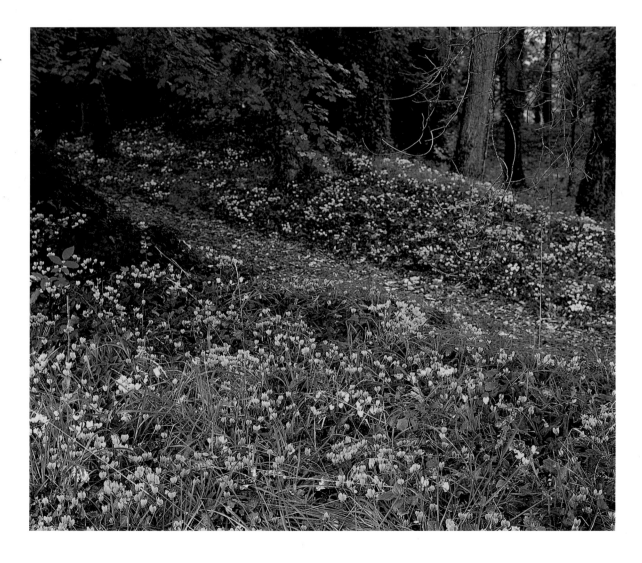

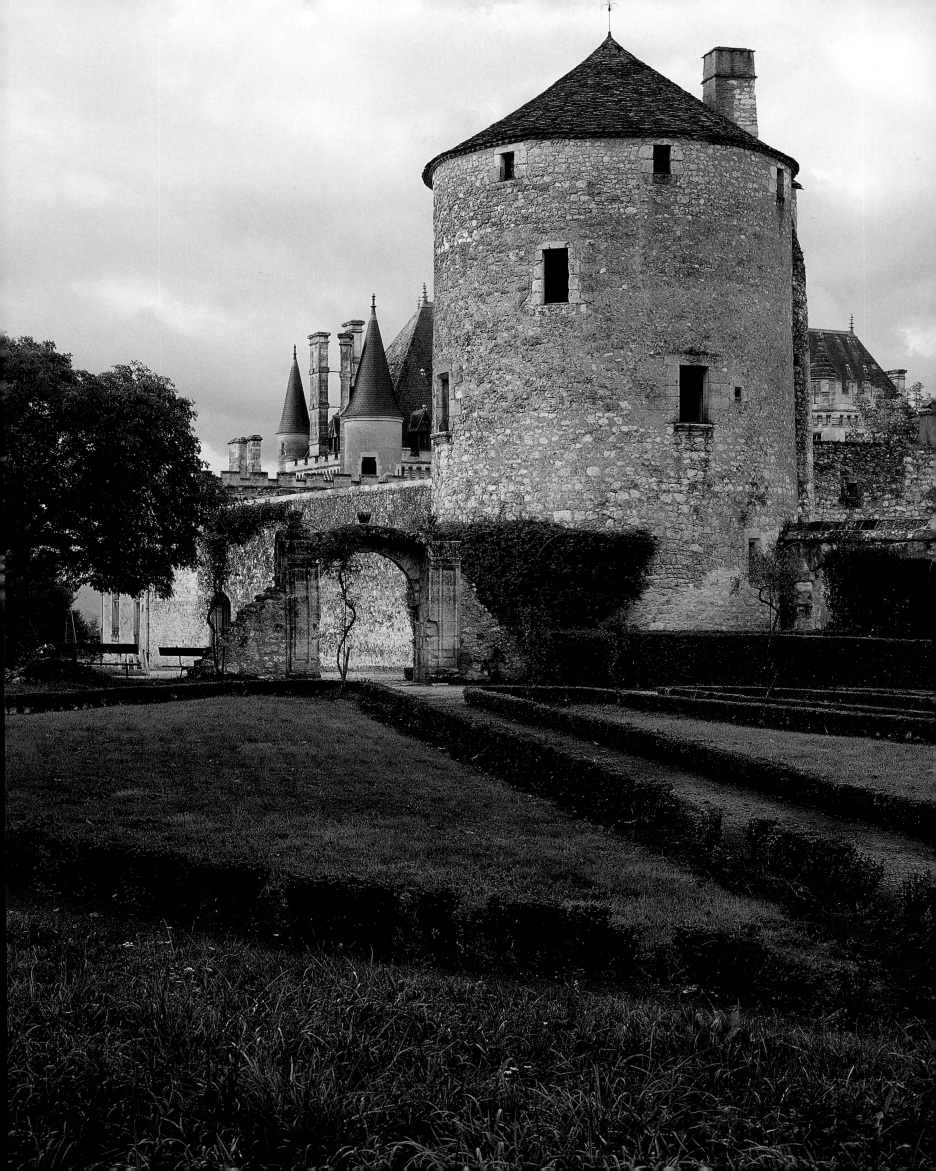

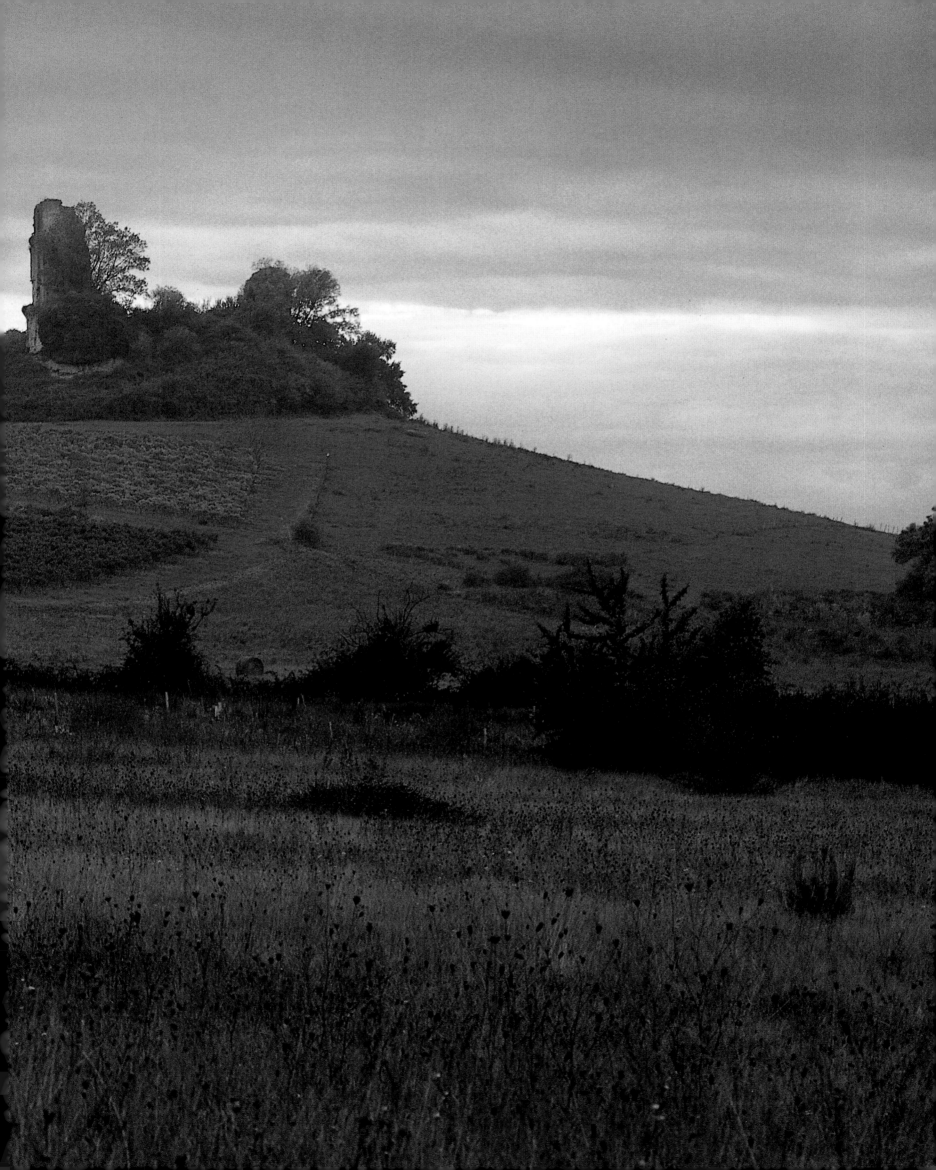

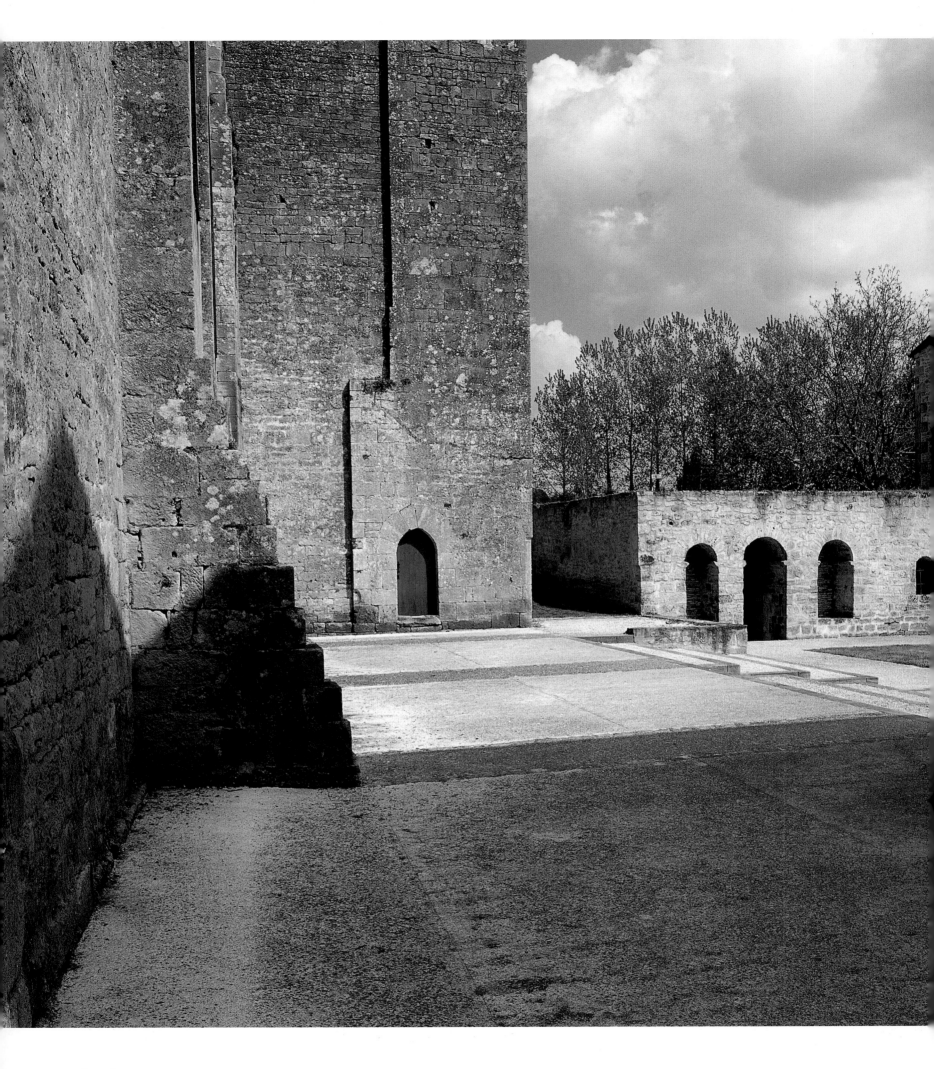

Trémolat

Trémolat rests above one of the two finest horseshoe curves (or *cingles*) of the river Dordogne, the other being at Montfort, and from the cliff the panorama across the river shows a patchwork quilt of beautifully cultivated fields, a view which André Maurois described as one of the wonders of the world. The village itself, which was once fortified, became famous as the birthplace of the sixth-century St. Cybard, around whose bones miracles were worked. His tomb was housed in a seventh-century church, and then Charlemagne commissioned a finer one and gave it what he considered was the shirt of the infant Jesus.

Today Trémolat's boundaries exactly conform to the domain of the parents of St. Cybard. The oldest houses in the village date from the twelfth century, and here are numerous noble sixteenth-, seventeenth- and eighteenth-century manor houses, some of them fortified. They cluster around one of the most extraordinary fortified churches of the Périgord, some of whose walls date back to the eleventh century. Virtually every element was designed for defence rather than worship. Scarcely a window pierces its walls. Instead, the church boasts loopholes for flinging débris on attackers. Even the belfry serves as a double-storeyed chamber of defence. And the walls are two metres thick and would not be out of place in a castle.

Later centuries humanized the church. In the seventeenth century a dignified porch was added to the belfry. In the fourteenth, part of the church was frescoed, and you can still make out the depiction of Jesus's entry into Jerusalem, of Judas betraying his master with a kiss and of the Last Supper, with (as at Beynac) St. Martial in attendance. Seventeenth-century additions include two Baroque reredoses and a painting of the Sacrifice of Isaac.

Don't miss the twelfth-century chapel of St. Hilaire, with its sculpted portal, in the exceptionally pretty village cemetery.

Trémolat is defended by a mighty twelfth-century church, seemingly built for military rather than ecclesiastical purposes, whose walls rise beside curious outbuildings (far left).

The Romanesque church of St. Hilaire, with its traditional wall-belfry, which stands in Trémolat's cemetery, was formerly also the village's parish church (left).

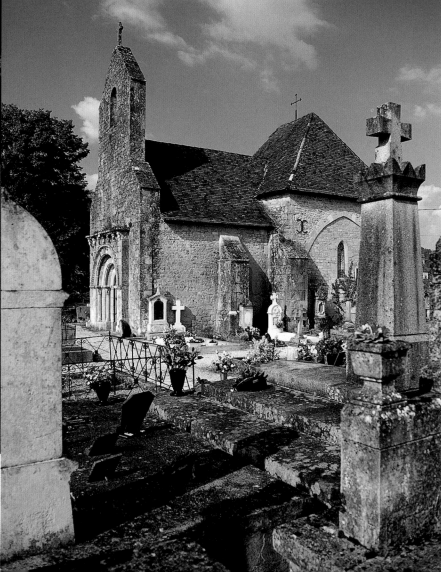

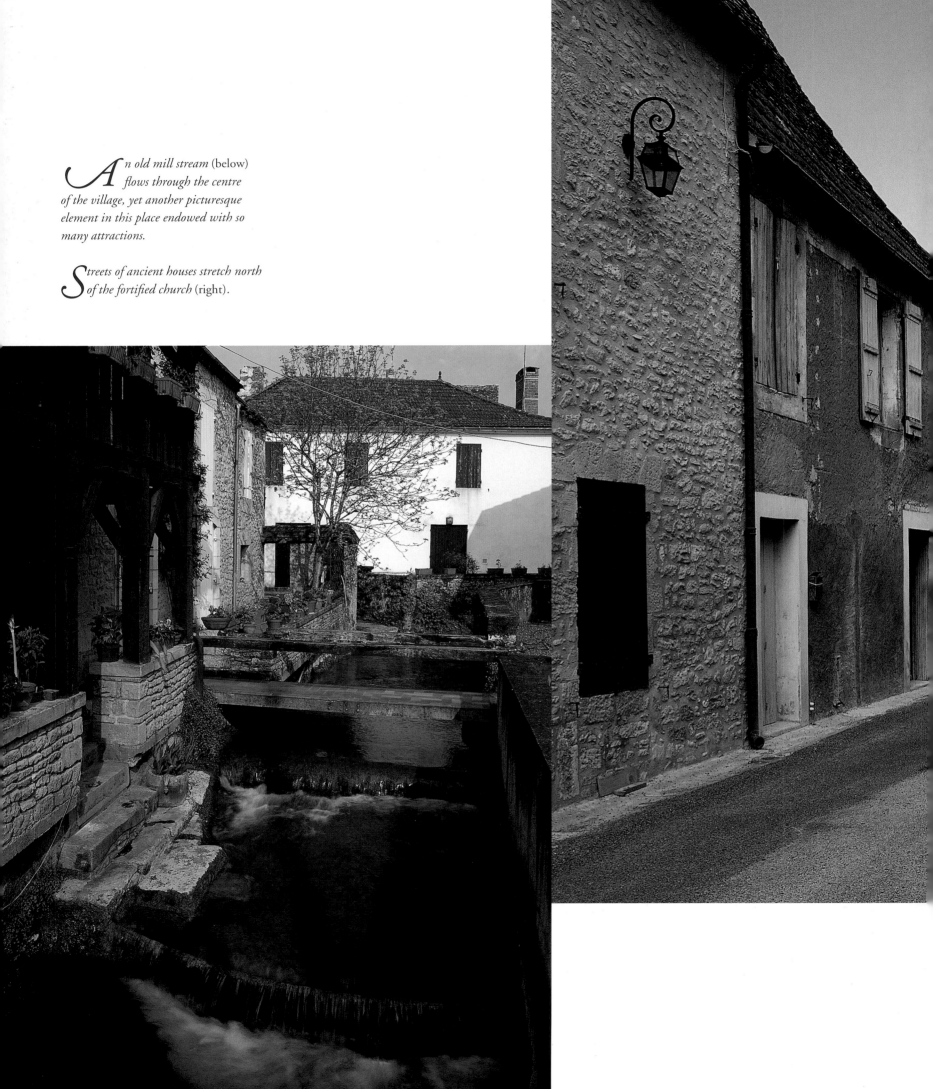

*A*n old mill stream (below)
flows through the centre
of the village, yet another picturesque
element in this place endowed with so
many attractions.

*S*treets of ancient houses stretch north
of the fortified church (right).

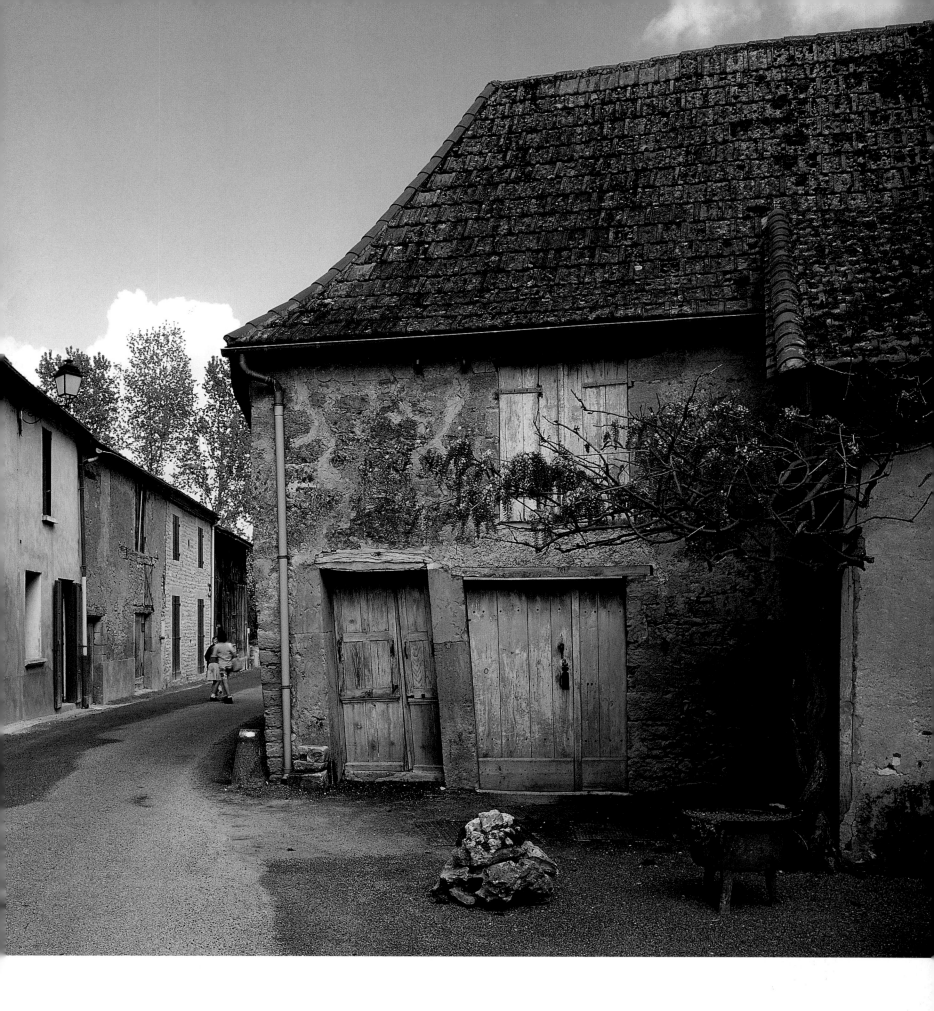

USEFUL
INFORMATION

MAP
HOTELS AND RESTAURANTS
MARKET DAYS AND FESTIVALS

LOCAL TOURIST AUTHORITIES
(see under individual villages for more detailed information)
Comité Départemental de Tourisme, 25, rue Président Wilson, 24000 Périgueux; tel. 53 53 44 35.
Office de Tourisme de Bergerac (and its region), 97, rue Neuve d'Argenson, 24100 Bergerac; tel. 53 57 03 11.
Camping Information Dordogne, Maison de la Boëtie, 24200 Sarlat-la-Canéda; tel. 53 31 28 01.

Preceding pages *The river Dordogne, here seen at dusk near the village of Lalinde, broadens as it swings west through the Périgord Pourpre.*

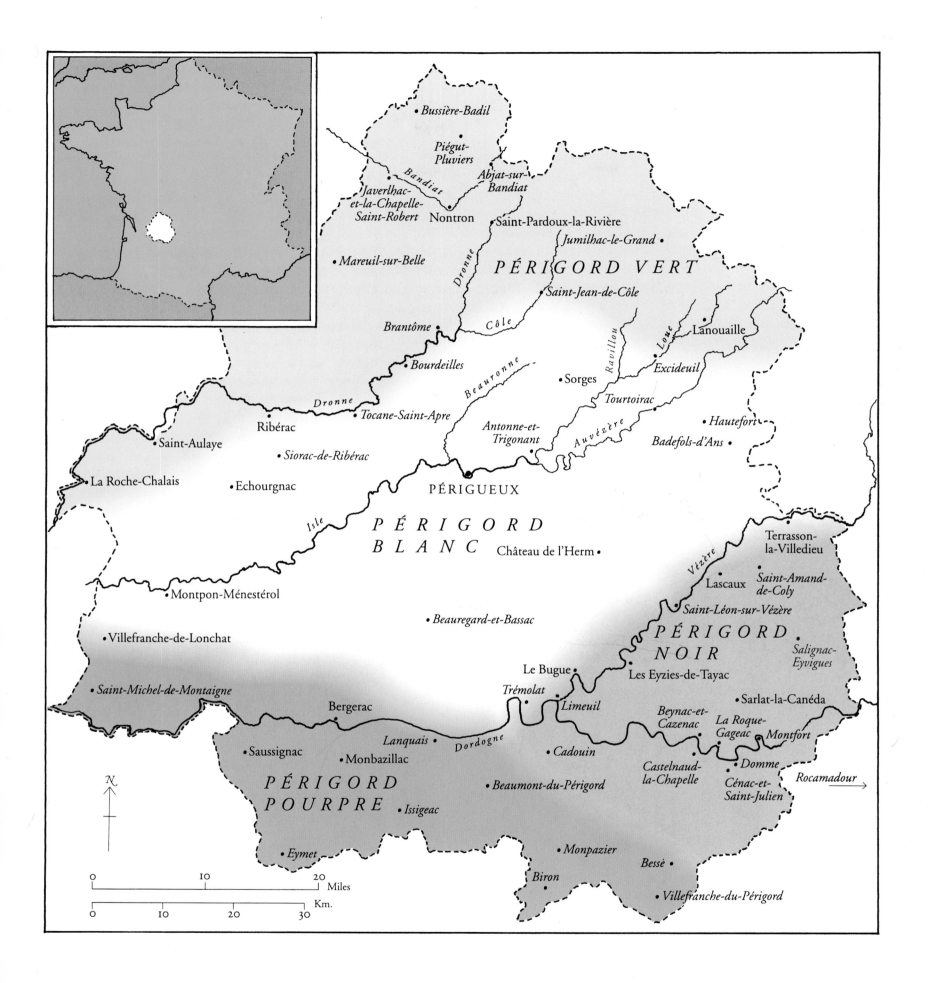

Bussière-Badil

Piégut-
Pluviers

Abjat-sur-
Bandiat

Bandiat

Javerlhac-
et-la-Chapelle-
Saint-Robert
Nontron

Saint-Pardoux-la-Rivière

Jumilhac-le-Grand

PÉRIGORD VERT

Mareuil-sur-Belle

Dronne

Saint-Jean-de-Côle

Côle

Ravillou

Loue

Lanouaille

Brantôme

Beauronne

Sorges

Tourtoirac

Excideuil

Bourdeilles

Dronne

Tocane-Saint-Apre

Ribérac

Antonne-et-
Trigonant

Auvézère

Hautefort

Badefols-d'Ans

Saint-Aulaye

Siorac-de-Ribérac

PÉRIGUEUX

La Roche-Chalais

Echourgnac

PÉRIGORD
BLANC

Château de l'Herm

Vézère

Terrasson-
la-Villedieu

Isle

Lascaux

*Saint-Amand-
de-Coly*

Montpon-Ménestérol

Saint-Léon-sur-Vézère

Beauregard-et-Bassac

PÉRIGORD
NOIR

*Salignac-
Eyvigues*

Villefranche-de-Lonchat

Le Bugue

Les Eyzies-de-Tayac

Saint-Michel-de-Montaigne

Trémolat

Limeuil

*Beynac-et-
Cazenac*

Sarlat-la-Canéda

La Roque-
Gageac
Montfort

Bergerac

Lanquais

Dordogne

Cadouin

Castelnaud-
la-Chapelle

Domme

Saussignac

Monbazillac

Rocamadour

PÉRIGORD
POURPRE

Issigeac

Beaumont-du-Périgord

Cénac-et-
Saint-Julien

N

Eymet

Monpazier

Bessè

Biron

Villefranche-du-Périgord

0 10 20
┗━━━━━━━━━━━━━━━━━━━━━━━━━━━━━━━━━┛ Miles

0 10 20 30
┗━━━━━━━━━━━━━━━━━━━━━━━━━━━━━┛ Km.

PÉRIGORD VERT

Abjat-sur-Bandiat (p.20)

Festivals and Fêtes
Patronal festival, the nearest Sunday to 30 September; communal festivals on last Sundays of May and August; summer theatre and dance festival.

Markets
Last Tuesday in the month.

Hôtel-Restaurants
Entente Cordiale; tel. 53 56 81 01.

Restaurants
Chez Berthet; tel. 53 56 81 04.

Camp Sites
Camping du Moulin de Masfrolet; tel. 53 56 82 70.

Bourdeilles (p.26)

Festivals and Fêtes
Fête on first Sunday in August.

Sights
Château open daily, July and August, 09.30–11.30 and 14.00–18.30, 15 September–15 June, daily except Tuesdays; tel. 53 53 44 35.

Hôtel-Restaurants
***Les Griffons; tel. 53 03 75 61.

Restaurants
Restaurant Les Tilleuls; tel. 53 03 76 40.

Camp Sites
Camping Fonseigner; tel. 53 03 42 95.

Information
Syndicat d'Initiative, Grand'Rue; tel. 53 03 42 96.

Brantôme (p.30)

Festivals and Fêtes
Fairs on 2 May and 25 September; walnut fair in October; truffle and *foie gras* fair during Christmas–January; horse show on 15 August.

Markets
Fridays.

Sights
Visits to the abbey, 16 June–15 September, daily except Tuesdays, 10.00–12.00 and 14.00–18.00; Dolmen de la Pierre Levée, a kilometre out of Brantôme on the road to Thiviers, a stone slab raised on three other stones; sixteenth-century Château de Richemont, seven kilometres north-west of Brantôme, 15 July–31 August, daily, 10.00–12.00 and 15.00–18.00, except Fridays and Sunday mornings.

Hôtel-Restaurants
****Hôtel-Restaurant Le Moulin de l'Abbaye, by the river Dronne on the Route de Bourdeilles; tel. 53 05 80 22.
***Hôtel-Restaurant Le Chabrol, by the river Dronne; tel. 53 05 84 74.
***Hôtel Domaine de la Roseraie, in a park 800 metres from the village, in the direction of Angoulême; tel. 53 05 77 94.
**Hôtel du Périgord Vert; tel. 53 05 72 42.
*Auberge du Soir, a sixteenth-century inn in the centre of Brantôme; tel. 53 05 82 93.

Restaurants
Restaurant de la Poste; tel. 53 05 78 55.
Restaurant Le Saint-Marc; tel. 53 05 58 04.

Camp Sites
Camping Municipal, beside the river, Route de Thiviers; tel. 53 05 75 24.

Information
Syndicat d'Initiative, Grand'Rue; tel. 53 05 80 52.

Bussière-Badil (p.38)

Festivals and Fêtes
Easter and 15 September; folklore festival, including ancient methods of threshing, on second Sunday in August; pottery fair at Ascensiontide.

Restaurants
Auberge des Arts; tel. 53 60 52 47.

Excideuil (p.46)

Festivals and Fêtes
Fairs on third Thursdays of January and October, first Thursday in May, second Thursday in December, Thursdays of mid-Lent and before Easter, fourth Thursday in June; communal fête on first Sunday in June; patronal festival on first Sunday in December, celebrated with an agricultural fair.

Markets
Thursdays.

Hôtel-Restaurants
***Hostellerie du Fin Chapon, at the foot of the château; tel. 53 62 42 38.

Restaurants
Restaurant Le Rustic; tel. 53 62 42 35.

Information
Syndicat d'Initiative, 1 Place du Château; tel. 53 62 06 09.

Javerlhac-et-la-Chapelle-Saint-Robert (p.50)

Festivals and Fêtes
Fairs on second Thursday of each month, 2 February and the Monday after 3 August; fête on Sunday after 3 August.

Hôtel-Restaurants
Auberge des Tilleuls; tel. 53 56 30 12.

Restaurants
Restaurant Le Saint Martin; tel. 53 56 12 80.

Jumilhac-le-Grand (p.56)

Festivals and Fêtes
Fairs on second and fourth Wednesday of the month; fêtes on Palm Sunday and the first Sunday of September; agricultural festival on third Sunday of September.

Sights
Visits to the château, 1 July–15 September, 10.00–12.00 and 14.00–18.30, otherwise 11.00–18.00; tel. 53 52 53 22.

Hôtel-Restaurants
La Grange; tel. 53 52 50 07.
Lou Boueiradour; tel. 53 52 50 47.

Chambres d'hôtes
Mme Tinon; tel. 53 52 85 76.

Camp Sites
Camping Municipal; tel. 53 52 57 36.

Information
Syndicat d'Initiative; tel. 53 52 55 43.

Mareuil-sur-Belle (p.60)

Festivals and Fêtes
Fair on 20 of each month; communal fête on Palm Sunday; patronal festival on Sunday after 10 August; pilgrimage on 8 September.

Sights
Château open Easter to All Saints' Day, 14.00–18.00, except Wednesdays, the rest of the year, except festivals and Sundays, 14.00–17.30; the *grand salon* of the château's living quarters now displays elegant Louis Quinze and Regency furniture, including a harp and several books which once belonged to Mme de Staël, the armchair of Mme de Maintenon, a collection of eighteenth-century fans and souvenirs of Napoleon's Marshal Lannes, who died at the battle of Essling.

Two kilometres south-west of Mareuil-sur-Belle stands the splendid Château de Beauregard, built between the fourteenth and the seventeenth centuries, its keep dating from the fifteenth. Close by is a fortified farmhouse.

Five kilometres south-east of Mareuil-sur-Belle is the village of Vieux-Mareuil, whose name indicates that it is older than the seat of the barony. Here, during the Hundred Years War, Guillaume de Mareuil saw his château razed by the English. Not surprisingly, the twelfth-century church of Vieux-Mareuil was fortified two hundred years later and has managed to preserve its three domes, its belfry and its Romanesque porch.

Restaurants
Relais du Château; tel. 53 60 90 86.
Restaurant La Rapière; tel. 53 60 95 50.

Information
Syndicat d'Initiative; tel. 53 60 99 85.

Piégut-Pluviers (p.64)

Festivals and Fêtes
Fête on Sunday after 7 September; antiques fair in August.

Markets
Wednesdays (includes piglets for sale).

Hôtel-Restaurants
Hôtel Continental; tel. 53 56 41 67.
Hôtel-Restaurant Le Minage; tel. 53 56 79 76.
La Vieille Auberge; tel. 53 56 41 96.

Restaurants
Le Périgord Vert; tel. 53 56 52 20.
Le Bistrot; tel. 53 56 53 73.

Saint-Jean-de-Côle (p.70)

Festivals and Fêtes
Fête on Sunday closest to 24 June; horse-racing in June; concerts in August.

Sights
Château de la Marthonie, open daily July and August, 10.00–12.00 and 14.00–19.00; tel. 52 62 30 25.
Museum of daily life in the past, open 15 July–end September, Sundays and holidays, 10.00–12.00 and 14.00–18.00.

Hôtel-Restaurants
Hôtel Le Saint Jean; tel. 53 52 23 20.

Restaurants
Auberge Le Coq Rouge; tel. 53 62 32 71.
Restaurant Les Templiers; tel. 53 62 31 75.

Information
Syndicat d'Initiative; tel. 53 62 14 15.

PÉRIGORD BLANC

Antonne-et-Trigonant (p.78)

Festivals and Fêtes
End of June/beginning of July.

Hôtel-Restaurants
***Les Chandelles; tel. 53 06 05 10.
**L'Écluse; tel. 53 06 00 04.
**La Charmille; tel. 53 06 00 45.

Badefols d'Ans (p.82)

Festivals and Fêtes
Patronal festival on Sunday after 8 September; fairs on third and fourth Mondays of each month and the Monday after 8 September.

Markets
Sundays.

Hôtel-Restaurants
Hôtel-Restaurant Les Tilleuls; tel. 53 51 52 97.

Restaurants
L'Estaminet; tel. 53 51 50 35.

Beauregard-et-Bassac (p.86)

Festivals and Fêtes
Exhibition of local handicrafts, 15 August.

Restaurants
Chez Monique; tel. 53 50 13 10.

Hautefort (p.88)

Festivals and Fêtes
Fairs on first Sunday in the month (selling turkeys in August); festivals on first Sundays of May and August, the second preceded by an agricultural festival, and on third Sunday in September.

Markets
Wednesdays.

Sights
The château is open for guided tours from Palm Sunday to All Saints' Day, 09.00–11.00 and 14.00–17.30 (18.30 in July and August). Château Hautefort houses sixteenth-century Flemish tapestries (as well as Brussels and Aubusson examples) seventeenth- and eighteenth-century furniture and ceramics, and seventeenth-century paintings. Its circular chapel has a choir with *trompe-l'oeil* decoration and paintings of St. Mary Magdalen

and St. Jerôme. The western tower has an exhibition devoted to the most celebrated novelist of the Périgord, Eugène le Roy, author of *Jacquou le Croquant*, who was born in the château in 1836.

Hôtel-Restaurants
Hôtel-Restaurant Le Mediéval; tel. 53 50 40 47.
Hôtel de Voyageurs; tel. 53 50 40 31.

Restaurants
Auberge du Parc; tel. 53 50 88 98.
Auberge à la Ferme Les Rocailles; tel. 53 50 44 38.

Chambres d'hôtes
Chez Bernard Faure, at nearby Le Buisson; tel. 53 50 41 76.

Information
Syndicat d'Initiative; tel. 53 50 40 27.

Limeuil (p.94)

Festivals and Fêtes
Palm Sunday.

Hôtel-Restaurants
Hôtel-Restaurant Bon Accueil; tel. 53 63 30 97.
Hôtel-Restaurant Isabeau de Limeuil; tel. 53 63 39 19.
**Les Terrasses de Beauregard, Route de Trémolat; tel. 53 63 30 85.

Restaurants
Restaurant Le Chai; tel. 53 63 39 36.

Camp Sites
***Camping du Port de Limeuil; tel. 53 63 29 76.
Camping Perdigat; tel. 53 63 31 54.

Information
Syndicat d'Initiative; tel. 53 63 38 90.

Saint-Léon-sur-Vézère (p.98)

Festivals and Fêtes
Fairs on first Monday of the month; communal festival on first Sunday in May; patronal festival on second Sunday in August.

Markets
Sundays.

Sights
Sergeac, to the south-east, has *lauze*-roofed houses, a fortified twelfth-century church and the remains of a thirteenth-century château of the Knights Templar. It is also a centre of prehistory, with five prehistoric

shelters nearby, the finest being the Abri Castelmerle, five hundred metres downstream from the village. Sergeac also has a museum of prehistory open daily Easter to September, except Wednesdays, 10.00–12.00 and 14.00–17.30 (July and August, daily 10.00–18.00); tel. 53 50 77 76.

Hôtel-Restaurants
Auberge du Pont; tel. 53 50 73 07.
Hôtel de la Poste; tel. 53 50 73 08.
**Le Relais de Saint-Léon; tel. 53 50 75 07.

Restaurants
Cave des Templiers; tel. 53 50 19 55.
Le Peyrol, Sergeac; tel. 53 50 72 91.
Restaurant Castel Merle, Castelmerle; tel. 53 50 70 06.

Camp Sites
***Camping Le Paradis; tel. 53 50 72 64.

Siorac-de-Ribérac (p.104)

Festivals and Fêtes
Communal fête on first Sunday of July; patronal festival on first Sunday of August.

Sights
The Double forest and the lake at La Jemaye to the west.
Restaurants
Restaurant Chez Bittard, La Jemaye; tel. 53 90 09 61.

Chambres d'hôtes
La Borie; tel. 53 91 80 09.

Camp Sites
Camping Bittard, by the lake at La Jemaye; tel. 53 90 09 61.

Tourtoirac (p.108)

Festivals and Fêtes
Fairs on 30 April and 30 November; communal fête on second Sunday in May; patronal festival on Sunday after 10 August.

Hôtel-Restaurants
**Hôtel-Restaurant des Voyageurs, with a terrace on the bank of the Auvézère; tel. 53 51 12 29.
Hôtel-Restaurant de la Poste; tel. 53 51 12 05.

Camp Sites
***Camping Les Tourterelles; tel. 53 51 11 17.

Besse (p.118)

Festivals and Fêtes
Fêtes on 25 August at Besse and on first Sunday in June at Prats-du-Périgord; Prats-du-Périgord also has a fair on 23 September and a horse show on the second Sunday after 14 July.

Restaurants
Bar-Buvette, near the Mairie; tel. 53 59 26 77.

Gîtes
Le Passejou, Besse; tel. 53 29 48 03.
Michel Gauthier Milhac, Prats-du-Périgord; tel. 53 29 88 50.

Beynac-et-Cazenac (p.122)

Festivals and Fêtes
Fête on 15 August.

Sights
Château Beynac, with its display of reconstructed medieval weapons, is open 1 March–15 November, 10.00–12.00 and 14.30–17.30, extending to 18.30 in the holiday season.
At Vézac (between Beynac and La Roque-Gageac) seventeenth-century Château de Marqueyssac rises high above the river, its massive round tower built two centuries earlier, its gardens designed by Le Nôtre.

Hôtel-Restaurants
**Hôtel-Restaurant Bonnet; tel. 53 29 50 01.
**Hostellerie Maleville; tel. 53 39 50 06.
Hôtel du Château; tel. 53 29 50 13.
Restaurant-Hôtel La Taverne des Remparts; tel. 53 29 57 76.
*Hôtel-Restaurant Le Relais des Cinq Châteaux, at Vézac; tel. 53 30 30 72.

Camp Sites
**Le Capeyrou; tel. 53 29 54 95.

Information
Syndicat d'Initiative; tel. 53 29 43 08.

Biron (p.128)

Festivals and Fêtes
Fair on 27 February; patronal festival on 29 September.

Sights
Between Easter and 30 September the château is open 10.00–12.00 and 14.00–18.30; at other times ring the doorbell or telephone in advance, except on Tuesdays, for a visit between 09.00–12.00 and 14.00–18.00; tel. 53 54 44 35.

Restaurants
Restaurant du Château; tel. 53 63 13 33.

Camp Sites
Le Moulinal; tel. 53 40 84 60.

Cadouin (p.132)

Festivals and Fêtes
Fête on Sunday before 14 July; fairs on the third Thursday of each month; sheep fair on 8 September; goose fair on 2 November.

Sights
The abbey buildings can be visited 09.30–12.00 and 14.00–18.00, except in March and between 15 December and 1 January; tel. 53 22 06 53.

Hôtel-Restaurants
Auberge de la Salvetat, two kilometres from Cadouin in the Bessède forest; tel. 53 63 42 79.
Hôtel du Périgord/Relais des Moines; tel. 53 61 24 97.
Hôtel Manoir de Bellerive, at Le Buisson de Cadouin; tel. 53 27 16 19.

Restaurants
Restaurant de l'Abbaye; tel. 53 63 40 93.
Restaurant Le Chabrol; tel. 53 63 32 58.

Chambres d'hôtes
Georges Moulin, Pech de la Garde; tel. 53 63 32 67.
At Le Buisson de Cadouin:
Auberge de la Ferme; tel. 53 22 04 26.
Ferme de l'Embellie; tel. 53 22 95 43.
Domaine du Pinquet; tel. 53 22 97 07.
Daniel Gaveau; tel. 53 22 06 43.
Gilbert Agraffel; tel. 53 22 93 97.
Jean-Lacoste Donval; tel. 53 23 95 37.
La Feuillantine; tel. 53 23 95 37.

Camp Sites
Air et Soleil, at Le Buisson de Cadouin; tel. 53 63 11 55.
Camping à la Ferme Beyne; tel. 53 22 00 73.
Camping du Pont de Vicq; tel. 52 22 01 73.

Information
Syndicat d'Initiative, Le Buisson de Cadouin; tel. 53 22 06 09.

Castelnaud-la-Chapelle (p.136)

Festivals and Fêtes
Fêtes on fourth Sunday in September at Castelnaud; first Sunday in February at La Chapelle-Péchaud; first Sunday in May at Fayrac.

Sights

The château is open 1 July–15 September, 10.00–13.00 and 14.00–19.00. Château de Fayrac, founded in the thirteenth century and defended by a double row of fortifications with two drawbridges, is now for the most part a Renaissance building, with sixteenth-century towers and turrets, as well as a square keep.

Hôtel-Restaurants

Ferme-auberge Carinne Rouzier; tel. 53 29 51 86.

Camp Sites

***Camping Maisonneuve; 53 29 51 29.

Restaurants

Le Tournepique; tel. 53 29 51 07.
Le Presbytère; tel. 53 59 30 14.

Cénac-et-Saint-Julien (p.142)

Festivals and Fêtes

Annual wine fair in the village park on first weekend in August; communal festival on Palm Sunday; patronal festival of the Church of the Nativity on 8 September; patronal festival of the second patron of the church, St. Fiacre, on 30 August; fairs on first Tuesday of each month.

Markets

Tuesdays.

Restaurants

Bar-Restaurant Pauly; tel. 53 28 30 10.

Camp Sites

*Camping Municipal; tel. 53 28 31 91.

Domme (p.146)

Festivals and Fêtes

Fête on first Sunday in June; folklore festival during second fortnight in July.

Markets

Thursdays.

Sights

Domme's hall now serves as the entrance to a prehistoric cave, the 450-metres long Grotte du Jubilé, rediscovered in 1912, inhabited in Palaeolithic times and also used as a refuge in the turbulent years of the Christian era, open April to October, 09.00–12.00 and 14.00–18.00 (19.00 in July and August).

Apply at the Syndicat d'Initiative in the afternoons between 1 April and 30 September to enter the towers of the Porte des Tours, where between 1307 and 1318 were imprisoned Knights Templar, who carved on the walls religious symbols as well as curses on Pope Clément V and King Philippe le Bel who were responsible for the destruction of their order.

The Musée Paul Reclus in the Rue du Vieux Moulin is a spaciously set out museum of past times in the region, more than usually interesting, with implements, furniture and costume, open daily, 1 April–30 September, 10.00–12.00 and 14.00–18.00.

Hôtel-Restaurants

***Hôtel l'Esplanade; tel. 53 28 31 41.
Hôtel Lou Cardil; tel. 53 28 38 92.
Le Nouvel Hôtel; tel. 53 28 38 67.

Camp Sites

**Le Bosquet; tel. 52 28 37 39.
*Le Perpétuum; tel. 53 28 35 18.
**La Rivière de Domme; tel. 53 28 33 46.
Jacques Marcillat; tel. 53 28 34 20.

Restaurants

La Maison du Passeur, just outside Domme on the route to Grolejac; tel. 53 28 21 74.
Le Grel, with an enormous welcome for children, open only in the evenings; tel. 53 28 23 42.
Restaurant Auberge de la Rode; tel. 53 28 36 97.

Information

Syndicat d'Initiative; tel. 53 28 37 09.

La Roque-Gageac (p.154)

Festivals and Fêtes

Fête on Sunday after 7 August.

Hôtel-Restaurants

*Hôtel-Restaurant La Belle Étoile; tel. 53 29 51 44.
Hôtel-Restaurant La Plume d'Oie; tel. 53 29 57 05.
Hôtel Gardette; tel. 53 29 51 58.
Hôtel Le Périgord; tel. 53 28 36 55.

Camp Sites

***La Butte; tel. 53 28 30 28.
**Beau Rivage; tel. 53 28 32 05.
**Le Lauzier; tel. 53 29 54 59.
La Plage; tel. 53 29 50 83.

Restaurants

L'Ancre d'Or; tel. 53 29 53 45.

Information

Syndicat d'Initiative; tel. 53 29 17 01.

Monpazier (p.160)

Festivals and Fêtes

Fairs on third Thursday in each month, as well as 7 January, 6 May, 8 July (for selling horses and sheep) and 6 August; fête on Corpus Christi; horse racing at Marsalès, third Sunday in May and first Sunday in August.

Markets
Thursdays.

Hôtel-Restaurants
***Hôtel Edward Ier; tel. 53 22 44 00.
**Hôtel Londres; tel. 53 22 60 64.
*Hôtel de France; tel. 53 22 60 06.

Restaurants
La Bastide; tel. 53 22 60 59.
Chez Prigent; tel. 53 22 60 59.
Restaurant Le Croquant; tel. 53 22 62 63.
Restaurant Le Menestrel; tel. 53 22 61 14.
Restaurant Privilège du Périgord; tel. 53 22 43 98.

Camp Sites
****Le Moulin de David; tel. 53 22 65 25.

Information
Syndicat d'Initiative; tel. 53 22 68 59.

Montfort (p.164)

Festivals and Fêtes
Fête at Vitrac, third Sunday in August and 11 September.
Sights
The gardens of Château Montfort are occasionally open to the general public.
 The hamlet of Vitrac-Bourg boasts a beautifully restored Romanesque church.

Hôtel-Restaurants
****Domaine de Rochebois, with private golf links abutting on to the river Dordogne; tel. 53 31 52 52.
**Hôtel Plaisance, Vitrac; tel. 53 28 33 04.
**Hôtel-Restaurant La Treille; tel. 53 28 33 19.

Restaurants
Restaurant Lacour-Escalier, Caudon, with sturdily traditional cooking; tel. 53 28 33 35.
Restaurant Pauly, Cénac-et-Saint-Julien; tel. 53 28 30 10.

Camp Sites
****Soleil-Plage, Vitrac; tel. 53 28 33 33.
***La Bouysse; tel. 53 28 33 05.
**Clos Bernard; tel. 53 28 33 44.

Rocamadour (p.168)

Festivals and Fêtes
National pilgrimage to Rocamadour in June; summer pilgrimage in July; Pilgrimage of the Nativity, 7–15 September; Whit Monday cheese fair. Arrangements through Pélerinage de Rocamadour, 46500 Gramat; tel. 65 33 63 29.

Sights
Guided tours of the shrines daily, except Sundays, arranged by the Syndicat d'Initiative.
 The forest of monkeys: 15 June–15 August, open 09.00–19.00, otherwise, except 12 November–31 March, open 10.00–12.00 and 14.00–18.00.
 The rock of the eagles: Palm Sunday to All Saints' Day, 10.00–12.00 and 14.00–19.00, demonstrations, 15.00–19.00.
 The prehistoric Grotte des Merveilles at L'Hospitalet, with stalactites, lakes and paintings; open 1 July–All Saints' Day 09.00–12.00 and 14.00–19.00.

Hôtel-Restaurants
***Beau-Site; tel. 65 33 63 08.
**Les Vieilles Tours, three kilometres away at Lafage; tel. 65 33 68 01.
**Sainte-Marie; tel. 65 33 63 07.
**Le Pagès, at Calès, fourteen kilometres away; tel. 65 37 95 87.
**Hôtel du Roc; tel. 65 33 62 43.
**Le Lion d'Or; tel. 65 33 62 04.
**Le Panoramic, at L'Hospitalet; tel. 65 33 63 06.
*Hôtel du Globe; tel. 65 33 67 73.
Auberge de Darnis; tel. 65 33 66 84.

Information
Syndicat d'Initiative; tel. 65 33 62 59.

Saint-Amand-de-Coly (p.172)

Festivals and Fêtes
Concerts in the church; annual fête, 15 August; similar fête at nearby Coly, 24 September.

Sights
The hamlet of Coly, with a ruined fortress which was once the residence of the abbots of Saint-Amand-de-Coly, a Romanesque church, windmills and dove-cot.

Hôtel-Restaurants
Manoir de Hautegente, fourteenth-century house at Coly, three kilometres north; tel. 53 51 60 18.
Hôtel-Restaurant Gardette, beside the abbey; tel. 53 51 68 50.

Restaurants
Restaurant de l'Abbaye; tel. 53 50 83 18.
Chez Sourzat, at Coly; tel. 53 51 68 08.

Camp Sites
Camping Hamelin; tel. 53 61 58 59.

Information
Mairie; tel. 53 51 67 50.

Salignac-Eyvigues (p.174)

Festivals and Fêtes
Fairs on 22 January, 22 February (fowl), 30 June and 9 December; patronal festival on first Sunday in June.

Markets
Second Thursday and last Friday of each month.

Sights
Visits to Château de Salignac-Fénelon, daily except Tuesdays, 1 April–31 October, 10.00–12.00 and 14.30–18.30.
 Guided tours of the gardens of the Manoir d'Eyrignac, 10.00–12.30 and 14.00–19.00, closing 17.00, November–March.

Hôtel-Restaurants
**Hôtel-Restaurant Coulier; tel. 53 28 86 46.
**Hôtel de la Terrasse; tel. 53 28 80 38.
Restaurant-Hôtel de France; tel. 53 28 80 14.

Restaurants
La Meynardie, outside the village in the direction of Sarlat; tel. 53 28 85 98.

Information
Syndicat d'Initiative; tel. 53 28 81 93.

Villefranche-du-Périgord (p.178)

Festivals and Fêtes
Fairs on 2 and 25 January, 8 May, 10 June, 24 July, 16 August, last Saturday and Sunday in August (bric-à-brac), 19 September, the third Saturday in October, 11 November (horses) and 12 December (cattle); fête on 15 August.

Markets
Saturdays (chestnuts and *cèpes* in September, October and November).

Hôtel-Restaurants
**Auberge La Clé des Champs; tel. 53 29 95 94.
**Hôtel-Restaurant La Petite Auberge; tel. 53 29 91 01.
Hôtel du Commerce; tel. 53 29 90 11.
Hôtel-Restaurant Les Bruyères; tel. 53 29 97 97.

Chambres d'hôtes
Jean-Paul Dubruel; tel. 53 29 49 99.

Information
Syndicat d'Initiative; tel. 53 29 98 37.

PÉRIGORD POURPRE

Beaumont-du-Périgord (p.186)

Festivals and Fêtes
Fairs on second Tuesday of each month; fête on Sunday after 15 August.

Hôtel-Restaurants
*Hôtel-Restaurant Chez Popaul (also called Hôtel des Voyageurs); tel. 53 22 30 11.
Hôtel-Restaurant Les Arcades; tel. 53 22 30 31.
Ferme-auberge Chez Mireille et Jean Lasplatte; tel. 53 22 30 73.

Restaurants
Grigoletto; tel. 53 22 45 52.

Chambres d'hôtes
Château de Regagnac; tel. 53 22 49 98.

Camp Sites
***Camping des Remparts; tel. 53 22 40 86.

Information
Syndicat d'Initiative; tel. 53 22 39 12.

Eymet (p.190)

Festivals and Fêtes
St. Catherine's fair, 25 November; votive festival, last Sunday in July.

Markets
Thursdays.

Sights
Museum in the keep open during the holiday season, 10.00–12.00 and 15.00–18.00, except Sundays.

Hôtel-Restaurants
*Hôtel Beauséjour; tel. 53 22 81 54.
Hôtel Les Fauchés; tel. 53 24 69 27.

Restaurants
La Bastide; tel. 53 23 71 37.
Restaurant La Ferme du Périgord; tel. 53 23 82 77.
Restaurant Italien des Arcades; tel. 53 29 90 05.
Le Relais des Ducs; tel. 53 23 89 10.
Les Vieilles Pierres; tel. 53 23 75 99.

Information
Syndicat d'Initiative; tel. 53 23 74 95.

Issigeac (p.194)

Festivals and Fêtes
Fairs on second Thursday and fourth Wednesday (lambs) in the month; agricultural fair every two years in September; June festival, with a procession of decorated carts; horse racing at Whitsun.

Markets
Sundays.

Sights
Eighteenth-century former charterhouse, at the nearby perched village of Montaut.

Hôtel-Restaurants
Les Bastides; tel. 53 58 72 28.
**La Brucelière; tel. 53 58 72 28.
Hôtel-Restaurant Le Lion d'Or; tel. 53 58 73 05.
Hôtel de France; tel. 53 58 76 43.

Restaurants
Relais Gastronomique du Périgord; tel. 53 58 70 29.

Chambres d'hôtes
La Chartreuse de Sord, Montaut; tel. 53 58 76 70.

Information
Mairie; tel. 53 58 79 62.

Lanquais (p.198)

Festivals and Fêtes
Cultural manifestations in the restored Grange; fêtes on Ascension Day and second Sunday in September.

Sights
Château open daily, except Thursdays, 1 April–30 September, 09.30–12.00 and 14.30–19.00; tel. 53 61 24 24.
On the opposite bank of the Dordogne, the feudal Château Baneuil, open daily in August, 14.00–18.00.

Hôtels
Ferme Équestre de la Crabe; tel. 53 24 99 13.

Restaurant
Auberge des Marronniers; tel. 53 24 93 78.

Gîtes
Patrick Delanes; tel. 53 61 13 48.

Saint-Michel-de-Montaigne (p.202)

Festivals and Fêtes
Third and fourth Sundays in May and fourth Sunday in September.

Sights
Montaigne's château, open 09.00–12.00 and 14.00–19.00, except Mondays and Tuesday mornings, closed 6 January–6 February.

Hôtel-Restaurants
***Hôtel Saint-Michel-de-Montaigne; tel. 53 24 89 59.
Auberge de la Tour (weekends); tel. 53 58 60 67.

Trémolat (p.206)

Festivals and Fêtes
Easter; international sailing competitions in August.

Hôtel-Restaurants
***Hôtel-Restaurant Le Vieux Logis, with a garden almost as appetizing as its food; tel. 53 22 80 06.
**Hostellerie Le Panoramic, with its view of the Dordogne 'loop'; tel. 53 22 80 42.
Hôtel-Restaurant Lou Cantou; tel. 53 27 95 61.
Hôtel-Restaurant Le Périgord; tel. 53 22 81 12.
Auberge de la Pénétie; tel. 53 22 80 53.

Restaurants
Restaurant Le Saint-Hilaire; tel. 53 22 82 92.

Camp Sites
***Camping International de Trémolat; tel. 53 22 81 18.

Information
Syndicat d'Initiative; tel. 53 22 89 33.

SELECT BIBLIOGRAPHY

Aubarbier, Jean-Luc, Binet, Michel, and Mandon, Guy,

 Nouveau Guide du Périgord-Quercy, 1987.

Bentley, James, *A Guide to the Dordogne*, 1985.

Bentley, James, *Life and Food in the Dordogne*, 1986.

Bentley, James, *Fort Towns of France*, 1993.

Bercé, Yves-Marie, *Croquants et Nu-pieds*, 1974.

Blancpain, Marc, *Histoires du Périgord*, 1974.

Brook, Stephen, *The Dordogne*, 1986.

Chavant, Jean-Paul, *Le Périgord*, 1976.

Fénelon, Paul, *Le Périgord*, 1982.

Guignadeau-Franc, Z., *Les Secrets des Fermes en Périgord Noir*, 1980.

Leray, Jean-Pierre, *Châteaux, Bastides, Commanderies*

 du Périgord, 1976.

Lormier, Dominique, *Connaître les Châteaux du Périgord*, 1989.

Maubourget, J., *Choses et Gens du Périgord*, 1941.

Michel, Léon, *Le Périgord et les Périgourdins*, 1965.

Oyler, Philip, *The Generous Earth*, 1950.

Penaud, Guy, *Histoire de la Résistance en Périgord*, 1991.

Renard, Bertrand, *Sarlat et le Périgord Noir*, 1982.

Richard, Dominique, et al., *Le Guide Dordogne Périgord*, 1993.

Rocal, G. and Balard, P., *Science de Gueule en Périgord*, 1938.

Le Roy, Eugène, *L'Année Rustique en Périgord*, new edition, 1966.

Secret, Jean, *Eglises du Périgord*, n.d.

White, Freda, *Three Rivers of France: Dordogne, Lot, Tarn*, 1952.

Wood, Katherine, *The Other Château Country. The Feudal Land of*

 the Dordogne, 1931.